CONTENTS

KU-577-380

PREFACE

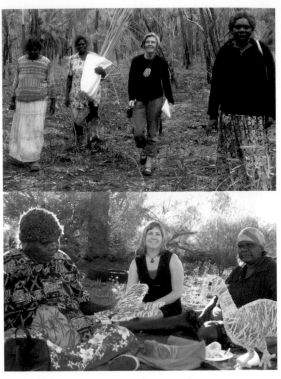

TOP: Lena Walunidjunali, Margaret Rarru Garruwurra, Susan McCulloch and Ruth Nalmakarra at Milingimbi, August 2007.

The ladies of Titjikala and Emily McCulloch Childs, Sept. 2005.

This book had its genesis during research for the 1994 edition of *McCulloch's Encyclopedia of Australian Art*. Frequently I found myself surrounded by many books on individual artists, historical texts, and general books on Aboriginal art (many listed at the back of this book). Missing was one book which explained, through clearly illustrated text, the regional and stylistic differences of Aboriginal art and the history of its modern development.

This book was written to fill that gap. First published in 1999, updated and re released in 2001, it proved very popular. This new edition has been completely revised and updated and charts the vast growth in this art movement since 2000.

The first edition took some five years from good idea to published book during which I visited and revisited as many arts centres, regions, and country as possible throughout the Centre, Arnhem Land and Kimberley. This was not a new journey, although it was more focused than those before. My first trip to the desert had been in 1964 on a school trip from Victoria's Mornington Peninsula to Hermannsburg, 125 west of Alice Springs. Later trips were to many other regions. My interest in Aboriginal art had also been backgrounded by my family, whose milieu included those such as Donald Thomson, ethnographer Leonhard Adam, the collector Karel Kupka, and many others whose work with Aboriginal art and culture had been significant from the 1940s. My mother Ellen was an inspirational, strong and independent thinker and great egalitarian; my father, Alan McCulloch was similarly visionary and had championed the positioning of Aboriginal art in a fine art context from the 1950s. In 1965 he curated an exhibition of barks from the Museum of Victoria for the Museum of Fine Arts, Houston, Texas. I typed the catalogue and will never forget the power of those early barks in the then dusty and very dark storage rooms of the old Museum of Victoria.

In 1994 I also became the visual arts writer for *The Australian*, writing over the ensuing ten years, often the equivalent of an average paperback each year on the visual arts, and especially the art of Aboriginal Australia. Many articles were features, profiles, reviews, editorials news stories and eventually obituaries of some of the great artists it has been my privilege to have known. Others were more confronting revelatory stories about fakes, frauds and industry malpractice.

Throughout, the travels continued – their reach extending with the evolution of art.

In 2006 my daughter, publishing partner and co-author Emily McCulloch Childs (whose interest in, and knowledge of, Aboriginal art is impressive) and I were deep into the update of

our huge *McCulloch's Encyclopedia of Australian Art,* Edition 4. We knew that next would be the much-requested update of this book.

So here we are. Many more trips – and many words and experiences later. Travels have included revisits to known areas but also to those not visited before – especially the vast and wonderful PY and NPY lands, throughout which art has mushroomed in recent years. New art from this region has been one of the most striking developments seen in this edition. So too the revival of art in many older-established art communities, notably Arnhem Land's Milingimbi and Queensland's Mornington Island. Queensland art, is, in general steaming ahead. So too the new directions for long established art communities such as the Papunya artists now based at Kintore; those at Yuendumu, Balgo, Maningrida, Yirrkala, Warmun and many more. Key regional cities or towns such as Darwin, Alice Springs and Kununurra have now also become centres for art production as well as display, and the increase in city-based and new media artists is expanding constantly.

The breadth of this art speaks for itself though the pages of this book, as well as by the numbers of new galleries and exhibitions featuring Aboriginal art, too numerous now to mention individually.

The 2001 edition comprised three main regions and 22 communities. This edition features nine regions and more than 80 places and arts centres.

Apart from this sheer growth, most striking in our research has been the significance of the homelands movements. It is very clear that when artists are in, or return to, their homelands, art blossoms.

As noted in the preface for the first edition, constant change is a given in any art form, and especially this, so by the time this book appears there will have been already new developments. Such dynamism alone speaks for the extraordinarily vibrant nature of this art and a growth which shows no sign of abating.

Susan McCulloch, Melbourne, July 2008

Acknowledgements

As always a huge thanks to those who worked with us most closely. Sandra Nobes for her, again, stunning text and other design. Susan Keogh and Nadine Davidoff for editing and Ophelia Leviny for maps. Jamie Anderson for his always knowledgeable proofreading and indexing. Marcelle Spangaro, for her stirling administrative work, and for her daily wit, warmth and cheer. Fil and Will at Hellcolour. To Lisa Reidy for her great fresh take on the cover design and other graphic material. Holy Cow! for their graphic work and a special thanks to Moo. Inventive Labs for web design. Anne Runhardt for her friendship, photos, invaluable professional help and for being a great travelling companion. So too our other sometime travelling buddy Alison Kelly. Reé Izett, thank you for your imaginative take on our marketing and publicity. All the galleries, artists, art centres, auction houses and others as noted in captions throughout for your generous supply of images, for reading and correcting our text and for responding with alacrity to our numerous requests. A special thanks to Anthony Wallis of Aboriginal Artists Agency Ltd. for his fine dealings on behalf of the many significant artists he represents and to Bob Edwards, long time friend, font of information and for being one of Australia's living treasures. Susan would like to thank all those at *The Australian* with whom she worked so closely with on so many stories in this world from 1994 to 2004; especially the news editors and Deborah Jones, Katrina Strickland and Michael Reid. To the family of the late Lin Onus, in memorium. Margo Neale for her great preface for previous editions and for her ongoing support. Janine Burke for her wonderful friendship and professional support. Alice (Alison Hunt) sister in spirit and Stan Butler who linked us together, miraculously, in a flash, after so many years. Emily would like to thank, once again, those who shared their incredible knowledge of Aboriginal art and helped set her on this journey – Sonia Heitlinger, Ada Bird Petyarre, Paul Walsh, Geri James, Charmaine Torres, Barbara Weir, Nina Bové, Hank Ebes and Fred Torres. To those on the ground in this art world who have shared their insights and knowledge with us, and the great artists now passed on who we were privileged to have spent time with. What experiences. To the sellers, buyers and supporters of this book – many thanks for your hugely warm responses. To all those whose knowledgeable texts we value highly and have noted throughout. A big thanks to all those out there in the lands – south, west, and north – for your hospitality and going out of your way over so many years, to educate and show us life as it is, and often always has been, in your worlds. And especially the artists of Australia, without whom, of course, none of this would exist. This book is for you all.

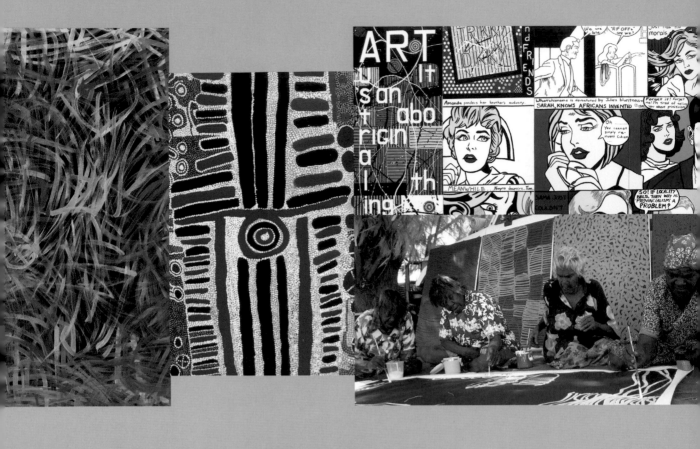

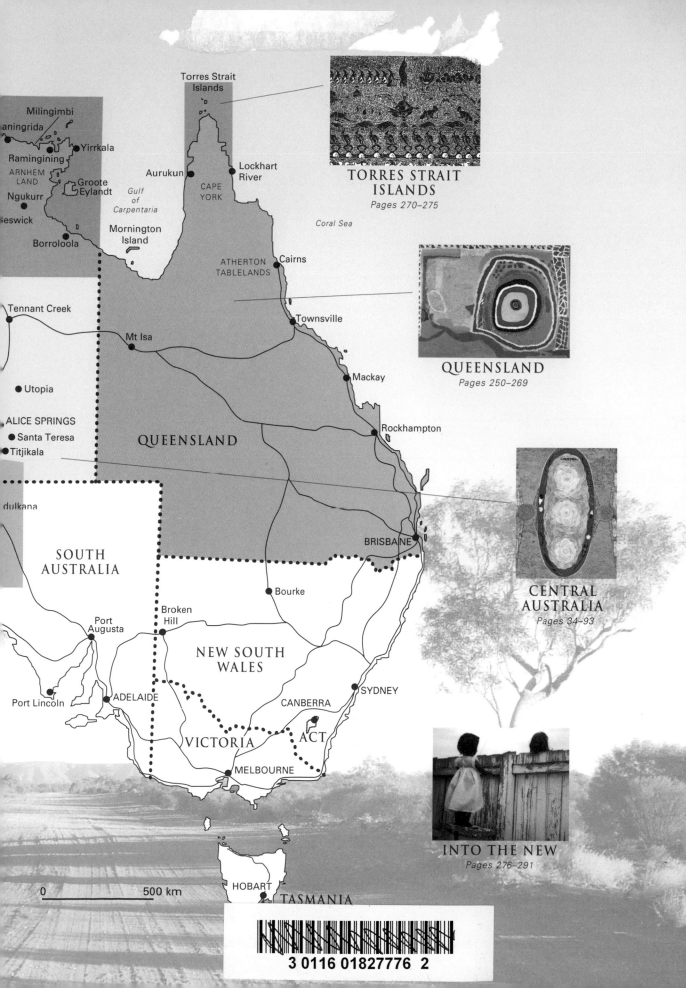

Milingimbi
aningrida
Ramingining
Yirrkala
ARNHEM
LAND
Groote
Eylandt
Ngukurr
eswick
Borroloola

Torres Strait
Islands

TORRES STRAIT
ISLANDS
Pages 270–275

Aurukun
Lockhart
River
CAPE
YORK

Gulf
of
Carpentaria

Mornington
Island

Coral Sea

ATHERTON
TABLELANDS
Cairns

Tennant Creek

Townsville

Mt Isa

QUEENSLAND
Pages 250–269

Utopia

Mackay

ALICE SPRINGS
Santa Teresa
Titjikala

QUEENSLAND

Rockhampton

dulkana

BRISBANE

CENTRAL
AUSTRALIA
Pages 34–93

SOUTH
AUSTRALIA

Bourke

Broken
Hill

Port
Augusta

NEW SOUTH
WALES

Port Lincoln

ADELAIDE

SYDNEY

CANBERRA

VICTORIA

ACT

INTO THE NEW
Pages 276–291

MELBOURNE

0 500 km

HOBART
TASMANIA

McCulloch's
contemporary
Aboriginal Art
the complete guide

Susan McCulloch
Emily McCulloch Childs

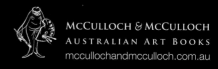

McCulloch & McCulloch
AUSTRALIAN ART BOOKS
mccullochandmcculloch.com.au

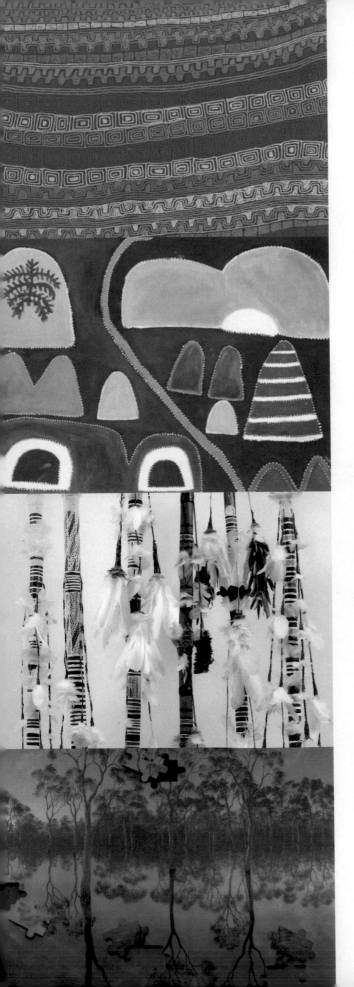

First published in 1999, updated edition in 2001
This edition published 2008 by
McCulloch & McCulloch Australian Art Books
PO Box 2482, Fitzroy, Vic, 3065.
www.mccullochandmcculloch.com.au

*The publishers thank the relations of those now passed on
who have allowed reproduction of images in this book.*

National Library of Australia
Cataloguing-in-Publication data
McCulloch, Susan
Contemporary aboriginal art. Susan McCulloch.
Emily McCulloch Childs.
Index. Bibliography.
1. Art, Australian Aboriginal artists. 2. Art, Aboriginal
Australian. 3. Painting, Aboriginal Australian.
Other authors: McCulloch, Emily, 1976 –

ISBN 978 0 98044 942 6

704.039915

Text design and typesetting by Sandra Nobes
Cover design by Lisa Reidy
Maps by Ophelia Leviny
Endpaper map by Sandra Nobes and Ophelia Leviny
Pre Press by Hellcolour, Richmond, Melbourne
Printed in China by Everbest Printing Company

www.mccullochandmcculloch.com.au

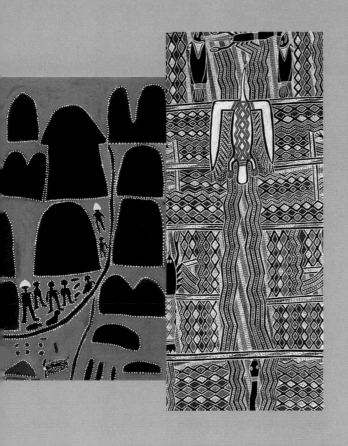

The LIVING ART of ABORIGINAL AUSTRALIA

The LIVING ART of ABORIGINAL AUSTRALIA

In June 1997 a small painting by Central Desert artist John Warangkula Tjupurrula painted in 1973 attracted worldwide attention by breaking all auction records for an Aboriginal work when it sold at Sotheby's Aboriginal art auction in Melbourne for $206 000. Three years later, the same painting resold for $486 500. Ten years later, Aboriginal art entered yet another new era with two paintings beating the $1 million mark. In May 2007 Emily Kame Kngwarreye's *Earth's Creation* sold at a Lawson Menzies Aboriginal art auction for $1.04 million and two months later, Clifford Possum Tjapaltjarri's 1977 painting *Warlugulong* doubled this by selling for $2.4 million.

Around 6000 to 7000 Aboriginal people, about one quarter of Australia's total indigenous population, are engaged, throughout Australia, in the making of art and artefacts with sales of their work in 1996 estimated at more than three times that of other Australian artists.[1]

These figures, combined with the increasing number of galleries showing and selling indigenous art, the vast increase in numbers of Aboriginal community arts centres (from around 30 in 1996 to close to 100 in 2008) and the rise

TOP RIGHT: Clifford Possum Tjapaltjarri, *Warlugurlong*, 1977 (detail), acrylic on canvas, 202 x 337.5. Collection, National Gallery of Australia. [Courtesy Sotheby's, the Ebes Collection and Aboriginal Artists Agency Ltd.]

FAR RIGHT: Johnny Warangkula Tjupurrula, *Water dreaming at Kalinpinypa*, 1972, acrylic on board, 80 x 75 cm. Private collection. [Courtesy Aboriginal Artists Agency Ltd.]

These two classics of 1970s desert art became auction record-breaking paintings in the 1990s and 2000s.

in the secondary market show that growth in this area is not only on the steady increase but rising dramatically. A proportion of these sales is tourist art and craft but an increasingly high percentage is fine art.

Aboriginal art has also been one of the most positive black–white cultural collaborations in modern history – one which benefits not only Aboriginal communities where it has become an important facet of cultural and financial restoration but also Australian society as a whole, and, at a broader level, the art-loving public of the world. It is the art form with which Australia has become most identified internationally.

Until the rise in popularity of modern Aboriginal art movements, much of Australia's Aboriginal culture was in danger of being entirely subsumed by European civilisation. Two hundred years of white occupation had brought to Australia's indigenous population death, dispossession of lands and debilitation in many forms. Until the 1920s or later, Aboriginal people had suffered massacres as well as debilitation, the introduction of diseases and altered ways of life. More recently poor diet and alcohol and other drugs have become major health risks.

'In retrospect this turned out to be one of the most subtle and brilliant marketing exercises in Australian art – and it's never really been acknowledged or credited as being that of Aboriginal people themselves.'

Bill Whiskey Tjapaltjarri, *Rockholes near the Olgas,* 2007
(detail), acrylic on canvas, n.s. Private collection. [Courtesy
Museum and Art Gallery of the Northern Territory.]

**The Pitjantjatjara of the south did not paint for many
years following the establishment of the Papunya
school, believing that many images were too sacred
to be publicly seen. It has only been since the 1990s
that painters like this master Pitjantjatjara painter
have started painting professionally and now have
become some of Australia's most dynamic painters.**

Societies, close knit and well ordered
for tens of thousands of years, became
fragmented and fragile lands were degraded
by the overgrazing of introduced animals.
While Christian missions provided sanctuaries,
shelters and food, the imposition of a foreign
belief system and the active repression of the
practice of traditional customs often led to the
further unravelling of indigenous societal bonds.

Between 1940 and 1960 under the Australian
government's 'assimilation' policy, the aim of
which was to 'rehabilitate' Aboriginal people
for inclusion in European society, a number
of programs were implemented. One was
to remove non full –blood children from their
homes to be brought up in foster homes
or orphanages (40 years later this would be
the subject of a major inquiry into Australia's
'stolen generations'). Another program was the
establishments, in the Central Desert regions,
of a number of Aboriginal-only communities

alongside those already established by
missionaries. People were literally rounded up
from their tribal lands with little consideration
given to the effect of forcing those of different
tribal heritage to live in close proximity; strictures
on travel meant that people could not visit their
home areas for important cultural activities, to
gather foods or for simply the pleasure or choice
of so doing. In one instance Warlpiri people
from Yuendumu were transported around 1000
kilometres to the north to form the community of
Lajamanu – the whole community walking back
to their Warlpiri homelands three times before
the birth of children in Lajamanu led to it being
accepted as a permanent home.

A similar dislocation occurred in the vast
West Australian regions.

In Australia's Top End, Arnhem Land, the
Tiwi and Torres Strait Islands, although Christian
belief systems were often introduced, fewer
people were removed from their lands and so
more readily able to maintain belief systems
(many often also incorporating Christianity) and
cultural practice.

It was not until 1967 that Aboriginal people,
previously ironically not regarded as 'Australian
citizens', were given the vote. During the 1960s
and 1970s, a growing social conscience in the
white population, awakened largely through
the civil rights movements of the USA and
South Africa and the initiatives of Aboriginal
people themselves, led throughout Australia

to a growing demand for both land rights and compensation for Aboriginal people. This was given further impetus in 1972 with the election of Australia's first Labor government for 23 years, led by Gough Whitlam, which made land rights a priority reform. Pivotal in this platform was the establishment of small 'outstation' or 'homelands' movement in which people were assisted, through servicing of basic food, health and sometimes educational needs, to move back to traditional areas. Throughout central, southern and western regions as well as in the Top End, people moved in family groupings to set up permanent outstation settlements on their traditional lands.

By the late 1980s most of the former government and mission-owned settlements had been given back to the control of their Aboriginal owners. This return to Aboriginal control of communities and the homelands movement has been highly significant for the development of art in these regions. From 2007, however, with a sudden Federal Government administrative and military intervention into Aboriginal communities as a result of revelations of serious issues of abuse of many kinds in some Aboriginal communities, the future of communities and especially those of smaller outstations is in a state of flux.

The basis of the art

Aboriginal art is based on stories and traditions of the creation of the world, during which creation ancestors took epic journeys and created people, flora, fauna, landforms and celestial bodies. It is from this that laws of kinship and marriage derived and regular ceremonies required to renew growth, protect

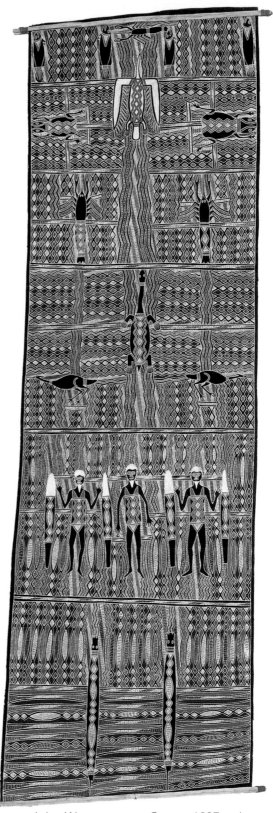

Yanggarirriny Wunungmurra, *Gangan*,1997, ochre on bark, 299 x 97.5 cm. Collection, Museum and Art Gallery of the Northern Territory. [Courtesy, Buku-Larrnggay Mulka and MAGNT.]

the land, ensure fertility and health and keep the stories of the ancestor creators and their creations alive. Unlike the time delineations of Western history, the Aboriginal belief system does not relate only to the past but is constantly evolving. It is kept alive through ceremonial practice, which guides and dictates customs and laws while re-affirming spiritual beliefs. Contemporary events such as floods, fires, cyclones and other natural phenomena and sometimes aspects of daily life such as sport and current events are also incorporated.

This concept is often called the 'Dreamtime' or 'Dreaming' named so by early 20th century anthropologists attempting to convey a belief system which is at one past, future and contemporary. The term 'dreaming' however implies a more fanciful concept that that denoted by Aboriginal belief system itself. Anthropologist W. E. H. Stanner attempted a more accurate, but less popularly evocative, title of the 'everywhen' (see *Wadeye*, p. 212) to denote the all encompassing nature of the Aboriginal belief system.

At the core of this belief system is that the land and its people are interdependent. Nor is the Aboriginal belief system one ideology but specific to each of hundreds of different tribal groupings with numerous different creation stories. The Rainbow Serpent is one of the powerful creation stories found through most parts of Australia; similarly that of the Dingo; Seven Sisters and a number of others. In the Top End and Arnhem Land creation ancestors include the Djang'kawu brother and the Wagilag Sisters who traversed the sea and land creating rivers, mountain ranges and other formations as well as the people themselves. In the north-western Kimberley, the supernatural Wandjina beings control rain and fertility. Ancestral Tingari men and women traversed areas of the Western Desert bringing law and culture. The Honey Ant, Lizard, and Fire Dreamings are just some of the other major creation stories of the central areas.

LEFT: Queenie McKenzie, *Three Massacres and the Rover Thomas Story*, 1996, (detail), ochre on canvas, 140 x 100 cm. Gantner Myer Collection, Museum Victoria. [Courtesy estate of the artist and William Mora Galleries.]

CENTRE: Rosella Namok, *Blue Water,* 2007, etching, 49.5 x 68 cm. Multiple collections. Printers, Basil Hall and Natasha Rowell. [Courtesy the artist, Leo Christie and Basil Hall Editions.]

Right: Emily Kame Kngwarreye, *Awelye*, 1996, (detail) acrylic on canvas, 90 x 60 cm. Private collection. [Courtesy estate of the artist and Utopia Art.]

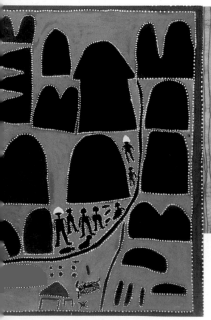

Dances and songs, designs made in sand, incising and paintings on rock walls and bark shelters, designs painted on the body and the making of a number of sacred objects and more recently acrylic, ochre paintings, and many other practices affirm and renew these stories and the laws they impart.

Imagery in Aboriginal Art

Aboriginal art from this base is not conceived, as is much Western art, from perceived subject matter. Neither does the western notion of aesthetics apply; nor that of an artist's desire to communicate emotions, thoughts or observations or comment in a highly individual manner. Under Aboriginal law, an artist is permitted to portray only those images and stories to which, through birthright, he or she is entitled. To do otherwise is a serious and punishable offence. Within this confine, the styles and imagery of work vary widely, and increasingly so as new forms evolve. There are artworks notable for meticulous layering and overlaying of fine dots to create works of shimmering luminosity; others have an appealingly fresh quality with bold use of colour and raw, free design; others still are notable for an adherence to traditional design while showing innovation of the application of finer and more rhythmic lines. Even paintings such as those by the late Emily Kame Kngwarreye, Rover Thomas, Minnie Pwerle and many others, which have been embraced and praised in Western terms for their similarity to internationally famous abstractionists, derive from this base.

For some viewers the story of the work is important; for others, the visual impact of the painting predominates. It is this combination of a strong sense of design, finely honed use of colour or surface texture, spatial relationships underpinned by an intangible but ever-present connection with the land, its creators and their stories, and the artist's rights to and interaction with this that gives much Aboriginal art its unique quality and power.

However, from the 1980s, a whole new generation of indigenous artists has evolved linked to this art but with their own, often highly individual styles. These often urban-based artists incorporate their indigenous histories as the basis of art which includes the commentary, the narrative, the personal, the aesthetic and the political. (See *Into the New* p. 276)

Background to the Art

The oldest forms of Australian indigenous art are the engravings on cave walls dating back at least 60 000 years. These are found throughout Australia in many forms. The caves of Arnhem Land, north-western Australia and northern Queensland are rich in representations of figures, birds, animals, mythological creatures and non-figurative designs, as well as paintings and engravings of more recent origin. In the Kimberley, the images of Wandjina, the rain spirit or fertility figures, are plentiful on cave walls, as are, to a lesser extent, the very different stick-figure Bradshaw figures. Rock art sites range throughout other areas of

Taken by ethnographer Charles Mountford in the 1940s, this photograph shows the confident graphic skills of desert peoples – the basis for much contemporary art.

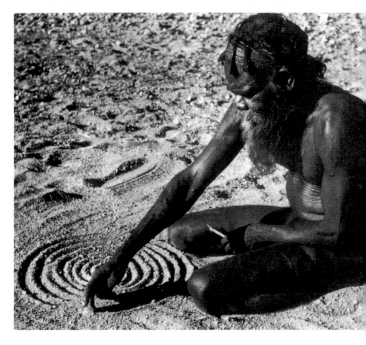

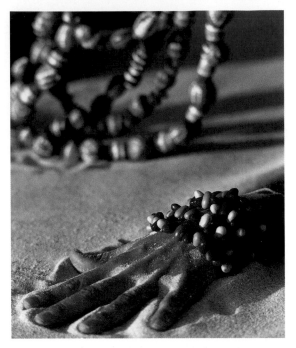

Aboriginal women in all regions of Australia make beads and other jewellery, such as these colourful beads made from the ininti (seeds of the bat wing coral tree) and painted gumnuts. [Photo. Andrew Rankin. Courtesy The Rainbow Serpent Gallery]

RIGHT: *These baskets are made by the Tiwi Islanders as part of the Pukumani burial ceremony.* [Photo. Tourism NT.]

Australia and include the incised carvings in the desert regions of western, central and eastern Australia and throughout the southern states; the figurative and other paintings of the areas around Lake Mungo, New South Wales; around Sydney's coastal fringes; the Blue Mountains; those of the Grampians in Victoria; and throughout Tasmania.

Body painting, which is the basis for much contemporary art design, is practised throughout Aboriginal Australia and remains an important part of cultural and ceremonial practice, especially for women.

Throughout central Australia, traditional means of perpetuating culture included the engravings on stone and wood such as those on the sacred tjurunga (the small and highly

sacred storytelling boards of desert regions that relate a man's history).

In many regions, especially the central areas, sand 'painting' in which ritual designs were made on cleared areas of sand before or as part of ceremony was an important method of passing on visual images. These were either created specially or by the feet of dancers while performing ritual ceremonies. Not intended to be a permanent record these were usually demolished, swept clean or simply abandoned after their purpose had been served.

Barks, Carving and Fibre

Arnhem Land and islands to the north are famed for bark paintings as well as weavings and carvings such as burial poles, originally for ceremonial use; in more recent times these have become art objects. The peoples of Yirrkala, Maningrida, Milingimbi, Elcho Island, Ramingining and other areas carve and paint different styles of memorial poles and hollow

log coffins in which traditionally the bones of the deceased were placed. Other forms of historically important indigenous sculpture include elaborately carved tree-trunks, decorated skulls (in some parts of Arnhem Land) and painted woodcarvings of heads and figures (northern coastal regions). Fibre work – bags, baskets, mats and other items – has a long and rich tradition. The hair or plant fibre string from which these items are made itself often carries spiritual power or is used in the numerous string games made by fingers and hands to tell stories both sacred and secular, to improve finger dexterity and coordination, and as entertainment.

From the mid-1900s, with the increase of tourism, some traditional desert artefacts, such as boomerangs, coolamons (carrying vessels) and music sticks, often decorated with incised designs, were made especially for sale. Other figurines, such as those of animals, birds and reptiles, were carved from wood and sometimes soapstone while more formal pottery workshops were established as an art and craft activity.

Early collections

In Australia's southern areas, 19th-century artists such as the tribal leader William Barak at Coranderrk (near Melbourne) painted and drew images of both his traditional stories and current events, as did Tommy McCrae of Victoria and New South Wales and the artist known as Mickey of Ulladulla of New South Wales. The first collection of barks were those from the Northern Territory's Cobourg Peninsula (on the western coast of Arnhem Land) from the short-lived European settlement of Victoria at Port Essington in 1838. Now in the collection of the Macleay Museum, University of Sydney, they comprise images painted on the walls of bark shelters.

From the early 1900s ethnographers and anthropologists such as Baldwin Spencer, Francis Gillen, Donald Thomson, T. G. H Strehlow, Charles Mountford, Ronald and Catherine Berndt, Leonhard Adam, Karel Kupka from Paris and others had collected bark paintings and numerous other objects that formed the bases of large collections in

Australian and some international museums. The collections, lectures and writings by these ethnographers and others such as A. P. Elkin, George Grey, Norman Tindale, Frederick McCarthy, Ursula McConnell, Phyllis Kaberry, Robert Edwards, Jim Davidson, Sandra Holmes and visits by southern-based artists to Arnhem Land from the 1940s to the 1960s, led to discussion in Australia's art circles about the types and significance of Aboriginal imagery. By 1950 it was estimated there were over 1000 barks in Australian public collections.

Early Exhibitions

The first display of Aboriginal art in the southern states was that from inmates of Darwin's Fannie Bay Gaol, gathered by deputy-sheriff of the gaol, J. G. Knight and shown as *The Dawn of Art* as part of the display of Northern Territory art in the 1888 Melbourne Exhibition. The first comprehensive exhibition of bark paintings and artefacts held in a public art gallery, as distinct from the permanent ethnological

William Barak, *Ceremony,* 1895, ochre, pencil and charcoal on canvas, 60 x 75.5 cm. Private collection. [Courtesy Sotheby's.]

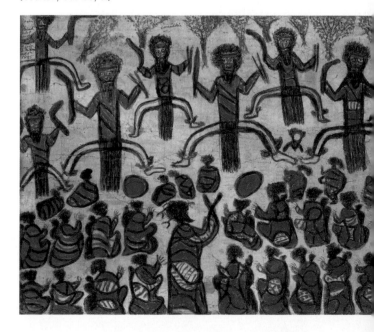

displays in Australian museums, was opened at the National Gallery of Victoria on 9 July 1929. The *Jubilee Exhibition of Australian Art*, which toured Australian state capital cities in 1951, included 26 Aboriginal bark paintings; but the first fully documented, comprehensive travelling exhibition, *Australian Aboriginal Art*, was organised by Tony Tuckson and toured Australian state galleries in 1960–61. A selection of works from this exhibition was sent later, under the auspices of the Commonwealth Art Advisory Board (CAAB), to represent Australia at the 1961 Bienal de São Paulo, Brazil, where it created widespread interest. Another important early exhibition, *Australian Aboriginal Art*, was held at the Qantas Gallery in New York in 1963 and an exhibition of Australian Aboriginal art put together by F. D. McCarthy was sent to the Commonwealth Arts Festival in 1965 and shown at Liverpool and London. In the same year, a loan exhibition of bark paintings from the National Museum of Victoria was organised by Alan McCulloch for the Museum of Fine Arts at Houston, Texas.

Otto Pareroultja, *Central Australian Landscape*, c. 1970s, watercolour on paper, 52 x 75 cm. Private collection.
[Courtesy Joel Fine Art.]

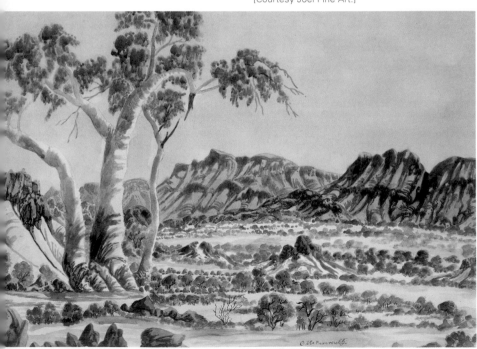

Images on Western materials

A number of pioneers including Central Australia's Daisy Bates and ethnographers such as Norman Tindale, Catherine and Ronald Berndt and Charles Mountford had, from the early years of the 20th century, requested Aboriginal peoples to record their traditional designs with western materials such as pencils and crayons on paper. (See *Introduction: NPY Lands*. pp. 98–101)

The Hermannsburg school: a vibrant watercolour school develops

During the mid 20th century, at Hermannsburg, 130 kilometres west of Alice Springs, the paintings by the man who was to become Australia's most famous Aboriginal artist of the first half of the 20th century were starting to come to the public's attention. Albert Namatjira was born at the Lutheran Mission in 1902. His early artistic skills were encouraged by the mission's pastor, J. W. Albrecht, who encouraged Namatjira to carve and decorate wall plaques for the church using a combination of Aboriginal and Western iconography. But it was Melbourne artists Rex Battarbee and John Gardner, who visited the area during the early 1930s, who introduced Namatjira to the style that made him famous. Namatjira's aptitude for the watercolour medium and a distinctive capturing of the high colouring of desert landscape, made his paintings an instant success from their first exhibition in 1938. National and international success followed, bringing great financial and other benefits to Namatjira and his extended family – along with increased alcohol consumption and health and other problems. (Namatjira died after a tragic period in jail in 1959.)

Namatjira's legacy was the creation of a whole school of younger watercolour painters – the Arrernte group of watercolourists – whose work continues today. As well he became a role modern for a subsequent generation of painters as diverse as the Melbourne-based artist Lin Onus and the Northern Territory artist Ginger Riley Munduwalawala.

1950s Ernabella

Shortly before Namatjira's death, another and quite different artistic development was taking place at Ernabella (Pukatja), 400 kilometres east of Alice Springs. Under the direction of art and craft adviser Winifred Hilliard, appointed in 1954, people were encouraged to paint traditional motifs using brightly coloured acrylic paints. A number were reproduced photographically in limited edition posters and postcards, as well as translated into carpets and other materials; the designs were quite startling in their use of clear, confident blocked-in colours and swirling shapes. Called 'walka' design, and marketed as 'Pitjantjatjara Abstracts', Hilliard described them as 'not of European or other influence and owing nothing to the art of styles of other areas.'[2]

The colourful patterns were unable to be placed in either an 'ethnographic' or contemporary Western art context and were viewed by the city-based art world with some suspicion. It was a contemporary movement perhaps ten years ahead of its time, but which led to the establishment some years later of an important batik-making and painting school at Ernabella and other communities throughout the south-west central regions.

1960s Modernism

In the early 1960s bark painting entered the contemporary sociological context when the major bark painters from the north-eastern tip of Arnhem Land at Yirrkala produced artworks to substantiate their claims for land rights. In 1963 the Yirrkala Bark Petition, (see p. 192) presented to the federal government, was the first example of an artwork making a powerful political and cultural statement. Simultaneously, Yirrkala elders, fearful of the complete loss of their culture, also instigated a unique community project to create encyclopedic bark paintings on an unprecedented scale to hang in their church.

Aboriginal art was also entering Australia's fine art domain. In 1958, Sydney abstractionist and deputy director of the Art Gallery of New South Wales, Tony Tuckson, accepted, for the gallery a set of traditional Tiwi burial poles (see p. 197) as a commissioned gift by ethnographer Dr Stuart Scougall. Carved and painted by the Tiwi of Melville Island, Tuckson, his wife Margaret and other had witnessed the making of the poles. (As an abstractionist, Tuckson's own work had a particular affinity with these and that of other Arnhem Land artists such as the Marika family of Yirrkala.) His placement of the 17 poles in the foyer of the Art Gallery of New South Wales (AGNSW) in 1959 put Aboriginal art into the fine art domain more prominently than anything before and caused a minor controversy. Some attacked this translation from 'ethnographic' to 'fine art'; others such as artists Russell Drysdale, Margaret Preston and Sali Herman, applauded it. In 1961 Tuckson reinforced the status of Aboriginal art in the fine art context by curating the major touring exhibition *Aboriginal Art.*

A Contemporary Art Movement Begins

Australian artists were also paying indigenous art more direct homage in their own art. Examples include works by Margaret Preston, cover designs for magazine such as *Meanjin* and other literary journals. Albert Namatjira himself used Aboriginal motifs very different to those of his watercolour landscapes for the cover design of the first (1958) monograph on his work by Charles Mountford.

Other indigenous images were used more commercially as designs for tea towels and other products in complete insensitivity to cultural practice. Vehement critics of this cultural raiding included a number of anthropologists such as A. P. Elkin, the Berndts and Donald Thomson, and artists such as

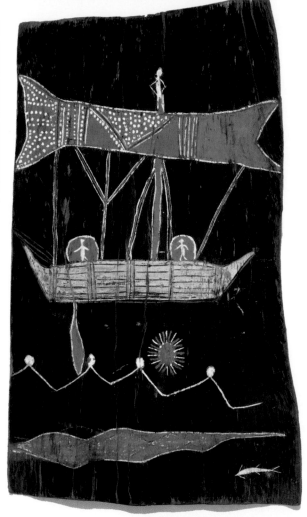

Minimini Numalkiyiya Mamarika, *Macassan prau with three figures, waves and sea creatures*, 1941–45, 58 x 37 cm. (irreg). Collection, University of Melbourne Art Collection. [Courtesy Ian Potter Museum of Art.]

Exhibited in *Creation Tracks and Trade Winds*, Ian Potter Museum of Art, 2006, this early bark typifies the style of Groote Eylandt paintings which depicted narratives of current events melded with traditional iconography.

Tuckson. In 1967 the members of the Australian Society for Education formally attacked this commercial appropriation of indigenous art as a highly inappropriate use of images that were often of secret and sacred nature. In 1965, the Society, (one of whose advisers was Professor Berndt), had instigated in 1965 a two-year survey on the status of art education programs for Aboriginal children in Western Australia and central Australia. Its results were published as

Aboriginal Art and Integration and presented at the Biennial Assembly of the Australian Society for Education through the Arts in Perth in May 1967. As well as the vehement attacks on inappropriate commercial uses, the report made numerous recommendations. These included giving high priority to the protection of Aboriginal sites and artefacts; employing teachers sensitive to the needs of Aboriginal children, encouraging the use of local materials such as clays, ochres and wood; encouraging children to practise traditional designs taught to them by their elders; understanding and following traditional leadership and kinship relationships; and that art teachers and artists should make 'every effort to provide the general public with a basis for the appreciation of Aboriginal art . . . [and respect] its ceremonial and magico-religious purposes'.[3]

That these recommendations were made in the context of an Australian society that was concurrently removing Aboriginal children from their families and people from their lands, the suggestions were both far-sighted and revolutionary.

Modern movement

As well as such philosophical discussions, there had also been many, from the 1940s, 50s and 60s who worked with Aboriginal people to encourage the making of art from a traditional, rather than tourist base. These included Fred Gray at Groote Eylandt, W.E. H. Stanner who worked with Nimbandik at Port Keats, the lay missionaries Harold and Ella Shepherdson at Milingimbi and Elcho Island and a number of missionaries and others at other Arnhem Land communities such as Gunbalunya (Oenpelli) and Yirrkala. During the 1960s the many arts and crafts workers in the communities of Amata, Fregon, Balgo, and Blackstone were highly significant as were the initiatives of numerous Aboriginal people such as Dick Roughsey (with white artist Percy Trezise), and his brother Lindsay Roughsey at Mornington Island, the Marikas at Yirrkala and those such as David Malangi at Ramingining. Most worked with

city-based collectors, galleries and other outlets and curators such as the Art Gallery of New South Wales' Tony Tuckson, Museum Victoria's Donald Thomson, Melbourne University's Leonhard Adam, the South Australian Museum's Norman Tindale, Charles Mountford and Robert Edwards and Western Australia's Ronald and Catherine Berndt towards educating the western world about Aboriginal art and culture through the collecting and showing of genuine traditional works.

The Papunya School

It was against this background that young teacher Geoffrey Bardon arrived in the Central Desert government settlement of Papunya. In 1971, as Bardon later described, the community was demoralised and 'divisive, depressed and lacking in either cohesion or direction'.[4]

Fascinated by children's drawings in the sand, Bardon sought explanations of their meanings and suggested to the children that they re-create the drawings in the classroom in watercolour on paper. Then the elders painted a mural on the school walls on the encouragement of Bardon, using traditional iconography. The power of this new medium enthused almost the entire community. Soon numerous others, mainly men, were painting on just about any flat surface to hand – most often boards but also packing cases and occasionally corrugated iron sheets. Paints were first crushed ochres, then, when available, postercolours, oils, house paint and finally acrylic. The designs were at first figurative and often graphically iconographic and became increasingly complex and more expressive when the custom of overlaying the imagery with veils of dots was developed by artists such as Johnny Warangkula Tjupurrula, Tim Leura Tjapaltjarri, Shorty Lungkarda Tjungurrayi and others.

For a few months the painting developed in the community without significant outside awareness. Then, in August 1971, Kaapa Tjampitjinpa won equal first prize at the Caltex Art Award in Alice Springs. By that time over 20 artists (all male) were painting: Geoffrey

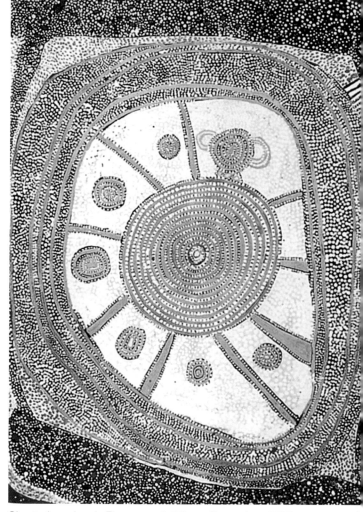

Shorty Lungkarda Tjungurrayi, *Water Dreaming*, 1972, acrylic on board, 58 x 41 cm. Private collection. [Courtesy Sotheby's and Aboriginal Artists Agency Ltd.]

Creeks flowing into a central large waterhole surrounded by smaller water holes with men sitting near it, were brilliantly captured in fine dotting by this founding Papunya artist.

Bardon estimated that in the first 18 months at least 1000 works were painted.

By 1972 when Peter Fannin, the first designated art adviser, was appointed, the number of painters had doubled; during the 1980s there were over 200. In 1972, the Papunya artists also established their own cooperative, Papunya Tula Artists Pty Ltd, the first Aboriginal-owned arts centre in Australia.

Although in the early years painting was prolific, sustaining the movement was far from

Towering trees dot the Central Australian landscape.
[Photo. D. Cram. Courtesy Mbantua Gallery.]

OPPOSITE: Makinti Napanangka, *Lupulinga,* 2003, (detail),
acrylic on canvas, 152 x 183 cm. Private collection.
[Courtesy Sotheby's and Aboriginal Artists Agency Ltd.]

easy. Richard (Dick) Kimber, a long-time Alice Springs resident, community worker, teacher and writer who has had a close relationship with the Papunya painting movement from its inception, described those days:

> The first painting I saw was one of Kaapa's [Tjampitjinpa] and the instant impact on me was amazing. I immediately wrote to Bob Edwards [then curator of anthropology at the South Australian Museum, who became the first director of the Aboriginal Arts Board of the Australia Council]. If credit is due to anyone for keeping Papunya painting going at that stage it ought to go to Bob Edwards. Bob had had a love of Aboriginal art especially rock paintings for years and he came out here and looked at the art and the community and organised funding for the administrator.

Peter Fannin's family bought some, and other workers at the community did too as well as some other locals, but generally up to about 1976 you couldn't give them away. Art in Alice itself was very much focused towards the Namatjira style [of realist watercolours]. This other stuff looked too different to be taken seriously at first. And we tried writing to all the Sydney dealers of greatest repute and the curators all over and no-one was interested in the new art.[5]

Most state art galleries and the new National Gallery of Australia were reluctant to acquire works of such difference. However local interest was stronger. The Museum and Art Gallery of the Northern Territory through its director Colin Jack-Hinton and curator Margie West bought significant quantities of early work (MAGNTs collection contains some of the gems of early Papunya art). Local residents and visitors also bought a substantial number of works which have subsequently appeared in auctions and have often fetched record prices.

Kaapa Tjampitjinpa's co-winning of the

Caltex Art Award in 1971 says Dick Kimber, was a very early recognition of the significance of the new painting. 'Then,' he says:

> there were a few newspaper articles about what was happening at Papunya and both the Australian Museum and Museum of Victoria bought some. Pat Hogan at the Stuart Art Centre at the caravan park she and her husband owned, showed quite a few. She also had people in there painting and made sure they were painting with the finest brushes (or ends of brushes) she could supply so the works that came from that source were usually very good.
>
> Then the late Andrew Crocker, an English barrister and quite a flamboyant character arrived as art-co-ordinator. He got on the phone and rang every wealthy person he could think of saying 'I think you ought to have a collection of this work'. He was the one who got Robert Holmes à Court interested. Holmes à Court was one of the most high-profile people in Australia and suddenly his collection from Papunya was photographed in *Vogue* and major newspapers. Suddenly art from Papunya was a highly desirable thing to be collecting.[6]

Others, such as Melbourne collector Margaret Carnegie, started collecting and introducing the art to a wider and more sophisticated audience.

The role of the Aboriginal Arts Board of the Australia Council, established in 1973, was also pivotal. The Board's charter, according to its inaugural director Robert Edwards (1973–1980), was that Aboriginal people should decide their own artistic future. 'At the time, many repressive things were still going on – like kids not being taught their own language, white people deciding on housing and telling Aboriginals this was the way it had to be, and so on,' he says.

> The logic was quite simple – the government would start to put money into Aboriginal affairs but many Aboriginals weren't at the time confident enough to make use of money to be really productive – mainly because everyone said their heritage was second rate, and they were believing it. There was also a lot of

disillusionment on the part of older Aboriginals with the next generation who seemed headed into adopting a Western way of life. They would withhold stories because they didn't trust the younger generation.

The setting up of the Aboriginal Arts Board was concurrent with other moves to enable Aboriginals control over their own heritage. Dick Roughsey, Billy Stockman and Wandjuk Marika were on the original Board and what happened in terms of the marketing of the art was at their suggestion.

Crucial in this, says Edwards was the strong belief that the best way of helping the artists was to buy the art.

'In non-Aboriginal art, grants are given out, and it buys artists time to develop ideas', he says.

> This, said our Aboriginal representatives would not work in an Aboriginal context. They said 'if you give an Aboriginal money he'll sit down and do nothing' because traditionally art has always been a part of food and other ceremonies.
>
> We should rather buy the work. Which we did. Right through Aboriginal Australia. We bought bark paintings, burial poles, Western Desert art. We helped the establishment of Papunya Tula Artists Pty Ltd and other artists cooperatives, supplied materials and bought vehicles. We set up a shop in Alice Springs and one at the Argyle Arts Centre in Sydney.

It was all aimed at introducing the art to a wider audience.

The problem, says Edwards was, as Kimber has noted that 'no-one else wanted to buy the art'.

We had art coming out of our ears! Papunya artists were in the first few years incredibly prolific and we were building up quite a stockpile. Boards and canvases were stacked several deep around all the office walls and it started to worry the [Australia] Council and government auditors, who weren't so used to the concrete effects of grants. What on earth were we going to do with it all? We tried to give it to galleries and museums and no-one would take it.

For example we offered the Art Gallery of South Australia the pick of several hundred really wonderful early Western Desert paintings. They simply wouldn't take them. Eventually because I knew many of the board members I virtually forced them to take them. Now, of course, the gallery acknowledges them as being amongst the most important Aboriginal works in their collection. This was typical of much gallery reaction.

Again, it was the Aboriginal board members who suggested a solution – that we send the work overseas. In four years we organised sixteen international exhibitions often in conjunction with large benevolent cultural foundations [such as Rothmans and Peter Stuvyesant]. Then there was the same problem – what to do with the art when the shows finished? 'Leave it there', said the Aboriginals, 'if you bring it back kill the market'. So we donated it to museums on the proviso that it would be on public show. This is why a number of overseas galleries and museums often have much better collections of early modern Aboriginal work than many in Australia.

In retrospect this turned out to be one of the most subtle and brilliant marketing exercises in Australian art – and it's never really been acknowledged or credited as being that of Aboriginal people themselves. If we'd given just money it would have killed it. It would have most probably been an experiment that went nowhere.

These days it has become a much more wide-open industry. But we set up the superstructure that in many ways enabled that to happen. We believed passionately in the possibilities of the art – a belief that has been well and truly justified.[7]

Success did not come without cost. As the financial stakes and popularity of particular artists' work became more pronounced, so did jealousies and interpersonal frictions. Not even the establishment of Papunya Tula Artists Pty Ltd was able to shield its artists from the intense pressures that arose as the art became a highly marketable commodity. Dealers flying in or travelling from various parts of Australia and the world offering large sums of cash became a common occurrence. In Aboriginal societies all goods are shared – the income derived by one family member is accessible to all – and the pressures on those artists generating the most income was, and remains, intense. The success of Papunya's painting movement significantly changed its community structure. Jealousies flared and issues of money and its distribution contributed to further divisions in the community. (See *From the Bush to the City: a buyer's guide*, p. 32). Amidst this, styles by those such as Mick Namarari Tjapaltjarri, Turkey Tolson Tjupurrula and Ronnie Tjampitijinpa became more distinctive and differentiated. Most highly sought after was the work of Clifford Possum Tjapaltjarri, whose complex narrative paintings, gregarious personality and love of travel made him one of the most well known of all the original Papunya 'painting men'. That the painting continued at Papunya and its outstation and lands around Kintore in the first years in the face of considerable difficulties was attributable to the determination, skill and hard work of founding artists such as the late Clifford Possum, Tim Leura, Mick Namarari, Kaapa Tjampitjinpa and Turkey Tolson, along with a succession of dedicated art advisers: the late Geoffrey Bardon, the late Andrew Crocker, Peter Fannin, John Kean, Dick Kimber, Daphne Williams and Janet

Wilson, and the many subsequent dedicated field officers and assistants.

Post-1970s Desert Developments

By the mid-1980s the painting movement had spread widely throughout eastern, Western and Central Desert communities. Community arts centres were established at Yuendumu (Warlukurlangu Arts Centre), Balgo Hills (Warlayirti Arts Centre), Lajamanu (Warnayaka Arts Centre) and Haasts Bluff (Ikuntji Arts Centre), joining the already-established art rooms at Ernabella and Hermannsburg. At Utopia and other eastern desert areas, batik-making and later painting became a unique and important art practice, especially for women of the regions.

There were also numerous debates about whether images traditionally only meant to be seen by those uninitiated should be made available to a wider audience and whether the art should be sold at all. Reaction was strongest by the Pitjantjatjara of the Ernabella area who in the early 1970s lodged a formal complaint to the Aboriginal Arts Board about Pitjantjatjara images being viewed publicly.[8]

In 1983 the debate was still continuing with the chair of the Lajamanu community council, Maurice Luther Jupurrula, saying of the 12-person constructed sand painting created at the exhibition *D'une autre continent: l'Australie – le rêve et le réel*, ARC/Musée d'Art Moderne de le Ville de Paris:

> We only want the world to accept and respect our culture. We only want recognition that we have a culture, and that we remain strong, as

Paddy Tjupurrula Nelson, Paddy Japaljarri Sims and Larry Jungurrayi Spencer, *Yanjilpirir Jukurrpa (Star Dreaming)*, 1985, acrylic on canvas, 372 x 171.4 cm. Collection National Gallery of Australia. [Courtesy the artists and Warlukurlangu Artists.]

Collaborative works such as this important early work have been a feature of painting by artists of this leading Central Desert community.

Warlpiri people in Australia. We just want to be recognised as part of the human race, with our own painting traditions which we maintain, as we always have. We will NEVER put this kind of painting on to canvas, or on to artboard, or on to any 'permanent' medium. The permanence of these designs is in our minds. We do not need museums or books to remind us of our traditions. We are forever renewing and re-creating those traditions in our ceremonies.[9]

Luther died in 1985 and about a year later Lajamanu elders decided that painting for sale could be a positive step and soon painting started at Lajamanu as well.

Gradually people in other communities – at Yuendumu, Balgo, Utopia, Fregon, and Ernabella – as well as numerous individuals started painting, making batik, sculpture and craft. The success of the new forms took hold in the outside world and by the early 1990s thousands of western and central desert people had become regular painters or craftspeople.

The Kimberley

Art developments in the adjoining Kimberley region followed those of the Central Desert. Art on transportable objects, save for carved boab nut and decorated pearl shells as well as the sacred tjurunga, had not been seen in the West until the start of the 1980s paintings movement. After European arrival in the 1880s, the Kimberley's Aboriginal population had been affected in much the same ways as Central and Western Desert people but the settlements, which have since become major art-producing centres, were more often established as missions than government settlements.

The first forms of modern Kimberley art were paintings of the Wandjina fertility–rain spirits (whose images are found in many caves throughout the Kimberley) at the settlement of Kalumburu. The performance boards used in the Kurrir Kurrir (or Krill Krill ceremony) of the area's Kukatja, Gija and other people led to the development of the ochre on canvas art of those such as Jack Britten, Hector Jandanay,

Queenie McKenzie, George Mung Mung, Rover Thomas and others.

In the mid-1980s, people of the Western Desert–Kimberley region of Balgo Hills who have very strong family connections with the Central Desert community of Papunya, started painting in acrylic on canvas. Fitzroy Crossing's Mangkaja Arts was established by Walmajarri and those of other language groups to create uniquely different bright watercolours. In Kununurra, Waringarri Arts was established to service the needs of all Kimberley artists, with other Kununurra-based outlets such as Jirrawun and Red Rock Arts being established during the 1990s as well as those at Derby and Bidyadanga (La Grange).

Arnhem Land

The development of modern art in Arnhem Land differed markedly from that in the Central and Western Desert areas. Here, art and artefacts had been produced for sale or barter for several hundred years. In the 1700s painted barks, carvings and other transportable objects were traded with the Macassan fishers and trepang gatherers and others who were constant visitors; from the early 1900s missionaries and anthropologists traded flour, tobacco and other goods for paintings. With the increase in tourism during the 1900s, paintings on bark were made specifically to supply to tourists. It was at this time that the practice of attaching a split stick pole to the top and bottom of a bark was devised.

Most Arnhem Land missions also promoted the making of art and artefacts. Some of the barks and carvings made in this way were sold to the not-so-frequent visitors and others collected by early ethnographers such as Baldwin Spencer, Charles Mountford and later Dr Stuart Scougall.

During the 1970s and 1980s, the Arnhem Land missions and settlements such as Yirrkala, Maningrida, Ramingining, Oenpelli (Gunbalunya), Milingimbi, Groote Eylandt and Elcho Island were returned to Aboriginal control. In all of these places as well as at a number of other centres, numerous individual artists have taken the traditional forms of bark, carving and weavings into the realm of contemporary art.

Queensland

The area of Laura in Queensland's Cape York region is famed for its rich variety of rock art. Many distinctive forms of carving and decorating of shields, masks, wooden drums and weavings such as the unique bi-cornial baskets had evolved throughout Queensland's vast tracts of lightly forested and open plained inland country as well as the lush rainforest areas over many hundreds of years. More modern art movements had been established from the 1940s by those such as Lindsay and Dick Roughsey at Mornington

Island. Aside from this more comprehensive movement which involved up to several hundred people producing art and craft much Queensland art from the mid 20th Century is identified by that of individuals. Until the 1990s however much indigenous art sold through the main outlet for Queensland art was imported from other regions. Since the 1990s, however, there has developed a strong and vibrant development of indigenous Queensland art in regions such as Lockhart River, Aurukun and significant new developments at Mornington Island and other communities. From the 2000s, with the support of several leading commercial galleries and the government agencies Arts Queensland and the Queensland Indigenous Arts Marketing and Export Agency, along with a vibrant contemporary art scene in Brisbane and the establishment of new community arts centres, Queensland's indigenous art is developing as one of the most dynamic movements in contemporary Aboriginal art.

The southern regions: New South Wales, Victoria, South Australia, Tasmania

Throughout southern regions of New South Wales, Victoria, South Australia and Tasmania new generations of indigenous artists are reforging links with their past in the creation of either contemporary forms of traditional art practices such as the shell jewellery made by Tasmanian women and the weavings such as that of the 1997 Venice Biennale exhibitor, South Australian Yvonne Koolmatrie. Bodies

TOP: Mariner shells. [Photo. S. McCulloch.]

LEFT: Trevor 'Turbo' Brown, *Two Dingos,* acrylic on canvas, 51 x 51 cm. Private collection. [Courtesy the artist, Mossenson Galleries and Koorie Heritage Trust.]

Marineer or mariner shells are prevalent in south-east coastal regions especially in Tasmania where they have been made into striking necklaces by Aboriginal women for generations. Young Victorian artist Trevor 'Turbo' Brown has become well known for his colourful naif figurative paintings.

Emily Kame Kngwarreye , *Kame Yam Awelye*, 1996,
acrylic on canvas, 151 x 90 cm. Private collection.
[Courtesy estate of the artist and the Holt Collection.]

RIGHT: Wingu Tingima, *Kungkarrakalpa*, 2007, (detail)
acrylic on canvas, 116 x 151 cm. Private collection.
[Courtesy Tjungu Palya and Randell Lane Fine Art.]

such as Victoria's Koorie Heritage Trust and
similar in other states have done much to
promote the work of indigenous artists in
their states which included entirely new
interpretations such as the colourful paintings
by Melbourne-based Turbo Brown.

The 1990s: a stylistic breakthrough

Although many of the images of bark paintings
of the north and the translations from sand
design and rock incising by the Papunya area
artists are abstracted in design, from the
1980s a new type of Aboriginal abstraction has
developed. The art world had never seen images

such as the bold, spare ochre works by the
Kimberley's Rover Thomas or the wild colourful,
gestural abstracts of the elderly Utopia artist
Emily Kngwarreye. Thomas's spare paintings,
made from deep brown, white ochre and blacks
ground from burnt woods were, with their
confident minimalism, reminiscent of those
of New York colorfield abstractionists such as
Mark Rothko. Kngwarreye's paintings were very
different. Her raw, painterly and gestural works
came to be compared to those of de Kooning,
Pollock and others, and, with their glowing
coloration, to those of the Claude Monet.

Thomas's work had had international impact
as Australia's co-representative to the Venice
Biennale in 1990; Kngwarreye was especially
lauded as an art phenomenon. In her six years
of painting, which lasted from her early 80s
until her death in 1996, this tribal woman, who
had never seen the European art that her work
would be compared to, produced a stream of
paintings of innovative style, confident imagery
and vivid coloration.

Thomas's and especially Kngwarreye's
art proved to be watershed moments in the
development of modern Australian art. The
work of the Papunya school and that of other
Aboriginal artists had already redefined the
meaning of Australian landscape art but the work
of these two artists took this into new realms and
challenged the perception of what constitutes

Aboriginal imagery more directly than anything before. Their work reignited interest in abstract painting of many types and paved the way for more expansive imagery by indigenous artists.

The public dimension

Parallel with this growth in contemporary art from the more remote areas has been a growth in activity by urban-based indigenous artists. The 1980s, especially leading up to Australia's bicentennial year in 1988 in which the rights of indigenous people were put on the public agenda, was accompanied by a growing interest in the work of urban-based Aboriginal artists. Artists such as Ian Abdulla, Gordon Bennett, Jodie Broun, Fiona Foley, Trevor Nickolls, Lin Onus, Leah King Smith, Judy Watson and numerous others offered either direct or more subtle evocations of what being Aboriginal meant. Sometimes confronting, sometimes poignant, their images speak clearly of recent Aboriginal history and add a further dimension to the work of painters, sculptors, weavers and craftspeople from the central desert, the Kimberley, Arnhem Land and other non-city regions. Since the early 1980s, exhibitions have increasingly played a major role in raising the profile of Aboriginal

art and introducing it either in a commercial or public gallery non-selling context to the world. Aboriginal art is represented to a significant degree in most of Australia's state collections, such as the Australian art gallery at the National Gallery of Victoria (NGV) – the Ian Potter Centre: NGV Australia – and Canberra's National Gallery of Australia. In 1994 the Art Gallery of New South Wales opened its Yiribana gallery, dedicated to the showing of Aboriginal art, and the Museum and Art Gallery of the Northern Territory in Darwin has the most significant collection of modern Aboriginal art. Alice Springs' Araluen Arts Centre has a Namatjira gallery and a unique selection of early Papunya paintings on loan from the Papunya community. Adelaide's Tandanya: National Aboriginal Cultural Institute, established in 1991, is Australia's only public gallery dedicated solely to the display of Aboriginal art.

The major indigenous art award – the National Aboriginal and Torres Strait Islander Art Award – was started in 1983 and has become the most significant annual showcase of contemporary

Richard Bell. *Telstra Painting*, 2006, acrylic on canvas, 240 x 360cm. Private collection. [Courtesy the artist and Bellas Milani Gallery.]

Tracey Moffatt, *Adventure Series 6*, 2004, from a series
of 10 images, colour print on Fujiflex paper,
132 x 114 cm. Multiple collections.
[Courtesy the artist and Roslyn Oxley9 Gallery.]

Aboriginal art, accompanied also in recent years
by a swag of exhibitions held in Darwin at the
same time. Significant also is Alice Springs'
annual Desert Mob survey exhibition of the latest
works of central, western and southern region
communities, and awards such as the Victorian
Indigenous Art Awards, the 2008 WA Indigenous
Awards and others.

The 1990 showing at the Venice Biennale
by Rover Thomas and urban-based Trevor
Nickolls brought indigenous art into the world's
contemporary art arena, as did the 1997
Venice showing of Emily Kngwarreye, Yvonne
Koolmatrie and Judy Watson. This was furthered
in Australia by leading solo survey exhibitions
including those by Kitty Kantilla, Emily Kame
Kngwarreye, David Malangi, George Milpurrurru,
Ginger Riley Munduwalawa, Dorothy
Napangardi, Lin Onus, Kathleen Petyarre, Rover
Thomas and Clifford Possum Tjapaltjarri. Major
survey exhibitions in leading public galleries
since the mid-1990s have included those noted
throughout the section following.

New Media

Many indigenous people in the urban areas
throughout Australia who have had fragmented
histories of connection with their lands and
heritage are also finding ways through art to
reconnect with this culture as well as create
entirely new, and entirely sophisticated imagery,
shown and seen as leading contemporary art on
the world art stage. (See *Into the New*, p. 276)

Much of this uses new media such as
photography, installation and DVD. However
throughout Australia, Aboriginal artists have
long embraced and incorporated new media
such as ceramics, fabric dyes, manufactured
fibres (as well as natural ones) for weaving,
glass and many other media. From the 1990s,
this has included an increase in the range and
quality of original prints. Print-making studios
such as Victoria's Australian Print Workshop,
Charles Darwin University's Northern Editions,
Darwin's Basil Hall Editions and Sydney's
Australian Art Print Network have come
to the fore in working with both individual
Aboriginal artists and community arts centres
in collaborative projects to create high-quality
and increasingly sought-after limited edition
etchings, screenprints, lithographs and other
limited edition original prints. Of note too has
been the increase in cross-cultural collaborative
projects with licensing of Aboriginal designs to
manufacturers of goods such as rugs, cushions,
leatherwork and a great range of printed
fabrics.

'Australian art it's an Aboriginal thing'

All these activities have led to the growth of
Aboriginal art over the 1990s becoming so
significant that, as indigenous painter Richard
Bell comments, Australian art may have
become all but an 'Aboriginal thing'. (In 2003,
Bell had won the prestigious Telstra-sponsored
National Aboriginal and Torres Strait Islander Art
Award (NATSIAA) with a painting called *Scientia
E Metaphysica (Bell's Theorem)*, which featured
the words 'Aboriginal art, it's a white thing'; his
later paintings offering commentary on both this
win and the significance of Aboriginal art itself.)

Significant also has been the vibrant new wave of painting throughout desert areas. The move back to areas such as Kintore and Kiwirrkura brought about a new style of 'op art'-like painting by some of the established Papunya artists such as Ronnie Tjampitjinpa, George Tjungurrayi, Kenny Williams Tjungurrayi, Willy Tjungurrayi and others. The passing of many of the original Papunya-school masters also enabled the work of women artists to come into its own. Inyuwa Nampitjinpa, Kayi Kayi Nampitjinpa, Nyurapayia Nampitjinpa, Makinti Napanangka, Ningura Napurrula and Naata Nungurrayi have become just some of this area's leading artists. One of the biggest growth areas has been that of the huge south-western regions around the junction of South Australia, Western Australia and the Northern Territory, which has developed more than 15 new painting communities from the mid-1990s to 2008.

The Old Made New

Another significant development has been that some of the newest painters of contemporary Aboriginal art from remote regions are also its oldest painters, who came to painting for the first time in their 70s or 80s. These artists have included Kimberley artist Paddy Bedford (c. 1922–2007), whose ochre paintings attracted much attention for their elegant stark minimalism; Mornington Island's Sally Gabori and her sisters, nieces and other female relatives from Bentinck Island off the far north Queensland coast, known for their vibrantly coloured work; the artists from Bidyadanga south of Broome; painters of the spinifex country of the southern Central Desert; Mount Liebig Pitjantjatjara painter Bill Whiskey Tjapaltjarri; Nyirripi's Paddy Lewis and numerous painters of the Ngaanyatjarra Pitjantjatjara and Yankunytjatjara (NPY) lands of the southern and western desert such as Jimmy Baker, Jimmy Donegan, Eileen Stevens, Wingu Tingima, Ngipi Ward, Tommy Watson and many others whose use of intense colours makes their paintings pulsate with vigour and life.

Younger Pintupi man Walala Tjapaltjarri has had a completely different experience again. Until 1984 Tjapaltjarri and his family had lived a fully tribal life on their Western Desert lands. In 1984 they 'walked in' from the desert to become urban dwellers. Dubbing them 'the last of the nomads', the world's media took up their story. Twenty years later, in his 40s, Tjapaltjarri and his brothers, Thomas and Warlimpirrnga Tjapaltjarri, had all become painters of great note.

Walala Tjapaltjarri's 2006 painting *Tingari* is most similar in its spare iconography to the sand designs and rock engravings denoting the journeys of the ancestral Tingari men and their travels through the lands. Yet in its use of gold and silver, it is also very much of the present. Painted in the Brisbane studios of the cross-cultural Campfire Group, this painting, and Tjapaltjarri's own story from tribal desert dweller to leading contemporary painter, summarises not only his life and work but the development of this extraordinary art movement itself.[10]

29 Walala Tjapaltjarri, *Tingari (gold and silver series)*, 2004, acrylic on canvas, 90 x 90 cm. Private collection. Photograph Bruce Thomas. [Courtesy the artist, Campfire Group, Outback Aboriginal Art and Aboriginal Aritsts Agency Ltd.]

From the BUSH to the CITY
a buyer's guide

Since the 1980s, when public demand for Aboriginal art developed, there has arisen a network of artists' representatives, art centres, agents and dealers through which art reaches its ultimate destination, whether this be public gallery, exhibition or retail outlets. The art and craft room at the central desert's Ernabella was opened in 1948, and is the longest continually run community art centre in Australia. Many other art and craft rooms and projects were similarly established during the 1950s, 60s and 70s and included those at the Arnhem Land communities of Gunbalunya (Oenpelli), Elcho Island, Milingimbi, Groote Eylandt, Yirrkala and Maningrida; at Queensland's Mornington Island, the Top End's Daly River and Port Keats, and the central and western desert region's Fregon (Kaltjiti), Amata, Balgo and Ayers Rock (Uluru).

The first Aboriginal artist-owned art cooperative, was Papunya Tula Artists Pty Ltd, established in 1972 and incorporated as a company in 1975. There was then a hiatus of more than ten years before other Aboriginal-owned art centres were established in central regions. With the return of many communities to Aboriginal control in the 1970s, a number of art and crafts rooms became Aboriginal-owned art centres. Their number grew steadily in the 1980s and 90s to around 25 in the late 1990s. Between 1998 and 2008, there has been an explosion of growth with more than 70 new community art centres established, bringing the number in 2008 to almost 100.

While the prime purpose of an art centre is to facilitate the making of art, almost all art centres are also heavily involved in the social, cultural, educational and health services of a community. Some communities also have cultural centres in which works of significance are retained for community benefit. Some art centres were established as women's centres for women to escape family and other pressures.

The style of art centre buildings varies widely. Some are temporary facilities taken over from other uses, others are sophisticated, architect-designed buildings with state-of-the-art computer facilities, storage and display areas. Some have separate working areas for men and women, and artists also often work on verandahs or paved areas outside the art centre. Many artists also work in their own homes, either in the community or at homeland outstations.

A number of art centres encourage visitors (permits however may be needed for visits to the community itself); others do not.

A great cross-cultural collaboration

The art centre manager and assistant managers, often with voluntary help supply artists with canvases and painting material, establish the prices of works, organise payments and the exhibition program, co-ordinate marketing and travel with artists to exhibitions. In many cases art has flowered in a community because of a unique interchange between artists and outsiders who bring new artistic skills.

Acting alone and other scenarios

Not all art regions, however, have art centres. Of note is the eastern desert community of Utopia whose artists have operated successfully largely without a formal art centre since the start of that region's painting movement in the late 1980s. Unlike those in many other desert regions, Utopia's Anmatyerre and Alyawarre people have never been removed from their lands; nor did they need to accommodate an influx of other peoples dislocated from their country. Since Utopia's return to Aboriginal control in the 1970s, people have established quite distinctive and very family-based small outstations near the area's many soakage bores. Individuality is prized with the region's hundreds of artists working with galleries and dealers throughout Australia and internationally.

In other regions and communities some artists are both members of art centres and sell

their art to individual agents or dealers who onsell the art to retail and other outlets. This system is unlike anything that operates in other areas of the contemporary Australian art market and has arisen largely as so many artists live far from capital cities. This has led to a large network of private dealing, the circumstances of which have often been highly contentious and include numerous instances of artists being underpaid for work, and many other quite bizarre situations in which artists have been 'kidnapped' for shorter or longer periods and sometimes removed interstate without adequate clothing or medicine.[1]

For these and other reasons including guarantee of provenance of work and wishing to support the arts centres, galleries, auction houses and clients may deal only in those works sourced from community art centres. An art centre's certificate of authenticity which contains biographical information and details about the work offers both great information and an excellent stamp of authenticity.

Yet this does not mean that every art work sold privately is either fake or necessarily of lesser quality. In Central Australia artists selling work directly to dealers or the public stems from the first days of Papunya art after Geoffrey Bardon appointed Alice Springs' Stuart Art Centre as a sales outlet. Although sales of Papunya art in the wider Australian art community was poor at this time, much early art was bought significantly by both locals and the Museum and Art Gallery of the Northern Territory (see p. 20). This, as Bardon later related, both encouraged artists' expectations and led to the proprietor of the Art Centre, Pat Hogan attempting to acquire the sole rights of sale for Papunya art, causing a bitter division.[2] As long time Papunya worker Dick Kimber also noted (p. 20) it was also routine for Papunya artists to work in Alice Springs itself. From this time

Artists Gladdy Kemarre (top right) paints in her Utopia bush camp, as did the late Minnie Pwerle and her sisters (fourth from top). Yuendumu's Warlukurlangu Art Centre and its art room [right] welcomes visitors while colourfully painted 4 WDs such as that of Kaltjiti Arts are frequently seen in art producing regions. [Photos. Barry Skipsey, Anne Runhardt and S. McCulloch.]

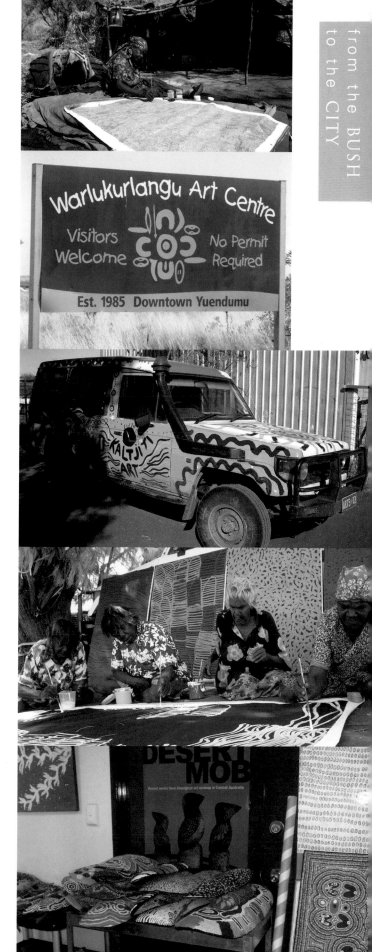

leading Papunya artists have worked with the co-operative they established (Papunya Tula Artists Pty Ltd) and with private dealers as well as selling their work directly to the public.

As the demand for the art grew, during the 1990s, throughout Alice Springs numerous privately-operated outfits generally termed 'painting sheds' were established. Artists work and sometimes live in these for periods. These include fairly primitive 'sheds' to normal suburban houses to substantially luxurious buildings and studios on country-style blocks of land just outside town. Whether artists are free to come and go, what sums they are paid and other issues, remain highly contentious, with published reports often adding to this lack of clarity by reporting on hearsay rather than through first hand investigation.

Making assumptions about the facilities in which artists work and how that necessarily equates with payments is also dangerous and needs to be made with some knowledge of conditions of many Aboriginal communities themselves. These were often assumed by the art-loving public (until more news coverage of conditions in some communities was more widely reported during the 2000s) to be lyrical 'back to nature' places in which artists could paint without pressures. And many are indeed so. But pressures on artists within a community are also often intense.

While there is no doubt that there exist many power discrepancies between some Aboriginal artists and those eager to acquire their works, assuming that all artists are unable to manage their own art sales is a sweeping generalization. It seems to ignore the reality that many artists are not only senior and strong cultural leaders, but have experienced huge changes through their lives which have required both massive adaptation and the ability to negotiate in the western system at many levels. An artist such as Clifford Possum Tjapaltjarri, for example, was both widely traveled and highly independent and would sell his art, proudly, to many people in countless different ways. And as curator Judith Ryan noted about Emily Kngwarreye, whose

art became equally highly sought-after. 'She elected to remain independent…and would paint wherever materials were provided and payment guaranteed…tailor [ing] the work…to the specific requirements of the representative concerned, each of whom had a chance of ending up with the best of her output.'[3]

In short, while there has been a long history of Aboriginal artists being shamelessly underpaid for their work and many other unconscionable behaviors, and while community art centres are unquestionably the heart and soul of the art movement without which art would not have developed as it has, not everyone who deals directly with artists, or who artists chose to work with, are of the same ilk or deal in the same manner. Whether Aboriginal artists are treated fairly in any transaction is largely determined by the ethics of all involved.

Arts centre representative groups such the central desert's Desart and the Top End's ANKAAA have been significant in debates surrounding these and other issues, as has the indigenous art galleries association Art.Trade which established a code of conduct for its members.

The middle ground

Sitting somewhere between community art centres and private dealerships are also groups or galleries that have an ongoing relationship and support a regular group of artists. These operate, in effect, as private art centres. They include the Kimberley's Red Rock Art, a group of artists at Derby working with Perth's Indigenart (Mossenson) gallery, Wangkatjungka artists working the Perth's Japingka Galleries, Utopia artists including Barbara Weir, the late Minnie Pwerle and her sisters relationship with Adelaide's Dacou, run by their younger relative; and with Alice Springs' Mbantua and other galleries. The Bidyadanga artists of Western Australia work with Short Street Gallery, Broome and there are many other similar instances. In addition, numerous individual artists from country as well as city regions throughout Australia often have relationships with one gallery or dealer.

The real deal

The growth in popularity of Aboriginal art since the mid 1980s has meant that demand has often exceeded supply. And wherever there is such demand and ready money to be made from the sale of art, there also arises a parallel industry of fakes, frauds, thefts and scams. As seen in the reports by the international journal *The Art Newspaper* such activities occur all over the world on a weekly basis. In indigenous art, these issues are made more complex by the differing cultural paradigms in which the art is produced and sold. There are issues of pressure on artists to paint to supply relatives with money, and artists' relatives or other community members creating works that are sold under the main 'star' artists' names as well as more clear cut instances of forgery. Since the 1980s questions of authenticity have arisen over the works of many leading artists including Emily Kngwarreye, Rover Thomas, Kathleen Petyarre, Turkey Tolson Tjupurrula, Mick Namarari Tjapaltjarri, Ginger Riley, Clifford Possum Tjapaltjarri, Makinti Napanangka, Naata Nungurrayi, Walangkura Napanangka, Minnie Pwerle and others. In 2001 convictions of faking of Clifford Possum Tjapaltjarri paintings led to a jail sentence for one white dealer; and in 2007 a Melbourne husband and wife convicted of forging and selling the paintings of Rover Thomas were jailed.

In 2000, largely as a result of articles in *The Australian* from 1997, the Federal government introduced an authenticity labelling system in an attempt to stamp out fakes. However, due to a variety of practical and other factors, this proved unworkable and faded into oblivion within four years. In 2007 the Federal government, largely prompted by a feature by Nicolas Rothwell in *The Australian*, conducted a Senate Inquiry into Aboriginal art.[4] The ten-month-long inquiry concluded with a series of succinctly formatted recommendations, however more than a year later it was hard to see any concrete effects of this costly exercise.

How to tell the difference

Aboriginal art is not all great simply because it is indigenous. As with all art it ranges from poor work (especially that produced to feed a hungry market) to masterpieces and much in between. Although all paintings are respected equally by Aboriginal people as representations of law and culture, there also exists a strong appreciation of the aesthetic expressed by the concepts 'flash' (good) and 'rubbish' (bad) painting.

In the sales of Aboriginal art there has also arisen a scenario in which provenance (the sales history of a work) is equated with authenticity. Often the consumer is told, for example, by one dealer or art seller that only works by artist X from source Y can be guaranteed authenticity; and quite a different set of information by another. This is highly confusing. The only advice for the would-be collector or enthusiast is to research this information, and investigate the work of artists directly in public and private galleries; to read copiously and generally familiarise oneself with an artist's work, development and styles. Developing one's own 'eye' is of crucial significance.

A parallel universe

During the 1980s and 90s, the problems within communities grew and included the problems of substance and sexual abuse, domestic violence, and younger people's departure from traditional ways. These situations are unlikely to be quickly or easily fixed. Yet within these fraught and often despairingly sad situations, and within an art marketplace itself often in considerable conflict, the practice of art, like a beacon, continues to flourish. In no small part this is due to Aboriginal people's ability to adapt and survive – to reforge links with traditions and to continue traditional practice in their own lands. It is from this basis that art evolves. And while its economic factors cannot be discounted, the practice of art is one of the most positive and empowering aspects of life for many Aboriginal people. Without it, not only would the visual representation of a people largely disappear but the soul, spirit and joy of many communities – and indeed, the cultural life of Australia itself – be significantly diminished.

CENTRAL AUSTRALIA

Birthplace of a Cultural Revolution

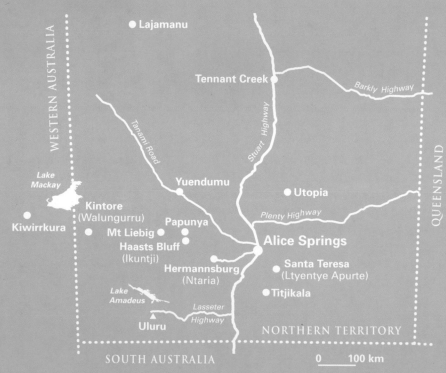

In Australia's centre the red-sanded plains, studded with majestic gums, and the rolling outcrops of mountain ranges stretch into the blue-hazed distance. Within this vastness, subtleties abound. Colours change with the progress of the day: from the early morning

CENTRAL AUSTRALIA
Birthplace of a Cultural Revolution

clear light that sharply defines shapes to the silent bleached flatness of the midday hours and the soft purple-reds and sage greens of dusk. At night temperatures plummet and the star-filled sky and inky night overwhelm with their sheer magnitude.

The word 'desert' is in itself a misnomer, evoking a landscape of flat, treeless sand-drifts. While rainfall is low, this 'desert' is more a park and a land of great variety: grassy slopes, shady tree-covered rocky hills, canyons, clear rock pools, mountain ranges and wide creek beds. The creeks, when filled with water, support a great variety of wildlife, and their sandy depths continue to do so long after the surface water has dried. Birds, lizards, kangaroos, frogs, wallabies and other animals remain plentiful despite the degradation of lands by cattle and an increased human population. Many Aboriginal people still hunt and gather foods as a regular and important social, health and cultural activity.

Art from the central, eastern, southern and western areas includes the famous 'dot' painting style, which has become the most widespread of all types of Aboriginal art.

Principal Areas of Art

The main art areas of the central region spread outwards for a radius of more than 400 kilometres from Alice Springs, which in itself has become an important art-producing community. Art and craft was practised at communities such as Ernabella (Pukatja), Amata, Fregon, Uluru (Ayers Rock), Hermannsburg and others since the 1960s. But it was at Papunya, 230 kilometres north-west of Alice Springs in the 1970s that the school of acrylic painting on canvas, which has since become one of the most widely practised forms of painting for Central and Western Desert people, began. This was followed by painting movements and often the establishment of community arts centres at

‘…red-sanded plains, studded with majestic gums, and the rolling outcrops of mountain ranges stretch into the blue-hazed distance…’

Nyurapayia Nampitjinpa (Mrs Bennett), *Tjalili*, 2006, acrylic on canvas, 183 x 152 cm. Private collection. [Courtesy the artist, Ballan + Pannan Galleries and Aboriginal Artists Agency Ltd.]

FAR LEFT: Darby Jampitjinpa Ross, *Manu Yankirri Jukurrpa (Water & Emu Dreaming),* 1989, acrylic on canvas, 183 x 152.5 cm. Private collection. [Courtesy Warlukurlangu Artists and Sotheby's.]

TOP LEFT: *The rocks of Kintore.* [Photo Grenville Turner, Wildlight.]

BELOW: Turkey Tolson Tjupurrula, *Straightening Spears at Illyingaungau,* 1996, acrylic on canvas, 151.5 x 183 cm. Private collection. [Courtesy Sotheby's and Aboriginal Artists Agency Ltd.]

the central areas of Yuendumu, Utopia, Haasts Bluff, Lajamanu, Kintore, Mount Liebig, Utopia, Titjikala and Tennant Creek.

Thriving art and craft practices have also developed in many other smaller communities. Artists here make a variety of goods including decorated beads, woodcarvings, printed fabrics and pottery.

History of the Desert Regions:
Indigenous Heritage and European Inroads

Until Europeans explored and settled Australia's desert regions from the early 1880s, the Warlpiri and Walmadjarri people of the north, the Kukatja and Pintupi of the west, Pitjantjatjara and Luritja of the south, the Arrernte of the central areas

From the colourful paintings of Yuendumu artists such as Darby Jampitjinpa Ross to the distinctive 'spear straightening' paintings of Turkey Tolson Tjupurrula which derive from the ancestral stories of this master painter's warrior creation ancestors, and the strong curvilinear designs by women artists such as Nyurapayia Nampitjinpa (Mrs Bennett), the art of central Australia is as varied and striking as the rocks, plains, waterholes, flora and fauna of the region itself.

37

Emily Kame Kngwarreye, *Earth's Creation*, 1995, acrylic on canvas, 275 x 632 cm (4 panels). Collection Mbantua Gallery. [Courtesy estate of the artist, Dacou and Mbantua Gallery.]

One of Australia's greatest modern painters, Emily Kame Kngwarreye's paintings such as this large, record-breaking work show the power and fluidity that often characterise the art of this senior woman from the Utopia region.

and many others had lived a traditional nomadic life. Cattle, introduced by Europeans for their pastoral properties that took over vast tracts of the land, trampled and ate down the fragile vegetation, often degrading it beyond the point where it can regenerate.

Until the mid-1900s, Aboriginal people could still maintain some connection to the land. Some worked as stockmen and women, others lived at the missionary communities of Ernabella and Hermannsburg from where

they could often travel. But, with the bringing in of many people to government-established reserves at Haasts Bluff (1941), Yuendumu (1946), Lajamanu (1946) and Papunya (1961), much connection to their land and country was broken. It was not until the 1970s – after agitation for Aboriginal landrights and the election of a Labor government which granted the first landrights to desert people – that restrictions on the settlements were eased. In the 1970s and 1980s most of these government communities were returned to Aboriginal control and people were free to move back to traditional lands to live in small outstation settlements. The establishment of outstations went hand-in-hand with the development of contemporary Aboriginal art (see *The Living Art of Aboriginal Australia* pp. 6–30). The outstation movement was challenged in 2007 when the Liberal federal government, acting in response to widely publicised community problems, removed

the group, for safety's sake, tjurunga were often stored en masse in a special keeping place for retrieval during times of ceremony.

Ceremonial sand paintings or 'sculptures' (some are also built up in bas-relief form) are made on a bed of cleared and smoothed sand – usually square or rectangular and several metres in dimension. Ritual designs, denoting journeys and events of the Dreaming ancestors, are made either before or during ceremony, carved into the sand or built up into a bas-relief through the addition of extra sand. Other materials such as coloured ochres, fibres, wood and feathers, all with specific references and meanings, are also often added. Sometimes made before the start of a ceremony, which may be performed to relate the journeys of ancestors or as fertility, rain or food gathering rites, patterns are also frequently made by the feet of dancers during the ceremony itself, marking out the designs as part of the ritualistic song and dance.

Body decorations are also an important part of ceremonial practice and made from ochres ground to a paste with water then applied in striped or circular designs to the face and torso. Leading painter from the Utopia community Kathleen Petyarre describes how women's body painting forms an integral part of ceremonial life.

The old women used to paint the ceremonial designs on their breasts, first with their fingers, and on their chests, and then with a brush called a tyepale, made from a stick. They painted their thighs with white paint. They painted with red and white ochres. Then they danced, showing their legs. The old women danced with a ceremonial stick in the earth.

The spirits of the country gave women's ceremonies to the old woman. The woman sings, then she gives that ceremony to the others, to make it strong. The old woman is the boss because the spirits of the country have given her the ceremony. So all the women get together and sing.

The old women sing these ceremonies if people are sick; they sing to heal young girls, or children. If a child is sick in the stomach,

the permit system for non-Aboriginal people to travel Aboriginal lands and initiated military intervention into many communities. With the election of a new Labor government in late 2007, the situation changed again with permit systems reinstated and other changes made.

Art of the Desert: From Sand and Body Decoration to Gallery Walls

The main forms of traditional visual representations by desert people are sand and body painting made as part of ceremony. Weapons such as spears and clubs, utilitarian objects such as coolamons (women's carrying vessels) and the sacred wood or stone men's 'message boards', tjurunga were also engraved for either decorative or ceremonial purposes. The small, usually oval-shaped tjurunga carry particular meaning, detailing the story of a man's life, his clan associations and major Dreamings. Of great significance to both the individual and

they sing. The old women are also holding their country as they dance. The old women dance with that in mind. They teach the younger women and give them the knowledge, to their granddaughters, so then all the grandmothers and granddaughters continue the tradition.[1]

The modern acrylic paintings of many Central and Western Desert artists are based on these body-painting designs. Circles may indicate waterholes, a campsite or fire; lines may denote lightning, watercourses or ancestral paths; a U-shape usually

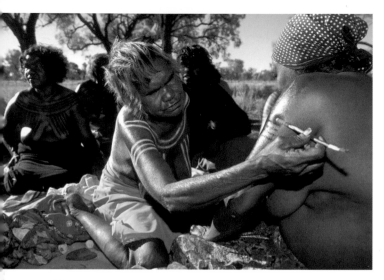

Aboriginal women at Utopia painting up for ceremonies.
[Photo. Penny Tweedie, Wildlight.]

RIGHT: *Some symbols used in Central and Western Desert art*

FAR RIGHT: Clifford Possum Tjapaltjarri, *Honey Ant Ceremony*, 1972, acrylic on canvas board, 100 x 78 cm. Collection, Art Gallery of South Australia. [Courtesy Sotheby's and Aboriginal Artists Agency Ltd.]

The ochre body paint used for ceremonies is often the basis for art, and includes the designs (right) which are seen also drawn in sand and on rock walls. Clifford Possum Tjapaltjarri's glowing painting of the honey ant remains one of the classics of early Papunya painting.

rainbow, cloud, cliff or sandhill

rain

fire, smoke, water or blood

waterhole *waterhole*
running water

boomerangs or windbreaks

star

a spiralling line can mean water, a rainbow, a snake, lightning, string, a cliff or native bee or honey storage

man

two men sitting

concentric circles can mean a campsite, a stone, a well, rock hole, a breast, fire or fruit.

four women sitting

sitting-down place

footprints or animal tracks

travelling sign, with the concentric circles representing a resting place

40

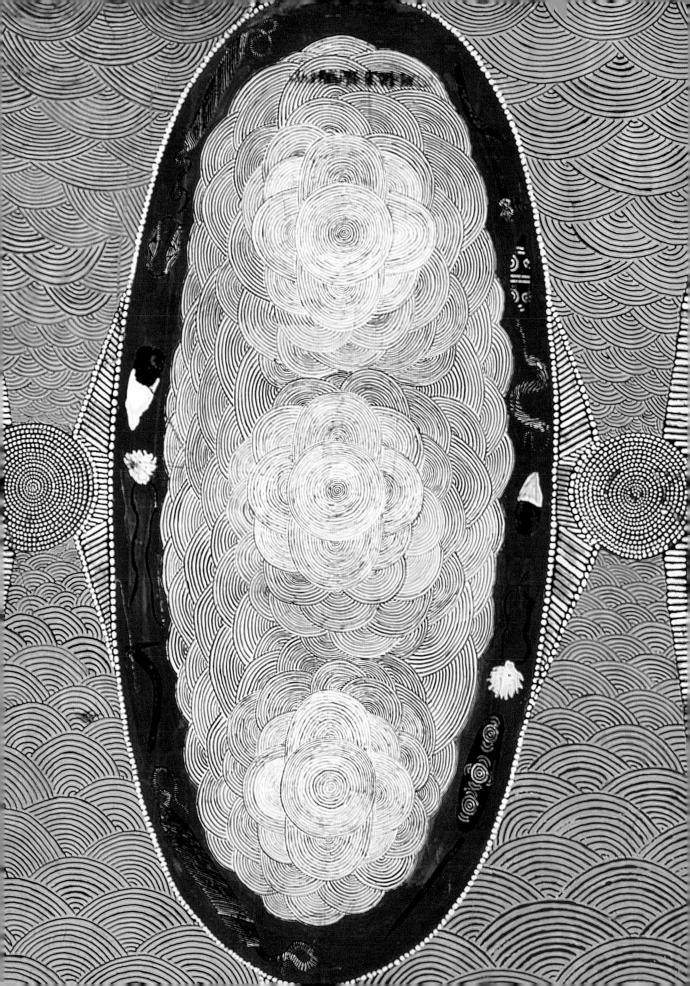

'The art of Central Australia is as varied and striking as the rocks, plains, waterholes, flora and fauna of the region itself.'

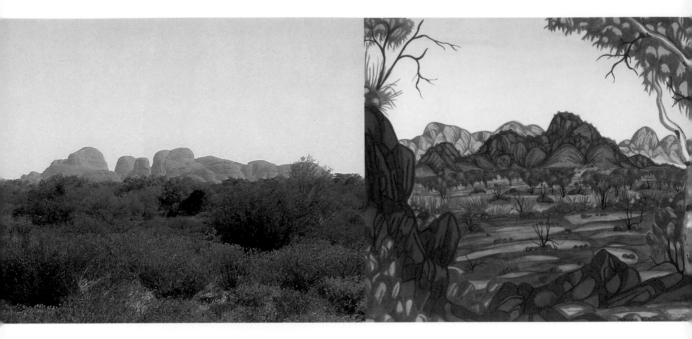

TOP: *Kata Tjuta (the Olgas)*. [Photo Anne Runhardt.]

RIGHT: Mervyn Rubuntja, *Mount Jakataka*, 2007, watercolour on paper, n.s. Private collection. [Courtesy Museum and Art Gallery of the Northern Territory.]

indicates a sitting place or breasts; arcs may be boomerangs; short lines may be digging sticks or spears. Realistic animal tracks and footprints are also often included.

The dots, which in various forms have become the most characteristic element of desert art, represent many things – stars, sparks, burnt ground, clouds. The dense fine layering of dots seen in many Central and Western Desert paintings was developed as an artistic style in the mid-1970s by Papunya master painters including John Warungkula Tjupurrula, Yala Yala Gibbs Tjungurrayi, Mick Namarari Tjapaltjarri and others. They developed the technique largely to mask the more direct symbolism and stories whose representation on early board was considered inappropriate for general viewing.

Styles of Art

With an estimated 2000-plus Aboriginal artists and craftspeople living in the central, western and eastern regions, styles of art vary widely. Artists of Papunya for a number of years chose to paint in acrylics of earth colours – red, yellow, black and white. This range broadened to include a greater use of colour by painters such as Clifford Possum Tjapaltjarri, Ronnie Tjampitjinpa, Johnny Warungkula Tjupurrula, Mick Namarari Tjapaltjarri and others, while Turkey Tolson Tjupurrula continued using ochre-yellows, red, black and white almost throughout his entire painting career from 1971 to 1999.

With the move back to their lands around Kintore, near Papunya, and the passing of many of the first generation of Papunya painters, the art of women of the area came greatly to the fore. Artists such as Makinti Napanangka, Naata Nungurrayi, Ningura Napurrula, Nyurapayia Nampitjinpa (Mrs Bennett) and

CENTRAL AUSTRALIA

many others have painted, since the late 1990s, many classic works that often relate very directly the iconography of long-told stories.

Styles of each region or community are numerous and usually specific to that region. Artists from Yuendumu, such as Maggie Watson Napangardi, Shorty Jangala Robertson, Paddy Japaljarri Sims and Bessie Nakamarra Sims are noted for their use of colour, which has long characterised art from this area.

In her use of not only colour but also strong gestural innovation, Utopia artist Emily Kame Kngwarreye became one of the most significant modern Australian artists. Other notable artists of her Utopia region have included Gloria Petyarre, Kathleen Petyarre, Barbara Weir, Minnie Pwerle and many others.

In addition to painting, which is the predominant medium for most artists, pottery, beads, woodcarvings, weaving, original prints and printed fabrics are also often favoured media.

Dinni Kemarre and Josie Kunoth Petyarre, *Mark Williams*, 2007, painted wood, 50 x 30 cm. Private collection. [Courtesy the artist and Mossenson Galleries.]

LEFT: *Ormiston Gorge waterhole in flood*, 2008. [Courtesy Tourism NT.]

While the perception of Australia's heart is often that of a flat, featureless barren land, it is actually a landscape of great variety, as these pictures show. The carvings of Utopia artists, such as that of footballer Mark Williams, demonstrate the importance of sport in everyday community life.

43

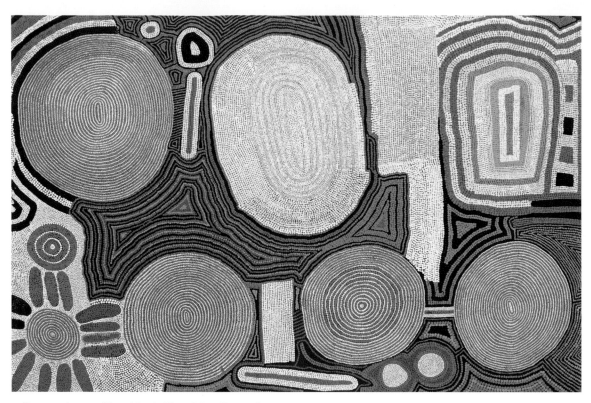

Tommy Lowry Tjapaltjarri, *Two Men Dreaming at Kuluntjarranya*, 1995, acrylic on canvas, 121.5 x 183 cm. Private collection. [Courtesy Sotheby's and Aboriginal Artists Agency Ltd.]

Latest Developments

Many artists work exclusively through the community centres they own; others sell their work both through the arts centres and privately. Some artists to deal through both avenues have included the founders of Papunya Tula Artists Pty Ltd such as Clifford Possum Tjapaltjarri, Turkey Tolson Tjupurrula and Ronnie Tjampitjinpa. Some areas, such as Utopia have not established a permanent community arts centre since that area's formative batik-making workshops of the mid-1980s. Yet the development of the community arts system and the artists it fosters has been of incalculable significance in fostering Aboriginal art and bringing it the national and international recognition it now commands.

Between 1997 and 2008 approximately 25 new arts centres were established in communities throughout the desert areas. The total number throughout the central, eastern, western and southern regions (including the Ngaanyatjarra, Pitjantjatjara and Yankunytjatjara (NPY) lands listed with the arts centre body Desart, is around 40. The background and development of art through the centres is often fascinating and highly individual. The history, styles and art practices of the most significant regions and their arts centres are detailed in the following pages.

With tourism to Australia's outback of increasing interest, there is also growing interest by visitors – ranging from the committed collector to the first-time tourist – in Aboriginal art and in visiting the regions, communities and centres in which it is made. Alice Springs is, increasingly, becoming an art-tourist mecca, especially at its annual survey exhibition Desert Mob. Many artists also visit or live in Alice and a number of arts centres have been established to represent artists living in town as well as those from outlying areas. Visitors are welcomed in these and in many regions and arts centres but visitors should always check with centres on an individual basis to determine opening times and permit requirements for Aboriginal lands, and whether or not the arts centre welcomes visitors.

A group of eager buyers search through the more than 2000 works for sale every year at the annual marketplace that precedes Alice Springs' Desert Mob exhibition. Drawing in the sand as the basis of art is an everyday activity for the Centre's Aboriginal residents, as the photo below demonstrates.

Established in 1991 Alice Springs' annual Desert Mob is a large showcase exhibition for Central Australia's Aboriginal-owned art centres.

Held at Araluen Galleries in partnership with the arts centre professional organisation Desart, the exhibition showcases more than 250 works from more than 35 art-producing communities each September.

Until around 2001, Desert Mob played, in the art-loving public's perception, something of second fiddle to the longer-established Telstra-sponsored National Aboriginal and Torres Strait Islander Art Award (NATSIAA) in Darwin. The two exhibitions have become clearly differentiated.

NATSIAA showcase works from around Australia, while Desert Mob shows only those working through community arts centres in the desert regions. Desert Mob also deliberately retains its 'mob' aspect by showing as many works as possible in the space, whereas NATSIAA has become a more select, curated exhibition, featuring fewer and larger works. Desert Mob, as its name implies, offers a different experience. Queues of dealers and keen private collectors form outside waiting eagerly for the doors to open. The same feeling spills into the works themselves – bold, often raw, sometimes heart-stoppingly beautiful, often boldly innovative.

The day before the opening of the exhibition is the highly popular Desert Mob market. Originally started to enable locals to buy works at affordable prices (works are usually under $200), the market has become of huge interest to the Aboriginal art-loving public and is packed with those eager for a bargain, or the chance to buy directly from the community arts centres and artists manning the stands.

An important meeting place for arts centre managers and artists, the scope of Desert Mob has also broadened into a three-day affair with a forum preceding the Saturday market and Sunday exhibition opening.

Here, in micocrocosm, is Australia's contemporary Aboriginal art and the industry that supports it – from debates on authenticity, industry issues of finances, issues within communities themselves and the broader political scenario to alleged dealer skulduggery and fakes.

The art, by its sheer presence, shines through. There is always something extraordinary, fresh and different to be found here: whether a new interpretation of an ancient style by an elder from a remote community seen in public for the first time, a unique painting style of a brilliant young artist or a change in direction or medium to inject energy and greater artistic expression in a long-established community.

desert mob

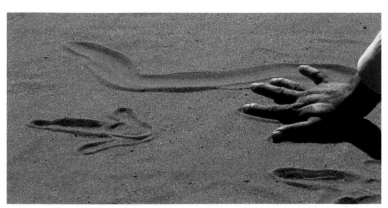

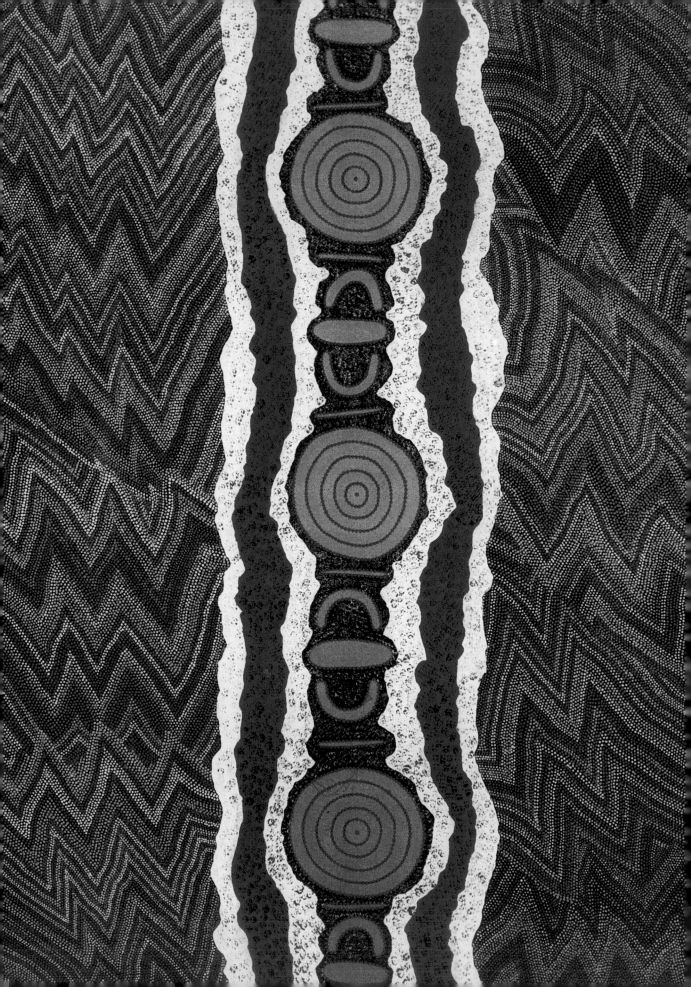

Located almost in the centre of Australia, Alice Springs is Australia's Aboriginal art 'hub'. Art is immediate in this once-pioneer, now tourist and business town. The first thing the visitor arriving in Alice Springs by plane sees upon entering the small, open-plan airport is a painting by the Australia's most famous modern Aboriginal artist, the Anmatyerre painter Clifford Possum Tjapaltjarri (c. 1932–2002).

Near Possum's striking painting is a large work by Pansy Napangardi, who is considered the first modern female desert artist. During the 1970s Napangardi was unusual for painting her own works, rather than, as was common for female artists of the day, assisting her male relatives with their paintings. She would also often walk some 250 kilometres from her home at Papunya into Alice Springs and sell her paintings herself. Clifford Possum, a leading founder of the Papunya movement, was a similarly well-known figure in Alice Springs, selling his now-legendary paintings of ancestral journeys and totemic mythology to tourists, collectors, dealers and galleries, as well as through the cooperative of which he was a founding member, Papunya Tula Artists Pty Ltd.

Possum and Napangardi symbolise the independence and resilience of spirit that characterises the Territorian character, and the sense of independent entrepreneurship and dedication that founded what is now recognised as one of the world's greatest art movements: Aboriginal desert painting.

The area's traditional owners are the Arrernte people, whose name for the Alice Springs area is Mparntwe (pronounced 'm-ban-tjua'). An important ceremonial site for the Arrernte, Alice Springs has been crucial to the development of art and as a meeting place, place of exchange and part-time residence for people from the hundreds of Aboriginal communities throughout the central, northern, southern and western regions. As well, it is a place of near-mythological proportions for Australian city-dwellers and international tourists.

The road into the 'the Alice' from the airport passes through Heavitree Gap, a gap in the monolithic and dramatic MacDonnell Ranges, created, according to Aboriginal lore by the ancestor caterpillar beings – Ayepe-arenye, Ntyarlke and Utnerrengatye. Caterpillar Dreaming is one of the most significant Dreaming stories of the town and increasingly celebrated as such by

ALICE SPRINGS (Mparntwe)
Australia's Art Heart and its surrounds

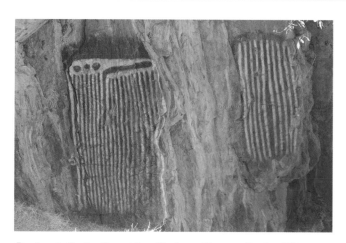

Rock art, Emily Gap, Alice Springs. [Courtesy Tourism NT.]

LEFT: Pansy Napangardi, *Women's Ceremonies at Pikilili,* 1989, acrylic on canvas, 182 x 120 cm. Private collection. [Courtesy Gallery Gabrielle Pizzi and Aboriginal Artists Agency Ltd.]

the naming of public building such as shopping centres (Yeperenye), streets and areas. Rock art such as the famous incisions at Emily Gap are easily accessible and demonstrate the meld of ancient and modern that is Alice Springs.

The dramatic quartzite and sandstone MacDonnell Ranges – filled with caves, once the repository of Aboriginal men's sacred tjurunga which relate their particular stories in specific iconography dominate the skyline. They are backgrounded by colours of the centre – reds of the earth, greens and whites of majestic gums and a clear light against a sapphire sky.

The town of Alice Springs was originally named Stuart, after the explorer John McDouall Stuart who led an expedition to central Australia in 1862. It became Alice Springs in

BELOW: Harold Thomas, Aboriginal flag, 1971.
RIGHT: Kukula McDonald, *Sleepy Yellow Tail*, 2007, acrylic on canvas, 45 x 45 cm. Private collection. [Courtesy the artist, Bindi Inc. Mwerre Anthurre Artists and Gallery Gabrielle Pizzi.]

Traditional rock art of the Alice Springs region depicting the area's caterpillar dreaming can be seen at Emily Gap on the outskirts of the town. The designer of the Aboriginal flag, Harold Thomas, is a Luritja painter born in Alice Springs but removed as a child as one of the stolen generations. He is now a leading Northern Territory artist. Pitjantjatjara artist Kukula McDonald, born in Papunya and resident in Alice Springs, paints the flora and fauna of everyday life.

1933 after a more substantial settlement had grown up around the telegraph station, built for the overland telegraph line from Adelaide to Darwin, situated next to a fertile spring. The usually dry sandy sweep of the broad Todd River runs through the town.

Art in the Alice

Alice Springs has been a serious art destination for collectors and tourists alike since the 1970s with outlets catering for all buyers located largely in and around Todd Mall, the town's main street. The number of galleries has grown vastly since the 1970s and 1980s, when Iris Harvey's Arunta Art Gallery and Bookshop and Pat Hogan's Stuart Art Centre sold works by Papunya artists. The first Papunya Tula Artists gallery, the famous cooperative of Western Desert artists known collectively as the 'Papunya School', was opened in 1973 at 86 Todd Mall, with Papunya Tula artists selling works both from their office in the back and through the Aboriginal Arts and Crafts Gallery in the front.[1]

The cooperative was run for many years by the indomitable Daphne Williams. Since Paul Sweeney became director in 2000, Papunya Tula has grown into a large, sophisticated gallery in a prime position in the middle of Todd Mall and where beginner collectors and experienced dealers alike converge to buy paintings by the important senior artists and younger up-and-coming painters.

Increasingly, Alice Springs is becoming not only an outlet for art from outlying communities through galleries but communities themselves are establishing outlets 'in town'. Alice Springs is, itself, also becoming an art-producing area with the post-2000 establishment of both Aboriginal-owned arts centres and a range of private operators creating permanent painting sheds and houses in the centre of town and on its outskirts.

Alice is also a thriving cultural centre for dance – it is home to the dance group, the Jangpanga Performance Group – music and craft of many types, as well as frequent music, film and other festivals and the Central Australian Aboriginal Media Association (CAAMA). Many events and exhibitions such as the Alice Prize, the imaginative and much-loved Beanie Festival and the annual Desert Mob exhibition are held at the town's arts centre, the Araluen Centre for Arts and Entertainment, which also houses a permanent display of Albert Namatjira watercolours as well as showcasing a gem-like collection of the Papunya Primary School's early board paintings.

The Association of Central Australian Aboriginal Art and Craft Centres and the Aboriginal community arts centre body Desart are based in Alice Springs and provide important support networks for both artists and arts centres. The Greenbush Art Group (established as the Alice Springs Prison Group in the mid-1990s) has provided significantly

important artistic avenues to people in prison. Historically, centres such as Warumpi Arts, which operated during the 1990s, provided a space for Alice Springs Aboriginal people to produce and sell art in an environment that they could maintain and control.

In 2008 there were eight Aboriginal-owned arts centres in Alice Springs including Tjanpi Desert Weavers, the retail outlet and office for the Western Desert's Ngaanyatjarra Pitjantjatjara Yankunytjara (NPY) women's council-established initiative that has resulted in a widespread and significantly innovative contemporary weaving movement. The Aboriginal-owned art centre Aboriginal Australia Art & Culture Centre represents a small collection of artists including Maureen Hudson, and conducts cultural tours around the local area.

Important in the emergence of Alice Springs as an art-producing region in its own right has been an innovative program of art- and craft-making in Alice's numerous town 'camps',

Billy Benn Perrurle, *Artetyerre*, 2007, synthetic polymer paint on linen, 120 x 240 cm. Private collection. [Courtesy the artist, Bindi Inc. Mwerre Anthurre Artists and Alcaston Gallery.]

Luminous in colour and often small in scale, the expressionistic landscapes of Billy Benn Perrurle, who works with Mwerre Anthurre Artists and was winner of the 2006 Alice Prize, have attracted attention for their fluidity, coloration and immediacy.

where out-of-town people stay and which are often riddled with problems of alcohol, drug abuse, violence and illness.

Another organisation is Mwerre Anthurre Artists run by Bindi Inc., that provides employment, education and training to Aboriginal people with disabilities. Bindi has been running for over 20 years and its products include woodwork, metalwork and furniture. Out of Bindi emerged the art studio Mwerre Anthurre (pronounced 'mura andura', meaning 'very good' or 'very proper' in Arrernte).

Some of the most distinctive works from Mwerre Anthurre are the naive, startlingly beautiful and often miniature paintings of Billy Benn Perrurle, the brother of Utopia artists Ally and Gladdy Kemarre, remarkable for their small-scale depiction. His work has included some unique 'lightboxes' capturing the brilliant light of his country – Arteteyerre (Harts Range). Benn began painting on scrap wooden boards from the Alice Springs timber mill, showing a unique

ability to render the vast Central Australian landscape in small plane. Benn won the 2006 Alice Prize and his work is widely collected by public and private collectors and shown in leading galleries around Australia.

Kukula McDonald, another Mwerre Anthurre artist, has been painting from her late teens. Born at Papunya, she grew up watching the elder Pintupi artists paint, and whilst drawn to their famous love of geometric design, her themes, such as the red-tailed black cockatoo and sleepy yellow tail parrot, reflect the flora and fauna of Alice Springs, where she has lived since the age of seven.

In the same area as Bindi, the large Ngurratjuta Iltja Ntjarra ('Many Hands') Art Centre was established in 2004 to nurture the tradition laid out by Albert Namatjira and the Aboriginal watercolour artists continue to paint in the tradition of the Hermannsburg style.

Many Hands Art Centre was developed by the Board of Ngurratjuta / Pmara Ntjarra Aboriginal Corporation in 2002, in recognition of a century of the birth of Albert Namatjira. An association of those communities affected by the oil and gas mining operations at Mereenie and Palm Valley in Central Australia, there are approximately 70 member communities, many of which are small outstations. The Art Centre was officially opened on 27 February 2004. Artists include permanent residents of Alice Springs together with long and short-term visitors from the above mentioned communities and those

Iris Taylor, *Driving along the Stuart Highway at Sunset*, 2007, acrylic on canvas, n.s. Private collection. [Exhibited National Aboriginal and Torres Strait Islander Art Award, 2007. Courtesy Museum and Art Gallery of the Northern Territory.]

Figuration and a fresh naive quality characterise the colourful paintings of this leading Alice Springs artist.

painting in the communities themselves. As well as the Namatjira style, the central Australian 'dot painting' style is practised, as is naive figurative art such as that of Iris Taylor in which she documents life in Alice Springs and surrounding areas in a fusion of Western and Aboriginal imagery.

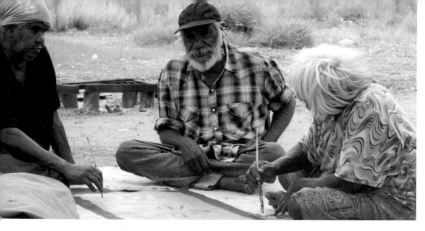

LEFT TO RIGHT: *Daisy Morton, Nugget Morton, Carmel Chisholm*, 2006. [Photo. Liesl Rockchild. Courtesy Tangentyere Artists.]

RIGHT: *Yarrenyty-Arltere learning centre*, 2007.
[Photo Emily McCulloch Childs.]

The Tangentyere Artists town camp program encompasses 19 town camps and caters to around 1600 people such as these artists painting at Truckies Camp. The Larapinta Valley camp program Yarrenyty-Arltere housed in the learning centre (right) offers an ongoing program of innovative arts and crafts activities.

Yarrenyty-Arltere Artists, part of the Tangentyere Council Town Camp program, was established at Larapinta Valley Town Camp in 2000; the arts centre was originally established as part of a program aimed at helping overcome anti-social problems such as petrol sniffing. The name Yarrenyty-Arltere refers to the sacred 'White Dog' totem, an important site next to the camp. The Batchelor Institute at the Yarrenyty-Arltere Learning Centre began a two-year program that taught residents art and craft, with the aim of them establishing their own art centre. Larapinta Valley Town Camp, which was the base of famous artists Albert Namatjira, Wenten Rubuntja and Arnulf Ebatarinja and is home to around 150 people, now has 15 artists who produce creative work, often working on recycled materials, such as furniture and boards.

Yarrenyty-Arltere holds annual exhibitions of paintings, prints, ceramics and craft in Alice Springs. The works include subtly shaded silk scarves, dyed with unusual mixes of plants, rusted metals and other materials found on the camp grounds. Often incorporating feathers and other decorations, the sophisticated soft browns and greys of these scarves are utterly distinctive and stand out from the normally bright colours used in Aboriginal scarf painting and dyeing. 'Found object' jewellery is also particularly notable. The beaded necklaces, created from found materials, reflect the palette of the scarves; unusually, brown and grey gumnuts are left unpainted, producing what may be termed a 'Gothic Australian' effect. They represent not only the harshness of the artists' lives and surrounding environment, and the daily problems of abuse which the artists themselves have endured, but also the beauty and strength that still exists through living within a community and belonging to an easily identifiable cultural group. Unpainted, the seeds represent the Australian landscape as it is – expressions of the Western Arrernte people's love of the land in all its natural beauty.

Tangentyere Artists, operating in Alice Springs from Tangentyere Council, is a large organisation representing artists living in all 19 of the town camps and specialises in painting. These camps are home to around 1600 Indigenous people from both the local area as well as many short and long-term visitors from remote communities across Central Australia.

Tangentyere Artists, under the direction of long-time arts centre coordinator Liesl Rockchild, opened in 2005. Four months after the beginning of production, the centre held its first exhibition at the Araluen Arts Centre. More than 100 works by 61 artists demonstrated the huge range and variety of art from the many different artists living in town. Tangentyere Artists represents over 370 artists and offers town-camp people huge opportunities to hone their art skills and to reconnect with culture – especially important given that many artists living in town camps have reduced contact with their country and traditions.

TOP: *Irrkerlantye Artists Centre*.
[Photo Emily McCulloch Childs.]

Near the Todd River, this multifaceted arts centre offers a peaceful and shady environment in which artists paint and make a variety of crafts as part of an extensive education program.

BELOW: Mitjili Napanangka Gibson, *Tarkunpa,* Private collection. [Courtesy the artist and Gallery Gondwana.]

Leading Western Desert painter Mitjili Napanangka Gibson works with Alice Springs' Gallery Gondwana.

RIGHT: Dorothy Napangardi and Paddy Lewis Japanangka, *Untitled*, 2004, acrylic on canvas, 137 x 30 cm. Collection Ken Hinds. [Courtesy the artists, Yanda Aboriginal Art and the Hinds Collection.]

Daughter Dorothy Napangardi and her father Paddy Lewis Japanangka collaborated on a canvas showing their distinctive styles.

Irrkerlantye Arts was founded in 1999 by mostly female Central and Eastern Arrernte artists, such as Faye Oliver, Therese Ryder and Margaret Turner. Situated on the banks of the Todd River, Irrkerlantye is a peaceful and shaded building. Irrkerlantye (pronounced 'irra-kur-lunge') is the Arrernte word for the brown falcon or whistling kite country on the outskirts of Alice Springs, home to many of the artists. The arts centre is part of a multi-faceted intergenerational learning centre in which painting, prints, sculpture, ceramics and fabric design all feature. Styles of paintings reflect the artists' differing heritage and includes decorative dot paintings and delightful figurative prints of everyday events. Artists actively promote their art through stalls at the Todd Street Mall markets and online.

Working privately

As well as the many arts centres in Alice, artists also work in town and on its outskirts, with numerous private dealers and galleries. While issues surrounding this, as related in *From the Bush to the City*, have sometimes attracted much media and art-industry attention, the artist/ private dealer relationship is a factor of art in the Alice, and one of the reasons the town itself has become a significant art-producing region. Artists who work with galleries such as the long-established Gallery Gondwana, include

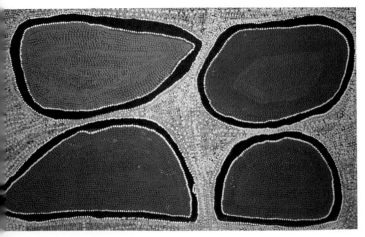

National Aboriginal and Torres Strait Islander Art Award winner Dorothy Napangardi, and her aunt Pintupi/Warlpiri woman Mitjili Napanangka Gibson, whose story featured in the exhibition *Colliding Worlds*, Adelaide, 2006. Other galleries that have had long-term commitment to working with artists on an individual basis include Mbantua which has long represented artists of the Utopia region through its large Alice Springs gallery, a 2006-established Darwin gallery and in other venues; Aboriginal Desert Art Gallery and its related galleries in Sydney (Jinta Desert Art Gallery) and Melbourne (Aboriginal Desert Art Gallery); Yanda Aboriginal Art which in 2008 became Armstrong, Ballan & Pannan and the 2004-established Central Art Aboriginal Art Store.

Surrounding Alice: Santa Teresa, Titjikala, Ali Curung and Tennant Creek

Several art-producing communities are in close proximity to Alice Springs. One of the more recently established is Imanpa Arts, which opened in 2005 at the Imanpa community between Alice Springs and Uluru. Created to promote the making of punu (woodcarvings) and paintings of the local people, the Imanpa artists sell their work through an outlet at the Mount Ebenezer Roadhouse on the Lasseter Highway.

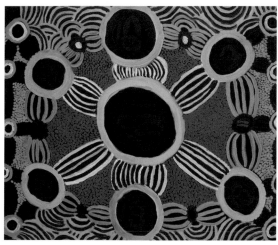

Dora Wari, *Untitled*, 2004, acrylic on canvas, 50 x 70 cm. Private collection.
[Courtesy Titjikala Art Centre.]

Paddy Lewis Japanangka, *Untitled*, 2007, acrylic on canvas, 182 x 305 cm. Private collection.
[Courtesy the artists, Yanda Aboriginal Art and Trevor Victor Harvey Gallery.]

A senior Warlpirri artist based at Nyirripi, Paddy Lewis Japanangka has been painting since the mid-2000s; his work is hailed for its clarity and authoritative power.

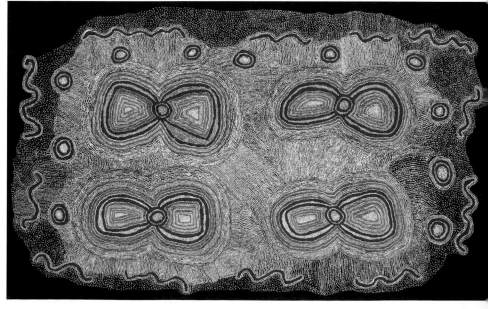

LEFT: *Landscape near Tennant Creek.*
[Photo Grenville Turner, Wildlight.]

RIGHT: Evelyn Young, *Untitled*, 2007, acrylic on ceramic
vase, 23 x 13 cm. Private collection.
[Courtesy Ali Curung Women's Centre and Birrung Gallery.]

**The land around Tennant Creek shows
a dramatic interplay of red earth and mineral-laden
rocky outcrops.**

Other communities have a substantial art-making history. One example is Santa Teresa, or Ltyentye Apurta (which means 'stand of beef-wood trees' in Eastern Arrernte). Art, in particular painting, has been practised at Santa Teresa, some 80 kilometres south-east of Alice Springs, since the 1950s. Originally established as a Catholic mission in 1953, Santa Teresa's origins lie in the Little Flower mission, named after Saint Thérèse of Lisieux, established at Alice Springs by Father Patrick Maloney in 1935. The mission was later moved to Arltunga, north-east of Alice Springs, in 1942 and then finally to the site of Santa Teresa, a sacred and historically important place for the Eastern Arrernte people.

The community was returned to its original owners under the Aboriginal Land Rights (Northern Territory) Act 1976 in 1978. The name of the art centre, Keringke Arts, relates to an important Dreaming and sacred site (keringke means 'kangaroo tracks').[2] The art centre began in 1987 with coordinators including Cait

Wait, Tim Rollason and Leisl Rockchild who fostered the artists and enabled them to create their intricate, brightly coloured work. This has included painted silk scarves, finely dotted paintings and ceramics, such as the ceramics by Evelyn Young, which illustrate the artist's skill at depicting the energy of her land.

The small township of Titjikala lies 120 kilometres south of Alice Springs, through Ewaninga, site of some important rock carving and one of the former stops of the Ghan railway. Originally established as a women's art centre, Titjikala Arts Centre opened in 1995 and was renovated with a new extension in 2007. The community of mostly Arrernte, Luritja and Pitjantjatjara language groups is unlike most other communities around Alice Springs: it is not on government-returned Aboriginal land, so no permits are required for visitors. Nearby Chambers Pillar, a large, red rock column used by 19th-century European explorers as a marker, is a popular destination point for tourists.

Titjikala is surrounded by red, sandy plains, punctuated by large, flat-topped hills, that support a rich variety of desert oaks, grasses and flowers, which appear in abundance after the infrequent rains. The colours of the land are represented in the art produced at the centre, which includes paintings, batik, woodcarving, block printing on fabric, silk painting and jewellery.

Several of the artists, such as Dora Wari are gaining recognition for their acrylics and gouaches on paper or board, often in a naive figurative style, that depict their bush flowers and animals as well as traditional ceremonial designs that relate to the surrounding tjukurrpa (Dreaming) stories.

The adaptability of central Australians, notable in painting, is seen here in the imaginative range of craft art such as the three-dimensional animals, often woven in raffia or carved in wood. Some are of creation ancestors such as emus and kangaroos, but also include introduced species such as camels and rabbits. The white kangaroo is a particularly significant important totemic animal. In addition to the paintings, weavings and other craft art produced by the women at the centre, two male artists from Titjikala have had special success with their three-dimensional work. Johnny Young and David Wallace have become known for their highly imaginative 'Bush Toys', which document the cultural and social aspects of life in the bush and at communities such as Titjikala, Santa Teresa and Engawala, and have been included in major exhibitions and collections in Australia and overseas.

The creative sculptures made from pipe cleaners and other scrap metals joyfully and imaginatively depict football matches, concerts by local Aboriginal bands and the highly respected Aboriginal stockmen on horses or motorbikes or with working helicopters. They also celebrate the many positive aspects of life in a small

Johnny Young, *Essendon vs Collingwood at Titjikala*, 2003, mixed media, 100 x 100 cm. National Gallery of Victoria. [Courtesy Titjikala Art Centre.]

Quirky, innovative and imaginative 'bush toys' such as those by Johnny Young are both contemporary and have links with a long history of traditional toys made by Aboriginal people throughout Australia for thousands of years.

community such as Titjikala, where music, sport and farmwork provide important social frameworks and create a sense of pride and enjoyment. In their use of materials to hand they are also a continuation of long-practised traditions of making children's toys and sculptures from bark, wood, fibres, shells and other materials.

The art centre at Ali Curung, about 390 kilometres north-east of Alice Springs in the southern Barkly region, reopened in 2007. Established in 1995 as the Ali Curung Women's Art and Craft Centre, the Arleheyarenge Art Centre provides an important artistic outlet for many of the community's 500 Warlpiri, Warumungu, Kaiditch and Alyawarre residents. Their paintings are largely those of the Central Desert 'dot art' style with a palette ranging from natural ochre to brighter acrylics.

The northern community of Tennant Creek, with its varying language groups (amongst them Warumungu) has both an art centre and a cultural centre, established in 2004. Julalikari Arts was established in 1994, and is known

Peggy Napangardi Jones, *Birds and Bush Tucker*, 2005, acrylic on canvas, 155 x 165 cm. Private collection.
[Courtesy Julalikari Arts and Alcaston Gallery.]

colloquially as 'the Pink Palace', due to the building in which the arts centre is housed.

Tennant Creek's most well-known artists include Joan Stokes, who exhibits with Karen Brown Gallery, Darwin and Peggy Napangardi Jones, whose brightly coloured naive-style canvases depicting birds, animals and bush tucker have been the basis of her much-seen art. The art centre itself evolved out of an Art and Craft Centre for local Aboriginal women. Julalikari artists are also linked with the nearby Nyinkka Nyunyu Art and Culture Centre, a gallery–museum–performance space dedicated to displaying Warumungu culture in five central interpretive themes: Punttu (Family), Nyinta Manungku (Living in the Land), Wanjjal Payinti Manu (Yesterday and Today), Wurrmulalkki Mukka (Returned Histories) and Pona Parinyi Manu Purtakijji (Getting the Land Back).

Since the mid-1990s with the commencement of direct flights to Australia's number-one tourist destination – Uluru (Ayers Rock) – tourism in Alice Springs has been in decline. But growth has been evident in the retail, meeting and business sectors and, increasingly, 'the Alice' is becoming a popular destination for those wishing to experience a greater engagement with the Centralian environment and culture. To this end, art, especially Aboriginal art, is a unique drawcard – and one which is attracting an increasing number of visitors, professionals and enthusiasts every year.

Some artists

Ngurratjuta Iltja Ntjarra: Doris Abbott, Alison Anderson, Marilyn Armstrong, Emma Daniel, Daisy Nakamarra Leura (widow of Tim Leura Tjapaltjarri), Lenie Namatjira, Mavis Nampitjinpa, Pansy Napangarti, Gloria Napanangka Panka, Hubert Pareroultja, Ivy Pareroultja, Marie Ramjohn, Mervyn Rubuntja, Iris Taylor, Elton Warri.

Tangentyere: Carmel Chisholm, Mervyn Franey, Esther Furber, Yvonne Kunoth, Daisy Morton, Nugget Morton, Margaret K Turner.

Irrkerlantye: Faye Oliver, Therese Ryder, Margaret Turner.

Imanpa: Carolyn Coombs, Gracie Kunoth.

Santa Teresa: Justin Hayes, Jilary Lynch, Mary Mullidad, Benita Patrica, June Smith, Josette Young, Leonie Young, Kathleen Wallace, Muriel Williams, Paul Williams.

Titjikala: Susan Amungura, Lena Campbell, Rene Douglas, Sarah Entata, Josie Mulder, Doris Thomas, Annie Wallace, David Wallace, Dora Wari, Mavis Wari, June Wiluka, Lisa Wiluka, Johnny Young.

Ali Curung: Gabriela Beasley, Agnes Brown, Miranda Brown, Henrietta Driver, Marjory Hayes, Mona Haywood, Eunice Lane, Linda Lane, Maureen Limbiari, Savannah Long, Marleen Presley, Joyleen Robertson.

Tennant Creek: Le Tamara Alley, Gladys Anderson, Pearl Burns, Bessie Campbell, Ruth Dawson, Rosalyn Dick, Linda Dixon, Bessie Graham, Annie Grant, Noreen Grant, Raylene Green, Flora Holt, Jessica Jones, Peggy Jones, Betty Kelly, Nikkie Morrison, Janet Napurrula, Mavis Ricky, Evonne Thompson, Pauline Weston.

It was quite a moment as we all watched…the first hieroglyph being put on the wall lovingly and beautifully with a marvellous painting technique. Some of the men went across and touched the wall even before the paint had dried. Then the little children came across and stood beside the old painting men and Kaapa [Kaapa Tjampitjinpa, one of the most significant early painters] and we all stood back and watched the start of the honey ant mural as it was finally to appear. This was the beginning of the Western Desert painting movement, when led by Kaapa, the Aboriginal men saw themselves in their own image before their very eyes, on a European building, something strange and marvellous was set in motion.[1]

This Honey Ant mural, the painting of which had been encouraged by a teacher, the late Geoffrey Bardon, on the walls of the schoolhouse building at Papunya in 1971, was the start of what has become the largest and most well known of all Aboriginal art styles and one of the best-known movements in modern Australian art.

Papunya, 250 kilometres west of Alice Springs, was the last of the Aboriginal reserves to be set up by the federal government in 1961. By the time Bardon arrived in 1971 it was a community of over 1000 people beset by poor living conditions, health problems and great inter-tribal conflicts between groups – including the Pintupi, Anmatyerre, Warlpiri and others – forced to live in close proximity for the first time. Yet from these raw beginnings and rocky start has grown one of the greatest art schools Australia has ever known.

In 1972 the first Aboriginal-owned arts centre, Papunya Tula, was formed. (Papunya Tula means 'a meeting place for brothers and cousins' as explained by Charlie Tarawa Tjungurrayi, who told Bardon the men's decision to choose this name in 1972).[2]

The early development of art at Papunya is intertwined with that of contemporary Aboriginal art and was of fundamental significance to this movement all through the 1970s. With the return of Aboriginal communities to Aboriginal control from the mid-1970s, by the early 1980s many of Papunya's

PAPUNYA and KINTORE (Walungurru)

'An entire continent wondrously re-perceived'

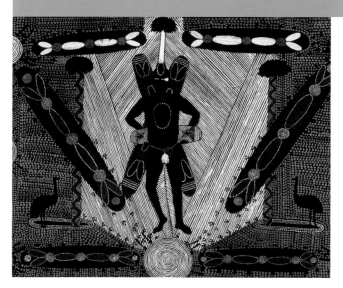

Clifford Possum Tjapaltjarri, *Emu Corroboree Man*, 1972, acrylic on board, 46 x 61.5 cm. Private collection.
[Courtesy Sotheby's and Aboriginal Artists Agency Ltd.]

The first works in acrylic at Papunya in the early 1970s were painted on board and a variety of other media and showed highly iconographic and often quite realistic imagery such as this striking painting by the youngest of the original group of 'painting men'.

'we all stood back and watched the start of the honey ant mural as it was finally to appear. This was the beginning of the Western Desert painting movement…'

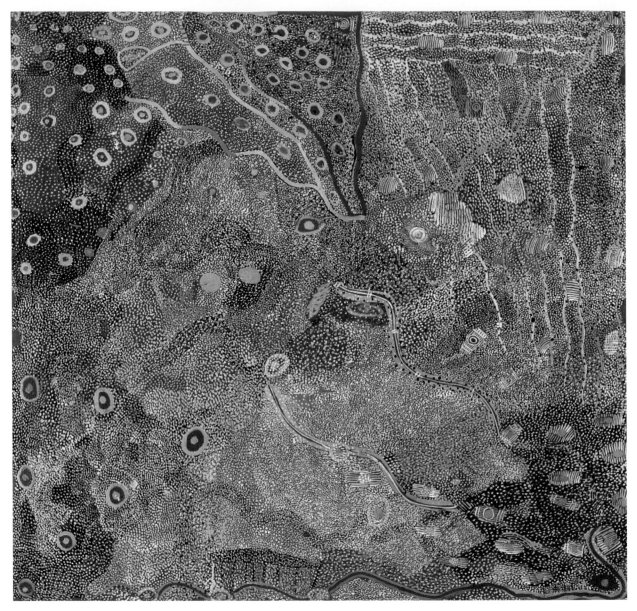

Johnny Warangkula Tjupurrula, *Rain Dreaming*, 1972, acrylic on board, 69.5 x 68 cm. Museum and Art Gallery of the Northern Territory. [Courtesy MAGNT and Aboriginal Artists Agency Ltd.]

A master of colour and the fine application of dots to overlay sacred-secret imagery, Johnny Warangkula Tjupurrula's early paintings such as this have become classics of contemporary Australian art.

founding painters had moved to live elsewhere or travel extensively. A Pintupi community of around 300 people was established at Kintore, next to the Western Australian border in 1981; Kiwirrkura, 250 kilometres further west (in Western Australia) was established in 1983. Others moved back to Haasts Bluff, to Mount Liebig, Mount Allan and to other smaller outstations in their traditional homelands throughout the region. Many also spent time in Alice Springs, painting for private dealers as well as for the Papunya Tula cooperative they owned. The most far-ranging was the famous painter Clifford Possum Tjapaltjarri (1932–2002) whose career took him to live in Alice Springs,

Melbourne, Sydney and other cities, and to travel the world showing and selling his art.

By 2008 all but three of the approximately 40 founding 'painting men' of the original Papunya school – Ronnie Tjampitjinpa, Billy Stockman Tjapaltjarri and Long Jack Phillipus Tjakamarra – had died, as had teacher Geoffrey Bardon. With these men's passing came the end of a wave of painting, the significance of which was marked in the important and much-loved major retrospective exhibition *Genesis and Genius* at the Art Gallery of New South Wales (AGNSW) in 2004. The legacy of their art and efforts has been the growth of a vast industry and the foundation of a new and vibrant school of Western Desert painting.

By 2008, the population of Papunya had dropped to around 300 and, while painting still continues in the community, nothing remains to remind the visitor of the first days of Papunya Tula itself. The famous school mural was painted over some years after it was painted; the tin shed painting-room, a hive of incandescent activity in the 1970s, is similarly long gone.

During the 1980s, the administrative headquarters of Papunya Tula Artists Pty Ltd followed the core Pintupi artists to their homeland settlement of Kintore, with field officers travelling between Alice Springs, Kintore and Kiwirrkura and working from a small, under-equipped office at Kintore until the opening of a new, large architect-designed painting studio in 2007.

At Papunya itself during the 1990s the community-based Warumpi Arts serviced the needs of artists living at Papunya with a gallery–shop in Alice Springs until this closed in 2004. In 2007 a new community-based arts centre, Papunya Tjupi (the Honey Ant) was initiated at Papunya by writer and academic Vivien Johnson supported by artists Michael Nelson Jagamara, Long Jack Phillipus Tjakamarra and William Sandy. In late 2007 the first arts centre manager, Sara Twigg-Patterson, former manager of the Western Desert's Tjala Arts was appointed and a small arts centre opened.

Papunya Tula Artists Pty Ltd, based at

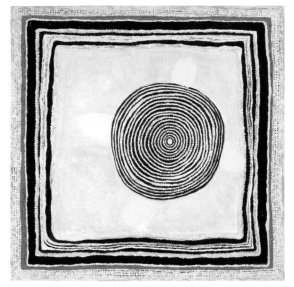

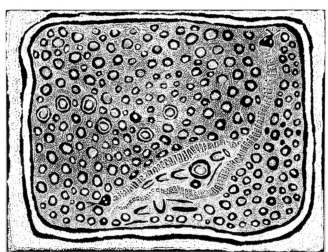

TOP: Charlie Tarawa Tjungurrayi, *An audience with the Queen*, 1989, acrylic on canvas, 121 x 121 cm. Private collection. [Courtesy Sotheby's and Aboriginal Artists Agency Ltd.]

BELOW: Ningura Napurrula, *Untitled,* 2000, acrylic on canvas, 85 x 105 cm. Private collection. [Courtesy William Mora Galleries and Aboriginal Artists Agency Ltd.]

Monochromatic hues, clear and deliberate patterns and a spatial quality are seen in two very different works by Papunya/Kintore artists. Tjungurrayi's work was painted in memory of having met the English monarch and Napurrula paints classic images based on ancestral women's stories.

Makinti Napanangka, *Kungka Kutjarra Lake MacDonald*, 1998, acrylic on canvas, 91 x 46 cm. Private collection.

[Courtesy Papunya Tula Artists Pty Ltd and Aboriginal Artists Agency Ltd.]

Loose brushwork and deep and intense colour characterise this painting based on the travels of two female ancestors in the Lake MacDonald region of the Western Desert by this famous Kintore artist.

Kintore and with a large shopfront gallery in Alice Springs, has become the largest and most well-known Aboriginal arts centre in Australia. Community projects have included a partnership with Sotheby's auction-house to raise almost $2 million for the establishment of a mobile dialysis unit and a swimming pool at Kintore. In 2008 Papunya Tula Artists Pty Ltd was owned by 49 shareholders and represented around 120 artists.

The artists of this area whose art has become amongst the most sought-after in contemporary Australian art, have always sold their work and worked with private dealers and the public concurrent with selling their art through the community arts centre they own. Many have formed long and ongoing relationships with dealers, while other less salubrious transactions include artists being paid a fraction of the value of their paintings, and a range of other dubious dealings. Market opinion and gallery and auction practice is split between those who show and buy art sourced only through Papunya Tula Artists Pty Ltd, those who work and show directly with artists of the area, and others who do both. (See *From the Bush to the City* p. 30)

The work of Papunya and Kintore artists is the most widely exhibited of any Aboriginal art and has been seen in countless thousands of solo and group exhibitions at hundreds of leading galleries throughout Australia and internationally since 1972. Group exhibitions in which their work has featured have included *Mr Sandman Bring Me a Dream*, USA and touring, 1981; *Art of the Western Desert*, Peter Stuyvesant Foundation and touring Australian state galleries, 1983; *Dot and Circle*, Royal Melbourne Institute of Technology, 1985; *The Face of the Centre*, National Gallery of Victoria (NGV), 1985; *The Great Australian Art Exhibition*, 1988; *Dreamings*, The Asia Society and South Australian Museum, 1988; *Mythscapes*, NGV, 1989; *Aratjara*, Düsseldorf and touring, 1993–94; *Crossroads, Towards a New Reality*, National Museums of Australia, Kyoto and Tokyo, 1992; *Power of the Land*, NGV, 1994; *Yirabana*, AGNSW, 1994; *Nangara, the Aboriginal art*

exhibition,(touring internationally since 1999); *Dreamings of the Desert*, Art Gallery of South Australia (AGSA), 1995; *Spirit Country*, San Francisco Museums and touring, 1999–2001; *Transitions*, Museum and Art Galleries of the Northern Territory (MAGNT) and touring nationally, 2000; *Cultural Warriors*, National Gallery of Australia (NGA), 2007.

An important specific exhibition was the Flinders University Art Museum's *Twenty-Five Years and Beyond: Papunya Tula Painting*, 1999; the AGNSW's 2000 *Papunya Tula: Genesis and Genius* provided the largest and most significant survey of the history and art of this movement and, in 2007–08, the National Museum of Australia (NMA) held *Papunya Painting: Out of the Desert*, a highly significant exhibition of early Papunya works from its collection.

The Evolving Art of Papunya:
The Emergence of a Modern School of Classical Art

The style of Papunya art has developed significantly since the 1970s but remains clearly identifiable. The first paintings mirrored in fashion and intent, the mural paintings: documenting and relating stories with direct symbolism. Symbols and designs were largely codified over a plain red-brown, black or yellow ground; shapes were simple and few. Arcs, concentric circles and U-shapes predominated, sometimes outlined or linked by large dots and occasionally figurative elements such as painted spears, boomerangs, shields and axes were included. Colours were restricted to those of the earth – white, yellow, red and black.

Before this new painting movement, many of these images were intended only to be viewed by the initiated, or made in sand as part of ceremony after which they were destroyed. Translating them into a permanent medium caused an immediate dilemma. On the one hand, re-creating the images on more permanent materials meant that they were being recorded for posterity and as learning tools for youngsters as well as providing a means by which the non-Aboriginal population could learn

Yinarupa Nangala, *Untitled*, 2007, acrylic on canvas, 122 x 161 cm. Private collection. [Courtesy Cross-Cultural Art Exchange, Papunya Tula Artists Pty Ltd and Aboriginal Artists Agency Ltd.]

One of the new generation of Kintore artists, Nangala's works, with those of her contemporaries, are creating new dimensions for this early painting movement.

something of Aboriginal culture. On the other hand, for the uninitiated to see them – even people who had no idea of their significance – was a serious transgression of Aboriginal law.

How could the artists keep painting without revealing the sacred secret images? One solution was to reproduce only images of a secular nature – those which related stories and events but where viewing was not restricted to only the initiated. For the more secret sacred images, an innovative stylistic solution was decided on. The dots of sand painting and rock incision were reduced in size and used as shimmering overlays to obscure the stylised symbols. The symbols were thus all but hidden from view except to the initiated few who understood what they were looking at. Instigators of this 'dot' style – which has since, in one form or another, become the predominant style of Central and Western Desert art – included Anatjari Tjakamarra (c. 1930–1992), Kaapa Tjampitjinpa (c. 1920–1989), Shorty Lungkada Tjungurrayi (c. 1920–1987) and Johnny Warangkula Tjupurrula (c. 1925–2001). Warangkula's paintings, such as the 1973 *Rain Dreaming*, are particularly fine examples of the style and, aesthetically, works of enormous beauty and often great radiance. Gradually, as other artists took up the new style, the dots became not just a masking device but occupied larger areas of canvases as the main feature of the painting itself.

Colours of the Earth:
A Papunya Tradition

In the first years between 1972 and 1973, Papunya painters restricted their palette to the earth colours of red, white, black and yellow. From around 1974, this broadened to include blues, greens, purples and pinks. While these and other colours continued to be used, Papunya–Kintore painters largely prefer to use the original palette, mixed to create a striking variety of coloration, or reduced in images of striking graphic quality or optical illusion. The post-1990s Kintore school, in which women and a new generation of men have come to the fore, is characterised by striking black and whites, thickly applied and in clear outline as well as yellows, ranging from the soft and subtle to deeper shades. Some artists, such as Walangkura Napanangka, combine the yellows with reds to create oranges ranging from the subtle to the sizzling.

The Artists of the Desert:
Stylistic Formality and Beyond

Artists such as the Anmatyerre painter Clifford Possum Tjapaltjarri – whose main painting themes included those of fire dreaming, men's love stories and honey ant stories – are distinctive for their consistent narration of the events and maps of places where these stories occurred. One of the youngest of the original 'Bardon painting men' and the last to join, Possum had been a skilled woodcarver, originally employed at Papunya to teach carving to children. He went on to become one of the most well known, gregarious and broadly travelled of the original group, whose works all consistently displayed a strong narrative quality. Another founding member, Turkey Tolson Tjupurrula (1942–2001), honed, refined and later, simplified his linear 'spear straightening' paintings, whereas others such as Mick Namarari Tjapaltjarri continued to make stylistic changes from the sparsely codified iconography and the effects of dotted overlays during the mid-1970s to later broad-painted bands and interlinking geometric squares.

During the 1980s and concurrent with the continuing work of the original painters, a new generation of painters evolved. Michael Jagamarra Nelson started painting in 1983 and in 1988 designed the mosaic for the

LEFT: Ronnie Tjampitjinpa, *Kaakuratintja (Lake MacDonald)*, 1996, acrylic on canvas, 152 x 122 cm. Private collection. [Courtesy the artist, Joel Fine Art and Aboriginal Artists Agency Ltd.]

One of Papunya's earliest painters from the 1970s, Ronnie Tjampitjinpa uses both bold monochromes and brilliantly clear colours for his classic paintings of Tingari ancestor stories.

forecourt of the new Parliament House in Canberra. Painters based at Kintore included Dini Campbell Tjampitjinpa, Ronnie Tjampitjinpa, Fred Ward Tjungurrayi, George Tjungurrayi and many others. One of the longest-painting of the original 'Bardon' painters, Ronnie Tjampitjinpa's Tingari paintings are often in clear blacks, whites and reds but also often surprise in more dazzling coloration such as hot pinks and sky blues.

Warlimpirrnga, Walala and Thomas Tjapaltjarri, and their relatives Yukultji and Yuyuya, hailed as the last desert indigenous peoples to 'walk out' of the desert into a European organised community in 1984, have since been based at Kiwikurra and in Alice Springs and have become leading painters. Significant in the work of these and other Kintore and Kiwinitiuna-based artists has been the development of a style based on fine, closely placed lines with a strong quality of optical illusion.

Women Painters:
A New Freedom Evolves

Until the 1990s, painting had been largely the preserve of men, save for a rare few women such as Pansy and Eunice Napangardi, who sold their work largely independently from the arts centre. In 1994 a women's painting project was held with the women of the Haasts Bluff area (who hold strong familial ties with the Kintore women), the result of which was exhibited at Sydney's Utopia Art and included the *Kiwirrkura Women's Painting*, as well as numerous individual works. Many of these women, such as Doreen Reid Nakamarra, Josephine Nangala, Lorna Brown Napanangka, Walangkura Napanangka and others were the wives, sisters and daughters of other relatives of the famous male painters. Many had been ably assisting the men with paintings for many years. During the 1990s, many Kintore-

Various artists, *Kiwirrkura Women's Painting,* 1999, acrylic on canvas, 257 x 257 cm. Art Gallery of New South Wales.
[Courtesy Aboriginal Artists Agency Ltd.]

Doreen Reid Nakamarra, *Untitled*, 2007, acrylic on canvas, 122 x 122 cm. Private collection. [Courtesy Cross-Cultural Art Exchange, Papunya Tula Artists Pty Ltd and Aboriginal Artists Agency Ltd.]

based women painters evolved their own and distinctly different styles. Paint is often thickly applied, the designs are free and the colours varied. The palettes range from the monochromatic black and whites of Ningura Napurrula, whose designs now adorn the ceiling of the offices of the Musée du Quai Branly in Paris, to the glowing golds, pinks and yellows of Makinti Napanangka, and the vivid oranges and pinks of Naata Nungurrayi.

Subjects include the creation ancestor women such as Katungka and her sisters, who went on epic journeys through vast tracts of the western deserts. Sandhills, rockholes and other important sites feature as do objects such as digging sticks and ceremonial hair-string belts. Women's fighting clubs or nulla nullas, relating the travels of female creation ancestors are frequently painted. As with the early paintings of the Papunya men, the women's

designs are outlined first, then covered over by layers of paint. Yet the technique and effect of these earlier works is different; women artists often use a 'spider-web' layering technique, in which the surface of the canvas is built, almost like bas-relief, leaving elements of the underlying outline visible but creating an illusion of being on top of, rather than underneath the paint surface.

'An Entire Continent Wonderfully Re-perceived'

A new level of sophistication and dynamism has grown in the work of these women and men, as well as in that of a younger generation. Artists such as Deborah Nakamarra, Mantua Nangala, Elizabeth Marks Napurrula, Joseph Jurra Tjapaltjarri, Patrick Olodoodi Tjungurrayi and numerous others have brought their own style to this now largely Pintupi style. Many of these painters are the children of the first generation of Papunya artists, and learnt art from their families whilst in their infancy. Much of their art continues the 'op art' style as practised by Kenny Williams Tjungurrayi and Ray James Tjangala. An extension of the line work of Ronnie Tjampitjinpa and George Tjungurrayi, the myriad of intense fines lines create great shimmer in which lines weave and dance before the viewer's eyes. Although appearing purely abstracted in form, these lines symbolise the pathways and journeys of the creation Tingari ancestor and offer both physical and spiritual maps. Mantua Nangala and Elizabeth Nakamarra are among the women

Richard Yukenbarri Tjakamarra, *The Water Soakage Site of Nyuyarlti*, 2005, (detail), acrylic on canvas, 153 x 122 cm. [Courtesy Gallery Gabrielle Pizzi and Aboriginal Artists Agency Ltd.]

Painted by 18 Kiwirrkura and Kintore women, the large collaborative 1999 painting (left) was an important initiative in establishing the women's painting movement at Kintore, which includes the younger artist Doreen Reid and senior artist Walangkura Napanangka.

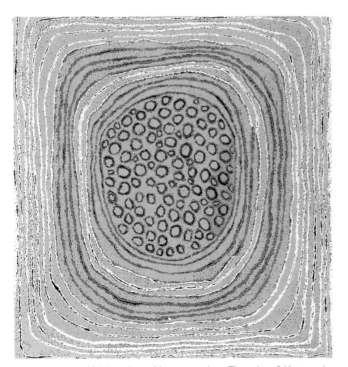

Walangkura Napanangka, *Travels of Kutungka Napanangka*, 2001, acrylic on canvas, 137 x 122 cm.
[Courtesy Papunya Tula Artists Pty Ltd, Sotheby's and Aboriginal Artists Agency Ltd.]

artists who have gained permission from their male relatives to paint the geometric Tingari paintings, previously the preserve of men.

Each year, there emerges a new group of talented artists who breathe new life into this seminal school of Australian art. Of the Papunya–Kintore painting movement itself, there remains no greater summation than words of the late Geoffrey Bardon, returning to Papunya in 1980 at a time when people were breaking free of Papunya to move to their traditional homelands:

> I sometimes thought, among those new fires and shattered expectations, that an older Australia was passing away forever, that our own symmetries had been set aside and made helpless, and that a new visualisation and idea of the continent had come forth, quite literally out of that burning or freezing red sand. It is hard to be clear about an entire continent wondrously re-perceived by the brutally

rejected and sick, and poor. Yet this is what occurred. This was the gift that time gave, and I know this, in my heart, for I was there.[3]

Some Papunya artists

1970s Pansy Napangarti, Narpula Scobie Napurrula, Anatjari Tjakamarra, Anatjari Tjakamarra (i and iii), Freddy West Tjakamarra, John Tjakamarra, Long Jack Phillipus Tjakamarra, Anatjari Tjamptijinpa, Dini Campbell Tjampitjinpa, Dini Nolan Tjampitjinpa, Kaapa Mbitjana Tjampitjinpa, Old Mick Tjampitjinpa, Old Walter Tjampitjinpa, Pinta Pinta Tjapanangka, Uta Uta Tjangala, Billy Stockman Tjapaltjarri, Charlie Egalie Tjapaltjarri, Clifford Possum Tjapaltjarri, David Corby Tjapaltjarri, Mick Namarari Tjapaltjarri, Tim Leura Tjapaltjarri, Old Tutuma Tjapangarti, Tim Payungka Tjapangarti, Tommy Lowry Tjapaltjarri, Charlie Tjararu Tjungurrayi, Paddy Carroll Tjungurrayi, Shorty Lungkarda Tjungurrayi, Yala Yala Gibbs Tjungurrayi, Johnny Warangkula Tjupurrula and Turkey Tolson Tjupurrula

Some Papunya–Kintore–Kiwirrkura artists

Post-1980s Deborah Nakamarra, Elizabeth Marks Nakamarra, Katherine Nakamarra, Narrabri Nakamarra, Kawayi Nampitjinpa, Kayi Kayi Nampitjinpa, Mary Anne Nampitjinpa, Nyurapayia Nampitjinpa, Yuyuya Nampitjinpa, Mantua Nangala, Tatali Nangala, Eileen Napaltjarri, Takariya Napaltjarri, Tjunkiya Napaltjarri, Wintjiya Napaltjarri, Yalti Napaltjarri, Lorna Napanangka, Makinti Napanangka, Walungkura Napanangka, Mary Brown Napangati, Doreen Reid Nakamarra, Kim Napurrula, Mitjili Napurrula, Ningura Napurrula, Rubilee Napurrula, Naata Nungurrayi, Nancy Ross Nungurrayi, Kenny Williams Tjampitjinpa, Martin Tjamptijinpa, Ronnie Tjampitjinpa, George Ward Tjangala, Ray James Tjangala, Joseph Jurra Tjapaltjarri, Raymond Tjapaltjarri, Thomas Tjapaltjarri, Walala Tjapaltjarri, Warlimpirrnga Tjapaltjarri, Kanya Tjapangati, Nyilyari Tjapangarti, George Tjungurrayi, Patrick Olodoodi Tjungurrayi, Willy Tjungurrayi, Johnny Yungut Tjupurrula and Richard Tjakamarra Yukenbarri.

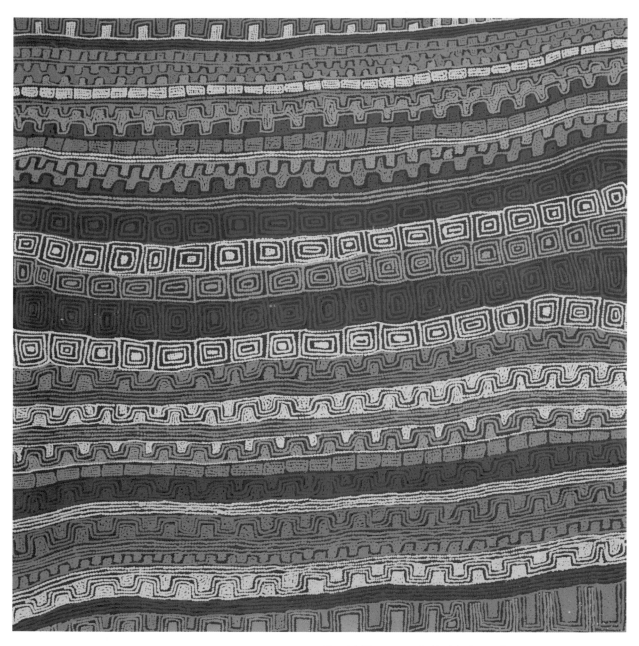

Patrick Tjungurrayi, *Untitled,* acrylic on canvas,
130 x 130 cm. Corrigan Collection. [Courtesy Corrigan
Collection and Aboriginal Artists Agency Ltd.]

Mount Liebig, 350 kilometres from Alice Springs, is situated at the base of one of the highest peaks of the western MacDonnell Ranges. It was named after a German scientist, as were the nearby peaks Mount Zeil and Mount Sonder. Mount Liebig is a small community of around 320 inhabitants, comprising mainly

MOUNT LIEBIG
(Amunturrnga)

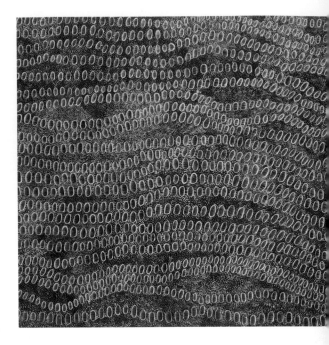

Pintupi, Warlpiri, Arrernte and Pitjantjatjara people. Most speak Luritja, one of the most widely shared languages of the eastern, central and western areas.

Mount Liebig began in 1978 as an outstation of Papunya, 80 kilometres west, with more people moving back to Mount Liebig from Papunya and Haasts Bluff during the 1980s. The community council formed in the mid-1980s. Some of the founding artists of the Papunya school, including Ronnie Tjampitjinpa, Billy Stockman Tjapaltjarri, Mick Namarari Tjapaltjarri, Turkey Tolson Tjupurrula and others whose traditional lands were in this area, lived for periods or regularly visited and painted at Mount Liebig during the 1980s and 1990s. Former Haasts Bluff husband and wife painters Mitjili Napurrula and the late Long Tom Tjapanangka moved to Mount Liebig in the 1990s. But Mount Liebig has developed as a painting community in its own right only since the early 2000s, with the desire by more of the permanent residents to establish representation from within the community.

The art world of Australia embraced, with great enthusiasm, the striking linear monochromatic paintings by Mount Liebig resident Lily Kelly Napangardi when her

works were seen in exhibition and at art fairs in the late 1990s. This continued when she won the 2003 general painting award at the National Aboriginal and Torres Strait Islander Art Award(NATSIAA) and helped to lift the profile of Mount Liebig artists. Art has been coordinated by Mount Liebig resident Glenis Wilkins since the early 1980s. In 2004 Wilkins became the first manager of the newly created community arts centre, Watiyawanu Artists of Amunturrnga.

Variety and Finesse:
The Paintings of Watiyawanu

In 2003 Ngoia Pollard Napaltjarri, a Warlpiri artist from the Nyirripi area north-west of Mount Liebig who had lived at Papunya and Kintore before moving to Mount Liebig some years before a community was established, followed the success of Lily Kelly with some striking paintings based on the swamp regions of her homelands. In 2005 Pollard's work, with that of Wentja 2 Napaltjarri, was acquired from the NATSIAA by the Queensland Art Gallery and the following year Pollard won the main NATSIAA award with her striking monochromatic painting *Swamps West of Nyirripi*.

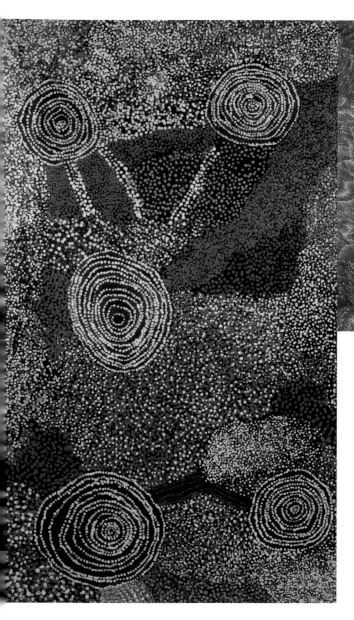

Lily Kelly Napangardi, *Sandhills*, 2008 ,(detail), acrylic on canvas, 181 x 152 cm. Private collection. [Courtesy Watiyawanu Artists and Japingka Gallery.]

FAR LEFT: Ngoia Pollard Napaltjarri, *Swamps West of Kintore*, 2008, (detail), acrylic on canvas, 180 x 150 cm. Private collection. [Courtesy Watiyawanu Artists and Japingka Gallery.]

CENTRE: Bill Whiskey Tjapaltjarri, *Rock Holes Near the Olgas*, 2006, acrylic on canvas, 120 x 80 cm. Corrigan Collection. [Courtesy the artist, Watiyawanu Artists of Amunturrngu and the Corrigan Collection.]

Striking works such as these from very different Mt Liebig residents have led to the formation of the community's arts centre Watiyawanu Artists of Amunturrnga.

With at least three major language groups painting at Mount Liebig, the styles of painting vary widely. Pitjantjatjara man Bill Whiskey (originally 'Whiskers') Tjapaltjarri's country is from the south-west of Uluru, the Olgas and further inland. Born around the 1920s near the Olgas, he visited the northern area as a young man and moved to Haasts Bluff some years later. He started painting in 2004 and has since become a highly sought-after artist for his confident, colourful, precisely dotted yet lyrically layered paintings of rockholes near the Olgas (Kata Tjuta).

Watiyawanu artists were involved in the exhibition *Colliding Worlds: Contact in the Western Desert* at the Tandanya Centre of Aboriginal Culture, Adelaide, 2005, and held an exhibition of works relating to the pre- and post-contact years adjacent to the main exhibition. Approximately 50 artists are represented by the arts centre, exhibiting in solo shows, internationally and in the NATSIAA, the Alice Prize, the annual Alice Springs Desert Mob and similar exhibitions.

The painting movement at Haasts Bluff (Ikuntji), 250 kilometres west of Alice Springs, has evolved since the early 1990s with the establishment of the Ikuntji Women's Centre, now the Ikuntji Art Centre, in 1992. This, as well as being a focal point for community concerns, became, with the appointment of art centre manager Marina Strocchi in 1992, the hub of a small but thriving painting movement. In her book *Ikuntji: Paintings from Haasts Bluff 1992–94*, Strocchi described how the centre was 'sung open' in April 1993. 'Since then', she said,

> many activities have taken place at the centre – which is also frequented by children and men. Painting has been the most popular. Some artists in their sixties have only just started painting. Others have set up studios in their own homes and paint daily.[1]

The Haasts Bluff area is home to the Western Arrernte, Pitjantjatjara and Pintupi people and was named after a little-known New Zealand geologist by an early white explorer. Situated between two mountain ranges, the settlement itself was established

HAASTS BLUFF (Ikuntji)

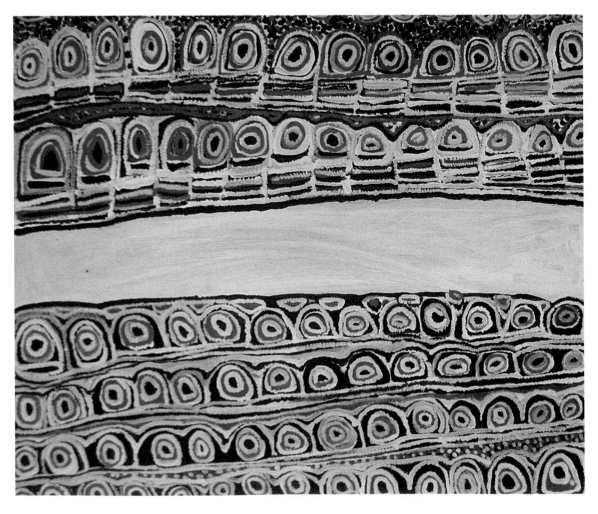

in 1946 after a Lutheran missionary team led by Pastor Albrecht of Hermannsburg mission, 100 kilometres south-east, started distributing rations in the vicinity.

The Emergence of a New Painting Movement from Desert Family Links

The Haasts Bluff community, which numbers between 80 and 160 people, grew from a one-room corrugated iron hut delivered from Alice Springs in 1946. A working cattle station was developed shortly after. But by 1959 many people from the area had been relocated to Papunya, 40 kilometres north, which had a more reliable water supply. During the 1970s, with the freeing up of Aboriginal people's ability to move from the government settlements, many Haasts Bluff people moved back to their own country. With so many family ties between people of the Haasts Bluff and Papunya communities, painting at Haasts Bluff after the emergence of the Papunya painting movement was, as early Papunya art worker Dick Kimber recalls, 'almost instantaneous'.

During the 1970s, Kimber said, he undertook regular trips to Papunya and Haasts Bluff and around various outstations, distributing boards, canvases and paints, picking them up a fortnight later and paying for sales. With the death of leading painters Barney Raggatt Tjupurrula and Timmy Jugudai Tjungurrayi, and the establishment of even further-flung outstations, painting at Haasts Bluff declined during the 1980s, before beginning to flourish again during the 1990s.

Haasts Bluff Paintings:
Individuation and Freedom

The paintings of Haasts Bluff artists are notable for their variety of styles and often-strong coloration. The paintings of 1996 Alice Prize winner and 1999 National Aboriginal and Torres Strait Islander Art Award (NATSIAA) winner Long Tom Tjapanangka (1920–2007) show a striking mix of figurative and abstracted landforms, flora and fauna. His widow Mitjili Napurrula's 'spear' paintings have a similar clarity of colour as well as defined linear patternation, while Eunice Napanangka's

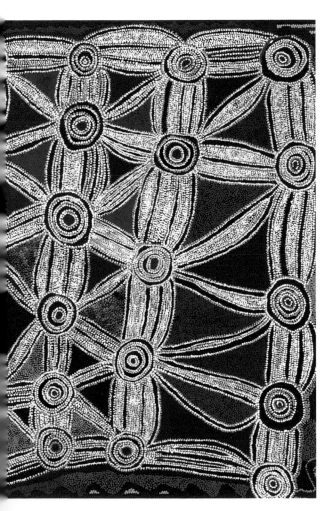

FAR LEFT: Narputta Nangala, *Kaarkurutinya*, 2006, acrylic on canvas, 93 x 101 cm. Private collection. [Courtesy Ikuntji Art Centre and Birrung Gallery.]

LEFT: Narputta Nangala, *Kuniya Kutjarra – Two Carpet Snakes*, 1996, acrylic on canvas, 181 x 153.5 cm. Private collection. [Courtesy Ikuntji Art Centre and Sotheby's.]

One of Haasts Bluff's most well-known artists, Narputta Nangala was born in 1933 at Lake MacDonald, west of Kintore. One of the first painters for Ikuntji Art Centre when painting evolved out of the establishment of a women's centre, the depictions of her western country have a particularly soft yet strong, painterly quality.

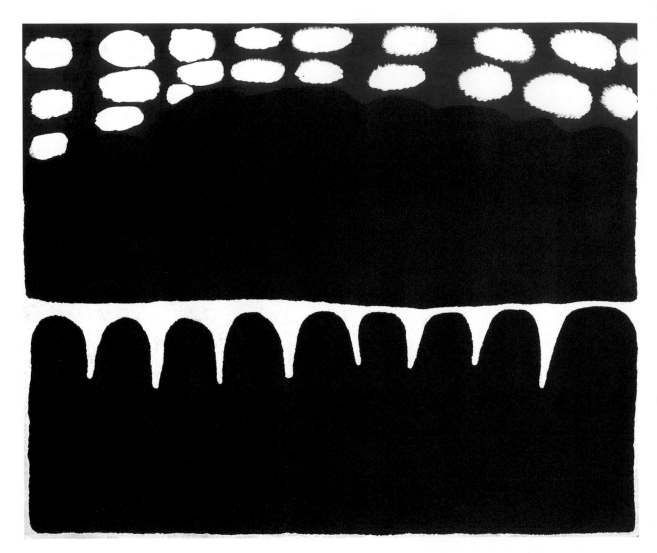

Long Tom Tjapanangka, *Ulampawurru*, 1996,
acrylic on canvas, 153 x 182 cm. Private collection.

[Courtesy Ikuntji Art Centre and Niagara Galleries.]

**The prize-winning Tjapanangka's paintings are
distinguished by large planes of bold colour outlining
the shapes and stories of his country.**

paintings show the exuberant lush colours and
strong forms that characterise the paintings of
artists from this area.

The women of Haasts Bluff have been the
prime painters of the community. By the 2000s,
two generations of women artists had evolved,

holding regular group exhibitions together as
well as many solo exhibitions in major galleries.
Their distinctive palette, often including blue,
as seen in the paintings of Narputta Nangala
Jugadai, are distinctively different from other
Pintupi and Luritja artists of the region.

Some Haasts Bluff artists

Eunice Napanangka Jack, Molly Jugadai, Jillian
Kantarwarra, Daphne Naparulla Marks, Alice
Nampitjinpa, Maringka Nangala, Narputta
Nangala Jugadai, Kutungka Napanangka, Linda
Ngitjangka Napurrula, Anmanari Napanangka
Nolan, Marlene Jack Pareroultja, Janie Sharp,
Maluya Jugadai Zimran.

> 'Try to limit Warlpiri colours and you're in trouble…
> As Paddy Japaljarri Stewart said 'look we've got
> these colours all around us everywhere.' [1]

Yuendumu art has, from its outset in the mid-1980s, been notable for its use of bright colours and intricate patterns. As founding member of its art movement, Paddy Japaljarri Stewart described, colours of the land and its flora, as well as those of the sky, have been fundamental to Warlpiri art since its inception.

Three hundred kilometres north-west of Alice Springs, Yuendumu (named after the Yundum Hills to the south) was founded in 1946 as a small settlement and ration station for the Warlpiri of the Tanami desert. Yuendumu was returned to Aboriginal community control in 1978. Unlike many government and mission-established settlements, almost all of Yuendumu's approximately 1000 residents are of one language group, the Warlpiri. This has led to a far more cohesive development at Yuendumu compared with other communities, in which the numerous differing tribal and language groups, contributed to perpetual friction.

Like most of the settlements established from the 1940s to 1960s under the Australian government's assimilation policy, the main Yuendumu settlement comprises a mixture of buildings linked by winding unpaved streets. The outside walls of the original community arts centre, Warlukurlangu Arts (Warlukurlangu means 'Fire Dreaming'), are completely covered by brilliantly coloured murals. In 2005, the community celebrated its 20th year of painting by adding a large new extension, which tripled the size of the original building.

Women's Body Painting:
An Art Movement Is Born

Yuendumu's modern painting movement started some ten years after that of Papunya, 100 kilometres to the south. It came about after the distribution of art materials by anthropologists

YUENDUMU
Fire Dreaming and the Colours of Our World

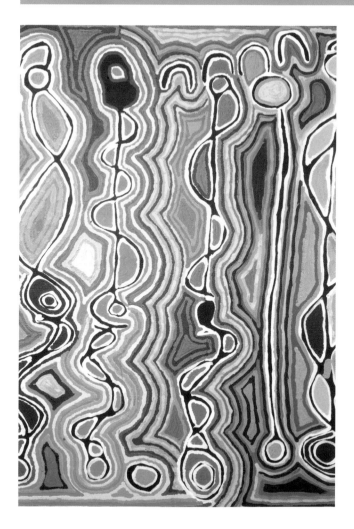

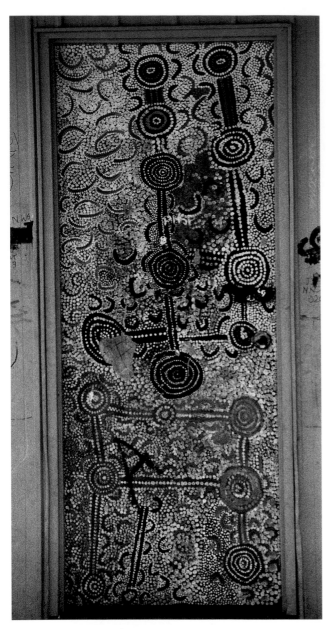

Paddy Japaljarri Stewart, *Honey Ant and Mulga Worm Dreaming, Yuendumu*, 1993, acrylic painted on door, approx. 600 x 300 cm. South Australian Museum.
[Photo Susan McCulloch.]

PREVIOUS PAGE: Judy Watson, *Mina Mina Jukurrpa*, 2006, acrylic on canvas, 122 x 107 cm. Private collection.
[Courtesy Warlukurlangu Artists and Aranda Aboriginal Art.]

The colours of Yuendumu art seen in paintings such as Judy Watson's 2006 work evolved out of the painted door project of 1983 in which a group of male elders painted doors of the school building to educate children about their history and culture.

Françoise Dussart and Meredith Morris as a continuation of their research and recording of women's body-painting designs. The women greeted the new materials enthusiastically. A group of about 30 women undertook to paint and sell enough decorated coolamons, beads and small boards to raise money to buy a four-wheel drive vehicle for the all-important trips to collect bush foods and for ceremonies.

The project was a success and, shortly after, the community asked several of the male elders to paint Dreaming stories on the school's doors in order to pass them on to the children and younger members of the community. Forty-two doors were painted — their creation documented in photographs (a book on the project was later published).[2] Their purpose served, the condition of the doors deteriorated until they were acquired in 1995 by the South Australian Museum (SAM). After a substantial conservation project, the doors went on exhibition, touring Australia and internationally until the early 2000s before returning to permanent display in the Museum.

The first exhibition of Yuendumu paintings was held in 1985 at Sydney's Hogarth Galleries. As the show's press release indicated, the paintings stood out from much other desert art of the time being 'less contrived, freer and less stylised than other desert paintings … the effect … more contemporary, even post-modernist, in the striking application of colour'. The sale at the exhibition of a large night-sky painting to the National Gallery of Australia (NGA) for $3000 and other smaller works enabled the establishment of the artists' cooperative Warlukurlangu Artists Association. The next year an exhibition in Perth was a huge financial and public success, sealing Yuendumu as a major force in Australian art.

In 1989 six Yuendumu artists were invited to exhibit a large 10-metre x 4-metre ground painting, *Yarla*, as part of the exhibition *Magiciens de la Terre* at the Pompidou Centre, Paris. Made entirely from natural materials, including ochre, charcoal, hair and string, the painting created international interest in both

the Yuendumu community and Australian Aboriginal art in general.

Since then, the work of Yuendumu artists has come to be amongst the most widely exhibited of any contemporary Aboriginal art in major galleries in Australian capital cities and overseas. Yuendumu artists have participated in well over 1500 group exhibitions and major commissions have included an external mural by six Warlpiri women artists for the South Australian Museum in 1988; a 7-metre x 3-metre painting by 42 contributing artists for the *Aratjara – Australian Aboriginal Art* touring exhibition in 1990; 14 paintings for the National Gallery of Australia (NGA) in 1992 and, in 1995, a set of thematically linked works in a major Pacific Arts Exhibition at St Louis Museum, USA.

When it was established in 1986, Warlukurlangu Artists comprised 90 members; on its 20th anniversary in 2008 it represented 600 artists with numbers continuing to increase.

A Riot of Colour:
Paintings of Yuendumu

Unlike those of the earlier-established painting community at Papunya, whose artists decided to restrict their palette to ochre-like colours, Yuendumu painters have always used bright acrylics of many hues. Jukurrpa, the Dreaming lore on which the painting is based, pervades all aspects of life. It is fundamental to lifestyle, behaviour, respect for the land, the law, relationships, the ritual and ceremony, hunting and food gathering.

'The main Dreaming of the women who worked with Françoise Dussart was Warlukurlangu – Fire Dreaming,' says former art coordinator Christine Lennard. 'So they called themselves 'Warlukurlangu'. When it came to naming the organisation, the women said, 'We started it and we're naming it'. And that was the end to it.[3]

Many of Warlukurlangu's art coordinators have also been women and, while many men have become leading painters and there is a significant male painting contingent, a strong women's component has continued.

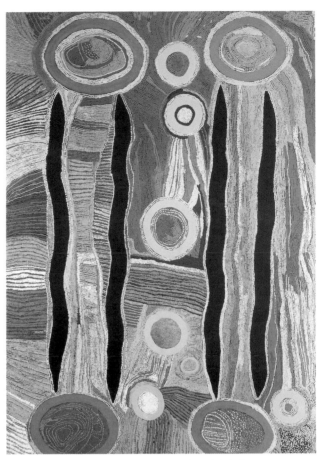

Maggie Napangardi Watson, *Digging Stick Ceremony*, 1997, acrylic on canvas, 222 x 151 cm. Private collection.
[Courtesy estate of the artist, Kimberley Art and Christie's Australia.]

With their streams of colour, Watson's distinctive paintings were often based on the Warlpiri women's stories of the ceremonial digging sticks, their emergence from the land and the creation ancestor women who travelled with them.

Collaboration in the Community Context

The strong sense of cohesion in the painting community has been evident in the largely steady stream of good-quality works and competent organisation, underpinned by the regular undertaking of some large cooperative projects. These often have to do with trips to specific Dreaming sites. Groups of sometimes up to 40 go on the trips, which may take days or weeks, with large collaborative paintings the result.

Paddy Japaljarri Stewart, *Muturnapardukurla Jukurrpa (Old Woman Dreaming)*, 2006, acrylic on canvas, 122 x 76 cm. Corrigan Collection. [Courtesy Warlukurlangu Artists, Aranda Aboriginal Art and the Corrigan Collection.]

This powerful painting of a creation woman and her travels shows an innovative boldness of colour and iconography by one of the founding members of Yuendumu's modern art movement.

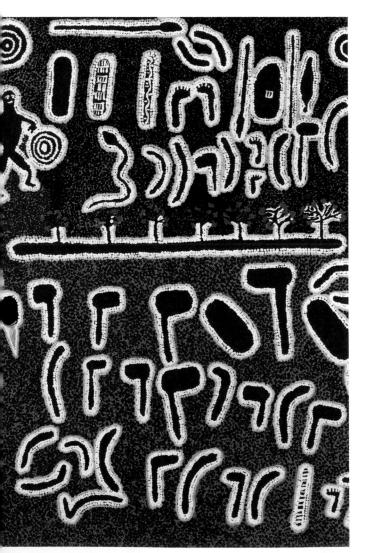

Yuendumu's paintings showed particular vibrancy and almost explosive coloration from the start. This has been a feature of the works of many Aboriginal artists from the mid-1990s but, ten years earlier, the brilliance of colour of these Warlpiri works was quite revolutionary.

Judy Napangardi Watson's paintings typify the confident and precise use of colours including reds, yellows, hot pinks, and greens which continue to set Yuendumu works apart.

Warlukurlangu Artists

Warlukurlangu Artists Association has grown steadily since its early years. Solo exhibitions of founding artists including Darby Jampitjinpa Ross, Bessie Nakamarra Sims, Paddy Japaljarri Sims and Paddy Japaljarri Stewart have been held in leading galleries around Australia since the late 1980s. The works of Maggie Napangardi Watson (1921–2004) whose powerful works depicting women's stories, such as those relating to string made from human hair used in ceremonies, have become highly sought after by major collectors for their stream-like colours. The works of many other artists including Shorty Jangala Robertson known for his more minimalist but shimmeringly coloured water dreaming paintings, are similarly attractive to collectors. The work of younger artists has also always been encouraged; this is seen in such projects as the small boards made by children during school holidays.

Art centre managers have included Christine Lennard, Felicity Wright and, since the early 2000s, Gloria Morales and Cecilia Alfonso. Under their direction, the new art centre was opened in 2005 with more than $1 million worth of art sold each year, making Warlukurlangu one of the top five art centres in Australia.

The art centre, says manager Cecilia Alfonso, is one of the pivotal social and cultural hubs of the community. 'We're committed to providing a safe and happy environment, not only for painting, but for community members to gather and socialise,' she says. 'The staff organise regular barbecues, bush trips and film nights and the centre works hard to build strong relationships with all of the other community

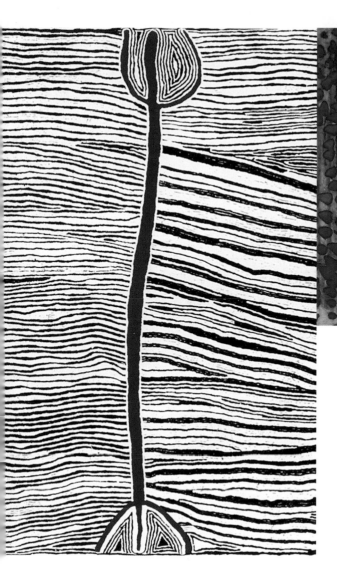

Darby Jampitjinpa Ross, *Yankirri Jukurpa (Emu Dreaming)*, 2001, etching, 32.5 x 49.5 cm (image) 53 x 70 cm (sheet). Multiple collections. Collaborating printer Basil Hall. [Courtesy Warlukurlangu Artists, Northern Editions Printmaking Studio and Charles Darwin University Collection, Darwin.]

LEFT: Maggie Napangardi Watson, *Mina Mina Hair-String Story*, 2004, acrylic on canvas, 187 x 154 cm. Private collection. [Courtesy the artist, Kimberley Art and Lawson-Menzies Aboriginal Art, 2006.]

Watson's striking painting based on the hair-string used in women's ceremony and lore has a strong graphic quality while Darby Jampitjinpa Ross's vibrant reds, yellows and oranges show the range and depth of colour possible in the medium of etching.

organisations.' The art centre also sponsors events during the famous annual Yuendumu Sports weekend, offers financial support for 'sorry camps' and provides feathers, ochres and other items for ceremony.[3]

Major exhibitions in which Yuendumu work has been seen between 1989 and 2008 include *Dreamings*, Asia Society and SAM, 1988; *Mythscapes*, National Gallery of Victoria (NGV), 1989; *L'été Australien*, Musée Fabre, France, 1990; *Tjukurrpa: Desert Dreamings*, Art Gallery of Western Australia, 1993; The Assembly Hall of the Territorial Parliament, Tahiti, French Polynesia, 1994; *Aratjara*, Düsseldorf and touring, 1993–94; *Nangara, Aboriginal Gallery of Dreamings*, Australia and touring internationally, 1996–2006; *Colour Power: Aboriginal art post 1984*, NGV, 2005–06.

In 2005 Warlukurlangu Artists was asked to establish and manage a satellite art production centre at the small community of Nyirripi, 160 kilometres south-west of Yuendumu, where the Warlpiri community members had been painting small works for some time.

Some Yuendumu artists

Paddy Tjungurrayi Carroll, Dolly Nampijinpa Daniels, Jeannie Nungurrayi Egan, Lorna Napurrula Nelson, Paddy Jupurrula Nelson, Darby Jampitjinpa Ross, Paddy Japaljarri Sims, Bessie Nakamarra Sims, Larry Jungurrayi Spencer, Paddy Japaljarri Stewart, Liddy Napanangka Walker, Judy Napangardi Watson, Maggie Napangardi Watson.

> '**Her work … enabled the flowering of a whole new generation of Aboriginal artists.**'

The 1800-square-kilometre Utopia region, 270 kilometres north-east of Alice Springs, is made up of a series of pastoral stations claimed by European settlers from the 1920s and returned to Aboriginal ownership progressively from 1979. The Utopia station after which the region is named was chosen apparently by the Kunoth brothers who settled it in anticipation of a bountiful life after they found some rabbits 'so tame they could be caught by hand'.[1]

The area's Anmatyerre and Alyawerre population of several hundred worked as stockmen and women and in other domestic and farming jobs at Utopia and neighbouring pastoral stations for much of the 20th century. During both the period of pastoral lease and since the area's return to Aboriginal control, family groupings have lived in small and quite distinct outstation communities near the 17 or so soakage bores spread throughout the area. Unlike many other Central Desert settlements, where people were often removed to great distances from their traditional lands, Utopia residents have had a far more continuous connection to traditional lands. The effects of this have been not only of significance to the health and wellbeing of people – enabling them to live a more closely connected traditional hunting and food-gathering lifestyle – but of profound cultural significance, with particular impact in the highly individualised art practice that has developed. From the start of the painting movement at Utopia in the early 1990s, the region's 200-plus painters, batik-makers and woodcarvers have largely made their own arrangements for the sale and exhibition of their work.

The UTOPIA REGION
Diversity in the Desert

Greg Weight, *Emily Kame Kngwarreye*, 1994, gelatin silver photograph, 25.3 x 21.1 cm. [Courtesy Greg Weight.]

LEFT: Emily Kame Kngwarreye, *Untitled*, 1991, (detail), synthetic polymer paint on canvas, 230 x 131.5 cm. [Courtesy estate of the artist and Sotheby's 2001.]

Photographer Greg Weight captured Kngwarreye's strength of character. The subtle greens, yellows and reds punctuated by whites of her 1991 painting show the densely layered qualities of Kngwarreye's work and her great skill as a colourist.

From Batik to Canvas: The Evolution of a School of Desert Art

Utopia's modern art movement started in 1977 when a batik-making fabric workshop evolved as an offshoot from a women's adult education literacy course set up several years earlier by teachers Toly Sawenko and Jenny Green. As an extension of sewing and woodblock printing classes, Green suggested to the 20 to 30 women who attended classes every day that they may like to learn the traditional Indonesian form of batik-making, which had been practised in other desert Aboriginal communities – Ernabella and Fregon – since the early 1970s. Fregon fabric artist Nyankula brought her skills, along with 'roving craftsperson' Suzy Bryce and coordinator Julia Murray, to classes attended first by about 25 women. Batiks developed from utilitarian clothing fabrics into more adventurous designs on silk created as works of art and shown in exhibitions from the early 1980s. These artworks often depicted free representations of seeds, grasses, flowers, berries, yams and other plants integral to

women's ceremonies. While some men learned batik-making, the numbers of women involved from the start made the enterprise fairly much 'women's business'.

By 1988, the Utopia Women's Batik Group had more than 80 members and was well established. In that year, the late Rodney Gooch, the Central Aboriginal Artists Media Association (CAAMA) coordinator, took over as its organiser.[2] He suggested to the women that they tell their own stories through producing one batik each. Eighty-eight women responded – each contributing a panel to the overall work. Called *A Picture Story*, the whole work was acquired by the Robert Holmes à Court Collection and became the opening exhibition of Adelaide's Tandanya Aboriginal Art and Culture Centre in 1989.

Fabric-making proved difficult to promote as a contemporary art medium, especially given the far greater public success of the Papunya painting movement, which was by then firmly underway. Did the artists want to try their hand at canvas? 'Absolutely,' said Gooch.[3] and another community project was undertaken with 100 canvases being handed out over the hot summer months of 1988-89. Several months later 81 canvases were collected. Some of the artists translated their batik images into acrylics but others experimented with the freedom the new medium offered, producing strikingly different paintings. Emily Kame Kngwarreye, whose batiks had been noticed for their unfettered free imagery, produced a work that, said Gooch, was instantly exciting. 'As soon as I saw it it just shone out at you and I knew it would be the star of the show.'[4] Other works contained a similar power and, shown in Sydney's S. H. Ervin Gallery in mid-1989, the Summer Project exhibition attracted instant attention – launching Utopia art and Emily Kngwarreye into a new era of artistic growth and public acclaim.

Soon output was prodigious, with demand for the work constant. At its peak in 1989–90, said Gooch, the turnover for Utopia art exceeded $1 million. Demand for Emily Kngwarreye's paintings in particular grew

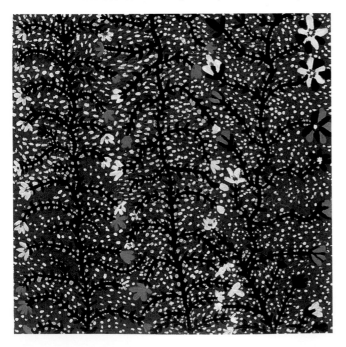

Ally Kemarre, *Untitled,* 1989, batik on silk, 90 x 60 cm. Private collection. [Courtesy the artist and Utopia Art.]

steadily. Although Kngwarreye was only one of several hundred painters, carvers and batik-makers who have contributed to Utopia's status as an enduringly vibrant art-making community, it was largely due to her success that Utopia was placed on the art map.

Re-perceiving the Land:
Emily Kame Kngwarreye

Emily Kame Kngwarreye (c. 1919–1996) telescoped the production of a lifetime's worth of 3000–4000 paintings into just eight years and her work continues to sell more on the secondary market than that of any other Aboriginal artist.[5] Lauded for their stylistic diversity and superb coloration, her works were quickly hailed as contemporary masterpieces and likened to the paintings of international art stars including Willem de Kooning, Jackson Pollock, Sol Le Witt, Bridget Riley and, in their intensity of hues, the great colourist Claude Monet.

Stylistically Kngwarreye's paintings were freer than the more formal, regulated and clearly defined patterned designs of many other Aboriginal artists of the era. Her first works to attract attention were in what is known as her 'dump-dump' dot style. Painting with such vigour and using the full bristles of a large brush (not unlike the action of pounding a clove of garlic in a mortar and pestle), she would build layers of brilliant colours under which can be traced veins of the land and its vegetation.

In the Wild Yam Dreaming pictures, that emerged several years later, layers of crisscrossed lines evoke roots stretching deep into the soil. Later styles included the horizontal and vertical broadly brushed brown, black and blue strokes representing women's ochre body painting. Kngwarreye received a federal government Creative Artists Fellowship and, in 1997, was one of three Aboriginal artists to represent Australia at the Venice Biennale. In 2007, her massive work *Earth's Creation* sold for A$1.56 million, the highest price ever paid for a painting by a female Australian artist. Two retrospectives were curated by Margo Neale in 1997 and 2008 in Japan, and later Australia.

Emily Kame Kngwarreye, *Alhalkere*, 1996, acrylic on canvas, 120 x 106 cm. Ebes Collection, Melbourne.
[Courtesy estate of the artist and the Ebes Collection.]

Produced just two weeks before she died, a new series of fluorescent works shows the vitality of this extraordinary artist's style.

Just two weeks before she died, Kngwarreye produced a startling new series of 22 works. With their broad sweeps of luminous, almost fluorescent colours, these paintings demonstrate the immense vibrancy of Kngwarreye's work and its sheer physical power. Of these works, artist and art dealer Michael Eather commented on the lack of 'customary symbols and narrative traces'.

'What were Kngwarreye's intentions with these final, baffling, sublime works?' he wrote.

Perhaps she was reacting to the irony of it all – sparse conditions yet an unimaginably rich cultural heritage? Perhaps the reductionism was simply a filtering of her holistic view of her internal and external landscapes? Perhaps a sly joke? A criticism of our white consumer reliance on her providence, the vulgarity of it all? We will never really know.[6]

When she died aged in her late 80s, the fame of this desert Aboriginal painter had achieved almost mythic proportions. That this acclaim was set against a background of a daily life spent entirely on her land at Utopia and in conditions Westerners would largely regard as primitive further fuelled the mystique.

As with other 'big name' artists, success for Kngwarreye and her community did not come without its price. Dealers descended upon the community and bitter feuds were fought over provenance. Rumours of fakes of her works have abounded since the early 1990s. Due to a change in policy direction, the Alice Springs–based CAAMA relinquished its role as provider of

canvas, sales organiser and exhibition coordinator in 1991, superseded, as Rodney Gooch noted, by the artists' preference for individual arrangements with dozens of different dealers.

Utopia Art: Individual Expression and Worldwide Success

Kngwarreye was the best known and the most stylistically adventurous of Utopia's artists of the 1990s. Her work, with that of the Kimberley's Rover Thomas took Aboriginal art into new dimensions and enabled the flowering of a whole new generation of Aboriginal artists. After her death in 1996, there was a brief quietening of interest in the region's art. But Utopia's art hit the headlines again when Kathleen Petyarre won the 1997 National Aboriginal and Torres Strait Islander Art Award (NAATSIA) – and a year later when Petyarre's white husband claimed that it was he who had largely painted the award-winning painting. Petyarre has since had a solo exhibition at Sydney's Museum of Contemporary Art (MCA) and continues as one of the area's most successful artists.[7]

Numerous other Utopia artists have also been highly noteworthy. The paintings of

LEFT: Gloria Temare Petyarre, *Mountain Devil Lizard,*
2003, acrylic on canvas, 122 x 45.5 cm. Private collection.
[Courtesy the artist and Alison Kelly Gallery.]

BELOW: Lindsay Bird Mpetyane, *Carpet Snake & Bush
Plum Dreaming,* 2007, (detail), acrylic on canvas,
270 x 120 cm. Collection Mbantua Gallery. [Photo Barry
Skipsey. Courtesy the artist and Mbantua Gallery.]

**Wynne prize-winner Gloria Petyarre's vibrant
paintings are often based on bush medicine and
the leaves and plants used in their making.
Those of senior artist and community leader
Lindsay Bird Mpetyane show the strong graphic
quality and balance of Utopia men's painting.**

UTOPIA

sisters Ada, Nancy, Kathleen and especially
Gloria Petyarre who won the Wynne Prize for
landscape art in 2003, show a similar enthusiasm
for experimentation. Images based on flora and
fauna similar to those seen in the early batik-
making days also continue to resonate in both
paintings and batiks as in the works of Ally
Kemare while Angelina Pwerle's subtle paintings
are notable for her use of a restricted colour base.

Utopia men's painting such as those by the
leader of the Mulga Bore community Lindsay
Bird Mbetyane is notable for a more formal
quality based on ceremonial design.

Works on paper have also been a part of
Utopia's oeuvre with artists participating in
woodblock and silk-screening workshops both in
the community and in other centres. Many men
and women have continued their long-practised
carving skills (boomerangs, clapping sticks,
spears, coolamons) to produce a wide variety of
imaginative figurative wooden sculptures. Since
the early 1990s, these have become quite a
feature of art from Utopia with favourite subjects
including animals or characters in traditional
stories such as the law enforcer or 'bogey man'
spirit Kwertatye and his helper, the 'Devil Dog'.

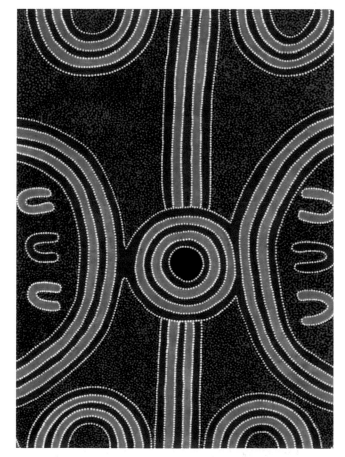

Ada Bird Petyarre, *Mountain Devil Lizard (Body Painting)*, 2000, acrylic on canvas, 118 x 88 cm. Trevor Victor Harvey Collection. [Courtesy the artist and Trevor Victor Harvey Gallery.]

Senior Utopia region painter Ada Bird Petyarre's paintings are closely based on women's ceremonial body painting.

Barbara Weir, *Grass Seed Dreaming*, 2006, acrylic on canvas, 118 x 176 cm. Private collection. [Courtesy the artist and Gallery Savah.]

Josie Petrick Kemarre and especially Barbara Weir have become highly successful and very individual painters. A younger generation includes Janelle Stockman, daughter of Papunya painter Billy Stockman Tjapaltjarri.

Another late-blooming genius

In 1999 artist Barbara Weir and her son, Aboriginal art dealer Fred Torres, were in Adelaide, working with Utopia artists. Weir's mother, Minnie Pwerle, who was Emily Kame Kngwarreye's tribal sister (being married to her cousin), asked for some paint and canvas. The results were startling for their strength and boldness and for the natural aptitude Pwerle showed for working with colour and paint. Pwerle was almost 80 years old. As well as Kngwarreye, Pwerle was related to artists such as Gloria, Ada and Kathleen Petyarre, among whom she had sat for years as they painted. Apart from a brief foray into painting alongside her husband, known as Motorcar Jim (old catalogues erroneously refer to her as 'Minnie Motorcar'), no-one had thought to ask this shy, quiet woman if she would like to paint. When she did, a new dimension of artistic expression burst forth. Torres immediately contacted Melbourne dealer Hank Ebes, a long-time representative for Utopia art. Enthused, Ebes bought a large amount of her work. A solo exhibition at Flinders Lane Gallery in Melbourne followed, and by 2002 Pwerle's output was as prodigious as Kngwarreye's. Like Kngwarreye,

she rose early and painted quickly. Paintings such as Awelye–Atnwengerrp (women's ceremony) those featuring 'bush melon' and the rarer akelye (bush orange) danced vibrantly in gallery windows. Again as with Kngwarreye, fakes appeared on the market – as inevitable a sign of success of a painter as bootleg albums are to the successful musician.

There was also great joy in this artist's late-blooming career. She enjoyed the spotlight, which came early in her career, with an exhibition at the AMP Building in Sydney during the 2000 Olympics. More importantly, she held exhibitions with her daughter, Barbara Weir. Barbara Weir's father was station owner Jack Weir. Both Jack Weir and Minnie Pwerle had been imprisoned for their interracial union. On release from jail Pwerle spent three months walking home to Utopia with her baby. Nine years later, despite attempts at hiding the child, Barbara Weir was taken from Pwerle and sent for foster care. For many years, Pwerle believed her daughter was dead until Weir, aged 19 and with children of her own, refound her community and her mother.[8] Years later, when both women had become painters, the wounds of the past healing through the shared connection of painting.

Pwerle's work (and life) is often compared with Kngwarreye's, yet the artists' lands and imagery were different. Kngwarreye was from Alhalkere, the title of her famous retrospective

Minnie Pwerle, *Aweleye-Atnwengerrp*, 2005, acrylic on canvas, 182 x 142 cm. Corrigan Collection. [Courtesy estate of the artist, Dacou and the Corrigan Collection.]

TOP: Minnie Pwerle, *Awelye-Atnwengerrp*, 2001, 356.5 x 165 cm, acrylic on canvas, Private collection. [Courtesy Dacou and Alison Kelly Gallery.]

The grasses and their seeds that used to grow in abundance and were important sources of food bush for Utopia people are the basis of many of Barbara Weir's paintings. The energetic work and sense of spontaneity of the works of her mother, Minnie Pwerle, lead to the work of this elderly artist becoming highly sought-after.

exhibition, while Pwerle hailed from the quiet, small family-based Utopia community of Atnwengerrp, some 30 kilometres away. The main similarities between the artists' oeuvres were their body-paint images – both favoured monochromes and blues. Their work also shared an expressionistic quality, a sense of confidence in their bold brushstrokes, and a love of bright colours. Pwerle's Awelye (women's body-painting designs) was also very different from Kngwarreye's; Pwerle featured designs of small round bush melons that grew only on her land.

In late 2004 Torres and Weir initiated another workshop with Pwerle and her sisters, Emily, Galya and Molly. This time, the workshop was held at Irrultja in Utopia, where the sisters had lived all their lives; they had not even ventured into Alice Springs. The work of Pwerle's sisters was just as fresh and vibrant. Sharing the same Dreaming but with distinctly different ways of expressing it visually, the sisters worked on collaborative paintings as well as individual works. The sisters continued to paint after Minnie Pwerle's passing in March 2006.

Independence and Individuality

From the beginnings of the batik movement through the explosive impact of Kngwarreye and Pwerle to the new work by the Pwerle sisters, the art of Utopia is constantly inventing and reinventing itself. Utopia artists have developed strong and continuous relationships with many leading galleries. These include Alice Springs' Mbantua Gallery, which concentrates solely on the sale of art from the region in both Alice Springs and Darwin. Its owner, Tim Jennings, bought Emily Kngwarreye's record-breaking painting *Earth's Creation*. Sydney's Utopia Art, established during the early years

Emily Pwerle, *Untitled*, 2007, acrylic on canvas, 80 x 120 cm. Private collection. [Courtesy the artist, Dacou and Art Mob.]

Densely layered, the luminous paintings of Emily Pwerle, one of Minnie Pwerle's sisters, have proved an exciting new development for Utopia art when she and another three of her sisters started painting in 2004.

of modern art at Utopia, continues to represent some artists from the region including Gloria Petyarre. Adelaide's Dreaming Arts Centre of Utopia, is one of the few Aboriginal-owned galleries that represents art from the owner's own region. Artists from the region are represented by a number of other leading galleries including in Melbourne's Flinders Lane (and until closure in 2008, the Aboriginal Gallery of Dreamings) and Alison Kelly Gallery; Perth's Artitjia and Japingka galleries, Sydney's Gallery Savah and Alice Springs' Gallery Gondwana. Janet and Donald Holt, owners of Delmore Downs, one of the stations abutting Utopia, were one of Emily Kngwarreye's dealers and represent a number of other artists from the region. Many other galleries have defined links with individual artists such as Adelaide's Gallery Australis's representation of Kathleen Petyarre; Melbourne's Aranda Gallery also shows works by Petyarre, Josie Petrick Kemarre and other Utopia artists; Melbourne's Mossenson Galleries and the associated Indigenart Gallery in Perth show works by Josie Kunoth Petyarre and Dinni Kunoth Kemarre as well as other artists of the region. Melbourne's Niagara Galleries represents Angelina Pwerle and other Utopia artists. Lauraine Diggins represents Gloria Petyarre. Alice Springs' Aboriginal Desert Art Gallery and its sister galleries in Melbourne and Sydney (Jinta Art) have long shown Utopia art as have many other galleries Australia-wide and internationally.

TOP: Chloe Morton Kngwarreye, *Ammaroo Site*, 2003, acrylic on canvas, 121 x 91 cm. Marshall Collection. [Courtesy the artist and Marshall Arts.]

RIGHT: Billy Kngwarreye, *Untitled*, c.1997, painted wood, variable sizes. Private collection. [Courtesy the artist and Utopia Art.]

Chloe Morton Kngwarreye's colourful art exemplifies the style of artists of Ampilawatja whose work is known for its lively figuration. Carvings of birds, animals and figures are also a feature of art from the Utopia region.

Dinni Kemarre and Josie Kunoth Petyarre, *Melbourne
Story*, 2007, acrylic on canvas, 200 x 195 cm. Private
collection. [Courtesy the artists and Mossenson Galleries.]

**This couple, who live on the remote Pungalindum
outstation of the Utopia region, visited Melbourne
in 2007. They created a major series of exuberantly
colourful works of their observations such as this, a
finalist in the Basil Sellers Art Prize, 2008.**

That Utopia artists have not felt the
necessity to form an arts centre since their
mid-1970s batik-making workshop is reflective
of the very different community conditions of
this region. People have not been dispossessed
from their lands and live in small communities
on their traditional land, rather than in a
centralised community 'town'. Such continuous
connection has enabled the development
of a strongly defined sense of place and the
strength of individuality that it promotes.

Artists of Ampilawatja

About 320 kilometres north-east of Alice Springs on the former Ammarroo Station, a sister art community of Alyawarr speakers has developed. The Artists of Ampilawatja was established as an art cooperative in 1999 with long-time coordinator Narayan Kozeluh (who resigned in 2006); Susan Graham became arts centre manager in 2007. Ampilawatja Artists, while sharing a language with many Utopia residents, features distinctly different imagery based more on the figurative. Painters such as Eileen Bonney Akemarr, Lily Morton Akemarr, Josephine Holmes, Serina Holmes Kngwarreye, Rosie Morton and Wally Morton work in a unique, freshly figurative and naive style. In landscapes by Ampilawatja artists Western figuration is melded with an Aboriginal perspective. Landscapes are often seen from above, with plants, animals and land features depicted as though in silhouette. Bush plants feature heavily in works abundant with colour, line and form. Artists of Ampilawatja have exhibited at Lauraine Diggins Gallery, Melbourne, and many other galleries throughout Australia including Japingka, Perth, and Marshall Arts, Adelaide, as well as in a number of survey shows in public galleries in Australia and internationally.

Some Utopia artists

Gladdy Kemarre, Queenie Kemarre, Emily Kame Kngwarreye, Wendy Kunoth, Abie Loy, Lindsay Bird Mbetyane, Lucky Morton, Polly Ngale, Glory Ngarle, Ada Bird Petyarre, Anna Petyarre, Gloria Petyarre, Greeny Purvis Petyarre, Kathleen Petyarre, Nancy Petyarre, Angelina Pwerle, Emily Pwerle, Galya Pwerle, Minnie Pwerle, Molly Pwerle, Janelle Stockman, Barbara Weir.

Some Ampilawatja artists

Eileen Bonney Akemarr, Lily Morton Akemarr, Josephine Holmes, Elizabeth Bonney Kngwarreye, Serina Holmes Kngwarreye, Chloe Morton Kngwarreye, Rosie Morton, Wally Morton.

Angelina Pwerle, *Bush Plum*, 2006, acrylic on canvas, 199.5 x 119 cm. Private collection. [Courtesy the artist and Niagara Galleries.]

Deep colours and subtle patterns characterise the work of Angelina Pwerle which often depicts this important bush tucker food.

Hermannsburg, 130 kilometres west of Alice Springs is an Arrernte community, established as the Lutheran Finke River Mission in 1877. Still with its white-painted former schoolrooms and houses shaded by large trees, the older section of the community offers a rarely seen glimpse into central Australia's early mission days.

HERMANNSBURG (Ntaria)

The Ongoing Legacy of Namatjira Watercolours and Unique Pottery

BELOW: *Mount Sonder.* [Courtesy Tourism NT.]

CENTRE: Albert Namatjira, *Ghost Gum Mt Sonder, MacDonnell Ranges*, c.1953–57, watercolour over pencil on paper, 36.8 x 53.8 cm. National Gallery of Australia. [Courtesy The Legend Press.]

RIGHT: Albert Namatjira, *Talipate, Western MacDonnells*, watercolour and pencil on paper, 56 x 37.8 cm. Ledger Bequest, Benalla Art Gallery. [Courtesy The Legend Press.]

Famed central Australian artist Albert Namatjira's panoramic vistas of landforms, mountains, gorges and plains made him one of Australia's best known artists of the 20th century. His detailed views of riverbeds and valleys often sing with a luminous coloration, as in these pictures shown in the major 2002–03 retrospective, *Seeing the Centre*.

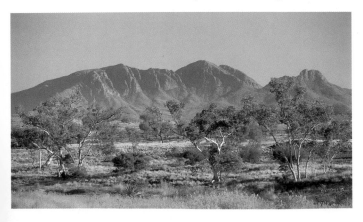

Artistically, Hermannsburg is best known for two very different art forms. One is the school of naturalist realist-style watercolour paintings made famous by Albert Namatjira (1902–1959). The other is a post-1990s development of a unique school of innovative pottery. A newer school of painting in acrylics on silk and canvas has also developed, in conjunction with the Ntaria women's centre in the community.

Arrernte Watercolours

Pioneer missionaries including Pastor Albrecht encouraged the Arrernte people from the 1920s in the making of lacework, embroidery and carving, often decorated with designs burnt by poker or fence wire, for sale in missionary outlets in the southern states.[1] The school of naturalist realist watercolour paintings started in 1932 when two Melbourne painters, John Gardner and Rex Battarbee, travelled by caravan

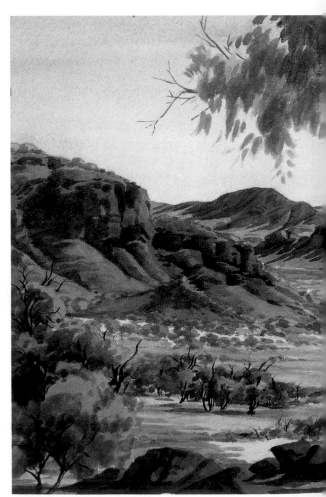

to Hermannsburg, holding painting classes as part of art and craft activities. (Other artists to visit Hermannsburg in the 1930s included Melbourne artist sisters Violet and Una Teague, who later organised an exhibition with works by Arthur Streeton, Hans Heysen, Rex Battarbee and themselves to raise money for a water pipeline from Alice Springs to Hermannsburg.)

In 1936, Battarbee gave Namatjira materials and lessons in watercolour painting. The young man, who had already shown proficiency for carving and painting, quickly became talent in his depictions of the surrounding landscape, its trees and subtle changes of light. Battarbee introduced the world to Namatjira's art by holding exhibitions in Australian capital cities. His work was eagerly taken up by the Western art world, bringing Namatjira great fame and a life that included the triumphal and the tragic (see *The Living Art of Aboriginal Australia*, pp. 6–30).

By the late 1940s at least ten other Hermannsburg men were painting in what has come to be known as the style of the Hermannsburg School that continues as a vibrant art form.

Many of the subsequent artists have been descendants of Namatjira and his wife, Clara Inkamala, who was known for her sewing prowess. The work of Hermannsburg artists is sold throughout Alice Springs and galleries in capital cities. The contemporary school of Hermannsburg watercolourists is particularly represented by Alice Springs' Ngurratjuta Iltja Ntjarra (Many Hands) art centre (see p. 50).

Much of the history of this era and subsequent development of Hermannsburg art is given in Alison French's book that accompanied the exhibition *Seeing the Centre: The Art of Albert Namatjira 1902–1959* as well as in Wenten Rubuntja and Jenny Green's *The Town Grew Up Dancing: The Life and Art of Wenten Rubuntja*.

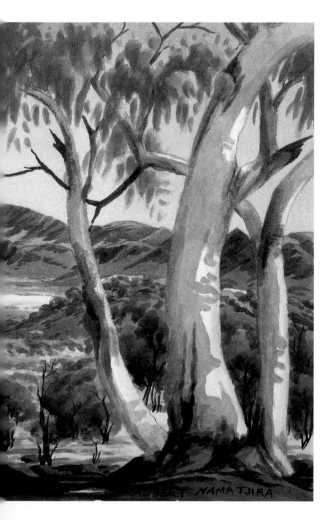

Early Experiments with Pottery

In the 1960s, a pottery school was established by mission employee V. A. Jaensch, who had been impressed with a display of pottery in Adelaide. After making contact with the Adelaide Potters Club, Jaensch returned to Hermannsburg where he sought out suitable clays, involving the community in the new project. A kiln was built, the old blacksmith's shop converted to a pottery workshop and production started in May 1963.

Emus, kangaroos, camels, birds and human figures were hand-modelled in a style not unlike those produced by Sydney potter Martin Boyd and others whose works similarly featured Australian flora and fauna. The figurines were sold in the community craft shed along with other tourist curios but the nascent pottery movement lasted only a year and lapsed by 1964.[2]

Hermannsburg Pots: A Unique Modern Art Form Is Born

The early experience was not forgotten by at least one influential community member; Pastor Nashasson Ungwanaka never forgot the enjoyment he had experienced working with clay as a young man in the 1960s. When discussions were held with the Aboriginal and Torres Strait Islander Commission in 1990 about possible enterprise development at Hermannsburg he suggested that a pottery workshop be established. In late 1990, largely due to his efforts, the Northern Territory Open College of TAFE provided the infrastructure to set up a pottery program, appointing American-born potter Naomi Sharp as coordinator.

Sharp brought her observations of the pots made in other parts of the world – especially those of the Native American Pueblo Indians – to her new role. A simple rounded shape was devised by the artists and Sharp as the most suitable for the effects the artists wanted to achieve. Individualism is expressed in the widely differing decorations on the lids and body of the pots. Lids often comprise a sculptured figurine of an animal or aspect of a plant (seeds, leaves, fruit) with the underglaze of the pot usually decorated with both paintings and bas-relief designs. They are also often

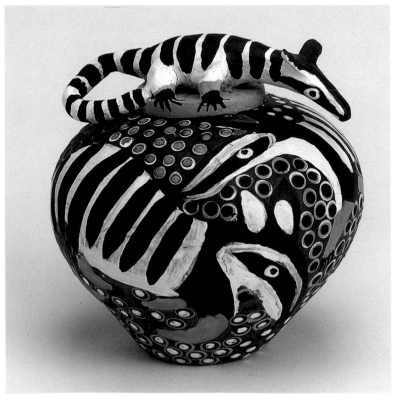

Gwen Mbetyane Inkamala, *Tyelpe (Quoll)*, 1996, glazed ceramic, 300 x 25 cm. Private collection.
[Courtesy Hermmansburg Potters.]

Whimsy and an imaginative depiction of flora and fauna characterise the unique, colourful pots made by artists of the Hermannsburg Potters.

characterised by the addition of a bird, animal or other representation adorning their tops and winding throughout the design of the pot itself in often-vivid colours representing the flora and fauna, the sky and earth.

In 1991 the Hermannsburg Potters Aboriginal Corporation was formed with a core group of around 14 potters, mostly women. Many have remained with the project consistently, and as many as 40 people have been involved. In 1991 four of the potters also worked on a month-long collaborative project to produce a 24-tile mural for an internal wall of the Alice Springs Department of Education and Employment. By 1996 some 11 murals had been completed; the largest is the 114 cm x 314 cm *Cycle of Life; Amphibians and Reptiles from the Hermannsburg Area* for Taronga Park Zoo's Amphibian and Reptile House in Sydney.

The work of Hermannsburg potters has been seen in group and solo exhibitions at many leading galleries throughout Australia. Between 1991 and 2006 galleries that exhibited the works included Gallery Gondwana (Alice Springs), Alcaston (Melbourne), Hogarth (Sydney), Redback and Woolloongabba (Brisbane), Gadfly (Perth) and a number of public galleries including Cairns Regional Gallery. Internationally, the pottery has been seen in London, Paris, Singapore, Berlin and other cities. It has been widely included in the annual National Aboriginal and Torres Strait Islander Art Awardand Desert Mob exhibitions. In 1996 the survey exhibition *Now We Are Working with Clay*, the Museum and Art Galleries of the Northern Territory offered a comprehensive overview of the history of the development of the pottery and work of the individual potters. Other group exhibitions in which their work has featured include *Australia Now: Contemporary Aboriginal Art*, Groningen Museum, Groningen, the Netherlands, 1995; *Objects from the Dreaming: Aboriginal Decorated and Woven Objects*, Art Gallery of South Australia, 1996; *Delinquent Angel*, S. H. Ervin Gallery and touring nationally, 1996; *The Somatic Object*, Ivan Dougherty Gallery

and touring internationally, 1997; *Spirituality and Australian Aboriginal Art*, Madrid, Spain (touring 16 regional and central galleries), 2001; *Seeing The Centre: The Art of Albert Namatjira*, Araluen and National Gallery of Australia and touring, 2002–03.

A number of potters have also conducted workshops in conjunction with festivals and exhibitions in Sydney, the Cook Islands and other locations, and have been artists-in-residence and part of cultural exchange programs at the Institute for American Indian Research, University of Santa Fe, USA, 1994, and Lombok Pottery Centre, Bali, 1996.

Boldly colourful and imaginatively designed, the pots reflect the strength of their makers' connection to the earth in their use of red clay, white ochres and other natural materials. The development of this pottery movement in an Aboriginal art practice largely dominated by painting has given the artists a unique and significant place.

Some Hermannsburg artists
Arrernte watercolour school

Clem Abbott, Cordula Ebatarinja, Walter Ebatarinja, Kenneth Entata, Adolf Inkamala, Benjamin Landara, Gustav Malbunka, Gloria Moketarinja (née Emitja), Richard Moketarinja, Elaine Namatjira, Enos Namatjira, Ewald Namatjira, Gabriel Namatjira, Keith Namatjira, Maurice Namatjira, Oscar Namatjira, Claude Pannka, Edwin Pareroultja, Otto Pareroultja, Reuben Pareroultja, Brenton Raberaba, Henoch Raberaba, Herbert Raberaba, Otto Rubuntja, Wenten Rubuntja.

Some artists Hermmansburg Potters

Irene Mbitjana Entata, Clara Ngala Inkamala, Esther Ngala Kennedy, Carol Panangka Rontji, Lindy Panangka Rontji, Rona Panangka Rubuntja, Rachel Kngwarria Ungwanaka.

Some artists Ntaria Arts Centre

Delrose Abbott, Freda Campbell, Lillian Impu, Tina Malbunka, Marjory Wheeler, Martha Wheeler.

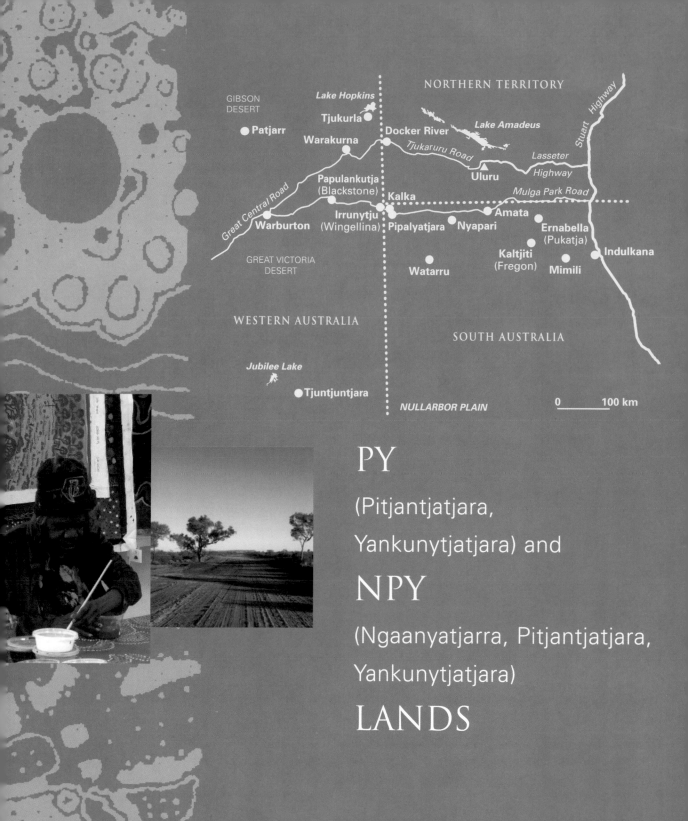

NORTHERN TERRITORY

GIBSON DESERT

● Patjarr

Lake Hopkins

Tjukurla

Warakurna

Docker River

Tjukaruru Road

Lake Amadeus

Stuart Highway

Uluru

Lasseter Highway

Papulankutja (Blackstone)

Great Central Road

Kalka

Mulga Park Road

Irrunytju (Wingellina)

Pipalyatjara

Nyapari

Amata

Ernabella (Pukatja)

Warburton

Watarru

Kaltjiti (Fregon)

Mimili

Indulkana

GREAT VICTORIA DESERT

WESTERN AUSTRALIA

SOUTH AUSTRALIA

Jubilee Lake

● Tjuntjuntjara

NULLARBOR PLAIN

0 — 100 km

PY

(Pitjantjatjara, Yankunytjatjara) and

NPY

(Ngaanyatjarra, Pitjantjatjara, Yankunytjatjara)

LANDS

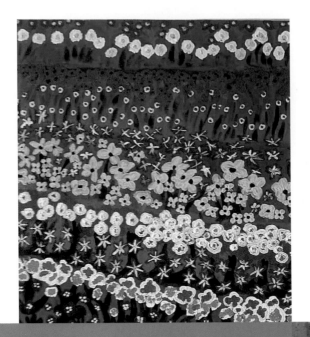

From the flat-plained deserts of South Australia to the majestic Everard, Petermann and Rawlinson ranges, traversing hundreds of thousands of square kilometres over three states, the PY and NPY lands encompass some of the most sweepingly spacious and diverse country in Australia. Sparse in vegetation during the years of dry conditions, the desert earth springs to life after rains, with permanent soakage areas and creek beds nourishing a wide variety of native tomato, fig, tobacco and other plants as well as grass seeds that can be ground to form an edible paste. Stands of desert oaks and towering white and red rivergums line the creek beds. Until introduced animals such as rabbits and especially camels denuded it, the land sustained a number of small and larger

PY and NPY LANDS

Art in the deserts of the South and West

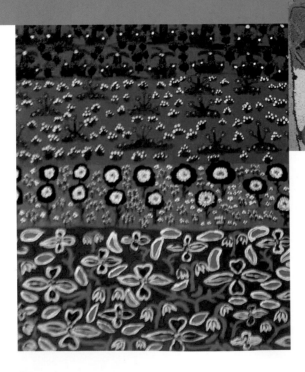

'Art in the PY and NPY Lands ranges from that of Australia's oldest art centre at Pukatja (Ernabella) to some of its newest.'

animals such as the bilby, many varieties of wallaby and kangaroo, birds, lizards and snakes.

The region encompasses the famed Uluru (Ayers Rock) and nearby Kata Tjuta (the Olgas) as well as the Great Victoria and Gibson deserts, and is home to more than 100 communities and small outstation settlements.

Uluru and Kata Tjuta were first mapped by Europeans in the 1870s during the construction of the Overland Telegraph Line in 1872. Ernest Giles and William Gosse, in separate expeditions, were the first European explorers to this area; Gosse was the first white explorer to see Uluru in 1873, naming it Ayers Rock after Sir Henry Ayers, the Chief Secretary of South Australia.

Between 1918 and 1921 large adjoining areas of South Australia, Western Australia and the Northern Territory were declared as the Central and Southern Central Aboriginal reserves, as sanctuaries for a nomadic people who had had virtually no contact with white people.

Some white people, nevertheless, continued to visit the area on camel, horse and later in cars. These included missionaries, members of the Native Welfare Patrol, adventurers, doggers, police, as well as prospectors such as Lewis Hubert (Harold Bell) Lasseter who searched in vain for a 'lost reef' of gold until his death in the Petermann Ranges in 1931. In 1940 tracts of the land were excised from the Aboriginal reserves to allow for more substantial mining explorations and not returned to Aboriginal control until the 1970s.

Pitjantjatjara and Yankunytjatjara (PY) people are called Anangu, which originally meant 'human' or 'all people' but has come to refer specifically to those from this region – hence the name Anangu Pitjantjatjara, Yankunytjatjara (APY) lands. The Ngaanyatjarra and Yankunytjatjara of the west are called Yarnangu.

Art in the PY and NPY lands ranges from that of Australia's oldest-established arts centre at Ernabella (Pukatja) to that of the

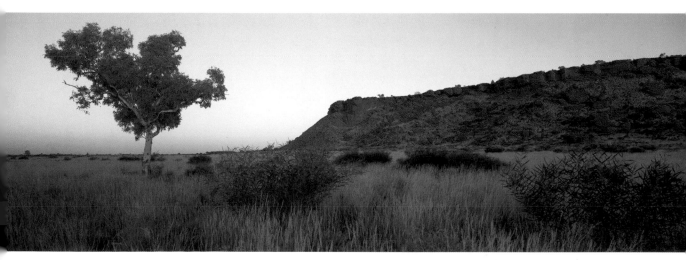

Rock formation, Durba Hills, Little Sandy Desert, WA. [Photo Phillip Quirk, Wildlight.]

FAR LEFT: Delma Forbes, *Tjulpun-tjulpunpa (Wildflowers)*, 2007, (detail), acrylic on canvas, 137.2 x 61 cm. Private collection. [Courtesy the artist and Kaltjiti Arts.]

LEFT: Kuntjil Cooper, *Minyma Kutjara*, 2005, (detail), acrylic on canvas, 147 x 80 cm. Private collection. [Courtesy the artist, Irrunytju Arts and Vivien Anderson Gallery.]

The sun's morning and evening rays turn a rocky desert mountain range into glowing reds. The colours of this vast region are captured in very different but equally vibrant fashion by its several thousand artists, many of whom live in some of the smallest and most remote communities in Australia.

Carolanne Ken, *Milpatjunanyi Walka (Story Telling Designs)*, 2007, acrylic on canvas, 25 x 25 cm. Private collection. [Courtesy the artist and Kaltjiti Arts.]

The colourful 'walka' designs made famous by the artists of Ernabella in the 1960s are continued by today's artists.

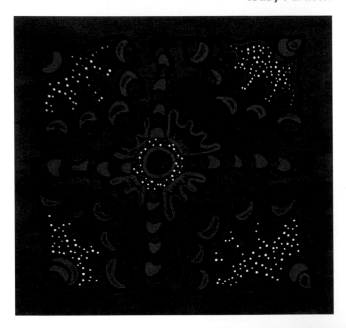

country's newest arts centres, especially those throughout the western NPY lands. Entirely new arts centres established during the 1990s and 2000s include those at Warakurna, Warburton, Wingellina (Irrunytju), Nyapari, Patjarr and Tjukurla. As well, during the 1990s and 2000s many long-established arts and crafts centres such as those of Fregon (Kaltjiti), Amata, Uluru, Kalka, Blackstone (Papulankutja), Indulkana, Mimili and smaller outstation communities have experienced a great revival of interest in their art. In 2000 the Spinifex people of the large region south of Warburton, had an important native title victory, in which art played a major part and has since developed into a leading art movement.

Some early research

Since the 1990s artists of this area, especially those in their 60s and 70s, have burst forth as some of Australia's most brilliant contemporary painters. Their skill is grounded in a solid foundation of countless generations who honed sand, rock and body decoration; practised a great range of weaving; and carved and incised decorations on utensils, weapons and ceremonial objects.

From the 1930s those such as the Central Australian pioneer and Aboriginal protagonist,

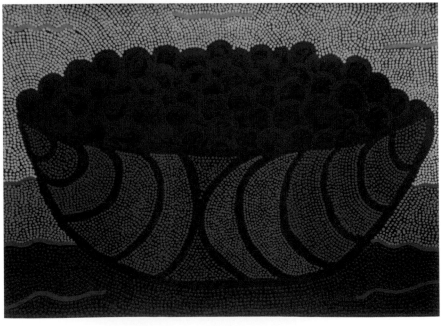

Carolanne Ken, *Kampurarpa (Quandongs)*, 2007, acrylic on canvas, 30 cm x 40 cm. Private collection. [Courtesy the artist and Kaltjiti Arts.]

Daisy Bates, ethnographer Norman Tindale and others had been collecting traditional Aboriginal designs. And in 1932, Adelaide University mounted an anthropological expedition by Tindale and others, to Mt. Liebig in Central Australia to study Aboriginal people living a pre contact life. Included in the study was the provision of crayons and paper for Aboriginal men to make traditional drawings. A number of these, and information about this early material culture expedition was shown in the important 2006 exhibition *Colliding Worlds* (Tandanya and touring). (Included were drawings made by the father of leading Papunya painter Johnny Warangkula Tjupurrula.)

In 1940 another Adelaide-based anthropologist Charles Mountford conducted a more substantial survey of the art of people

BELOW BOTTOM LEFT: Unknown artist, *Wanami at Muljabi*, c.1940, crayon on paper. [Reproduced from Charles Mountford, *Nomads of the Desert*, Rigby, 1976.]

BELOW LEFT: Unknown artist, *Snakes and topography of Piltadi*, c.1940, crayon on paper. [Reproduced from Charles Mountford, *Nomads of the Desert*, Rigby, 1976.]

BELOW: Jimmy Baker, *Piltati*, 2008, acrylic on canvas, 155 x 95 cm. Corrigan Collection. [Courtesy the artist, Tjungu Palya and the Corrigan Collection.]

The works drawn for ethnographer Charles Mountford in the 1940s show some of the earliest examples of the use of Western materials by the people of the region. These include the immediate forebears of today's painters such as leading Pitjantjatjara painter and healer Jimmy Baker who paints, in more colourful rendition, the same stories, such as those of the Piltati Gorge, home of the Wanambi water snake creation ancestors.

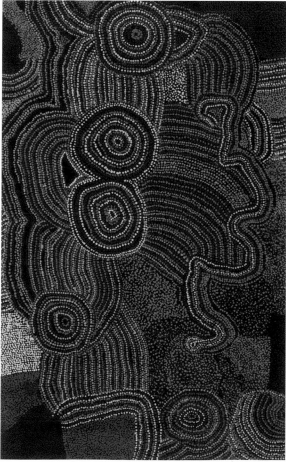

further west. From the 1930s Mountford had undertaken numerous excursions through vast tracts of Australia, from South Australia and Western Australia through the centre and around the Top End, to record the life and culture of Aboriginal people.

On a 1930s expedition to the Warburton Ranges, WA, he observed that the drawings on paper by the Yarnangu were, not surprisingly, similar to those of rock painting. He, however noted a difference: 'Whereas the motifs engraved on the rock faces…were the remnants of a dead art, without meaning to any living person, these belonged to a living art, in which the artist had a meaning for every design he made.'[1]

A desire to record some of this 'living' art prompted Mountford to undertake more extensive study in the Mann and Musgrave ranges in 1940. Basing his party at the then recently established missionary settlement of Ernabella (Pukatja), the small group travelled west more than 1000 kilometres through Pitjantjatjara and Yankunytjatjara lands, camping at various areas and recording in great detail the extensive creation stories related to him by the people. As well, he gave brown paper and black, white, red and yellow crayons to the men of the groups noting that 'As soon as the adult men became used to the new medium, which took only a few days, they made drawings that, almost without exception, illustrated their mythology…'

As well as admiring the complexity of stories able to be represented in drawing, Mountford was also extremely impressed by their intrinsic design elements. 'No matter whether the drawing was simple or complex,' he observed, 'there was always a natural tendency on the part of the artist to maintain an artistic balance between the design elements…' This, he said, included the occasional deliberate inclusion of motifs with no other purpose than to balance a work.

A superficial examination of the art of the desert nomads would suggest that their

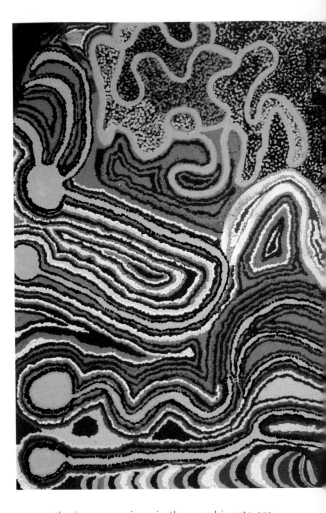

aesthetic expressions in the graphic arts are limited almost entirely to a few cave paintings and rock marking, simple body decorations and string head-ornaments. On this assumption it would have been reasonable to assume that these people were not particularly interested in graphic representation. This assumption however can be dismissed at once on the evidence of the crayon drawings, for when the men became used to the new mediums they straight away drew…with confidence and skill, often producing pictures of considerable beauty.

For a while it was puzzling to account for the confidence and ability with which the men not only portrayed many aspects of tribal beliefs on the sheets of paper, but also… obeyed, almost without exception, the laws of composition and artistic balance.

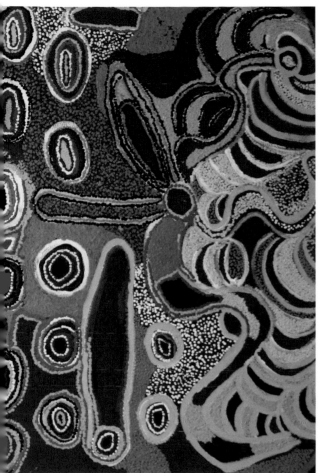

Angampa Martin, *Wati Kutjara (Two Men)*, 2006, acrylic on canvas, 94 x 136 cm. Marshall Collection.
[Courtesy the artist and Marshall Arts.]

One of the founding painters of the Irrunytju (Wingellina) painting movement, Martin learnt spinning and weaving at Pukatja (Ernabella) before returning to her home further west.

also some by women. Years later, in 1976, he published these his magnum opus, *Nomads of the Australian Desert* – a 650-page tome which documents many stories in great detail. The book, however, became the subject of considerable controversy for its reproduction of photographs of likely sacred/secret ceremonies, and was withdrawn from sale shortly after publication with most copies pulped.[3]

Many of these early designs bear a striking resemblance to those underlying the paintings of today's leading artists: hardly surprising as they were made by the immediate forebears of today's artists. As arts centre manager Edwina Circuitt comments, it is the 'drawing within' a painting that often determines its power.[4] And it is this quality, so evident in these early designs that gives contemporary desert paintings much of their potency.

Move to Western life

Mountford's and other's recording of these stories and ways of life was especially significant at the time as the region was suffering a severe drought and many people were being forced away from their land into missions such as those of Ernabella, Fregon, Warburton and others.

During the 1950s and 60s people were further removed from their lands due to the establishment of the Woomera Rocket Range at Maralinga in South Australia whose range for nuclear and rocket testing extended thousands of kilometres over the region. The full extent and effects of the nuclear testing were not known for many decades yet many Anangu and Yarnangu remember seeing the rockets and their fallout. Despite this, many people

It was only when later we saw these men drawing in the sand, with equal confidence and skill, that we realised this was the medium by which they acquired the ability to produce an equally rich art on sheets of paper.

It is of some interest to discover that in the art of the desert nomads and possibly in other Aboriginal groups, there is a hidden and unsuspected art in the sand drawings that was only revealed by the techniques of crayon drawing and finger painting. The rich symbolism of the drawings and the information they contained about the philosophy of the desert nomads would never have been revealed to us without the use of these homely European materials.[2]

Mountford returned to Adelaide with some 300 drawings mostly by men and children, but

Carved and decorated wooden bowl.
[Courtesy Tourism NT.]

TOP RIGHT: *Uluru (Ayers Rock)*. [Photo Mark Lang, Wildlight.]

RIGHT: Edith Immantura Richards, *Untitled Walka Board*, 2007, (detail), acrylic and hot wire etching on masonite, 40 x 30 cm. [Courtesy Maruku Arts and Birrung Gallery.]

Decorated carvings such as these large bowls, or piti (top left) have been made throughout the PY and NPY lands and marketed by the arts centre Maruku at Uluru since the 1960s. The technique of using red-hot wire to incise the wood is now also the basis of effective paintings called 'Walka Boards' (left) in which masonite boards, burnt with hot wire, are overlayed with paint.

continued to visit their homelands for shorter or longer periods and when the testing was over, with the encouragement of the homelands movement (see *The Living Art of Aboriginal Australia* pp. 6–30), there were immediate moves back to traditional lands to form small and mainly family-based communities throughout the region.

It is from this base that, from the 1990s, an art movement – one of the most exciting in contemporary Aboriginal art – has grown and continues to flourish into the new millennium.

As well as being Australia's most famed land form, Uluru (Ayers Rock) and the nearby rock formations Kata Tjuta (the Olgas) are areas rich in cultural heritage. Even the briefest of trips offers the visitor the opportunity to learn about the environment, art and culture of the region's Pitjantjatjara, Arrernte and other peoples. The Uluru–Kata Tjuta Cultural Centre at the base of the Rock incorporates a comprehensive educative historical display as well as a large arts and crafts shop. The area's main arts centre Maruku (meaning 'for black people') Arts has a retail outlet at the cultural centre and shows a large range of paintings and punu (the area's well known incised and decorated wood carvings) as well as weavings, bead and seed jewellery, and other traditionally made goods.

ULURU

Bonnie Connelly, *Ngayuku Tjamuku Ngura (Grandfather's Country)*, 2007, acrylic on canvas, 150 x 120 cm. [Courtesy Maruku Arts and Alison Kelly Gallery.]

Maruku Arts is the trading arm of the Anangu Uwankaraku Punu Aboriginal Corporation set up in 1984. Its name means 'wood belonging to Aboriginal people (Anangu) of the region'. It is a unique organisation that operates throughout the Pitjantjatjara, Yankunytjatjara and Ngaanyatjarra (NPY) and Pitjantjatjara, Yankunytjatjara (PY) lands to co-ordinate, collect, market and promote carving and other art and artefacts. Maruku field officers service more than 18 communities including Amata, Indulkana, Fregon, Ernabella, Mimili, Docker River, Pipalyatjara, Kalka, Wingellina, Blackstone, Jameson, Warburton, Warakuna, Tjukurla, Kanpi, Nyapari, Finke, Mutitjulu and many smaller homeland centres. The Maruku bush truck visits each community on a regular basis, craftspeople are paid cash

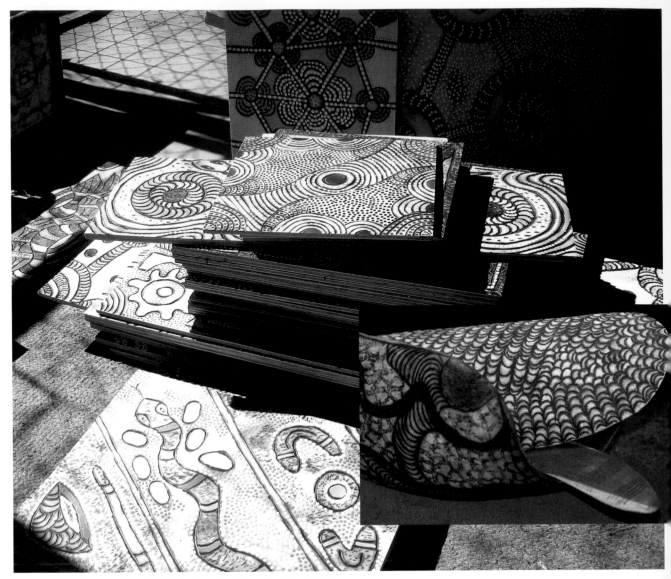

A selection of Walka Boards, Maruku Arts, 2007.
[Photo E. McCulloch Childs.]

INSET: *Carvings.* [Courtesy Tourism NT.]

Translating the established form of decorating carvings with hot wire designs has been adapted highly effectively by many of Maruku's more than 1000 artists.

for their work, and can buy tools from the truck. The visits also give Maruku employees the opportunity to talk to the craftspeople about the operations of Maruku and hear any new ideas that the craftspeople might have.

There are approximately 1000 who work with Maruku which supplies work to hundreds

of retail outlets including tourist shops and fine art galleries throughout Australia and internationally. Maruku's wholesale storeroom, which stocks up to 30,000 items, is located at the Aboriginal community of Mutitjulu.

Punu: the evolution of an art form

Desert people have been producing traditional weapons and utensils for tens of thousands of years. The technique of carving animals and incising them with burnt wire decoration evolved during the mid-20th century, as did the carving of figurative animals and other items. This was promoted at mission-established communities such as Hermannsburg, Pukatja (Ernabella) and Kaltjiti (Fregon). By the 1950s the decorated

carving tradition was well established. Punu, meaning 'wood', has come to refer to such carvings. Some of the main objects carved by men are kali (boomerangs), kulata (hunting spears), tjutinypa (clubs) and tjara (shields). Made from mulga and bloodwood, these are often beautifully and simply incised with fluted designs. A great variety of bowls (pita, kanyilpa and wira) are carved by both men and women from mulga and red gum and often decorated with the burnt wire decoration – often also called 'poker work' due to the designs being burnt into the wood by metal fencing wire and other heavy wires heated over camp fires.

Figurative animals and birds are still carved as are the popular timpilypa (music sticks), made largely by women from mulga wood for optimal resonance.[1] Many of those who have become well-known modern painters such as Clifford Possum Tjapaltjarri, George Ward Tjungurrayi, Tommy Watson, Jimmy Baker, Tiger Panpatja and numerous others have been or continue to be fine carvers, having practised these skills all their lives.

Walka boards:
another new direction

'Walka' is the name of the design used for silks, cottons and other fabric-making, prints and postcards which developed in the Pitjantjatjara community of Pukatja (Ernabella) in the 1950s and 60s. Yet 'walka' (which literally means 'design') has also come to mean a very different style in an entirely new technique developed by artists at Mutitjulu and in other areas of the PY and NPY lands working with Maruku. In these striking small board paintings, the design is made by a mix of burnt wire incision and acrylic paint. Designs are most often those based on sand and body design with the first series strikingly effective in their restricted palette of brown, black and white. Now other colours such as orange and red are also used. Exhibited at Sydney's Birrung Gallery for the first time in 2007, the boards became an instant success as an innovative melding of existing and new techniques.

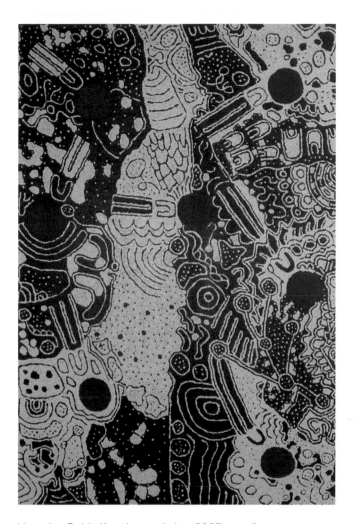

Veronica Reid, *Kungkarangkalpa*, 2007, acrylic on canvas, 124 x 83 cm. Private collection. [Courtesy the artist, Maruku Arts and Randell Lane Fine Art.]

This young painter from Docker River is one of the newer generation of painters of the region including Bonnie Connelly (previous page) whose works are distinctive for precise iconography yet fluid lines.

Painting

As well as the huge range of artefacts, carvings and walka boards, Maruku also works with painters from the Mutitjulu and Docker River communities, the latter not having a community-based arts centre. Maruku also wholesales paintings supplied by other arts centres throughout the region.

A unique weaving project, Tjanpi Desert Weavers is the dynamic social enterprise of the Ngaanyatjarra Pitjantjatjara Yankunytjatjara (NPY) Women's Council a resource, advocacy and support organisation for Aboriginal women residing in remote communities across the Central and Western desert region.

Tjanpi began in 1995 after a series of basket-making workshops were facilitated by the NPY Women's Council in the Ngaanyatjarra Lands of Western Australia in response to a request by the Council's membership for assistance in developing meaningful and appropriate employment in their homelands. Shortly after, the first art coordinator, Thisbe Purich, was employed.

Building on a long history of working

TJANPI:
Weaving the Desert

with natural fibres to create objects such as mowillari (hair-string skirts), manguri (head rings for carrying wooden dishes), wipiya tjina (emu feather shoes) and yakultja (small pouches for bush tobacco), women took easily to making coiled baskets using locally collected grass. New found skills were shared with friends and family, and basket-making spread rapidly. More than 300 women have since become regularly involved in the project.

The area covered by Tjanpi Desert Weavers is huge – across all the NPY and PY lands of more than 350,000 square kilometres – from Indulkana and Mimili in the south, to Warburton in the west, Kiwirrkura in the north, and around the Uluru region. Tjanpi staff travel throughout, working with the women to collect grasses and other materials, delivering creative

development workshops and purchasing fibreworks to take back to the weaver's Alice Springs administrative and wholesale headquarters which also houses a retail shop.

Tjanpi is the Ngaanyatjarra word for the grass that forms the basis of the weavers work. While out collecting grass women take time to hunt, gather food, visit sacred sites and teach their children about country. The first Tjanpi exhibition, *Bush Baskets and Bags*, was held at Alice Springs' Araluen Arts Centre in 1996 and the weavings hailed as a major new art form. By 1997 seeds, emu and bush turkey feathers as well as a variety of other found natural materials were being used and, shortly after, raffia was introduced.

Today, weavings range from the small and intimate to large sculptural works depicting animals, birds, figures and many other objects. The works of artists such as Kantjupayi Benson have included a life-size series based on the Seven Sisters story. In 2000 the weavers produced a 'Big Basket' – an eight-metre-long basket for the Hanover World Expo.

In 2004, 20 weavers from Papulankutja (Blackstone) community made a similarly bold statement by weaving a full-size woven Toyota truck complete with a driver, which won the National Aboriginal and Torres Strait Islander Art Award. A symbol of desert women's independence, it was a skilful work and typical of the spirit of teamwork and the women's quirky sense of humour which characterises much of their work. Many of the weavers are also painters who work with their community art centres throughout the extensive NPY lands.

TOP: *Landscape near Papulangkutja (Blackstone)*, 2007. [Photo Susan McCulloch.]

LEFT: Tjanpi Desert Weavers, *Tjanpi Papa Uwankara (Big Mob of Tjanpi Dogs)*, 2007, mixed media. [Photo courtesy Museum and Art Gallery of the Northern Territory.]

Imaginative weavings and sculptures are made by women of the area such as this installation that featured in the 2007 National Aboriginal and Torres Strait Islander Art Award, Darwin.

TJANPI

Situated around 300 kilometres south of Warburton in the midst of the Great Victoria Desert, Tjuntjuntjara is home to the Spinifex Arts Project. The area was directly affected by the Maralinga nuclear tests in the 1950s, being only several hundred kilometres from the test site. Due to the testing and the drought of the 1940s, people were removed from the area and taken to various missions including Cundeelee, 200 kilometres east of Kalgoorlie. They started returning to their country, to communities such as Tjuntjuntjara and Ilkurlka, in the 1980s.

Art and native title

The Spinifex Arts Project was established in 1997 as a means of documenting the

PEOPLE of the SPINIFEX

people's traditional ownership of the lands as part of a native title claim. A number of large collaborative canvases were made by men and women to document the entire Spinifex area showing claimants' birthplaces and important stories that traverse and give form to the area. Rich in detailed design, the paintings were formally included in the claim which came before the Federal Court in 2000. In celebration of this historic event, the people donated ten major paintings worked on by more than 30 artists to the Western Australian Museum.[1]

Since then, around 30 artists continue to paint, often using a vibrant unrestricted palette underpinned by a pronounced structural design. Collaborative works – both women and men only as well as husbands and wives and other

relatives – continue to be a feature of Spinifex paintings which have been exhibited at London's Rebecca Hossack Gallery, Melbourne's Flinders Lane Gallery, Perth's Gadfly Gallery, Sydney's Coo-ee Gallery and others.

Men's collaborative painting, *Irbilli*, 2005, acrylic on canvas, 151 x 131 cm. Private collection. [Courtesy the artists, Spinifex Arts Project and Coo-ee Gallery.]

Large and complex collaborative men's and women's paintings such as this striking 2005 men's work from Tjuntjuntjara, WA, have become a feature of the work of painters of this remote south-western desert region.

Some Spinifex artists

Jerome Anderson, Bryon Brookes, Mr Cyril Brown, Frank Davis, Karli Davis, Judith Donaldson, Kathleen Donegan, Anne Hogan, Annette Hogan, Simon Hogan, Estelle Hogan, Alan Jamieson, Betty Kennedy, Neville McCarthur, Lawrence Pennington, Ester Rice, Clem Rictor, Ian Rictor, Mrs Nulbinga Simms, Elaine Thomas, Roy Underwood, Lennard Walker, Carlene West, Angelina Woods.

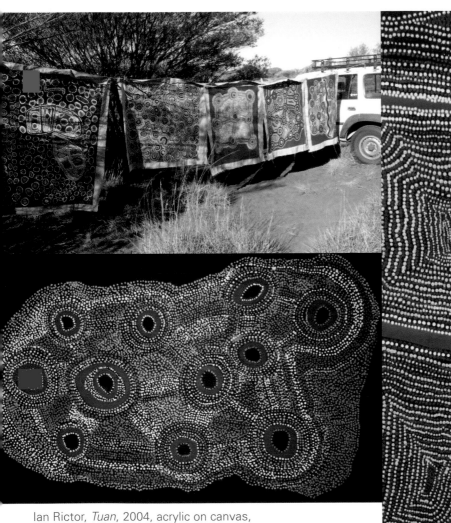

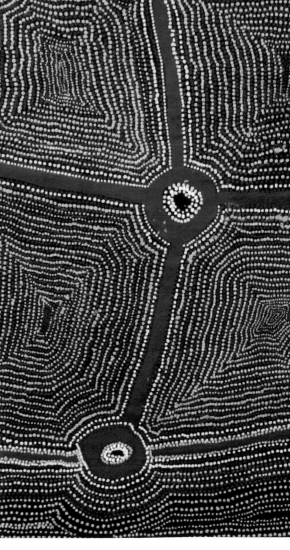

Ian Rictor, *Tuan*, 2004, acrylic on canvas, 82 x 138 cm. Private collection. [Courtesy the artist, Spinifex Arts Project and Flinders Lane Gallery.]

ABOVE: *Works drying in the sun, Tjuntjuntjara, Spinifex Arts Project*, 2006. [Photo Louise Allerton. Courtesy Flinders Lane Gallery.]

RIGHT: Carlene West, *Tjirrtjitii*, (detail), 2006, acrylic on canvas, 153 x 157 cm. Private collection. [Courtesy the artist, Spinifex Arts Project and Coo-ee Gallery.]

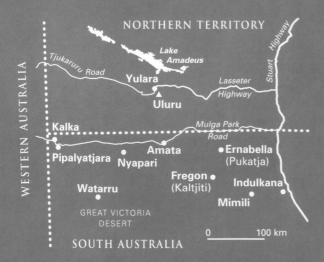

NORTHERN TERRITORY

Tjukaruru Road

Lake Amadeus

Yulara

▲ **Uluru**

Lasseter Highway

Stuart Highway

WESTERN AUSTRALIA

Kalka

Mulga Park Road

Pipalyatjara

Amata
Nyapari

● **Ernabella**
(Pukatja)

Watarru

Fregon
(Kaltjiti)

Indulkana

Mimili

GREAT VICTORIA
DESERT

0 100 km

SOUTH AUSTRALIA

PY LANDS

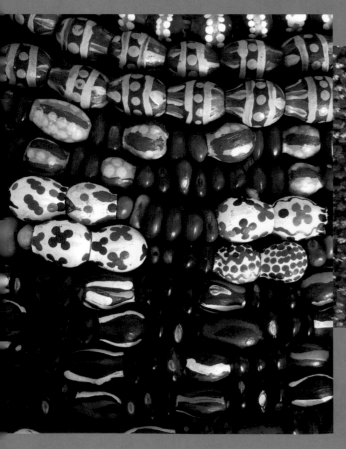

The southern Anangu Pitjantjatjara Yankunytjatjara (APY or PY) lands comprise around 103,000 square kilometres ranging west and south of the Stuart Highway from around Iwantja and further south, then west, almost to the West Australian border. Returned to the traditional owners under freehold title in 1981, with a population of around 2000, the region supports more than 50 communities of varying sizes. Anangu originally meant 'human' or 'all people' but has come to refer specifically to the Pitjantjatjara and Yankunytjatjara of the region. The area itself is referred to colloquially by many who live and work in it as simply 'the Lands'. Its administrative headquarters is at Umuwa and the region includes the tri-state border of Western Australia, South Australia and the Northern Territory, known as Surveyor-General's Corner, close to the community of Kalka.

Art in 'the Lands'

The PY region includes the longest-established arts centre in Australia at Pukatja (Ernabella) which was opened in the 1940s, as well as

LEFT: *Painted gumnut, ininti seed and other beads.* [Photo Susan McCulloch.]

CENTRE: Kathy Maringka, *Tjulpun-tjulpunpa (Wildflowers)*, 2007, acrylic on canvas, 40.6 x 101.6 cm. Private collection. [Courtesy the artist and Kaltjiti Arts.]

BELOW: Katanari Tjilya Burton, *Untitled*, 2006, punugraph, 60 x 95 cm. Multiple collections. Printer Joe Diggens for Basil Hall Editions. [Courtesy Basil Hall Editions and Tjala Arts.]

Painted beads made from nuts and the seeds of the coral wing bat tree (ininti) are a feature of desert women's jewellery. Wildflowers feature in many works of Kaltjiti artists such as Kathy Maringka's colourful painting, and the etching by Katanari Burton shows clear links between designs in sand and on the body and today's art.

'Whether figurative or those of circle, line or square, all art relates to the land ... and its people ...'

Lance Peck, *Kata Kata*, 2007, acrylic on canvas, 110 x 172 cm. Collection, National Gallery of Victoria.

[Courtesy the artist and Tjungu Palya.]

OPPOSITE PAGE: *Artists painting, Kalka, 2008.*

[Photo Bronwyn Taylor. Courtesy Ninuku Artists.]

The lusciously coloured and detailed acrylic of this leading Tjungu Palya artist from Nyapari traces the maps of his country, while the artists of the small community of Kalka paint in a peaceful bush environment for their Ninuku arts centre.

other well-established art rooms such as those at Kaltjiti (Fregon), Indulkana and Amata. Arts centres Tjungu Palya and Ninuku arts centres were founded at Nyapari and Kalka in 2006 and 2007 respectively. The arts centres of the PY lands are members of the promotional and representative body Ku Arts as well as the Alice Springs-based Desart.

Art has included grass weavings, knitting, crochet and other crafts practised in the art and craft rooms of Pukatja and Kaltjiti during the 1940s and 50s, and the fabric-making and painting enterprises using the colourful walka (see p. 114) designs that arose from those.

A new collaboration

Several arts centres of the region have pioneered the licensing of their designs for broader art production. In 1996 Kaltjiti Art licensed designs to Adelaide-based firm Better Worlds Arts to create a unique series of rugs that combine traditional Aboriginal designs with the weaving methods developed by the Kashmiri over centuries. The success of the rugs led to further projects with Better Worlds that have included the production of popular cushion covers, printed cotton bags and other items. Other projects include the licensing of designs for leather bags and other products from Iwantja Art made in India through the firm OzAboriginal, and a number of other such collaborative efforts.

Printmaking and fine art

Several of the PY communities, including Pukatja and Amata, have, in recent years collaborated with leading printmakers such as Darwin's Basil Hall and Charles Darwin University's Northern Editions to create limited edition etchings and other original prints. As well, paintings from communities throughout the region exhibited in leading capital city private and public galleries, have become highly sought-after by top collectors and acquired by key state, regional and national public collections.

The making of punu (carved wooden objects) is widely practised by both men and women, and the women also make bead and other jewellery. As well as a thriving silk and cotton batik enterprise, Ernabella also developed a significant school of pottery during the 1990s. In the 2000s, acrylic painting on canvas has come to the fore in many regions. Styles range from those based on or incorporating naïve figuration to those based solely on codified designs. Whether figurative or those of circle, square and line, all art relates to traditional stories of the land and its people, but may also include depictions of contemporary life.

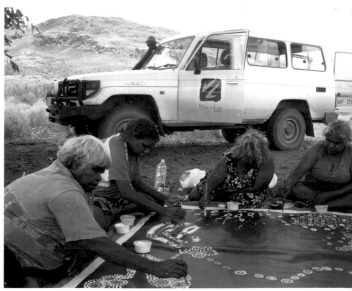

Four hundred and forty kilometres south-west of Alice Springs, in the Eastern Musgrave Ranges, Ernabella is the longest running Aboriginal art centre in Australia with a strong tradition of fabric, weaving and craft and, more recently painting and pottery. Established as a sheep station, it was acquired by the Presbyterian mission in 1936. Ernabella and its surrounding homelands are home to between 500 and 700 Pitjantjatjara, Yankunytjatjara and Ngaanyatjarra people. Ernabella missionaries believed in the 'two-way' system in which indigenous people are encouraged to maintain their language and culture while also receiving Christian tutelage.

The craft room was established at Ernabella in 1948 by its first co-ordinator, Mary Bennett.

ERNABELLA
(Pukatja)
Home of Colourful Batiks

Women spun the wool from the mission's sheep station to knit berets, jumpers and other clothing, crochet rugs and similar items. Traditional crafts such as grass and other weavings were encouraged, along with the making of wooden artefacts. Bennett also encouraged the children to paint in whatever form they chose. In 1954 Winifred Hilliard arrived as art and craft teacher and encouraged the women to further experiment with a variety of materials such as pastel, watercolour and ink, and, later, brightly coloured acrylic paints.

Painting became more sophisticated each year with stylised representations (called 'walka') of desert vegetation and body painting, characterised by large swirling blocks of often highly coloured arabesque designs. Reproduced as postcards and posters and promoted by some city agencies during the 1960s, this new style attracted a good deal of attention. But, as noted in the introduction to this section, due to a variety of factors, the paintings were not a great success in the fine art world, although they did have limited commercial success. Weaving also continued during the 1960s with some designs being commissioned by a leading fabric manufacturer to be made into rugs – some of which were large in scale and collected by public galleries.

Allison Carroll (left) and Renita Stanley with their Ernabella artwork at the Fabric for Life shop, North Adelaide.
[Photo Sam Mooy, News Ltd.]

OPPOSITE PAGE: Nura Rupert, *Minyma, titji mai putija uranyingi*, 2007, acrylic on canvas, 60 x 90 cm. Private collection.
[Courtesy the artist, Ernabella Arts and Alison Kelly Gallery.]

Senior artist Nura Rupert, whose paintings are distinctive for their free naïve expression, remembers the 'old days' of weaving and craft-making at the Ernabella art and craft room.

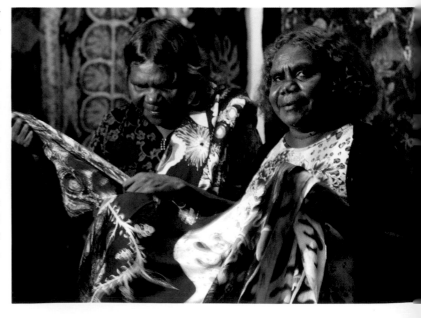

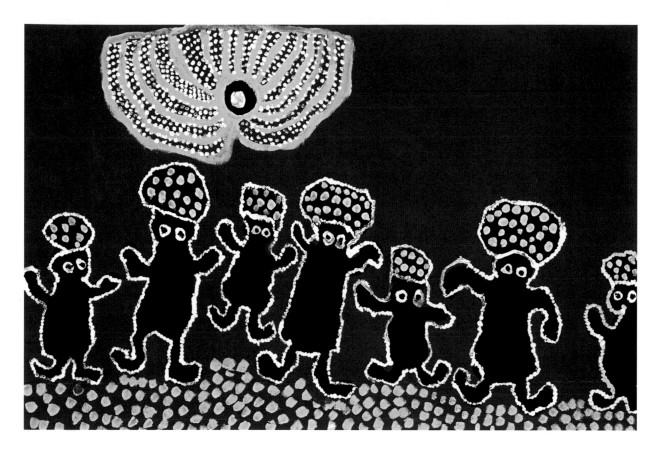

Batiks and Beyond:
Contemporary Art at Ernabella

In 1971, following Winifred Hilliard's discussions with others including author and then Craft Council of Australia representative Jennifer Isaacs, Hilliard organised a workshop in the Indonesian craft of batik-making, conducted by Leo Brereton, a young batik artist from New York. The medium suited the walka designs well and, after further refinement of the technique during the 1970s, developed into a successful commercial fabric business.[1]

The colours of the fabrics include the reds and browns of the earth, with greens, blues, violets, pinks, reds and other brilliant colours of desert flora such as wildflowers, grasses and seeds. Cotton and silk featured and have been made into a wide range of clothing and scarves as well as wall hangings shown in the fine art context. Many of the earlier batik pieces can be seen in the Hilliard Collection of the National Museum of Australia, and were featured in the exhibition Raiki Wara: Long Cloth from Aboriginal Australia and the Torres Strait, National Gallery of Victoria, 1993, and seen in many solo and group exhibitions in leading galleries around Australia and internationally.

A New Painting Movement Emerges

Until the late 1980s no-one was painting Western Desert dot-style paintings at Ernabella – largely because, as with the Warlpiri people of Lajamanu, many Pitjantjatjara people strongly resisted the notion that traditional designs, whether secret or not, should be on public view.[2] However since about 1988, this view has broadened. Paintings from the late 1980s and 1990s combined Western Desert style and design elements of the walka. From around 2000, painting became more widely practised, with a large variety of styles that include figurative works, such as Nura Rupert's naive animals, as well as traditional designs and others whose imagery is highly personal and interpretive.

Ceramics

In the late 1990s Ernabella art entered another new dimension with workshops held with

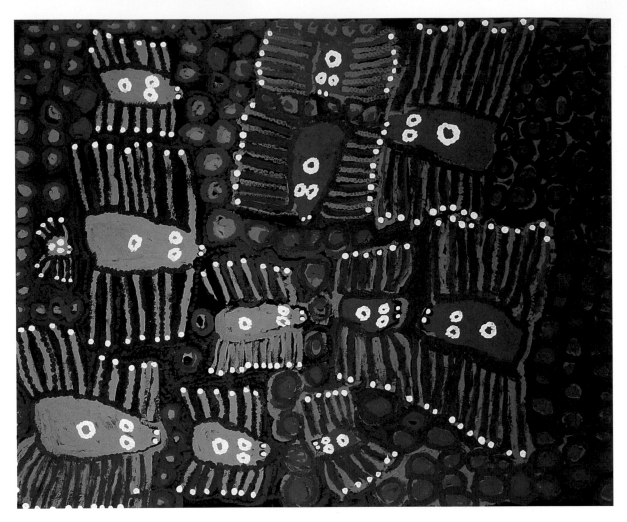

Harry Tjutuna, *Spiderman*, 2007, (detail), acrylic on canvas, 140 x 117 cm. Marshall Collection.
[Courtesy the artist, Ernabella Arts and Marshall Arts.]

leading ceramicists and potters, including Adelaide's Jam Factory and ceramicist Robin Best. Since then, ceramics have included those using an adaptation of the batik lost-wax technique on painted underglaze and finely inscribed sgraffico in which designs are made by scratching back a painted surface. The ceramics studio occupies the original art and craft room, leading through a large undercover painting area to the newer display and sales area.

Limited edition prints produced in collaboration with printmakers such as Darwin's Basil Hall have added another element to Ernabella art.

Around 50 to 70 artists work regularly at the centre – painting, weaving, decorating pots and making seed, bead and other jewellery.

In 1998 Ernabella art celebrated its 50th year of practice with major exhibitions of batik, and the publication of a book, *Don't Ask for Stories*, which traces the development of Ernabella art and the styles of its women artists.

In 2008 the arts centre celebrated 60 years of operations with a series of special exhibitions, workshops and demonstrations, ceremonies and displays of historical and archival material.

Some Ernabella artists

Nyukana (Daisy) Baker, Alison (Milyika) Carroll, Langkali De Rose, Yaritji Heffernan, Angkuna Kulyuru, Melissa Lewis, Pantjiti Lionel, Makinti Minutjukur, Ktungu (Betty) Munti, Yipati Riley, Nura Rupert, Tjunkaya Tapaya, Harry Tjutuna.

One of the northernmost towns in South Australia, the small Pitjantjatjara community of Kaltjiti (Fregon) is 350 kilometres east of Uluru, 500 kilometres south-west of Alice Springs and 1100 kilometres north of Adelaide. Outcrops of rocky hills of the Everard Hills, dotted with caves and overhangs and slabs of smooth rocks, form the background against which 137 kilometres of red-sand road winds from the Stuart Highway, past the communities of Indulkana and Mimili, to Kaltjiti and its community of around 250 people. Sixty-five kilometres north is Pukatja (Ernabella) and in the distance the outline of the blue-hazed Musgrave Ranges can be glimpsed. Normally sparse in vegetation, the flat-plained country bursts into life with brilliant flowers of yellow, purple, blue, red and many other hues after the infrequent but often heavy rains.

Situated on Officer Creek, the white settlement of the area began in 1934 when a dingo-culler named Harold Brown was granted the water permit for a block of land (Shirley Well) near the existing community. Brown and his wife were killed in 1939 in their own house, having built an underground bedroom that collapsed on them following a downpour of more than 30 mm of rain that fell in less than 24 hours. Their four-year-old son survived. The lease was reclaimed by the South Australian Government and became sheep-grazing country under the management of Ernabella.

Shirley Well, a permanent Pitjantjatjara camp site, became an outstation of Ernabella in 1960. The present community, five kilometres south on Officer Creek, was established in 1961 as a base for cattlemen and their families. The name 'Fregon' is in honour of a donor by that

KALTJITI
(Fregon)
Painting in a land of wildflowers

Near Kaltjiti, 2007. [Photo. David Peacock.]

Kalka, 2007. [Photo Anne Runhardt.]

One of the most significant creation sites close to Nyapari is Piltati Gorge, an important site in the travels of Wanampi (Water-Snake Men). One of the major sites is their home in the upper rock-hole of the gorge – a large, deep, smooth-sided waterhole depicted in paintings such as those of Jimmy Baker. Eileen Yaritja Stevens (c.1919–2008) painted women's stories of the area including the native rabbit (mitika or betong) and other hunts by the women with their digging sticks around Piltati Gorge and adjacent areas.

Ethnographer Charles Mountford related the stories of Piltati in his 1976 epic work *Nomads of the Desert*, having researched these stories and collected images of their representation by artists of this region in the late 1930s.[2] The contemporary paintings of Baker, Stevens and other artists from the area resemble more colourful renditions of these images, which had been made by their forebears for Mountford some 70 years before.

Art in the land of the bilby

At Kalka, 100 kilometres west of Nyapari, Ninuku Artists is housed in an unusual mud-brick building (the only one of its type in the region) made in the 1980s by Aboriginal residents and a Melburnian wishing to live in this remote and beautiful place. On the plains nestled against the Tomkinson Ranges near the tri-state border of Western Australia, South Australia and the Northern Territory (known as Surveyor-General's Corner), Kalka is a small community of some 12 families comprising around 150 people. Fifteen kilometres south is Pipalyatjara (meaning 'by the Pipalya [red river gum] tree'), originally established as Mount Davies, with a population of similar size, a school and general store.

Many of the area's people are Pitjantjatjara (with some Ngaanyatjarra) who migrated from their lands during the 1940s and 1950s due to drought and the atomic testing at Maralinga, which affected the whole region. People started returning to small outstation homeland communities from the 1960s. Several of these developed craft rooms, but it was not until the appointment of Amanda Dent as 'roving co-ordinator' in 2004 that painting was established in earnest at Kalka with exhibitions from Kalka and four neighbouring communities held at Aboriginal and Pacific Arts, Sydney; Marshall Arts, Adelaide; and Vivien Anderson Gallery, Melbourne. With the formal opening of Ninuku (named after Ninu, the bilby) and Bronwyn Taylor's appointment as manager, the centre held its first exhibitions in Perth's Randell Lane Fine Art, Melbourne's Alcaston Gallery, Sydney's Hogarth Galleries and Adelaide's Marshall Arts in 2007 and 2008.

Some Ninuku artists

Yaritji Connelly, Renee Fox, Yangi Yangi Fox, Josephine Mick, Nyayati Stanley Young, Nyankulya Watson, Putjina Monica Watson, Tjuruparu Watson, Wimitja Watson.

Some Tjungu Palya artists

Jimmy Baker, Maringka Baker, Terese Baker, Angkaliya Curtis, Lance Peck, Eileen Yaritja Stevens, Wingu Tingima, Kani Patricia Tunkin, Bernard Tjalkuri, Nyankulya Watson, Ginger Wikilyiri.

NPY LANDS

Art of the West

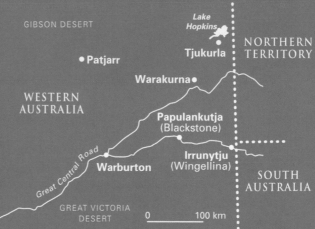

GIBSON DESERT

Lake Hopkins

NORTHERN TERRITORY

Tjukurla

• Patjarr

Warakurna •

WESTERN AUSTRALIA

Papulankutja (Blackstone)

Great Central Road

Irrunytju (Wingellina)

Warburton

SOUTH AUSTRALIA

GREAT VICTORIA DESERT

0 100 km

The **Ngaanyatjarra lands** of the west cover around 160 000 square kilometres (almost the size of New South Wales) in the Gibson and Great Victoria deserts. The area is home to around 2000 Yarnangu (Aboriginal people of the region) who live in 12 main communities and many smaller outstations.

Art production is based around six main communities: Blackstone (Papulankutja), Wingellina (Irrunytju), Patjarr, Tjukurla, Warakurna and Warburton, but the work also includes that from many artists on smaller outstations.

The largest community is the town of Warburton. From here the modern art movement grew in the 1990s through an extensive series of workshops and other cultural activities that were held throughout the

NPY LANDS
Art of the West

region. Carving, weaving and other crafts that had been practised for thousands of years were adapted and modernised by the artists. But it was the establishment of the Warburton Arts Project in 1989 that provided the foundation for today's continually expanding contemporary painting movement. Following the first workshops held in the region in the mid-1990s, four new arts centres were established. These, at Wingellina (Irrunytju) (2001), Patjarr (2004), Warakurna (2006) and Tjukurla (2007), joined the already established art and craft room at Blackstone (Papulankutja). A new, large regional art gallery, the Tjulyuru Regional Arts Centre, was opened at Warburton in 2000.

Previous page: *Desert oaks, off the Old Gunbarrel Highway, Gibson Desert*, 2007. [Photo S. McCulloch.]

NPY Lands

The whole area is usually referred to as the Ngaanyatjarra, Pitjantjatjara and Yankunytjatjara (NPY) lands due to the huge cross-overs of territories, customs, and family links. Many people travel regularly throughout the area as well as through the neighbouring Pitjantjatjara and Yankunytjatjara lands ceremonial and family

reasons, living for periods in or near a number of different communities. This fluidity is evidenced in art production. While some artists may work with their home community arts centre only, the work of others, including many of the best known, may appear on the artists lists of, or in exhibitions presented by different arts centres.

Tommy Watson, *Umutju*, 2004, acrylic on canvas, 108 x 182 cm. Private collection. [Courtesy the artist, Irrunytju Arts and Vivien Anderson Gallery.]

Amongst the earliest of the new generation of painters, Tommy Watson was one of the first artists at the tiny community of Irrunytju. Watson's confident use of brilliant colours such as these make his work especially highly sought-after.

BELOW: Kuntjil Cooper, *Minyma Kutjara (Two Sisters Dreaming)*, 2005, acrylic on canvas, 91 x 88 cm. Private collection. [Courtesy the artist, Mossgreen and Marshall Arts.]

RIGHT: Myra Cook, *Kartjinguku Creek, My Birthing Place*, 2005, acrylic on canvas, 76.2 x 152.4 cm. Marshall Collection. [Courtesy the artist, Warakurna Artists and Marshall Arts.]

Senior artist Myra Cook, whose vibrant work relates to her birthplace in the Western Desert, is a member of Warakurna Artists, one of the art centres of the Western Desert Mob alliance.

Western Desert Mob

In 2005 a new alliance of arts centres, the Western Desert Mob, was formed to promote community-based, Aboriginal-owned art centres of the region. Comprising the arts centres of Patjarr (Kayili Artists), Blackstone (Papulankutja Artists), Tjukurla (Tjarlili Art), Warakurna (Warakurna Artists), Uluru (Maruku Arts) and Tjanpi Desert Weavers, the group raises the profile of arts centres by issuing media releases commenting on art issues, such as the 2007 Senate Inquiry into Aboriginal Art; organising group exhibitions, such as the 2007 Perth exhibition *Kutju (One)*; supporting arts centre managers to speak in forums and other venues on the issues of authenticity, their experiences and knowledge of working in remote communities; developing educative programs and publications; and documenting the art of their member arts centres and the cultural and artistic heritage of the region.[1]

Phillip West, *Karatjitjarra*, 2001, acrylic on canvas, 133.6 x 198.5 cm. Warburton Art Collection, Tjulyuru Regional Arts Centre, WA.

[Courtesy Warburton Arts and Tjulyruru Regional Arts Centre.]

WARBURTON (Mirlirrtja)
Gateway to Wilurarra (the West)

To the south of the sprawling town of Warburton, 1500 kilometres north of Perth on the Great Central Road (Outback Highway), stretch the vast tracts of spinifex-covered hills, ranges and plains of the Great Victoria Desert. On Ngaanyatjarra lands, Warburton was established as a mission in 1934 by the Perth-based United Aboriginal Mission. The mission records from the 1930s list around 300 Yarnangu (Aboriginal people of the region) as having lived in or visited the mission each year. This grew to around 500–700 in the 1950s. With the return to lands and outstation settlements from the 1970s, Warburton remains an important service community with a strong, but fluctuating Aboriginal population.[1]

Warburton ranges (often referred to by locals as simply 'Ranges') has also become a popular stopover for outback four-wheel-drive and other tourists. Permits are needed from the Ngaanyatjarra Council for travel but visitors are welcomed at Warburton with amenities including a roadhouse with camping area, cabins and a shop. The Aboriginal community itself is several hundred metres away and

features the large contemporary gallery and cultural centre, Tjulyuru Regional Arts Centre. Situated in the valley between the Warburton and Brown ranges approximately eight kilometres from the base of the Warburton Ranges, the community is near the usually dry Elder Creek which, after heavy rains, flows with water from the hills. Before white settlement, soakages and rock-holes in the creek bed were important meeting places for Aboriginal people. Today's community amenities include a school, medical centre, police station, store, and a large swimming pool set in grassy surrounds with vibrant bougainvillea lining the fences. Nearby are several of the arts centre's facilities, which include a large art room with equipment for glass-making and pottery.

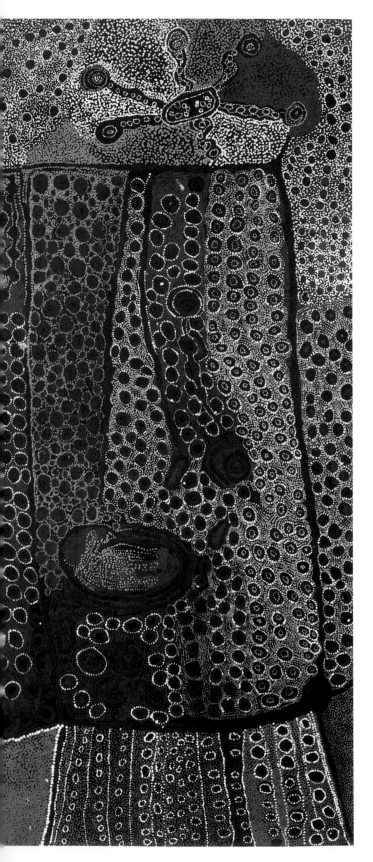

Warburton art

The Warburton Arts Project was established in 1989 by co-ordinator Gary Proctor, joined by Albie Viegas in the early 1990s. Initiatives of Warburton Arts have included a rock art program, assistance with inma (singing and dancing) and ceremonies, publications and exhibitions, and pottery. A youth arts program, Nintirringkula Youth Arts, also enables teenagers and young people to gain skills in many art forms including music, computer and video art, photography, fashion, jewellery-making, painting, drawing, films, DVDs, and working with the community radio station. Frequent workshops by craft and other art practitioners are held and in 2005 there was a month-long festival of youth arts projects and programs.

In 1995 Proctor also oversaw the establishment of a unique glass-making facility using the slump glass technique in which Ngaanyatjarra designs featured in large glass panels, bowls and other sculptural items for both domestic and architectural use. One of the large glass panels won for Warburton artist Tjaparti Bates the 1998 National Indigenous Heritage Art Award. The works are represented in many public and private collections in Australia and other countries.

Painting – a cultural heritage

Acrylic painting was established in the community in 1990. Its aim was not, as is the case elsewhere, to make paintings for sale but to keep them, through community purchase, within the community. Over the

Nyukul Dawson, Tommy Watson, Clem Rictor, Patju Presle
Bil-ku Story, 2003, acrylic on canvas, 332.2 x 154.7 cm.
Warburton Arts Collection, Tjulyuru Regional Arts Centre
[Courtesy Warburton Arts and Tjulyuru Regional Arts Centre.]

Large collaborative works of dazzling detail and colour are a feature of the works encouraged by the Warburton Arts Project which inspired the establishment of painting movements in dozens of small Western Desert communities.

Exterior Tjulyuru Regional Arts Centre, 2007.
[Photo Susan McCulloch.]

next ten years workshops at Warburton and throughout the Ngaanyatjarra lands, including Karilywara (Patjarr), Wingellina (Irrunytju), Blackstone (Papulankutja), Kiwirrkura, Jameson (Mantamaru), Tjirrkarli, Wanarn, Tjukurla and Warakurna were held. More than 350 paintings were created to become the basis of a permanent collection.

According to Proctor, the decision to keep rather than sell the paintings showed a fundamental 'shift in the usual values'. As he said, 'Whereas previously [painting] had been made for sale to an art marketplace, now it was recast as a depository for cultural knowledge and a container for shifting power relations. The paintings support a database, which includes genealogies, site locations, personal narratives, video and magnetic tape recordings, text and photographs.'[2]

The Tjulyuru Regional Arts Centre, a spacious new exhibition space and cultural centre, was opened in 2000 to show these and more recent works. A winding pathway takes the visitor through densely planted trees and shrubs, indicative of the variety of flora of the region, to the spinifex-coloured gallery itself. The bagged-brick, climate-controlled building includes a large display area that features an informative video on the region and its art and a changing exhibition of works from the collection. Exhibitions such as *Mission Time in Warburton* (2002) and

Trust (2003) presented surveys of the history of contact of the region. The paintings in the permanent collection are often large. They range from the figurative and narrative to dazzlingly colourful more abstract masterworks, which include many collaborative paintings by artists such as Kuntjil Cooper, Coiley Campbell, Tommy Watson, Clem Rictor, Patju Presley, Ngipi Ward, Arthur Robertson and Nyukul Dawson.

Art in Warburton continues to be largely produced for the benefit of the community although some exhibitions in capital cities include both works loaned from the collection and others for sale. A number of editioned sets of coloured prints have also been made of the works in the permanent collection, and are available for sale through Warburton Arts. Many artists such as those whose works are in the Warburton collection also live, work and paint at other communities throughout the Ngaanyatjarra lands.

Some Warburton artists

Tjaparti Bates, Kuntjil Cooper, Stewart Davies, Elizabeth Holland, Arthur Robertson, Ngipi Ward, Lalla West, Phillip West.

At the foot of the Blackstone Ranges, Papulankutja is a small and quiet community of around 150 Ngaanyatjarra people. With plentiful ground water, there are also many rock pools throughout the nearby ranges, whose caves and rocky overhangs provide shade and shelter. Remains of the traditional grass-covered dwellings or wiltjas of what had been a permanent community for many years are still evident at the foot of the ranges, about 10 kilometres from the modern community. This area is still visited frequently, especially by women of the region, to collect a variety of grasses and spinifex for weaving, and to make the spinifex paper which is one of Papulankutja's unique modern art forms.

The name Papulankutja is not, as is frequently supposed, a literal translation of

'This concept is quite magical,' says arts centre manager Dianna Isgar, who has lived at Papulankutja since 2000.'It's a quality which I find is both a part of everyday life and yet very powerful and elusive. People have lived a far less interrupted life in this region compared to many others, and these stories remain very much a part of everyday life.'[2]

The modern art movement at Blackstone has evolved out of art and craft activities of the 1980s. In 1989 artist Roy Churcher visited as art consultant, bringing with him large canvases, acrylics, oils and coloured inks and later related his experiences of the start of the community's modern painting movement in the book *Aboriginal Art and Spirituality*:

PAPULANKUTJA
(Blackstone)
a 'magical concept'

'Blackstone' but rather a concept relating to the story of the Wati Kutjarra (Two Men), a complex and multi-dimensional creation story of two men who each took the form of a goanna and travelled vast tracts of the land. Powerful magicians, to amuse themselves they sometimes played the trickster and transformed themselves into other animals. At Blackstone they 'tricked themselves' such that they only half-recognised each other upon meeting. 'Papulankutja' refers to the moment of familiarity without complete recognition.[1]

Near Papulankutja, 2007. [Photo S. McCulloch.]

The remains of wiltas (windbreak shelters) in which people lived for many years are still found only a few kilometres from the modern community.

I remember laying out a large canvas before a group of young women, expecting that they would work on it as a joint project. They began to do this when an older woman, a keeper of the law known only to me as 'Mrs Benson' [senior weaver and artist Kantjupayi Benson], observed this and stood back, dissociating herself from the randomness of what was being painted.

After a few hours she sat down and began painting in a very particular way... For two days she worked, colour against colour, shape against shape, until the whole canvas vibrated with colour. All the Aboriginal women understood the story and recognised the transfer of women's ritual body painting.[3]

Painting developed, along with the region's weaving movement of Tjanpi Desert Weavers (see p. 106), over some years following this. Unique to Papulankutja are small painted wooden jigsaw puzzles, made as an educative tool to relate stories as well as a fine-quality paper made from spinifex and other grasses and used for painting and prints. Much was initiated and developed by long-term art consultant Helen Gordon.

The painting room

The large tin-sided community hall has been used for art and craft workshops since the 1990s. In 2007 funding for a new arts centre adjacent to this one was announced.

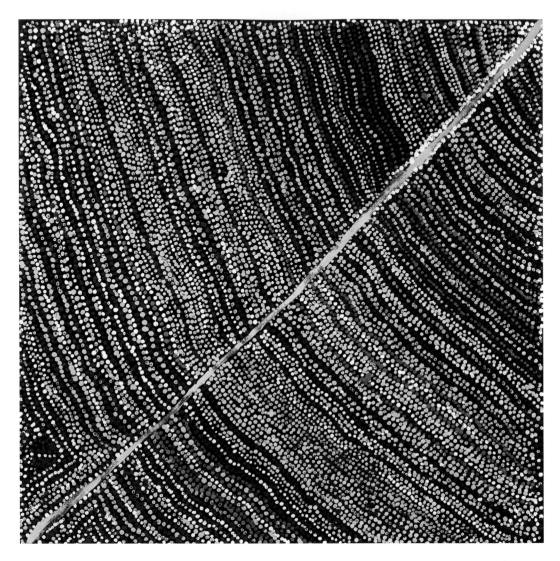

Jimmy Donegan, *Pukara*, 2005, acrylic on canvas, 101.6 x 101.6 cm. Corrigan Collection. [Courtesy the artist, Papulankutja Artists and the Corrigan Collection.]

This vibrant painting by a senior Papulankutja artist, relates the story of two water snake ancestral creators and the boomerang they threw which caused a mountain to split in two.

Papulankutja artists include a number of fibre artists who also work with the Tjanpi Desert Weavers. It was the Papulankutja group of Tjanpi weavers who won the 2005 National Aboriginal and Torres Strait Islander Art Award with a life-size woven Toyota, made in the community art room.

Painting is also developing strongly at Papulankutja, drawn from some major stories including those of the Seven Sisters, Wati Kutjarra (Two Men), bush tucker and other themes. A number incorporate the figurative as well as designs based on rock and sand art. Some, such as the work of senior painter Cliff Reid, refer to significant modern events; for example, the nuclear testing at Maralinga which affected the region in the 1950s.

Some Papulankutja artists

Kantjupayi Benson, Jimmy Donegan, Margaret Donegan, Mr Forbes, Reggie Jackson, Jean Lane, Elaine Lane, Angilyiya Mitchell, Cliff Reid, Tjayanka Woods.

Seven hundred and twenty kilometres south-west of Alice Springs on the edge of the Great Victoria Desert and 12 kilometres from the tri-state border of the Northern Territory, Western Australia and South Australia, the community of Irrunytju (Wingellina) was established in 1976 as a homelands station and headquarters for miners and prospectors for the nearby nickel mining country. Most of the community is Pitjantjatjara with some Ngaanyatjarra people. Many had lived a largely traditional bush life, and also at missions such as those at Ernabella (Pukatja) and Warburton, before the community was established.

Ringed by low hills, the country surrounding Irrunytju (whose name is taken from a sacred waterhole near the community) is arid red sand and sparse trees. The community's long-practised and well-honed skills include carvings of spears, shields, spear-throwers, and other weapons and utensils, sometimes decorated with incised designs or made by wire heated over fires, as well as hair string and other weavings.

Painting in acrylics started at Irrunytju around 1996 at the instigation of the Warburton Arts Project which held workshops throughout the Ngaanyatjarra lands. The Irrunytju project was co-ordinated by Amanda Dent who became the founding manager when an arts

centre in the Women's Centre was established in 2001. Strong commitment to the fledgling enterprise by galleries such as Melbourne's Vivien Anderson Gallery, Perth's Art Place, Adelaide's Marshall Arts, Sydney's Aboriginal and Pacific Arts and others encouraged the new centre.

Immediately evident in Irrunytju paintings was a shimmering and spectacularly vibrant coloration. The works of Anmanari Brown, Roma

Wingu Tingima, *Minyma Tjuta*, 2005, acrylic on canvas, 137 x 100 cm. Private collection. [Courtesy the artist and Vivien Anderson Gallery.]

Painting at Irrunytju started in the late 1990s through the iniative of the Warburton Arts Project.

IRRUNYTJU
(Wingellina)

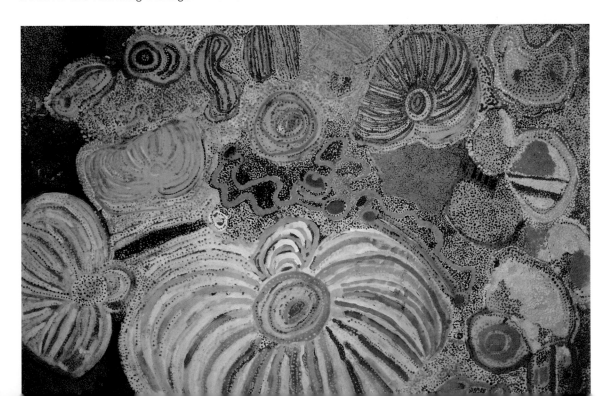

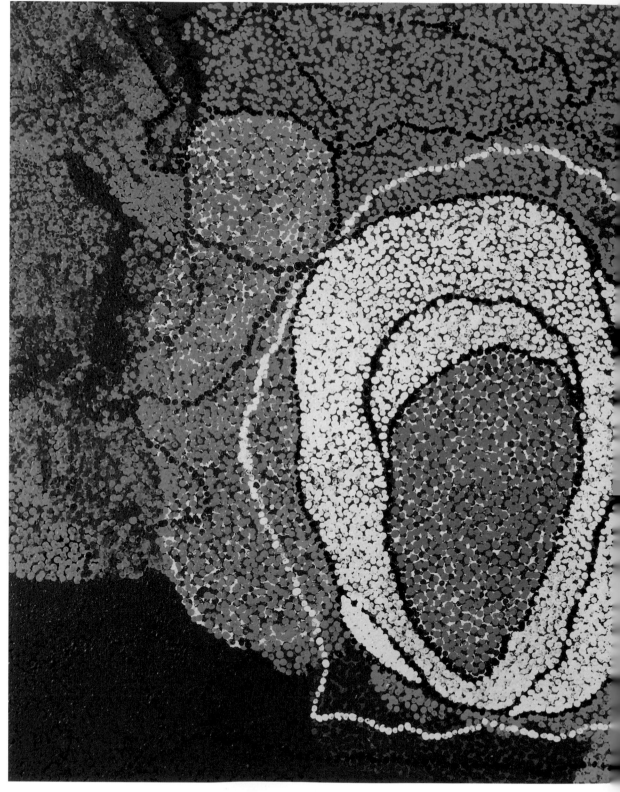

Tommy Watson, *Apinkapinkanja*, 2007, acrylic on canvas,
158 x 198 cm. Trevor Victor Harvey Collection. [Courtesy the
artist, Agathon Gallery and Trevor Victor Harvey.]

Nyutjangka Butler, Kuntjil Cooper, Alkawari Dawson, Nyukul Dawson, Patju Presley, Tommy Watson and Wingu Tingima were especially arresting. In 2003 Fiona Haasz became art co-ordinator, succeeded by Mary Knights from 2004–06, who was responsible for producing the informative booklet, *Irrunytju Arts*.

In early 2006 Sydney gallery director John Ioannou of Agathon Gallery (who at the time represented Regina Wilson and other artists of the Top End's Peppimenarti community) started to represent Tommy Watson, who by that time had become a highly sought-after artist and was working with several other galleries. Later that year Ioannou entered a contractual arrangement with the community management in which all new art from the community was managed by him.[1]

The appointment of a commercial gallery director as community arts centre representative caused a huge reaction in the Aboriginal art world. Nicolas Rothwell writing in *The Australian* noted:

> At a stroke the carefully maintained dividing lines between different categories in the Aboriginal art bazaar have been drastically eroded; the distinction between privately commissioned paintings and art from co-operative indigenous-run workshops is blurring, while simple questions about the propriety of desert art sales are becoming harder to pose.[2]

The reaction was fuelled, in no small part, by Ioannou's legal record.[3] Despite this, Ioannou has continued successful management of the arts centre, appointing a manager to work in the community, as well as providing the facilities in Alice Springs for painters to work. In 2008, star artist Tommy Watson's richly coloured paintings of high quality continue to command high prices as do the luminous works of a number of other Irrunytju artists whose works are shown regularly at Agathon Gallery in Sydney and Melbourne.

Jean Burke, *Ngayuku Ngura (My Country)*, 2007, acrylic on canvas, 125 x 95 cm. Corrigan Collection.
[Courtesy the artist, Agathon Gallery and the Corrigan Collection.]

Streams of colour often characterise the work of senior artists from this region.

Some Irrunytju artists

Anmanari Brown, Jean Burke, Roma Nyutjangka Butler, Kuntjil Cooper, Belle Karika Davidson, Alkawari Davidson, Nyukul Dawson, Angampa Martin, Kuntjiriya Mick, Raymond Nelson, Patju Presley, Clem Rictor, Noel Roberts, Tjawina Roberts, Tjinkuma Tjilya, Ngiyu Watson, Nyankulya Watson, Tjuruparu Watson, Tommy Watson, Tjayanka Woods.

Patjarr is a tiny community 243 kilometres north-west of Warburton in the Clutterbuck Hills of the Gibson Desert. It was established in 1992 as an outstation of Warburton and is home to around 30 Ngaanyatjarra and Ngaatjatjarra people. Kayili Artists ('kayili' is Ngaanyatjarra for 'north') was established in 2004 after people had been painting at Patjarr for some years as part of the Warburton Arts Project. Until houses were built in the late 1990s, Patjarr people lived in shelters made from tin, tree-branches, tarpaulins, and other coverings. Many still prefer this semi-outdoor way of life and the community resources are minimal, with water often in short supply. If the climate is often harsh the sense of space, of seemingly limitless land and skies, has its own great power and beauty. In certain areas, groves of desert oaks turn the red-sanded land into a desert park.

Most of the 50 or so artists represented by Kayili paint at their homes on the community or elsewhere. Their works leapt to the forefront of attention when first seen in exhibitions such as Alice Springs' *Desert Mob* in 2004. Ngipi Ward's paintings were especially hailed for her blend of luscious, subtle colours and positioning of images as though floating against a dark ground, in the manner of early Papunya board paintings. Pulpurru Davies' paintings are distinguished by a deep and rich patterning of colour, and Aubrey Carnegie's for their classic desert design of square and circle.

The Patjarr Cultural Centre, designed by architecture staff and students from the universities of New South Wales and South Australia in collaboration with the council, is next to the community airstrip and comprises a gallery for display, storage, sales of local art and craft, a place for meetings and shelter, and a dancing ground for Inma (ceremonial singing and dancing). Nearby, the painting room and office is the hub of everyday activity, while the ship containers that transported the materials for the community's housing are now used for storage. Silhouetted against deep azure skies and red sands, their rust-red surfaces painted with white designs make for a striking living art display.

Some Kayili artists

Manupa Butler, Aubrey Carnegie, Pulpurru Davies, Coiley Campbell, Jackie Kurltunyinja Giles, Norma Giles, Arthur Tjatitjarra Robertson, Fred Ward, Ngipi Ward.

PATJARR
(Karilywara)

Painted containers, Patjarr, WA.
[Photo Susan McCulloch.]

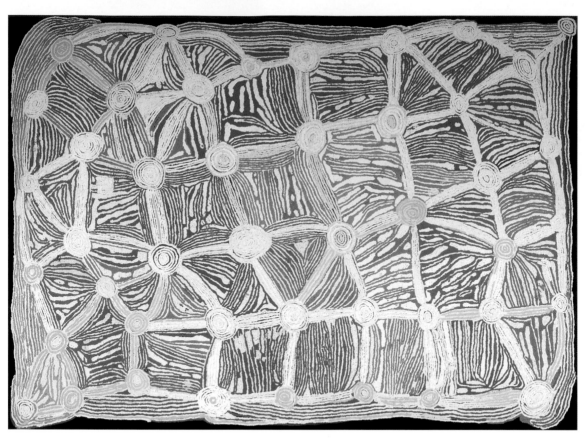

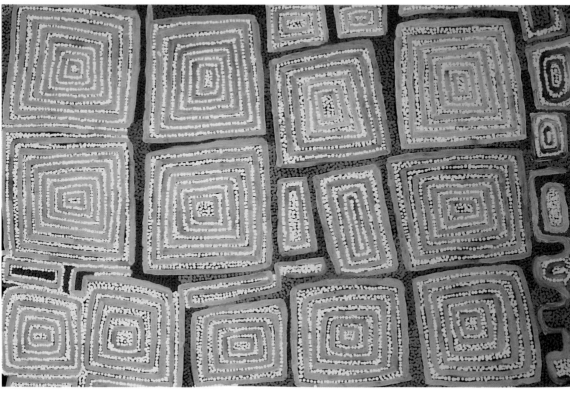

TOP: Ngipi Ward, *Kapitu Kapitu*, 2007, acrylic on canvas, n.s. Private collection. [Finalist National Aboriginal and Torres Strait Islander Art Award, 2007. Courtesy the artist, Kayili Artists and Museum and Art Gallery of the Northern Territory.]

Aubrey Carnegie, *Tingari Tjukurrpa*, 2004, acrylic on canvas, 140.5 x 96.5 cm. Marshall Collection. [Courtesy the artist, Kayili Artists and Marshall Arts.]

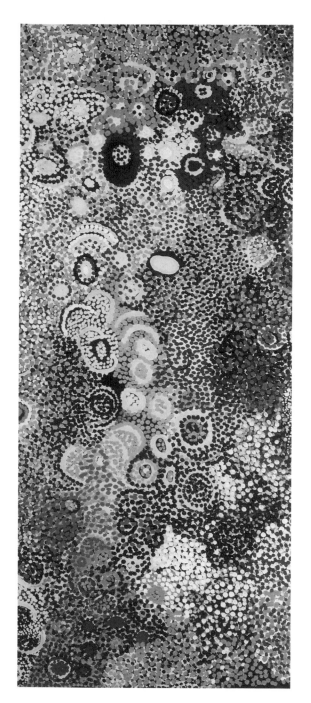

Two hundred and thirty kilometres north-east of Warburton, on the Great Central Road, is the peaceful Aboriginal community of Warakurna. Nestling at the foot of the Rawlinson Ranges in the Gibson Desert the community is home to around 180 Ngaanyatjarra people. In 1956 the site was chosen by the federal Department of Defence as the Giles Meteorological Station to monitor weather conditions for the rocket-testing program at Woomera, SA. (The station was transferred from the Department of Defence to the Bureau of Meteorology in 1972.)

Although officially moved away from the area, and unable to access their lands freely, a small group stayed on in the area living on the fringes of the Giles Meteorological Station. In 1975, as

WARAKURNA

Carol Maayatja Golding, *Walu Tjukurrrpa*, 2007, acrylic on canvas, 152 x 76 cm. Private collection. [Courtesy the artist, Warakurna Artists and Museum and Art Gallery of the Northern Territory.]

FOLLOWING PAGE: Carol Maayatja Golding Panaka, Nancy Nyanyarna Jackson Karimarra, Pirrmangka Reid Napanangka, Eunice Yunurupa Porter Panaka, *Kungkarangkalpa Tukurrpa*, 2006, acrylic on canvas, 213.4 x 152.4 cm. Private collection. Photographer John Brash. [Courtesy the artists, Warakurna Artists and Alcaston Gallery.]

Lush colours and a sense of energy imbue the works of leading Warakurna artists which include large collaborative canvases such as the brilliantly hued work (over) shown in *Power & Beauty*, Heide Museum of Modern Art, 2007.

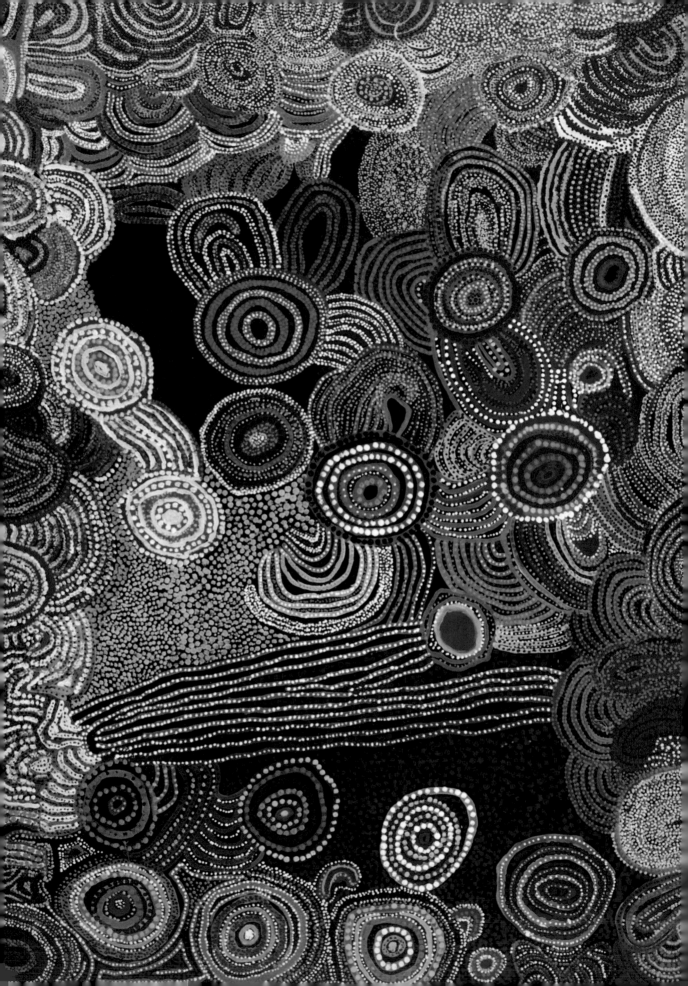

The vivid colours of Warakurna paintings are evident in the great variety of colours in the artists' brushes and the luminous decorated yellow exterior of the art centre.

part of the return to homelands movements, the Warakurna community was established.[1]

As with all Ngaanyatjarra, the people of Warakurna have had a long history of artistic expression. Early in 2004 the community was assisted by the Ngaanyatjarra Regional Arts officer Tim Pearn and the West Australian Office of Aboriginal Economic Development officer Tim Acker, to develop its own arts centre. This opened in 2005. As well as more than 50 artists from the Warakurna community, Warakurna Aboriginal Artists also supports artists from the nearby Wanarn community.

As well as the long tradition of ceremonial body painting and sand drawings, Warakurna people have had a long association with painting on contemporary media such as acrylic on canvas and crafts. Several senior artists painted for the Warburton Arts project in the 1990s (see Warburton). There is also a strong link between Warakurna, Kintore and Kiwirrkura with a number of artists including George Ward Tjungurrayi, the late Pirrmangka Reid Napanangka and others painting with Papunya Tula artists. As a result, some of the Warakurna artists such as Ernest Bennett, Ivan Shepherd and Ken Shepherd have been influenced stylistically.

Many women continue to be involved with Tjanpi Desert Weavers (see p. 106) and many also make artefacts for Maruku Arts (see p. 103) The energy and joy evident in the community's colourful paintings are reflected in the arts centre building itself, a substantially sized tin building whose entrance is marked by colourful painted poles set against the brilliant yellow and murals of the building's walls.

The works of Warakurna artists often have a particularly sensual painterly quality with rich oranges, blues, reds and pinks the favoured colours. Large multi-hued, colourful and intricate paintings created collaboratively by up to 15 artists are frequently made as are very small works of less than half a metre square, whose succinct design is often as powerful as that of larger works and yet whose price enables a great accessibility to this art.

Founding art centre manager Edwina Circuitt was instrumental in establishing the arts centre group Western Desert Mob (see p. 132) and is a passionate advocate for the art centre and art of the region which has been shown in leading capital city galleries since 2005.

Some Warakurna artists

Tjaparti Bates, Ernest Bennett, Judith Yinyika Chambers, Myra Cook, Carol Maayatja Golding, Nancy Nyanyarna Jackson, Nyurapayia Bennett Nampitjinpa, Polly Pyuwawyia Jackson, Walangkura Napanangka Jackson, Peter Tjarluri Lewis, Tjunka Lewis, Thelma McLean, Tommy Mitchell, Anna Porter, Eunice Yunurupa Porter, Anna Porter, Ivan Shepherd, George Ward Tjungurrayi, Cecily Yates.

The red-sanded road leading into the small community of Tjukurla (named after a round-shaped rock-hole) is backgrounded by the Petermann Ranges and lined with desert oaks. Four hundred kilometres west of Uluru and 1800 kilometres north-east of Kalgoorlie, the sense of remoteness adds to its supreme beauty, if also to tough living conditions. Services are fragile in this tiny community, which started as an outstation of Docker River some 150 kilometres to the south in the mid 1970s. Provisions were brought in from Docker River once a month and the community closed completely for a time after the death of two boys who attempted to travel to Docker River. It was re-opened again as an outstation of Warakurna in 1980.[1]

Most of the small community of around

TJUKURLA

80 people are Ngaanyatjarra, although the area around Tjukurla, especially towards the Kiwirrkura region to the north, crosses into Pintupi country. Nearby is the large salt lake, Lake Hopkins.

TOP RIGHT: *The road to Tjukurla*, 2007.
[Photo Susan McCulloch.]

RIGHT: Nyarrapyi Giles, *Warmarungu*, 2007, acrylic on canvas, 75 x 101 cm. [Courtesy the artist, Tjarlili Arts and Randell Lane Fine Art.]

A vivid contrast of red sanded road against deep blue skies characterises the landscape of this remote region whose new painters include some of its most senior cultural leaders such as Nyarrapyi Giles. Her resonant and lusciously painted women's story canvases were seen in a solo exhibition for the first time in 2008.

A women's centre was built at Tjukurla in the late 1980s and became a significant weaving and basket-making centre. Works were exhibited at the exhibition Bush Women at Perth's Fremantle Arts Centre in 1994. Carving and acrylic painting also developed during the 1990s, with many works being supplied to Maruku, the wholesale and retail outlet at Uluru whose shop at the Rock is very popular with tourists.

More painting developed from the early 2000s with artists travelling to Warakurna to sell their work to Warakurna Artists. By 2005 there were enough artists at Tjukurla to warrant the establishment of a community arts centre. Tjarlili Arts (named after three sacred rock-holes of the area) was formed in 2006 and Vicki Bosisto appointed as manager. Painters from Tjarlili still sell much work to Maruku, which has proved to be an important outlet. Fine art is also being developed and shown in exhibitions such as those at Alice Springs' Gallery Gondwana in 2007. In 2008 Perth's Randell Lane held the community's first solo exhibition of lush, painterly works by one of the community's senior women, Nyarrapyi Giles.

Some Tjukurla artists

Nola Bennett, Jason Butler, Katjarra Butler, Kim Butler, Maimie Butler, Annie Farmer, Nyarrapyi Giles, Lydia Young, Marlene Young.

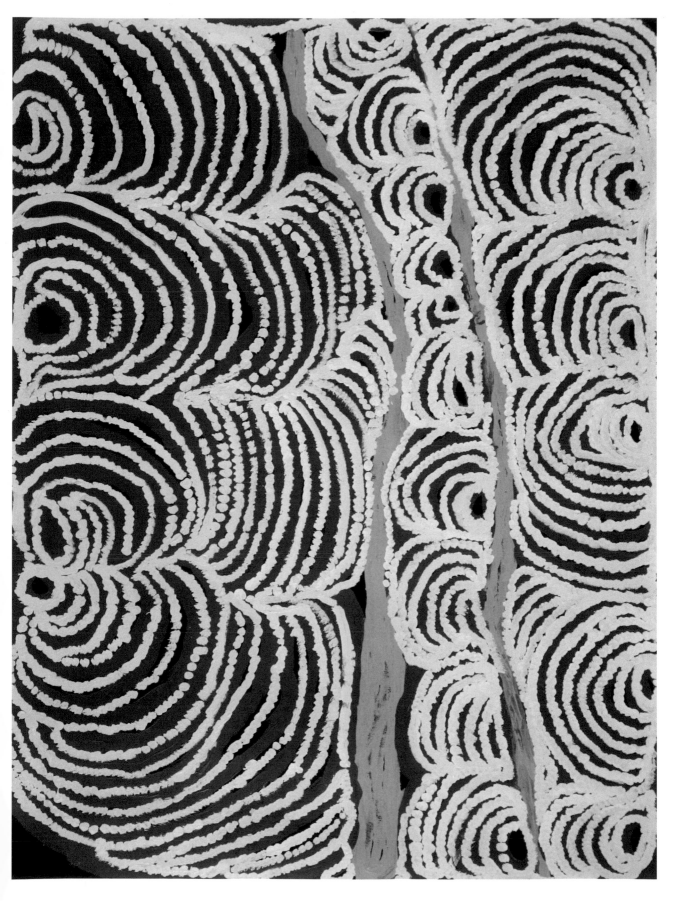

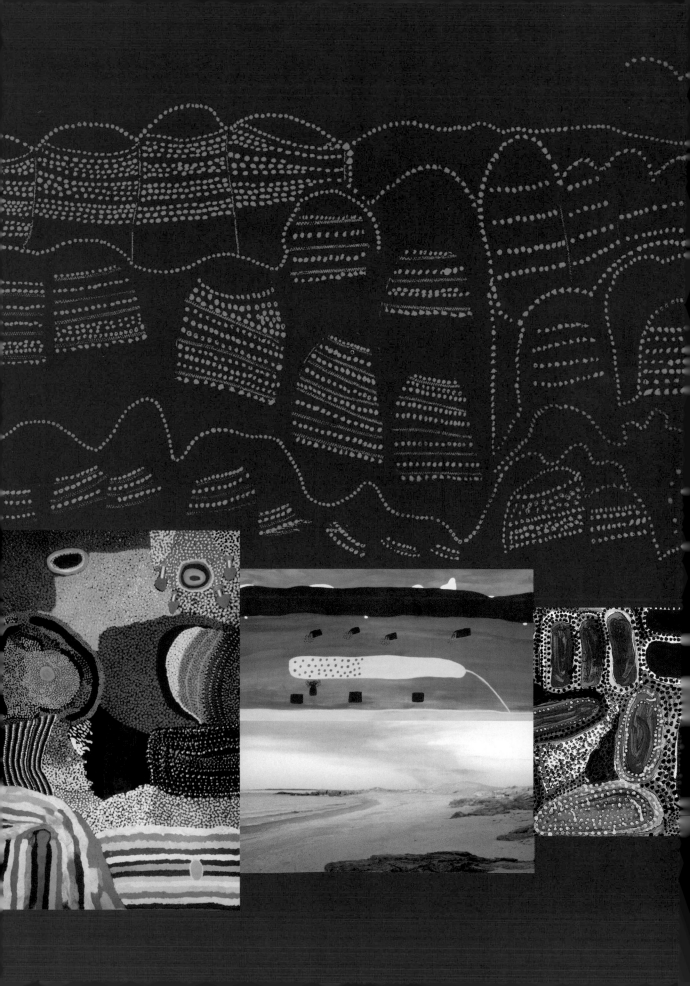

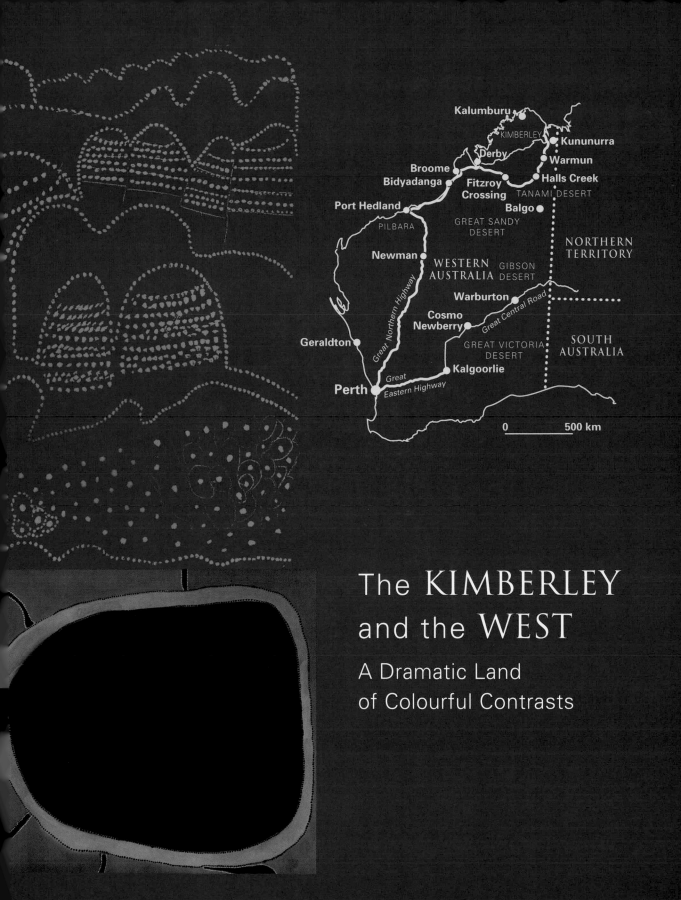

The KIMBERLEY and the WEST

A Dramatic Land
of Colourful Contrasts

Western Australia is Australia's largest state, with a greater expanse of coastline than any other Australian state. In all, WA covers a third of the mainland of Australia. The capital city, Perth, has a population of around one million people. Inland, vast expanses of savannah plains, mountains, salt lakes and many other features characterise the huge areas of the Simpson, Great Sandy, Victoria and Gibson deserts. The Pilbara's 407 926 square kilometres includes the towns of Port Hedland, Karratha, Wickham, Newman and Marble Bar. More than 60 different Aboriginal languages are spoken throughout Western Australia with 31 different languages in the Pilbara alone.

The art of Western Australia is as widely varied as the state itself. Perth's Nyoongar people, as with those in many highly settled areas, are increasingly reconnecting with their often-fragmented heritage through art and other cultural activities.

Contemporary Aboriginal art in Western Australia evolved from the Kimberley's Kalumburu, Balgo and Warmun artists who started painting on canvas in ochre (Kalumburu and Warmun) and acrylic (Balgo) in the 1980s. Since then, towns including Kununurra,

Bidyadanga, Warburton and numerous smaller communities to the north and east have become energetic centres for painting. In the state's more southern regions the art of the Ngaanyatjarra lands (see NPY/PY Lands) has come to the fore in the contemporary art movement as has that of the nascent school of contemporary painting at Martumili Arts Centre from around the Percival Lakes area.

The Kimberley

Bordered by the Indian Ocean, the 422 000 square kilometres of the Kimberley region form one of the most widely varied and dramatic parts of Australia. Wide sweeps of sandy coast broken by craggy red rock outcrops and crystal clear waters line the north-west coastal regions. Along the flat rocky plateaus of the King Leopold and Durack ranges, millions of tonnes of water are disgorged into the sea annually during the dramatic 'Wet' season (November–March) through vast sweeping

The KIMBERLEY and the WEST

A Dramatic Land of Colourful Contrasts

'The low sloping rays of sun at dawn and dusk turn spinifex into hues of mauve and lavender...'

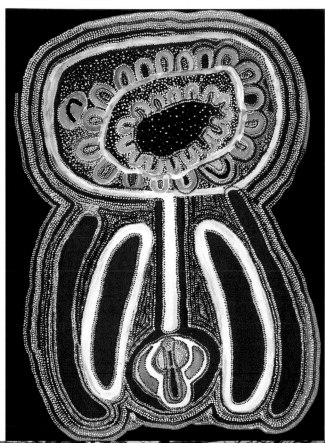

LEFT: Tommy Skeen Tjakamarra, *Undalarra*, 1993, acrylic on canvas, 121 x 91 cm. Private collection. [Courtesy Warlayirti Artists and Sotheby's.]

BELOW CENTRE: *Boab tree, Cockburn Range, Kimberley.* [Photo Mark Lang, Wildlight.]

BELOW LEFT: Basil 'Biggie' Albert, *Untitled (Policemen leading chained Aborigines)*, c.1970, boab nuts, 25 cm each. Private collection. [Courtesy Sotheby's.]

BELOW: Marie Yagun Napurrula, *Rainbow at Walkali*, 1990, acrylic on canvas, 90 x 60 cm. Western Australian State Art Collection. [Courtesy Art Gallery of Western Australia.]

Boab trees, unique to the Kimberley area of the West, store water in their bulbous trunks. Their incised nuts became a popular tourist item made by Kimberley Aboriginals who used the technique for both decorative and narrative art, such as these graphic portrayals which depict a less than salubrious aspect of early white-black contact.

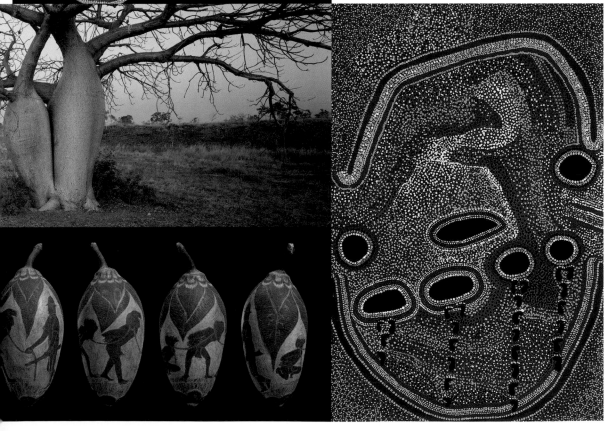

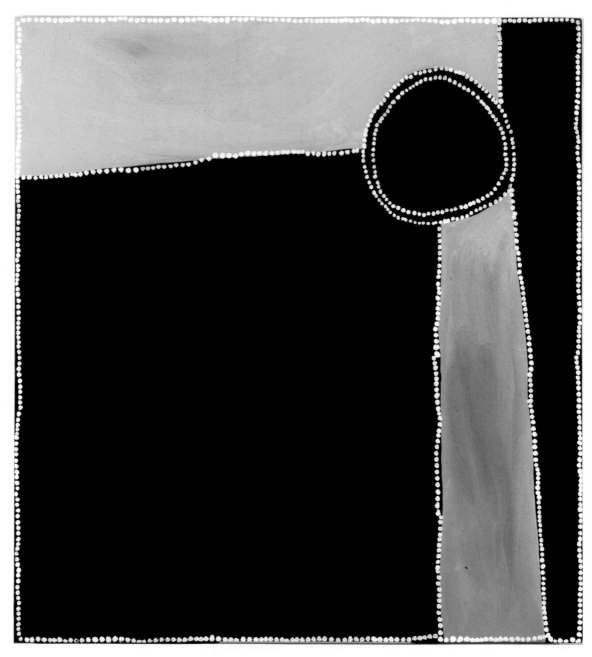

Paddy Bedford, *Dingo Dreaming*, 2001, ochre on canvas, 122 x 135 cm. Corrigan Collection. [Courtesy Jirrawun Aboriginal Art Corporation and the Corrigan Collection.]

Most well-known of the Kimberley's Jirrawun art centre artists, the late Paddy Bedford was given a large retrospective exhibition by Sydney's Museum of Contemporary Art, 2006, which toured until early 2008.

rivers and waterfalls. To the south are several thousand square kilometres of the Great Sandy and Tanami deserts – spinifex covered and once fertile life-supporting grounds. Inland, the wide Fitzroy River, its annual swell and fall carving huge towering cliffs, winds from Derby to the central Kimberley. Colours in the Kimberley are a mix of subtlety and drama. At Cape Leveque, 200 kilometres north of the tourist town of Broome brilliant red coastal cliffs combine with

basalt ocean rocks to form fine sand, tinged with pink. Further south, in the Great Sandy Desert, the low sloping rays of the sun at dawn and dusk turn desert spinifex into hues of mauve and lavender.

At the Kimberley's northern-most tip, a channel of the Joseph Bonaparte Gulf leads down to the exporting, farming and industrial centre of Wyndham. In the south-east is Kununurra, just west of the Northern Territory border – a bustling tourist and trade town that is also developing a healthy vegetable and fruit industry. One hundred and forty kilometres south, the dome-shaped Bungle Bungle Ranges (Purnululu) dominate the landscape, and relief from the burning midday heat is found in the cool black depths of their crevices and caves. Further south again is the small settlement of Balgo and, to the west, the Kimberley's southern-most point is just below the small settlement of Bidyadanga.

Displacement and Fragmentation:
A Modern History

The history of the Kimberley's Bunubu, Gadjerong, Gija, Gooniyandi, Kukatja, Mirrawong, Ngaranyin, Nyulnylan, Pama-Nyungan, Walmajarri, Wangkatjungka, Worrorran and other people is delineated sharply by the first European contact and the ensuing white domination of the country.[1]

Throughout the Kimberley, the early years of white settlement in the mid-1800s included many instances of massacres and black–white conflicts. A number of Kimberley artists including Rover Thomas (c. 1926–1998) and his relation Queenie McKenzie (c. 1915–1998) related some of these events in memorable paintings. Queenie McKenzie, who lived at the community of Warmun (Turkey Creek) near the Bungle Bungles, related how, as a young girl living on a Kimberley cattle station, a 'big mob' of her people had been killed by whites in retribution for killing a bullock. 'We were running everywhere, up hills, hiding behind rocks,' she said. 'They were shooting – didn't matter who they got – men, women, us children.'[2]

A Kukatja woman living at Balgo Hills, Tjemma Napanangka, born around the same time as McKenzie, described how her grandfather was shot dead in front of her and her family after throwing a boomerang (actually aimed at an Aboriginal stockman who had run away with his wife) that narrowly missed a white stockman. The stockman shot her grandfather then told Tjemma and her siblings to bring firewood, which he threw on the body, doused with kerosene and lit – ordering the women and children not to cry as their grandfather's body burnt before their eyes.[3]

Such chilling personal accounts occur throughout Kimberley history as well as reports of poisoned flour and waterholes, ethnocide and the rounding up and chaining of enslaved Aboriginal stockmen who left stations. But there are also other, far more positive stories of relationships between early European settlers and Aboriginal people in which mutual trust and respect was given and harmonious lives were lived.

Until the mid-1900s, many Kimberley Aboriginal men and women worked as drovers, fencers and in a variety of other jobs on pastoral stations, often for minimal wages but with the opportunity to live near or on their homelands and to travel for ceremonial purposes. In the 1940s Western Australian cattle workers were the first to strike for better pay. In 1969 the government-introduced Pastoral Award, aimed at instigating equal wages for Aboriginal workers backfired disastrously with pastoralists claiming inability to pay the wages and, in so doing, giving Aboriginal people no choice but to leave this way of life and, in many cases, their lands.

Most people gravitated to towns such as Fitzroy Crossing or Kununurra. At Turkey Creek, the eastern Kimberley Gija people pressed the government to assist them with the establishment of the Warmun Aboriginal community. Others moved to mission stations such as those of the Western Desert's Balgo Hills, the northern coast's Lombadina and Beagle Bay, and the southern coastal town of La Grange (now Bidyadanga). Most continue to

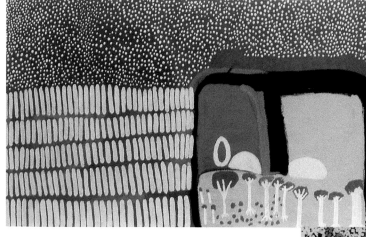

Lena Nyadbi, *Gimmenbayin Cave*, 2006, ochre and pigments on canvas, 82 x 198 cm. Collection the artist. [Courtesy the artist and Niagara Galleries.]

RIGHT: Elizabeth Nyumi, *Parwalla*, 2006, acrylic on canvas, 150 x 75 cm. Private collection. [Courtesy the artist, Warlayirti Artists and Gallery Gabrielle Pizzi.]

FAR RIGHT: Tommy May, *Kurtal*, 2007, acrylic on canvas, 120 x 90 cm. Private collection. [Courtesy the artist, Mangkaja Arts and Brigitte Braun Gallery.]

Senior Warmun artist Lena Nyadbi has developed a sophisticated and unique style of ochre painting. Balgo artist Elizabeth Nyumi's acrylics have become well known for her overlaying of colours by thick whites while Fitzroy Crossing's Tommy May's works often feature deeply vibrant hues.

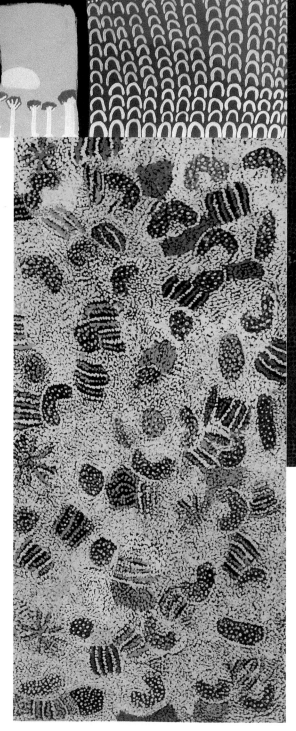

live in these communities. Title to their lands having been granted to some, but secure title is still outstanding for many indigenous people throughout the Kimberley and Western Australia.

It was in this climate that the modern Kimberley art movement began in the late 1970s, when people, first at Kalumburu, then Warmun, Balgo and other regions began to reconnect with their cultural heritage through their art.

Art of the Kimberley: A Joyous Resurgence of Traditional Values

Traditional art of the Kimberley includes the rock-art paintings of the fertility and rain Wandjina figures and the very different Bradshaw figures,

used in ceremony by Paddy Jaminji were commissioned by a Perth-based art adviser Mary Macha, while Tiger Moore also produced important early boards arising from ceremonies. The related art of Rover Thomas came to the fore some years after and developed into increasingly bold, minimalistic ochres. In 1990 Thomas was one of Australia's representatives at the Venice Biennale. The work of Thomas and that of the east Kimberley style is identifiable for its thickly applied ochre in a variety of hues and for silhouetted forms, usually outlined with white dots.

The popularity of Kimberley art developed quickly. It included paintings by Thomas and others of his Warmun-based community such as Hector Jandanay, Jack Britten, George Mung Mung, Queenie McKenzie and others; the Wandjina paintings by Lily, Rosie and other members of the Karedada family from Kalumburu; and the work of other artists from the Kununurra area such as Alan Griffiths and Paddy Carroll. This enabled the establishment of the area's first arts centre, Waringarri, which opened in Kununurra in 1985. In 1999 the artists of Warmun established their own arts centre with Betty Carrington, Katie Cox, Mabel Juli, Patrick Mung Mung, Lena Nyadbi, Shirley Purdie and others bringing a new wave of art to that community.

Further south, in the south-western desert, the artists of Balgo have been long noted for their works of colourful vibrancy. Some of the major artists of this area have included Eubena Nampitjin, Ningie Nangala, Bai Bai Napangarti, Kathleen Paddoon, Wimmitji Tjapangarti, Helicopter Joe Tjungurrayi, Lucy Yukenbarri, Elizabeth Nyumi and many others.

Colour also predominates in the very different images of the works of artists from Fitzroy Crossing and its Mangkaja Arts Centre, notable for their striking watercolours, and later, acrylics. Similar characteristics are found in art from the nearby community of Wangkatjungka. Since the start of its contemporary painting movement in the 1980s in conjunction with adult literacy classes, art from this area has

the incised decorated pearl shells called riji, masks and large story- and song-boards used in ceremony supported vertically on the back of the dancers and singers.

The first of the major Kimberley painting movements included those of the Wandjina on bark by artists around Kalumburu such as Charlie Numbulmoore, Sam Woolgoodgia and Alec Mingelmanganu. (These works were exhibited locally in Derby and in Perth in mid- to late 1970s.) Later artists, such as the Karedada family, continued this tradition.

From the late 1970s at Warmun, south of Kununurra, boards such as those

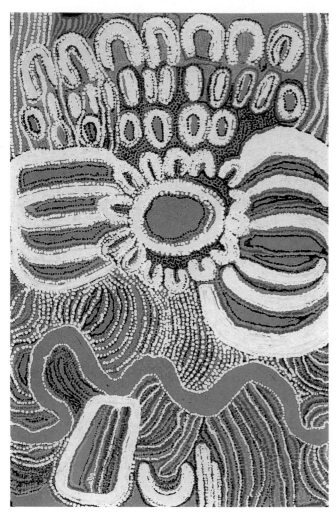

Anmanari Brown, Angampa Martin, Tjayanka Woods, *Seven Sisters*, 2004, screenprint, colour, 101.8 x 66.2 cm (image), 121.4 x 80.8 cm (sheet). Gift of Brigitte Braun 2004. Western Australian State Art Collection. [Courtesy Art Gallery of Western Australia.]

developed great vitality in brightly coloured, freely constructed paintings which portray both figurative images of trees, mountain ranges, animals, plants and abstracted planar forms. During the 1990s, several large collaborative works have also been made as statements of land claims and as collaborative ventures that link people, art and lands.

The Great Sandy Desert's Jimmy Pike (c. 1939–2002) was one of the area's most colourful, widely travelled and most-represented artists, who worked largely individually and set up his own company with Desert Designs. Other highly individual well-known Kimberley painters include Jarinyanu David Downs (c. 1925–1995), Mulgra Jimmy Nerrimah and the late Peter Skipper.

Newer Developments:
A Tradition Expands

Kununurra, the Kimberley's main town has, as with Alice Springs, become notable during the 1990s as an art region in its own right. Paddy Bedford (c. 1922–2007), Peggy Griffiths and others paint with the Jirrawun Aboriginal Artists Corporation (which opened a studio near the coastal town of Wyndham in 2007). Other artists including George Wallaby (1930–2001), Nancy Noonju (c. 1935–2007), Billy Thomas, Ned Johns and Lloyd Kwilla work through Red Rock Art in Kununurra while a variety of other artists work with private dealers and galleries.

Throughout the west, as well as newer styles by already established painters, there has been a flowering of new art since 2000. In 2003, the people of the coastal town of Bidyadanga (formerly La Grange mission) took up painting through Short Street Gallery in Broome. The vivid works by the 20 or so largely senior artists such as Weaver Jack, Alma Webou, Jan Billycan, Daniel Walbidi and others speak of a rediscovery of their heritage by those whose traditional lands lie several thousand kilometres south and inland.

At Halls Creek, 288 kilometres from Fitzroy Crossing on the Great Northern Highway Yarliyil Art Centre was established in 2004 to show the work of about 30 artists. Numerous different styles represent their very diverse heritages, which includes that of artists from the dramatic Wolf Creek Crater area, 100 kilometres further south.

A strong art movement has developed also in the more northern coastal town of Derby, 220 kilometres north-east of Broome. One of the most well known of its artists is Jack Dale (b. 1920) whose ochre paintings on canvas include depictions of the Wandjina as well as abstract pattern designs. His work has been seen in solo exhibitions throughout Australia, including at Perth's Japingka Galleries and at Sydney's Coo-ee

Shane Pickett, *Bunuroo Water Grounds and Travel Lines, 2007*, acrylic on canvas, 120 x 90 cm. *Private collection.* [Courtesy the artist and Mossenson Galleries.]

Leading Nyoongar artist Shane Pickett's evocative abstracted landscapes, and the work of other Perth-based artists such as Julie Dowling, Jodie Broun, Christopher Pease and Janine McAullay Bott offer new directions for urban art from the west.

since the mid-1990s. In Derby, Mowanjum Artists Spirit of the Wandjina is an Aboriginal corporation and arts centre representing around 30 artists.

The diversity of the region is seen in the stylistic differences of the work of a number of other Derby-based artists such as Lucy Ward, Ngarra, Omborrin, Loongkoonan and Peggy Wassi who exhibit with Indigenart: the Mossenson Galleries in Perth and Melbourne.

Some Kimberley Exhibitions

As well as being exhibited regularly in leading private galleries, Kimberley work has appeared in all general exhibitions of Aboriginal art such as the international touring exhibitions Dreamings, 1992, and Aratjara, 1994. Significant exhibitions which feature Kimberley work predominately have included *Art from the Great Sandy Desert*, Art Galley of Western Australia (AGWA), 1986; *Images of Power*,

National Gallery of Victoria (NGV), 1993; *Mythscapes*, NGV, 1989; *Yapa: Peintres Aborigènes de Balgo et Lajamanu*, Lebon Gallery, Paris, 1991; *Blood on the Spinifex*, Ian Potter Museum of Art, 2002–03; T*rue Stories: Art of the East Kimberley*, Art Gallery of New South Wales (AGNSW), 2003; *Satellites of the Desert*, AGWA, 2006. Individual exhibitions have included those on the work of Rover Thomas, *Venice Biennale*, 1990; *Roads Cross*, National Gallery of Australia, 1994; *I Want To Paint*, based on the Holmes à Court Collection, NGV and touring, 2003–05; and *Paddy Bedford*, Museum of Contemporary Art and touring Australia, 2005–2007.

Into the New Millennium

Between 2004 and 2008 more than 12 new arts centres were established in WA's east and in adjacent areas of South Australia and the Northern Territory throughout the Ngaanyatjarra Pitjantjatjara and Yankunytjatjara lands (see NPY Lands). New painting communities include those of the Martu people of Parnngurr, Jigalong, Newman and surrounding regions in the Pilbara who established their art centre, Martumili, in 2006. An increasing number of Nyoongar and other people of the south-west and including the capital city of Perth are developing highly individual art which links and interprets their heritage in completely contemporary and individual imagery.

other groups including the Walmajarri, Warlpiri, Pintupi, Ngardi and Tjaru. Established as a Catholic mission in 1939, Balgo was returned to Aboriginal control in 1981. Most of the older members of the community left their tribal life and 'walked in' from the bush in adulthood. Unlike a number of other Aboriginal settlements, Catholic practitioners at Balgo had a sympathetic relationship with the Aboriginal ways; children were not removed from their families, the use of traditional language and custom was encouraged and strong links remain between many at Balgo and Catholic educational institutions.

Around the small, spread-out settlement are the spinifex-covered plains of the Great Sandy and Tanami deserts. In the Wet, the community is frequently cut off for several months; in the Dry the earth is baked. Temperatures regularly reach more than 40°, although the Dry also has long periods of comfortable mid-20s, with nights often falling below zero. An easterly wind often persists, whipping up a gritty residue. (Balgo derives from the Kukatja word pulgu, which means 'dirty wind'.) Yet the land is one of supreme beauty – of huge skies, clear light and the almost unbroken silence of the desert itself. A vivid orange-red of a rocky outcrop contrasts with the deep blue of an equally intensely hued sky. At sunset the failing light fades the sage-green of the spinifex lining the rocky walls and plains of a vast amphitheatre-like escarpment to a soft purple grey.

In the community itself tracks meander round the houses – the slight slope on which the community sits divides it into a 'top' and 'bottom' camp. The Kukatja and Ngardi live at 'top camp' closest to their lands; the 'bottom camp' is home to the Walmajarri and Wangkatjungka. The original building of the Warlayirti Arts Centre was located between the two camps in a low rectangular building, originally the community kitchen and dining room.

In 1999 a new arts centre with large and light-filled display and storage facilities, large breezy verandah and walls painted in vibrant colours – against which the colourful paintings shone – revolutionised conditions for art production at Balgo

BALGO

sage greens, soft purples and brilliant hues: the art of isolation

Deep in the Western Desert, Balgo is 300 kilometres from the nearest town of Halls Creek and occupies 1420 hectares of the 2.125 million hectares that make up the Balwinna Aboriginal Reserve. A community of around 800, Balgo has seven different language and family groups, predominant of which is Kukatja, with

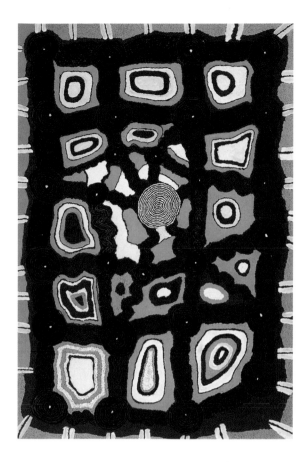

The rise of a contemporary art movement

There had been some moves towards establishing an art and craft movement in the late 1950s when some soapstone carvings of figures, birds and animals were made, and again during the 1970s, encouraged by mission staff and others such as Professor Ronald Berndt and art consultant Mary Macha from Perth. But it was after the establishment of an Adult Education Centre in 1981 and a bilingual Catholic school in 1983 that traditional painting on board started. Some years before, Papunya's founding artists, a number of whom had family connections with the Balgo community, had visited Balgo. In the 1980s when Kintore and Kiwirrkura were established closer to Balgo (which lies almost due north of Kiwirrkura), these links were further reinforced. The new painting at Papunya was watched with interest, and some concern. In her seminal book on

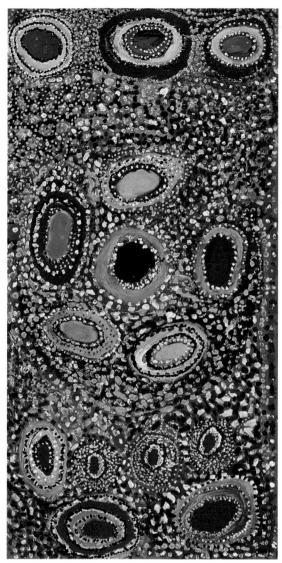

Milliga Napaljtarri, *Purrunga*, 1991, acrylic on canvas, 100 x 50 cm. Private collection. [Courtesy Warlayirti Artists and Sotheby's.]

FAR LEFT TOP: *The moon, morning, Balgo*, 1994. [Photo David Faggetter.]

TOP LEFT: Donkeyman Lee Tjupurrula, *Tingari Dreaming at Tarkun*, 1990, acrylic on canvas, 180 x 120 cm. Private collection. [Courtesy Warlayirti Artists and Sotheby's.]

Two of the original painters of the Balgo painting movement, Milliga Napaljtarri freely translated drawings in sand and on the body by painting directly on canvas with her fingers while Donkeyman Lee Tjupurrula's works include strongly coloured renditions of the classic Tingari story.

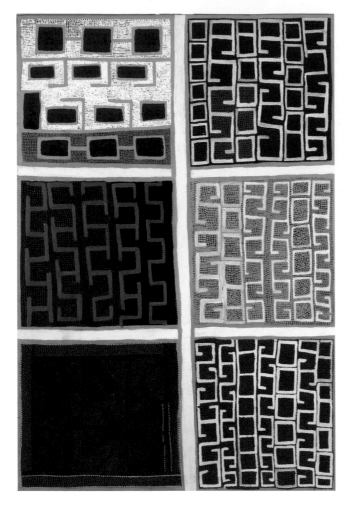

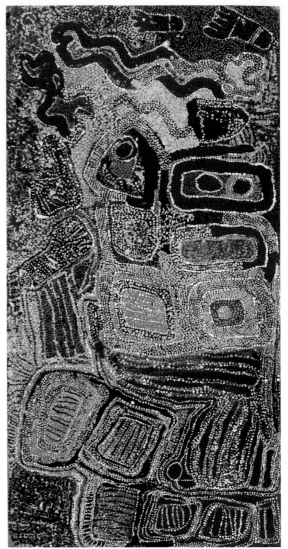

Boxer Milner Tjampitjin, *Purkitji*, 2003, acrylic on canvas, 180 x 120 cm. Private collection.

[Courtesy the artists, Warlayirti Artists and Mossgreen.]

TOP RIGHT: Wimmiti Tjapangarti, *Kutu*, 1989, acrylic on canvas, 120 x 60 cm. Private collection.

[Courtesy Warlayirti Artists and Sotheby's.]

CENTRE: Eubena Nampitjin, *Midjul*, 2006, acrylic on canvas, 150 x 100 cm. Private collection.

[Courtesy the artist, Warlayirti Artists and Raft Artspace.]

FAR RIGHT: Ningie Nangala, *Lirrwarti*, 2007, etching, image 60 x 49 cm. Edition of 50. [Courtesy the artist, Warlayirti Artists and Northern Editions, Charles Darwin University.]

Four of Balgo's most well-known painters show the huge variety and range of colours and individual styles of Balgo artists.

Balgo women's art, *Piercing the Ground*, Christine Watson notes that the long hiatus between the Balgo community's awareness of painting and its start at Balgo was likely 'due to problems which arose in Papunya between 1973 and 1975 as a result of the Papunya artists including secret ceremonial designs in their paintings for the market'. Similar concerns, she noted, had been raised in many desert communities during this period.[1]

In 1980 Warwick Nieass, a Swiss-born artist who came to Balgo as a cook in the same year, taught one of the adult education art classes established at Balgo by Sister Alice Dempsey of St John's Education Centre. The 'Modern Art' class featured Western landscape painting; 'Traditional Art and Culture' that Nieass took, comprised, according to Watson,

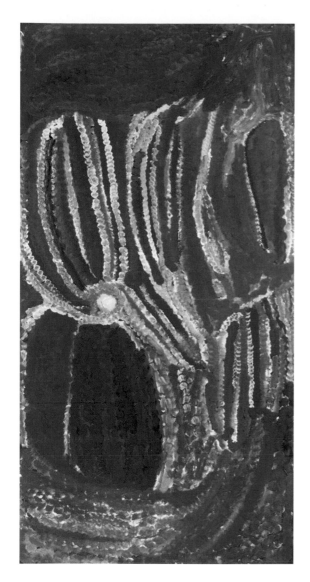

around 20 people, largely Kukatja, and including later well-known artists the late Sam Willikati Tjampitjin, Susie Bootja Bootja Napangardi, Mathew Gill, Mick Gill and Alan Winderoo. Some, such as Mathew Gill combined iconography of both the Western Desert landscapes, with imagery from traditional desert styles, and those of Arnhem Land, which he had seen in books. As in Papunya, painting was on composition board and other materials. The men who painted in this traditional manner worked in seclusion and did not publicly exhibit their works. [2]

After Nieass obtained funding for an art centre from the Australia Council's Aboriginal Art Board, the carving movement was revived. Bush camps under the direction of Sam Tjampitjin (c.1930 – 2000) were held to make stone carvings. These, as well as other artefacts and Western-style landscapes were shown in an exhibition in Broome in 1981. Shortly after, in a celebration for the priest Father Peile, who had worked with the Kukatja for many years and was held in high esteem, the elders first made paintings of traditional Dreaming stories for public display.

On Nieass's departure from Balgo in 1982, Sister Dempsey continued classes, with women becoming active participants. In 1986 Dempsey organised the first major exhibition – *Art from the Great Sandy Desert* – of 100 works from Balgo at the Art Gallery of Western Australia (AGWA). The show created great interest with buyers including AGWA and collectors such as the Holmes à Courts. A new cooperative was formed and Balgo art entered a new era with the appointment of its first art coordinator, Andrew Hughes.

The art co-operative was named Warlayirti Artists – 'Warlayirti' is another name for the

Kingfisher (Luurnpa), the main Dreaming site for the land on which the community is located.

The first painters included a number whose formative years had been spent in the bush with little contact with white people. Colours were earth tones and composition carefully constructed. Free expression was also developed by artists such as Milliga Napaltjarri (c. 1910–1994) who often painted by dabbing the images onto the canvas with her fingers in literal translation from the making of sand drawing.[3]

Eubena Nampitjin and her husband Wimmitji Tjapangarti (c. 1925–2000) exemplifies the freedom within the bounds of intricate mapping, demonstrated in Tjapangarti's 1989 *Kutu*, that also characterises many paintings from the late 1980s. *Tingari Dreaming* at Tarkun by another senior painter, Donkeyman Lee Tjupurrula (c. 1922–1993), shows the more stylised iconography of the classic men's Tingari song cycle

Boxer Milner Tjampitjin, a senior Tjaru man from the floodplain area of Sturt Creek around Bililuna north of Balgo, started painting in a distinctly different style from other Balgo artists in the late 1980s. His paintings have a rich clarity that reflects the seasonal changes of his very different country to the north of Balgo.

In the mid-1990s, the style of Balgo painting changed considerably under the encouragement of coordinators James and Wendy Cowan. A published author of spiritual-based works who had lived in numerous countries, James Cowan wrote several books on Balgo art and was an especially passionate advocate of the work of Eubena Nampitjin, encouraging her and other artists into a more painterly style. The wooden skewers, which had been the main painting tool for earlier works, were eschewed in favour of brushes. This led to an enhancement of dazzling coloration such as the pinks, reds and yellows that characterise the work of Nampitjin and others from the mid-1990s. Yet Balgo artists still maintain a strong structural element and design in their works, as seen in the much sought-after later style of Elizabeth Nyumi whose luminous-coloured design shines through layers of dense white over-dotting.

In 1992 the important *Images of Power* exhibition at the National Gallery of Victoria (NGV) introduced the art of the Kimberley, including Balgo to a wide southern audience. Since the late 1980s, the work of Balgo's artists has been seen in hundreds of exhibitions in leading private galleries around Australia, in regular *National Aboriginal and Torres Strait Islander Art Award* (NATSIAA) exhibitions and in numerous group survey exhibitions including *Art from the Great Sandy Desert*, AGWA, 1989; *Images of Power*, NGV, 1992; *Aratjara*, Düsseldorf and touring, 1993–94; *Nangara*, touring internationally, 1996–2006; *Spirit Country*, San Francisco and touring, 1999–2001; *Colour Power*, NGV, 2005.

Warlayirti Artists also work with printmakers producing original prints such as the 2004 Warlayirti Suite with Charles Darwin University's Northern Editions Print workshop and Warlayirti Suite New Edition in 2007.

In 2002 a large new cultural centre was opened to enable community members to access their heritage and to offer visitors an overview. In 2004 a glass-making workshop was opened, offering a new dimension for Balgo artists' work. With these new developments continue the varied and vibrant paintings of Balgo's approximately 70 artists with an ever-evolving younger generation including Pauline Sunfly Nangala, Kathleen Paddoon, Christine Yukenbarri and numerous others.

Some Balgo artists

Bridget Mudjidel, Eubena Nampitjin, Millie Skeen Nampitjin, Pauline Sunfly Nangala, Susie Bootja Bootja Napangardi, Bai Bai Napangarti (Bye Bye/Bayi Bayi), Elizabeth Nyumi Nungurrayi, Ena Gimme Nungurrayi, Kathleen Paddoon, Mick Gill Tjakamarra, Boxer Milner Tjampitjin, Murtiyarru (Pauline) Sunfly Tjampitjin, Tjumpo Tjapanangka, Wimmitji Tjapangarti, Helicopter Joe Tjungurrayi, Donkeyman Lee Tjupurrula, Christine Yukenbarri, Lucy Yukenbarri.

On Bunuba and Walmajarri land, Fitzroy Crossing is a bustling tourist town for travellers to and from the Kimberley and the coast of Western Australia as well as an attraction in its own right for its stunningly beautiful Fitzroy River and dramatic Geike Gorge.

The town's population is around 1200, mostly Aboriginal, people. Most are from the Bunuba, Gooniyandi, Nyigina, Walmajarri and Wangkatjungka language groups. Established as a ration station in the 1880s, the town has had at least a century of harsh inter-tribal and black–white conflicts – many Aboriginal people now living in the town were born or lived for much of their lives on pastoral stations, often hundreds of kilometres distant.

Rediscovery of Connections:
The Painting Movement Evolves

The painting movement at Fitzroy Crossing originated in 1982 with the establishment of an adult education centre – Karrayili Adult Education Centre – after requests from several senior men to start English classes. Out of this grew a desire for people to record their personal histories visually; the first works were crayon and pencil on paper. Later bright watercolours – a medium unique in Aboriginal art to Fitzroy Crossing artists – were introduced. Soon over 20 people were regularly painting and a special arts centre, Mangkaja Arts Centre, an extension of the Karrayili Centre, was established in 1984. Mangkaja (which means 'wet weather spinifex shelter') was originally located in a small building

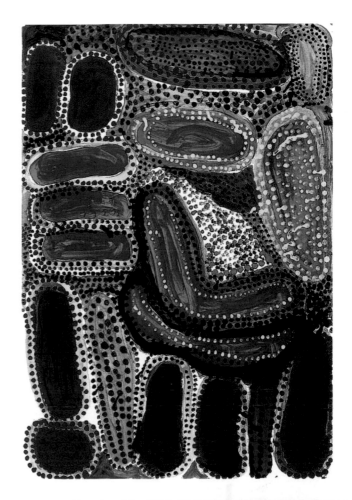

FITZROY CROSSING and WANGKATJUNGKA
A Vibrant Art Emerges

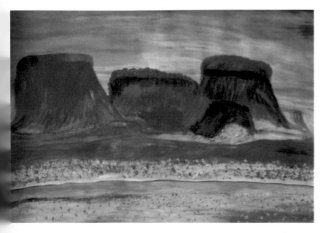

TOP: Wakurta Corey Surprise, *Untitled*, 1993, acrylic on paper, 76 x 105 cm. Western Australia State Art Collection.
[Courtesy the artist, Mangkaja Arts and the Art Gallery of Western Australia.]

LEFT: Daisy Andrews, *Lumpu-Lumpu*, 1994, watercolour on paper, 60 x 40 cm. Private collection.
[Courtesy the artist and Mangkaja Arts.]

Jarinyanu David Downs, *Untitled*, c.1983, natural earth pigments and acrylic on composition board, 119 x 120 cm. Private collection. [Courtesy estate of the artist and Sotheby's.]

RIGHT: Janangoo Butcher Cherel, *Mangarri*, 2006, acrylic on paper, 75 x 52 cm. Private collection. [Courtesy the artist, Mangkaja Arts and Brigitte Braun Gallery.]

in the centre of town. A large new painting shed and exhibition space was opened in 2007.

For many Mangkaja artists, whose work immediately attracted attention when it was exhibited in capital cities from 1986, the process of recording their histories has meant rediscovering their own heritage, This rediscovery often includes making journeys of reconnection to their land.

The experience of Wakurta Cory Surprise is just one of many.

I was born in the desert. I never saw my mother or father. They died in the desert. When I was crawling age I went to Christmas Creek station.

I was promised to an old man – he had two wives. We had no clothes …

We were all frightened. The station manager was hitting people so we ran away. The police tracked us down and put chains around the men. They tied my husband up. Then I worked at the main quarters for the police, collecting eggs and washing plates.[1]

Often dispossessed for years and in some cases several generations from their lands, art has enabled many people to re-create connections to their heritage.

As is the practice of other Kimberley artists, Fitzroy Crossing painters combine modern events with personal experiences and traditional stories in their art. Much Mangkaja art uses recognisable features: bright colour; large, freely drawn circular and oval shapes denoting waterholes; arrows or footprints to indicate tracks and journeys; figurative objects such as trees and animals; and sometimes semi-realistic landscape.

Jimmy Pike (1939–2002) was one of the first Fitzroy Crossing artists to gain recognition. His simplified, silhouetted figures related his latest travels or other experiences, or were based on a far longer history. In conjunction with Perth-based designers Stephen Culley and David Wroth, Pike also established Desert Designs in 1981 to translate his images onto a variety of printed media including fabric, posters and postcards.

Jarinyanu David Downs' (c. 1925–1995) work is similarly distinctive with its incorporation of Christian beliefs into traditional Aboriginal stories. Peter Skipper's (c.1930–2007) work, although

also reflecting a Christian influence, contains more traditional Aboriginal narrative elements.

The dazzling oranges and reds of the desert sand, silhouetted mountain ranges and brilliantly hued skies make the paintings of Daisy Andrews, who won the 1994 National Aboriginal and Torres Strait Islander Art Award (NATSIAA), especially arresting. They are particularly good examples of the journeys of joyous reconnection that characterise much of Fitzroy Crossing art.

Janangoo Butcher Cherel's paintings and prints depict his country north of Fitzroy Crossing, are notable for their balanced abstraction depicting details of bush fruits, spiders' webs and other natural phenomena. He also bases other works on the highly coloured designs on artefacts and the stitches used for the wool and fibre bags women made on pastoral stations. His works translate especially well to the medium of printmaking, which has also been a feature of Mangkaja arts over the years in joint projects with enterprises such as Melbourne's Australian Print Workshop and others organised for many years by long-term manager Karen Dayman.

A number of large canvases have also been created since the 1997 native title hearings.

Wangkatjungka Artists

Approximately 100 kilometres south-east of Fitzroy Crossing is the small community of Wangkatjungka (named after the language of the same name), an excision from the Christmas Creek Station. Between 1994 and 1998, the Karrayili Adult Education centre conducted classes, including painting, at Wangkatjungka. The works created there included a large collaborative painted canvas, exhibited in the 2001 NATSIAA and purchased by the National Gallery of Victoria (NGV).

In 2001 curator Susan Cochrane assisted the artists in documenting and organising exhibitions in leading Australian private galleries and in Paris. In 2002 Perth's Japingka Gallery held a workshop in the community and a successful ongoing relationship was

Collaborative work by eight artists of Wangkatjungka, *Country of our Fathers – Kirriwirri to Nyirla*, 2008, acrylic on canvas, 172 x 247 cm. Private collection. [Courtesy the artists, Wangkatjungka Artists and Japingka Gallery.]

Artists including Janie Lee, Biddy Bonney, Jill Jack, Willie Kew, Biddee Baadjo and three others collaborated on a number of large canvases relating to the Canning Stock Route and their surrounding country.

established. Some Wangkatjungka artists such as Nyuju Stumpy Brown work both through Mangkaja Artists and the Wangkatjungka community organisation.

The luminous acrylics of Wangkatjungka artists, whose country is largely that of the Great Sandy Desert, create stylistic links with the work of artists in Fitzroy Crossing and Balgo to the south.

Some artists

Mangkaja: Nyuju Stumpy Brown, Purlta Maryanne Downs, Dorothy May, Tommy Narralja May, Mulgra Jimmy Nerrimah, Ivy Janyka Nixon, Amy Rogers Nuggett, Many Nuggett, Hitler Pamba, Peter Skipper, Nyirlpiri Spider Snell, Wakurta Cory Surprise, Nipper Janjin Sweeney, Helen Wunmariar, Boxer Yankarr.

Wangkatjungka: Biddee Baadjo, Nyuju Stumpy Brown, Peter Goodjie, Rosie Goodjie, Willie Kew, Hitler Pamba, Nada Rawlins, George Tuckerbox.

The Kimberley's hub town of Kununurra is a meeting place for tourists and a thriving commercial and business centre. As with Alice Springs in the Central Desert, it has also become a significant area for regional art.

Waringarri Arts, established in 1985 and opened in 1988, is situated in the Waringarri community on Mirrrawong land and near to the town's dramatic rock form Kelly's Knob. The community of several hundred includes Mirrawong, Gajerriwoong, Ngariman, Jaminjung, Ngaliwuru, Murrinh-patha, Wunambul, Kija and Kjaru language groups. Waringarri Arts was, for a number of years, the only Aboriginal-owned arts centre servicing the art by northern and eastern Kimberley artists such as Jack Britten, Freddy Timms, Paddy Bedford, Rover Thomas, Queenie McKenzie, Hector Jandanay, George Mung Mung, Lily Karedada, Paddy Carroll, Alan Griffiths, Peggy Griffiths, Billy Thomas and others. As community arts centres opened at Warmun and other locations, these artists and others began to work through them. Waringarri continues to foster and to promote the arts and artists from the North Kimberley region, featuring a variety of artworks including painting, screenprinting, jewellery and carvings. Major exhibitions include Red Hot Ochre: Waringarri Paintings and Prints from the Kimberley, Kluge-Ruhe Aboriginal Art Collection, Virginia, USA, 2007.

Red Rock Art

Former Waringarri Arts coordinator Kevin Kelly and his wife, Jenny Kelly, established the arts dealership and gallery Red Rock Art at Kununurra in 1997. The Kellys had a close association with leading Kimberley artists including Rover Thomas and Queenie McKenzie (Kevin Kelly is executor of both their estates). The opening of Red Rock has led to some new work in ochre by artists of this area. For ten years it represented around 15 artists including Walmajarri artists Nancy Noonju (c. 1935–2007) and George Wallaby (1930–2001), who were born near Bililuna, south of Balgo Hills, but moved to live in a community on the outskirts of Kununurra. Some Red Rock artists live in Kununurra itself, while others are from the famed Gurindji-owned station of Wave Hill. Wangkatjungka artist Billy Thomas, whose lands are around Bililuna, became one of Red Rock's best-known artists. A finely dotted linear style characterises paintings by Ned Johns; George Wallaby's patterns are both formal in placement and boldly outlined; Alan Griffiths's paintings comprise horizontal layers of small outlined figures performing ceremonial dance; Billy Thomas's canvases have thick overlays of gritty ochre, in white, brown, and black swirls like almost literal translations of sand design. One of Thomas's sons, Wangkatjungka man Lloyd Kwilla, started painting with his father in 2003. His paintings of sandhills and rockholes

KUNUNURRA:
a thriving community

of the vast tracts of his traditional area, the Great Sandy Desert, have a dynamic rhythmic quality rarely seen in the medium of ochre.

Jirrawun: The Art of Minimalism

During the late 1990s the headquarters for the Jirrawun Aboriginal Art Corporation moved to Kununurra. Established in 1997 at the Kimberley community of Rugun (Crocodile Hole) with artists including Freddy Timms, Rusty Peters and Paddy Bedford, Jirrawun's founding manager and artistic director was Tony Oliver who had been director of several Melbourne galleries (Reconnaissance and Tony Oliver Gallery) in the 1980s and early 1990s. Jirrawun projects have included a joint exhibition of Rusty Peters and then Darwin-based artist Peter Adsett – who worked together at Crocodile Hole in a series of separate works, which appeared together in a large touring exhibition in 2000–01 – and the presentation of the theatre–art performance *Blood on the Spinifex* in 2002–03. The best known of the Jirrawun group of artists is Paddy Bedford (c. 1922–2007) who started painting with Waringarri Arts in the early 1990s and whose style developed, as he worked with Jirrawun, in scale with a minimalist and highly distinctive quality. Bedford was one of the artists whose designs were selected to form an architectural feature at Paris's Musée du Quai Branly and in 2006–08 Sydney's Museum of Contemporary Art curated and toured a large retrospective exhibition of his work.

The work of Rusty Peters, Freddy Timms, Peggy Patrick and other Jirrawun artists has been widely exhibited in leading galleries around Australia. In 2006 the exhibition *Women's Business* at Sydney's Sherman Galleries showed works by some teenage artists the Nocketta sisters: graffiti-inspired monochromatic paintings in ochre that graphically spelt out some of the reality for young Aboriginal people of daily life in towns such as Kununurra. In 2007 Jirrawun opened a white-walled studio of highly contemporary design at the coastal town of Wyndham. In early 2008, Oliver, described as an 'art svengali' by *The Australian's* Nicolas Rothwell, resigned from the position as arts manager – marking this move by an exhibition of Jirrawun works *Last Tango in Wyndham* at Darwin's Raft Artspace.[1]

Some Kununurra artists

Waringarri: Alan Griffiths, Peggy Griffiths, Mignonette Jamin, Jugy Mengil

Red Rock: Nellie Gordon, Alan Griffiths, Maggie Johns, Ned Johns, Lloyd Kwilla, Joe Lewis, Nancy Noonju, Ruby Packsaddle, Billy Thomas, George Wallaby.

Jirrawun: Goody Barrett, Paddy Bedford, Peter Eve, Vondean Nocketta, Peggy Patrick, Rusty Peters, Rammey Ramsey, Phyllis Thomas, Freddy Timms.

LEFT: *Ochre painted beads, Warringari Arts, Kununurra,* 2004. [Photo Susan McCulloch.]

BELOW LEFT: Agnes Armstrong, *Ivanhoe Station*, 2007, ochre on canvas, 60 x 90 cm. Private collection. [Finalist National Aboriginal and Torres Strait Islander Art Award, 2007. Courtesy the artist, Waringarri Arts and Museum and Art Gallery of the Northern Territory.]

BELOW RIGHT: Lloyd Kwilla, *Klurayi, Waterhole, Bushfire series 4*, 2007, (detail), ochre on canvas, 180 x 150 cm. Private collection. [Courtesy the artist, Red Rock Art and Randell Lane Fine Art.]

On the Kimberley coast, 180 kilometres south of Broome, Bidyadanga (formerly La Grange) was established as a station and became a Catholic mission settlement in the 1970s. It was returned to the control of its traditional owners, the Karrajarri, in 2002. With a population of around 200 people, Bidyadanga is the largest Aboriginal community in Western Australia.

The painting movement began in 2003,

BIDYADANGA
the heritage of the Yulparija

facilitated by Short Street Gallery in Broome. Although the approximately ten founding artists were largely elderly, Short Street gallery director Emily Rohr says that the movement itself had been initiated by a young Yulparija man Daniel Walbidi who had been encouraged to paint by the community's Sister Pat Sealy. 'In 1999 Daniel came into the gallery with

four paintings,' says Rohr. 'They showed extraordinary promise.' Walbidi also related the story of his people. The Yulparija, Martu and others came to live at Bidyadanga in the preceding decades after being displaced from their lands, often thousands of kilometres away, due to nuclear testing, mining and drought in their regions.

Around 100 Yulparija live at Bidyadanga. Their traditional country, however, runs from near Kintore in the Northern Territory, west across the Great Sandy and Gibson deserts to Telfer and Fitzroy Crossing. Those from the collective Martu people, whose land is further south and covers equally vast expanses of desert, also live at Bidyadanga as do others from the Kimberley and other coastal regions as well as the traditional owners, the Karrajarri. As with many resettled Aboriginal people, the birth of children and the establishment of the community meant Bidyadanga gradually came to be 'home' to the Yulparija and others.

FAR LEFT: *The Kimberley coastline*, 1997.
[Photo Susan McCulloch.]

CENTRE: *Bidyadanga artist Margaret Baragurra painting*, 2007 [Photo. Michael Hutchinson. Courtesy the photographer and Short St. Gallery.]

RIGHT: *Winpa country*, 2007. [Photo Michael Hutchinson.]

BELOW: Alma Webou, *Pinkalarta*, 2007, screenprint, 40 x 49 cm, edition of 40. [Courtesy the artist, Bidyadanga Artists and Northern Editions, Charles Darwin University.]

The Yulparija artists live at the coastal town of Bidyadanga but their country is many kilometres to the south in the vast south-western desert regions. Their vibrant paintings derive from traditional stories of that country in colours that also reflect the luminous blues and other hues of their coastal home.

The lead-up to the return of the community to Aboriginal control in the early 2000s provoked much discussion about the need for those of different heritage to further reconnect with that heritage. Many had not seen their lands for decades and their children and grandchildren had never seen them. After Walbidi's contact with Rohr, older community members asked her to supply them with painting materials. Within a month, the mainly elderly artists, most of whom are of Yulparija heritage, were painting with verve and vigour. Enthusiasm and commitment were evident, with the artists eagerly awaiting the weekly arrival of Rohr and her assistant and the paints and canvases they brought. For the first few months the painting area was the concrete floor of 'Sister Pat's' house. Day-long painting sessions were held with the artists working without a break, peppering their concentrated work with the occasional remark or snippet of a song remembered from long ago.

The vibrant, multi-hued work of the Yulparija artists includes both those on spare backgrounds in which the primed canvas shows through and those in which colours such as turquoise, red, white, yellow, greens and deep purples cover the entire surface. Senior Bidyadanga artist Weaver Jack, whose husband

Daniel Walbidi, *Winpa*, 2007, acrylic on canvas, 145 x 100 cm. Private collection. [Courtesy the artist, Bidyadanga Artists and Short Street Gallery.]

Young Yulparija man Daniel Walbidi, a talented painter, is also credited with having started the painting movement.

Donald Moko is also a painter, made an important breakthrough in 2006 when her self-portrait was included in the Archibald Prize for portraiture. Painted in seemingly abstract style, it is taken from her perspective – the basis of all her works – that she, herself, is her country.

The paintings of Alma Webou (Kalaju) are notable for their confident and often spare

imagery that translated successfully into the medium of printmaking when Bidyadanga created its first series of prints with Darwin's Northern Editions printmaking studio in 2007. Jan Billycan's often-segmented canvases were described by Rohr as notable. Billycan is a marpan (healer or medicine woman) and so has an 'ability to see in X Ray'. As gallery director Emily Rohr described:

She mixes the colours on the canvas and repeatedly works the lines until they have a density and colour that reflect the uniqueness of each sand dune in the desert and each bone in her body; her work reflects creation of the 'living'.[1]

In 2007, 25 Yulparija painters from Bidyadanga made an important journey home to an important creation site, Winpa, a waterhole on the edge of the Percival Lakes in the Great Sandy Desert. 'The importance of Winpa is hard to describe in English,' says Rohr. 'Having slept in this country and "met" Winpa I understand that it is a living place that is extremely powerful.'[2]

This sense of place, the artists' highly personal connection with it and interpretation of it, as well as the inter-personal connections and journeys that the Yulparija have shared during the evolution of their modern painting movement have made them, and their paintings, a significantly powerful force in contemporary Australian art.

Some Bidyadanga artists

Margaret Baragurra, Jan Billycan, Marilyn Bullen, Susie Gilbert, Darcy Hunter, Weaver Jack, Bertha Linty, Maya Marda, Mary Meribida, Donald Moko, Mervyn Mugabadie, Sally (Liki) Naniim, Rosie Spencer, Agnes Walbidi, Daniel Walbidi, Georgina Walbidi, Meridoo Walbidi, Alma Webou (Kalaju), Maureen Yanawana.

Close to the Bungle Bungle Ranges (Purnululu) the small outback town of Warmun (Turkey Creek) has become a meeting point for four-wheel drive excursions to Purnululu. The Warmun Aboriginal community opposite the Aboriginal-owned store and cafe is home to the Gija people. The community was home to many of the Kimberley's most famous early modern artists including Rover Thomas (c. 1926–1998), Queenie McKenzie (c. 1915–1998), Jack Britten (c. 1925–2002), George Mung Mung (c. 1920–1991), Hector Jandanay (c. 1925–2006) and others. Newer generations of painters continue the tradition of heavily textured ochre painting that characterises art of this famous painting community.

Modern Day Dreaming: The Evolution of a Painting Movement

Paintings on board and canvas for sale developed at Warmun as an extension of the modern song and dance cycle called Krill Krill (or Gurrir Gurrir) performed by people of the Warmun community. In 1974, an old woman, spiritually related to Rover Thomas, died while being transported by plane from Turkey Creek to Perth after a car accident. About a month after her death, during a break in a ceremony in which he was

Jack Britten, *Purnululu, the Bungle Bungles*, 1989, ochre on canvas, 160 x 200 cm. Private collection. [Courtesy estate of the artist and Sotheby's.]

TOP LEFT: *Purnululu (the Bungle Bungles).* [Photo Carolyn Johns, Wildlight.]

The rounded hills and outlined shapes of the unique rock formation Purnululu (the Bungle Bungles) are graphically portrayed by their traditional owners.

WARMUN (Turkey Creek)

From Purnululu to the Venice Biennale and beyond

'A central law woman…McKenzie's role in sustaining culture was formidable…her teachings also imbued with the humour, wit, compassion and practicality that were the hallmarks of her character.'

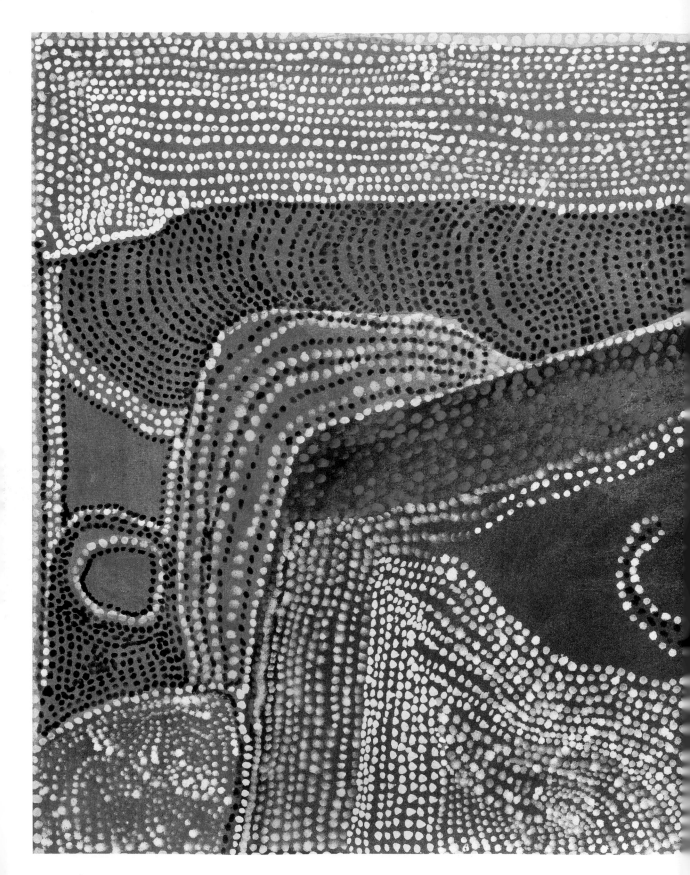

participating, Thomas was visited by her spirit. The spirit, he described, gave him a series of songs and stories relating to her death and many other events to do with a vast tract of the country. These included Dreaming stories such as that of the Rainbow Serpent and those relating to the formation of various landscape features, such as the creation of the dramatic Wolf Creek Crater, and forces of nature, such as Cyclone Tracy, which hit Darwin and surrounding coastal areas in 1974. Thomas was the 'dreamer' of the stories – the conduit through which they were told. After several years of his telling the stories, they evolved into a narrative song-cycle–dance ceremony, which was performed by members of the Warmun community. An integral element was the painting of boards carried by dancers in the ceremony. For several years the boards were not painted by Thomas but by his uncle, Paddy Jaminji (c. 1912–1996), from stories told to Jaminji by Thomas.

The late Queenie McKenzie, Jack Britten, Hector Jandanay and Henry Wambini. [Photo Tony Ellwood.]

LEFT: Rover Thomas, *Canning Stock Route – Long Long Way*, 1993, ochre on canvas, 80 x 100 cm. Private collection. [Courtesy estate of the artist and Sotheby's.]

Founding members of the Warmun painting community, McKenzie, Britten, Jandanay and Wambini, were a powerful force in the community. Their lives were intertwined with that of leading Kimberley painter Rover Thomas whose painting (left) is a soft and lyrical rendition of his Canning Stock Route birth place.

Perth-based art consultant Mary Macha, then manager and field officer for the Western Australian government aboriginal arts and crafts outlet and a frequent visitor to the Warmun area, says that she 'nearly fainted with joy' on seeing one of these boards for the first time.

'Paddy [Jaminji] showed it to me then the group took it touring with them while they performed the ceremony all over the Kimberley and the Northern Territory – bouncing around on the back of the truck for well over a year,' she says.

> More paintings were added and of course they suffered somewhat in their travels. Snails were squashed on them, the dogs walked over them, they had things spilt on them and they were covered in dust. But were they powerful!
>
> Eventually Paddy said I could buy them and they painted others. This happened three times over about three years. But no-one would buy the first collection. Eventually Lord McAlpine [a major collector of Aboriginal art especially for his Cable Beach Club in Broome, for whom Macha was art consultant] bought the first and third collections. Now they are in the Australian Museum, Sydney. Professor Ronald Berndt bought the second for the University of Western Australia.

Macha was also a witness to the first paintings of Rover Thomas.

> He came out of a crowd of people when I was at Warmun one day and said, 'I'm the one with the dreaming – and I want to start painting'. His first paintings were powerful and quite unique.[1]

Seen first in group exhibitions in Perth, Thomas's work almost immediately attracted attention. With its large planes of black, brown and yellow defined by large white or black dots, it was startlingly different from the multi-hued acrylic-painted Central and Western Desert paintings of the time.

Underpinning Thomas's minimalist forms is a strong narrative that integrates traditional beliefs with modern events. For Thomas, events of the recent present were as significant as those of the distant past. A man of strong character and forthright views, he held an 'abiding, strong sense of social justice', as Wally Caruana, curator of Thomas's 1994 solo exhibition at the National Gallery of Australia (NGA) notes. This is most graphically seen in paintings based on the 1920s and 1930s massacres of the Kimberley's indigenous people, such as those witnessed by his adopted aunt and fellow artist, the late Queenie McKenzie, at stations including Ruby Plains, Texas Downs and Bedford Downs.

Thomas was born at the tiny Yalda Soak on Western Australia's Canning Stock Route and lived there during World War II. For the next 40 years he travelled throughout the Kimberley and northern regions, working and living as a stockman and fencer. Thomas's first paintings were those of the Krill Krill song–dance– painting cycle. His work soon evolved into more reductive imagery in which he mapped the country and landforms, such as the many large lakes in the Kimberley and the dramatic Wolf Creek Crater in ground inky charcoals and dusty brown and yellow ochres. Thomas's paintings immediately captured public attention when first exhibited in Perth in 1989. Frequently their planar qualities have been compared with those of the colourfield abstractionists of the 1970s New York school. Thomas had never seen these works but, as Wally Caruana related, on seeing a large colourfield Mark Rothko for the first time at the gallery, Thomas exclaimed, 'That bugger paints like me!'[2]

Interest in and collecting of Thomas's art soon snowballed. A highly independent man who had had a lifetime's experience travelling and managing his own affairs, Thomas worked with the Kununurra-based Aboriginal-owned Waringarri Arts Centre when it was established in 1985 as well as with number of dealers and galleries throughout Australia. He travelled around Australia and internationally and continued painting despite health problems, almost until he died. In 1996, in a trip organised by Waringarri Arts Centre's manager Kevin Kelly (later owner of Red Rock Art, Kununurra, now executor of Thomas's estate), Thomas revisited

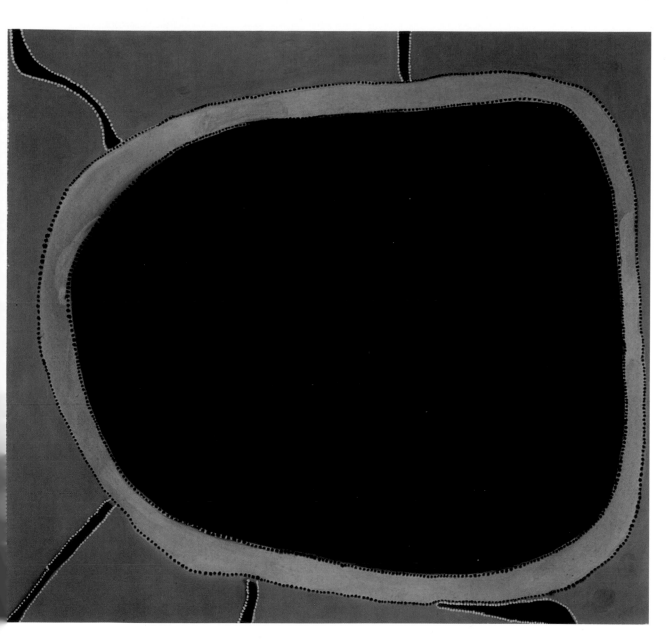

his Yalda Soak birthplace on the Canning Stock Route. The trip revitalised his spirit and resulted in a last great series of paintings. He died at the nursing home in his home community of Warmun, aged 83, on Easter Sunday, 1998. Thomas's works were seen in galleries around Australia and internationally, and he was one of Australia's representatives at the Venice Biennale in 1991. In 1994 the NGA held the solo exhibition *Roads Cross*, and works from the Holmes à Court collection formed the basis of the major touring exhibition, *Rover Thomas: I Want To Paint*, at the National Gallery of Victoria (NGV) and touring in 2003. From the 1990s,

Rover Thomas, *Lake Paruku*, 1991, ochre on canvas, 168 x 183 cm. Art Gallery of South Australia.
[Courtesy estate of the artist and Art Gallery of South Australia.]

One of the great modern Australian artists, Rover Thomas's works, such as this powerful minimalistic painting, were breakthroughs of style in contemporary Aboriginal art.

Thomas's works have also featured significantly on the secondary market with many works selling for many hundred thousands of dollars, such as the 2001 purchase by the NGA of *Big Rain Coming Down Topside* for $775,000. As with all other famous Aboriginal artists, the issue of fakes has dogged Thomas's work. In 2007 a Melbourne couple was convicted and jailed for fraud over a number of paintings that they had painted and sold through major auction houses and other outlets over several years.

Thomas's legacy has been remarkable. In relating the stories of its people and place he offered a unique interpretation of the Kimberley landscape; through his uncompromising sparse planar perspectives he, along with the late Emily Kame Kngwarreye, was a major force in breaking through to a new and highly individual imagery that placed Aboriginal art firmly at the forefront of international contemporary art.

Gija painter Queenie McKenzie (Nakarra) was a lifelong friend and classificatory aunt to Rover Thomas, who inspired her to begin painting in the 1980s. Soft pinks, her favourite and signature colour, as well as browns and yellows are used to great effect in her paintings but the subject matter is often far from gentle. Works such as the 1998 *Horseshoe Creek Massacre, Lajibany*, depict the horrific events of a massacre on Texas Downs – a recurring theme in her work. The 1996 *Three Massacres and the Rover Thomas Story* p. 12 combines a similar story with that of a later event in which she saved Thomas's life by stitching up his skull, split when he was kicked by a horse, with a primitive needle sterilised in the flames of a campfire. A central law woman and teacher at Warmun, McKenzie's role in sustaining culture and her responsibility in assuring that Gija culture was preserved and passed down to the younger generations was formidable. Her teachings were also imbued with the humour, wit, compassion and practicality that were the hallmarks of her character. McKenzie was instrumental in establishing the Warmun Art Centre and worked throughout her painting career to bring her story, and that of its culture,

to both the outside world and to the children in her community for whom she cared deeply. Her work was exhibited in major private galleries and many touring exhibitions in public galleries from 1989, and her estate is managed by the Kununurra gallery Red Rock Art.

As in other areas, painting at Warmun, once started, rapidly took hold. Until the creation of an arts centre on the community itself in 1998, much Warmun art was managed by the Waringarri Arts Centre at Kununurra. Many artists also maintained long and continuing relationships with private dealers. Originally housed in a converted two-storey house, the Warmun Art Centre opened a new purpose-built arts centre in 2007. Warmun artists have been featured in numerous group and

Patrick Mung Mung, *Ngarrgurrun Country*, 2004, ochres on canvas, 120 x 90 cm. Private collection. [Courtesy the artist, Warmun Art Centre and Hogarth Galleries.]

LEFT: Queenie McKenzie, *My Country – Texas Downs*, 1998, ochre on canvas, 101 x 140 cm. Museum and Art Gallery of the Northern Territory. [Purchased funds by Telstra. Courtesy estate of the artist and Museum and Art Gallery of the Northern Territory.]

Queenie McKenzie would often relate stories of massacres and contemporary life in her paintings as well as those, such as this, of her land. Patrick Mung Mung, an award-winning painter, is also a Warmun community leader and well-known artist.

WARMUN

solo exhibitions in leading private galleries throughout Australia since 1998. Their work has also been included in many leading survey exhibitions in public galleries, such as *Innovative Aboriginal Art of Western Australia*, University of Western Australia, 1988; *Images of Power*, NGV, 1989; *Balance 1990*, Queensland Art Gallery, 1990; *Flash Pictures by Aboriginal and Torres Strait Islander Artists*, NGA, 1991; *Crossroads: Toward a New Reality: Aboriginal Art from Australia*, the National Museum of Modern Art, Kyoto, Japan, 1992; *Abstraction: Signs, Marks, Symbols*, NGV, 1996; *Painting the Land Story*, National Museum of Australia, 1999; *Aboriginal Art in Modern Worlds*, NGA, 2000; *Beyond the Pale*, Adelaide Biennial, 2000; *Federation: Australian Art and Society 1901–2001*, NGA and touring, 2000–02; *True Stories*, Art Gallery of New South Wales, 2003.

The Art of Warmun: Textures and natural ochres meet in fine quality

Warmun paintings are notable for use of ochre in a great variety of colours, including many shades of brown, pinks, grey-blue and green-black. Often thickly applied, the ochres give the painting surface a unique, highly textural quality.

Hills rise, dome-like in cross-section and outlined in white dots, in the paintings of Jack Britten, whereas the Rover Thomas's works took a more planar perspective.

The spirit figures Jimpi and Manginta, featured in many of the joint 1980s paintings by Rover Thomas and Paddy Jaminji and were among the first images to be translated from ceremonial board to paintings designed to leave the community. Thomas's art was also characterised by its inclusion of narrative of modern events such as depictions of Cyclone Tracy. Both Thomas and Queenie McKenzie based many paintings on the massacres they or their immediate forebears witnessed. Warmun also has a particularly strong community group involved in teaching painting to a younger generation with an active formal art program starting with primary-school children.

The opening of the Warmun Art Centre, housed in the community's former post office in 1998 encouraged a newer generation of artists such as Mabel Juli, whose works often feature the moon and stars with a singular clarity; Patrick Mung Mung whose silhouetted-landscape painting won the East Kimberley Art Award in 1999; the black–brown and white 'spearhead' paintings of Lena Nyadbi who was one of the artists commissioned for an architectural feature for the 2006 opening of the Musée du Quai Branly in Paris and many others. In 2007 Warmun artist Shirley Purdie won the prestigious Blake Prize for her unique ochre Stations of the Cross, which combine Christian and Gija symbolism in a powerful statement about the community's 'two-way' belief system. In 2008 she won another prize for religious art, the Riddoch Gallery's Needham Prize.

More than 100 artists show at the art centre with numbers – especially in the 20–30 year old age bracket – having increased substantially since 2000. Stylistically too, there has been something of a revolution with the broadening of the base ochre colours of browns, black, white and grey to include mixes of blue-greys, charcoal greys, yellows, greens and pinks, all collected and ground by the artists from often prized local sources. Different shadings and textures – from pale washes to heavy opaques – are also being used. Warmun Art has also been translated successfully into prints in collaboration with printmaking studios such as Darwin's Northern Editions.

Lena Nyadbi, *Untitled*, 2005, etching, 49.5 x 49.5 cm. Printers Monique Auricchio and Jo Diggens, Basil Hall Editions. [Courtesy the artist, Warmun Art Centre and Basil Hall Editions.]

Some Warmun artists

Gordon Barney, Goody Barrett, Jack Britten, Churchill Cann, Paddy Carlton, Betty Carrington, Charlene Carrington, Katie Cox, Paddy Jaminji, Hector Jandanay, Mick Jawalji, Mabel Juli, Queenie McKenzie, Marika Mung, Beerbee Mungnari, George Mung Mung, Patrick Mung Mung, Gabriel Nodea, Nancy Nodea, Lena Nyadbi, Roseleen Park, Peggy Patrick, Shirley Purdie, Madigan Thomas, Phyllis Thomas, Rover Thomas, Freddy Timms, Henry Wambini.

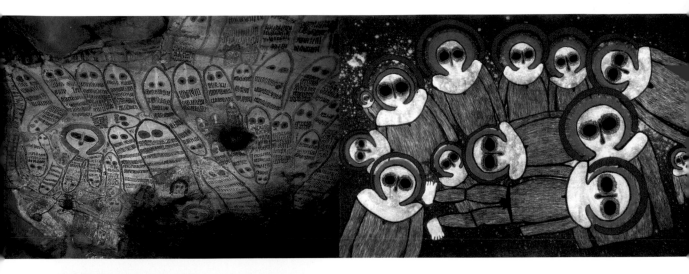

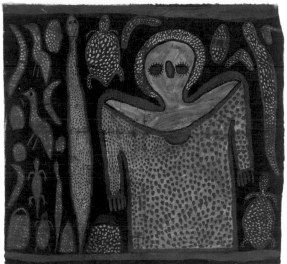

David Mowljarlji, *Wandjinas*, c.1995, acrylic on canvas, 120 x 180 cm. Hinds Collection. [Courtesy estate of the artist and the Hinds Collection.]

TOP LEFT: *Rock art, the Kimberley*, 1993. [Photo Susan McCulloch.]

LEFT: Lily Karedada, *Wandjina*, c.1970s, ochre and acrylic on canvas, 92 x 99.5 cm. Private collection. [Courtesy the artist and Niagara Galleries.]

KALUMBURU and DERBY
Wandjinas and beyond

Kalumburu, 550 km from Kununurra is the most northern permanent settlement in Western Australia. It was established as a mission settlement, originally called Pago (the name for a women's digging stick) by the Benedictine order from New Norcia, WA, in 1908. On the banks of the King Edward River, near its outlet to the sea, the population of Kalumburu is around 400 Kwini, Walbi and Cambra-Kulari people and some 30 non Aboriginal residents. The mission continues to have central significance to the town. Kalumburu is notable in the development of indigenous art of the West for its painters of the 1970s translating the traditional fertility/ rain creation ancestors, the Wandjina, from rock walls onto board and exhibiting them both locally and in Perth.

Six hundred and sixty kilometres south, the town of Derby, with a population of around 4500, is the area's administrative hub and tourist meeting place. Artists of very different

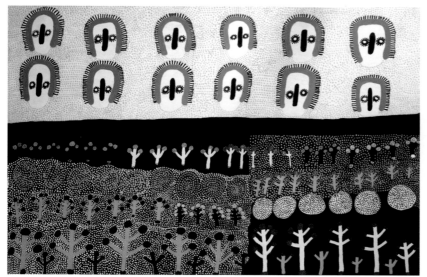

Lucy Ward, *Wandjinas in Ngarangarri Country*, 2007, acrylic on canvas, 198 x 298 cm. Private collection. [Courtesy the artist and Indigenart/Mossenson Galleries.]

Ignatia and Waigan Jangarra, Rosie and Louis Karedada, Lily and Jack Karedada and others based at Kalumburu have painted Wandjina on bark, board, canvas and paper using natural ochres. Kalumburu painters have had a long relationship of selling art through the Kununurra-based Waringarri Arts Centre as well as to galleries and dealers. As well as painting on canvas, works on paper such as original prints have been a feature of Kalumburu art since the mid 1990s.

styles and heritages live in Derby and have started to paint and sell their work through various facilities established in the town from the late 1990s.

Kalumburu

The painting of Wandjina images on bark and board started around 1930 with the encouragement of anthropologists who collected examples for Australian and international museums.[1]

Its modern development started in the early 1970s when painters such as Charlie Numbulmoore (c. 1907–1971), George Jomeri, Sam Woolgoodja and Cocky Wutjunga started painting Wandjina on bark. Interest was further sparked by Kalumburu resident Alec Mingelmanganu's (c. 1910–1981) Wandjina exhibited in the 1975 Derby Boab Week Art under the title Austral Gothic. Other members of the Kalumburu community followed suit – their works exhibited at Aboriginal Traditional Arts in Perth a year later. Some of the bark paintings in this exhibition used the mouth-spray and hand-stencil techniques derived from rock art, with the works attached to hooped cane frames or stick straighteners.[2] Since, artists such as

Derby: Spirit of the Wandjina and beyond

Fifteen kilometres from Derby at Mowanjum the Aboriginal arts corporation, Mowanjum Artists, Spirit of the Wandjina, is owned by the area's Worora, Ngaranyin and Wunumbul people. Leading song man, cultural leader and painter David Mowarljarli (c. 1930s–1997) was instrumental in establishing sales for artists from the area through the local store during the 1970s and promoted the idea of a more permanent art facility. A striking Wandjina figure by Donny Woolagoodja, chair of the corporation, was featured during the opening ceremony of the 2000 Olympic Games in Sydney.

A strong art movement has developed also in the more northern coastal town of Derby. One of the most well known of its artists is Jack Dale (b. 1920) whose art includes depictions of the Wandjina as well as abstract pattern designs. Often working in collaboration with his wife, Biddy Dale, the Dales' works have been seen in solo exhibitions throughout Australia, including those at Perth's Japingka Galleries, Hobart's Art Mob and Sydney's Coo-ee Gallery since the mid 1990s.

The senior Andinyan painter Ngarra born in the 1920s on Glenroy Station, depicts traditional Aboriginal culture such as boys' initiation camps and totemic animals and plants,

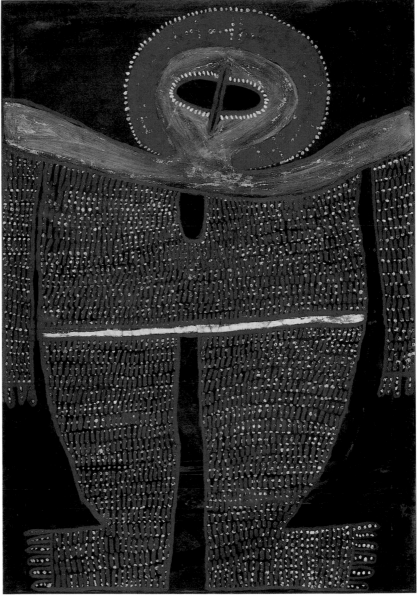

as well as aspects of European impact in the Kimberley environment, such as introduced animals. Ngarra is one of a group of other Derby-based artists who include Lucy Ward, Omborrin, Loongkoonan and Peggy Wassi who show with the Perth and Melbourne galleries Indigenart / The Mossenson Gallery.

Some Kalumburu artists

Ignatia and Waigan Jangarra, Lily and Jack Karedada, Rosie and Louis Karedada, Regina Karedada, Cassie Waina, Kevin Waina.

Some Mowanjum artists

Jeffrey Burrgu, Gordon Barunga, Putja Barunga, Gabriella Dolby, Mabel King, Janet Oobagooma, Ashley Oobagooma, Donny Woolagoodja.

Some Derby artists

Jack Dale, Biddy Dale, Loongkoonan, Ngarra, Omborrin, Peggy Wassi.

Alec Mingelmanganu, *Wandjina*, 1979, ochre on canvas, 127 x 90 cm. Private collection.
[Courtesy Aboriginal Artists Agency Ltd.]

Mingelmanganu's striking paintings, which speak of regeneration through portrayals of these powerful fertility/rain spirit figures, were first created for the public in the 1970s at Kalumburu.

People of more than eight different language groups including the Manyjilyjarra, Kartujarra, Putijarra,Warnman and Pikarli are known under the collective name of the Martu, a Manyjilyjarra word for 'one' or 'man'.[1] Their country includes the Percival Lakes, Lake Disappointment, and across the Canning Stock Route to the West Australian–Northern Territory border.

Traditional custodians of a vast area of the Great Sandy, Little Sandy and Gibson deserts, some Martu people moved or were transported to missions in the 1920s and 30s due to drought. Others were later removed from their lands during the 1950s Woomera Rocket Range testing, a joint Ango-Australian weapons project based 500 kilometres north-east of Adelaide but with a range thousands of kilometres west across the Martu region. Their story is graphically told in the 2005 award-winning book, *Cleared Out*.[2]

Until this 'clearing out', many Martu had lived a largely traditional bush life and were among the last people to abandon their traditional ways. Their new mission homes included that of Bidyadanga (La Grange) many hundreds of kilometres north, near the coastal town of Broome. Children whose parents worked as stockmen and women on stations in the region were sent to school at Bidyadanga and other missions closer to their own lands such as those at Jigalong (made famous in the film Rabbit-Proof Fence) and Warburton (see p. 133). In the 1980s many Martu returned to their homeland areas east of Jigalong.

Art in Martu country

In 2001, West Australian artist Galliano Fardin, who had previously lived in the area, was contracted to conduct painting workshops at Parnngurr near Jigalong and Newman, on the edge of the Great Sandy Desert. Fardin encouraged people to paint their country and their own stories. In 2002 the Martu won a native title claim to their lands, save for that of Rundall River National Park.

In 2003, the Parnngurr community decided to plan a more formal enterprise. Martumili Artists which commenced in October 2006, is based in the town of Newman and services the Martu communities of Parnngurr, Punmu, Kunawarritji, Jigalong, Irrungadji (Nullagine) and Parnpajinya (Newman).

A major painting theme is that of Wirnpa, the rain-making snake, his country and

The MARTU
People of Wirnpa
(the rain-making snake)

significant site of the same name.[3] This site is also central to the Yulparija of Bidyadanga (see p. 170) who are related to the Martu and share similarities of language with Warnman, Kartujarra and other Martu, as well as other western desert languages.[4]

Important creation stories that are also represented in contemporary paintings include those of Marlu (the Kangaroo), Kaarnka (the Crow), and Kirrki (the Banded Plover). In addition, the artists depict their own countries of Lake Disappointment Jigalong and the Rabbit-Proof Fence and those of the Canning Stock Route and places along it such as Well 33, which writer Stuart Rintoul described as a 'white man's landmarks scratched on a vast and ancient canvas'.[5]

In October 2007, Martumili Artists held a sell-out inaugural exhibition of some 75 works at Melbourne's William Mora Galleries. Purchasers included the National Gallery of Victoria which bought 12 works. Many of the canvases were small in scale and most in acrylics, with a rare few oil paintings by artists including Yanjami (Peter Rowlands) and Yirkatu Peterson. At the same time a partnership between Martumili Artists and BHP Billiton was launched with a contribution of $400,000 from BHP Billiton to the Martumili venture.

A subsequent exhibition in Perth's Randell Lane in 2008 comprised a number of large works, and gallery director Mark Walker noted:

> The strength of Martu Artists' commitment to artistic practice is visible not only in their artwork, but also in the markedly independent, rigorous and practical path they followed in establishing Martumili Artists … and to develop young and emerging artists while also growing the careers of established artists.

Parallel with the painting on canvas, Martu women began weaving – their styles and items woven diversifing through their own experimentation as well as a series of workshops facilitated by established fibre artists.[6]

Some Martu artists

Miriam Atkins, Ngamaru Bidu, Jakayu Biljabu, Nancy Chapman, Kumpaya Giriba, Milly Kelly, Lily Long, Mulyatingki Marney, Minyawe Miller, Janice Nixon, Nora Nungubar Dada Samson, Rita Simpson Ida Taylor, Wokka Taylor, Mabel Warrkarta, Bugai Whylouter.

FAR LEFT: *Martu country, 2007.* [Photo Michael Hutchinson.]

Nancy Chapman, *Untitled,* 2007, acrylic on canvas, 220 x 215 cm. Corrigan Collection. [Courtesy the artist, Martumili Arts and the Corrigan Collection.]

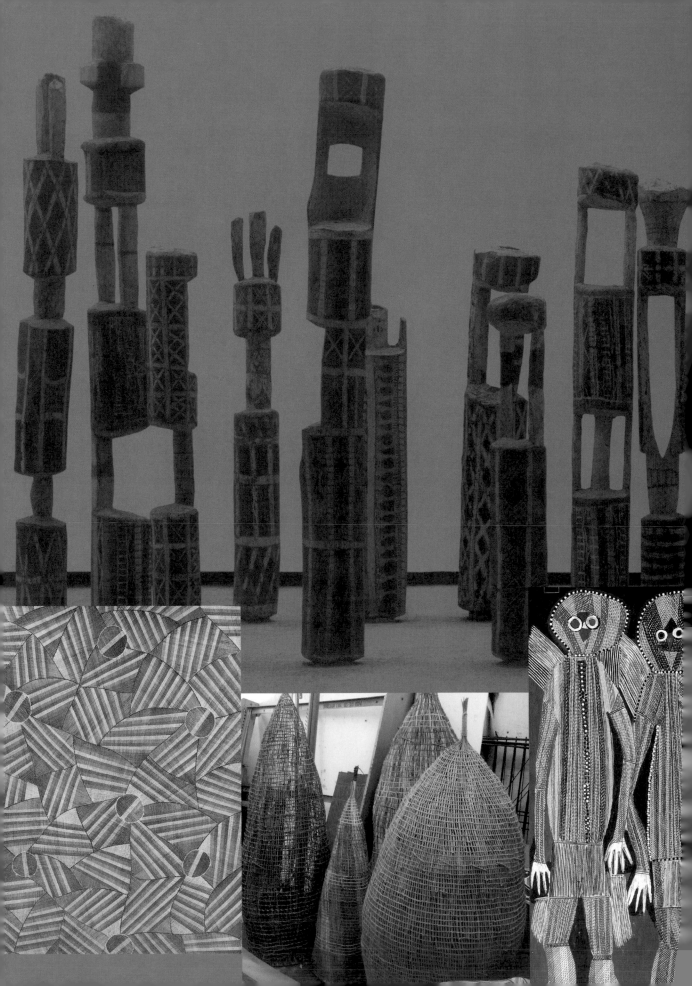

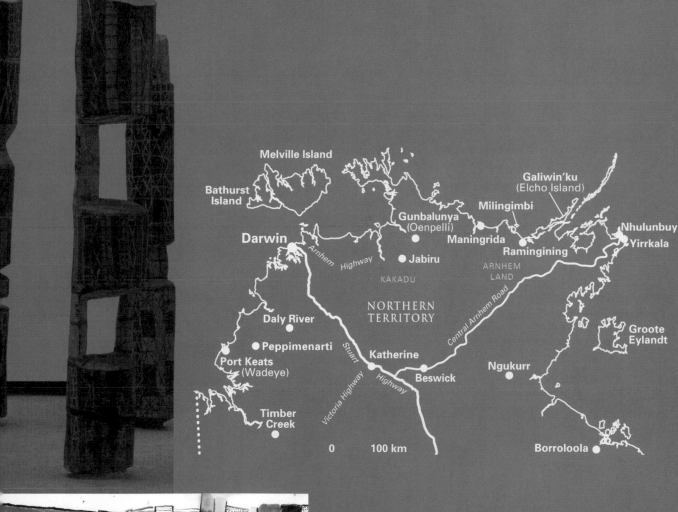

Melville Island

Bathurst
Island

Darwin

Gunbalunya
(Oenpelli)

Milingimbi

Galiwin'ku
(Elcho Island)

Nhulunbuy
Yirrkala

Maningrida

Ramingining

Arnhem Highway

Jabiru

ARNHEM
LAND

KAKADU

NORTHERN
TERRITORY

Central Arnhem Road

Daly River

Groote
Eylandt

Peppimenarti

Stuart Highway

Katherine

Ngukurr

Port Keats
(Wadeye)

Victoria Highway

Highway

Beswick

Timber
Creek

0 100 km

Borroloola

The TOP END &
ARNHEM LAND:

Art in the Land of Plenty

The art of Australia's far-northern region of the Top End and Arnhem Land reflects both the abundance of its land and its antiquity. The main city of Darwin is rich in cultural diversity and art, as are regions to its south-west including the art producing areas. To the north, the Tiwi Islands of Bathurst and Melville have distinctly different art due to their more insular history. Modern-day art in the Top End includes that from the Darwin city area and south to Katherine, Borooloola, south-west regions of Daly River, Peppimenarti and Port Keats (Wadeye).

The 97 000 square kilometres of Arnhem Land stretching from the East Alligator River in the east to the Gulf of Carpentaria in the west encompass a vast terrain of lush, fertile grasslands, rivers and lagoons, rugged stone areas, mud flats and huge sandstone plateaux. The area's wildlife is similarly abundant. As well as essential food sources, fauna such as sea-dwelling and river-dwelling fresh and saltwater crocodiles, dugongs, turtles and many species of fish, kangaroos, wallabies and other marsupials, lizards and snakes are integral parts of Arnhem Land's myths, lore and art.

Some of the main art producing areas of Arnhem Land include Groote Eylandt off the eastern coast; Ngukurr on the eastern mainland; Yirrkala to the north-east; the central coastal areas of Ramingining, Milingimbi, Galiwin'ku (Elcho Island) and Maningrida; the Cobourg Peninsula to the west; the central area of Gunbalunya (Oenpelli) which borders Kakadu National Park. As well numerous small art communities or outlets are spread throughout the Top End and Arnhem Land servicing more than 4000 artists and craftspeople.

Adjacent to Arnhem Land and readily accessible to tourists is the much-visited World Heritage site of Kakadu National Park. Impressive rock formations, including those at Nourlangie and Ubirr Rocks, contain numerous fine examples of rock art and are readily accessible to the public. Kakadu has two cultural centres, the Marrawuddi Gallery at the Bowali Visitor Centre, five kilometres from Jabiru, and the Warradjan Cultural Centre at Jim Jim. Both offer insightful and interpretative information about the region, its indigenous culture, history and the environment. Art, artefacts, books, CDs and a variety of other goods are for sale through the centres' galleries and shops.

People of the Top End

The single largest group of people of Arnhem Land, whose country ranges from its centre and east to the Yirrkala region, refer to themselves as 'Yolngu' while those further west call themselves 'Youl'. Non-Aboriginal people are referred to as 'Balanda'.

Arnhem Land became an Aboriginal reserve in 1931, although from 1913 non-Aboriginal visitors had been required to obtain permits. Aboriginal people had been living in Arnhem

The TOP END & ARNHEM LAND:
Art in the Land of Plenty

'While Arnhem Land art is often linked by familial connections , heritage and moiety, there is much differentiation in style between regions.'

Nourlangie Rock, Kakudu. [Tourism NT.]

LEFT: Yirawala, *Barramundi*, c.1968, ochre on bark, 92 x 32 cm. Private collection. [Courtesy Joel Fine Art and Aboriginal Artists Agency Ltd.]

Lush waters and stunning rock formations are features of the Kakudu region. Its art is represented by those such as master artist Yirawala whose barramundi image represents aspects of the Mardayin (body of knowledge) of the region's Kunwinjku peoples.

Prince of Wales (Midbul), *Body Marks*, 2002, acrylic on canvas, 137.5 x 81 cm. Private collection.
[Courtesy Sotheby's.]

attendant problems of racial battles, massacres and other potentially devastating influences such as disease. Missionary presence in the ten missionary settlements set up from the early 1900s (the first being at Roper River in 1907) until the early 1950s, helped survival of many Yolngu in a practical way.

As in other parts of Australia, missionary influence varied from those who virtually banned Aboriginal people from maintaining connection with the land and culture, to those who encouraged this contact. Most people lived in missionary settlements until the land rights movements of the 1970s, which returned both tracts of land and the running of the missions themselves to Aboriginal control. In 1911 the federal government assumed legal guardianship of Aboriginal people, establishing reserves and also removing part-Aboriginal children from their families.

Military stations had also been set up in several northern areas from the 1820s, with mining and other exploration also impacting on traditional life. The greatest continuous influence was not from within Australian borders but from overseas. From the mid 1700s to the 1800s, Macassan traders from Indonesia and further north harvested the Asian delicacy, trepang (bêche-de-mer or sea cucumber), from the seas of north-east Arnhem Land from around January to May each year. Permanent or semi-permanent camps were set up by the Macassans on beaches – their regular visits leading to an exchange of goods, artefacts and the establishment of ongoing relationships. Aspects of Macassan culture and stories about the visits also became incorporated into the area's lore, and rock art. Stylistic influences and some imagery has carried over into modern-day bark paintings, weaving and carving.

The Second World War had a far greater impact on Arnhem Land and the Top End than other parts of Australia. Some northern areas, including a number of places in Arnhem Land, became military, navy and air force bases. Many members of the white population were evacuated with the local populace left to fend

Land for at least 50 000 years before regular contact with outsiders. European influence in Arnhem Land, even before it became an Aboriginal area, was significantly less than in many other parts of Aboriginal Australia, largely because of its location in the far north of Australia and the unsuitability of the climate and terrain for grazing cattle. Nor was there the 'trucking-in' of people to form settlements, as happened in many central and western regions of Australia under federal government edict.

Yet the cattle industry did make some inroads into Arnhem Land communities with the

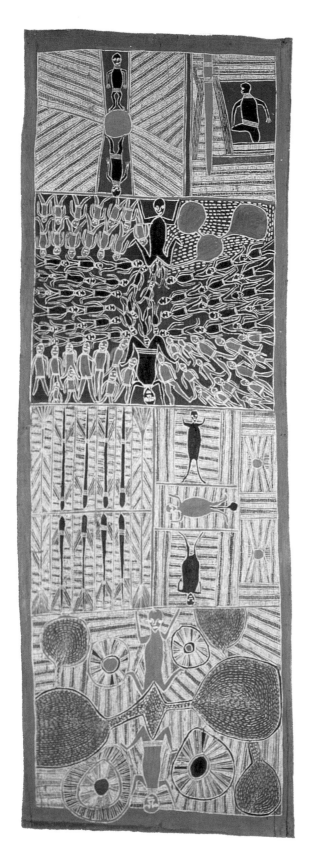

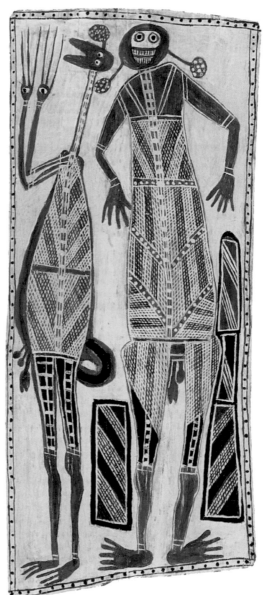

Yirawala, *Luma Luma and Wind Man*, 1971, ochre on bark, 70 x 30.5 cm. Private collection. [Courtesy Sotheby's and Aboriginal Artists Agency.]

LEFT: Mawalan Marika, *Djang'kawu Creation Story*, 1959, ochre on bark, 187 x 64.7 cm. Art Gallery of New South Wales. [Courtesy Buku-Larrnggay Mulka and Art Gallery of New South Wales.]

Paintings by two of Arnhem Land's master painters include those of encyclopaedic detail such as Mawalan Marika's 1950s classic creation story and Yirawala's depiction of creation ancestor, Luma Luma.

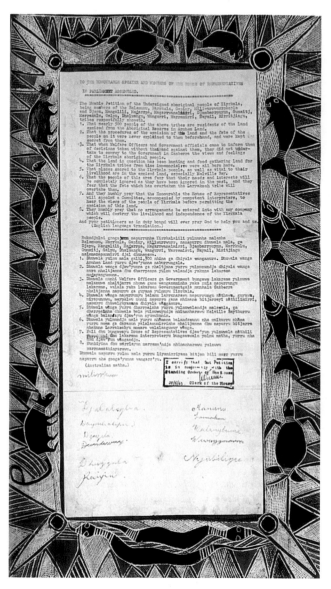

Various artists, *Bark Petition, Yirrkala*, 1963.

[Courtesy Buku-Larrnggay Mulka.]

The Yirrkala Bark petition presented to the federal government in 1963 to support the Yolngu's land claims was initially unsuccessful. However land claims and management of mining rights were subsequently awarded.

for themselves. Darwin was bombed severely a number of times in 1942 and 1943, as was the island of Milingimbi in 1943. Aboriginal people were also recruited for the army '[as] messengers, observers of coastal areas and some were recruited into the services. Some were never seen again,' recalled Aboriginal leader Gatjil Djerrkura.[1]

Self-Determination and Beyond

Moves to Aboriginal self-determination and return of lands to indigenous control were sparked by the Commonwealth Government granting mining rights in 1962 to the Nabalco mining company for the establishment of a bauxite mine on the Gove Peninsula near the community of Yirrkala. The company planned to mine vast areas of the peninsula and set up a processing plant at Nhulunbuy, 20 kilometres from Yirrkala. The traditional owners made representation to stop the mining and presented the Yirrkala Bark Petition to express their concerns to the federal government in 1963. Although this claim was not won – the mining company established huge open-cut bauxite mines on traditional lands near the settlement of Yirrkala – subsequent claims were more successful, with the Yolngu eventually able to negotiate mining rights on their own terms.

Self-determination also advanced as Aboriginal people started moving back to their homelands to form small outstations. The connections between returning back to traditional land and the subsequent developments in contemporary Aboriginal art are intertwined and inseparable.

From Rock to Bark:
A Continuing Artistic Tradition

Arnhem Land and the far north is Australia's most prolific bark art and rock art area. Both art forms have been practised for centuries, with a number of Arnhem Land rock sites dating back at least 50 000 years. The art of this area has had far more continuous development from the traditional to the modern than that

of many other areas where people were removed from their lands. Images portrayed for generations on cave walls and bark from the stringy bark trees have been translated into present-day materials. Ochre on bark remains predominant as a painting medium, with acrylic on canvas favoured in only a few areas, such as at Ngukurr. Weaving, jewellery-making and carving remain strong in contemporary practice with original prints also made with leading printmakers and printmaking studios.

The degree of individual interpretation of subject matter varies from area to area but always remains within the bounds relating to

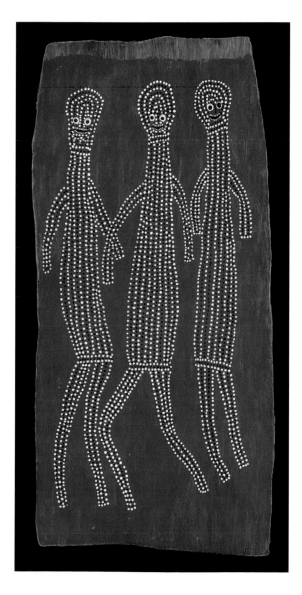

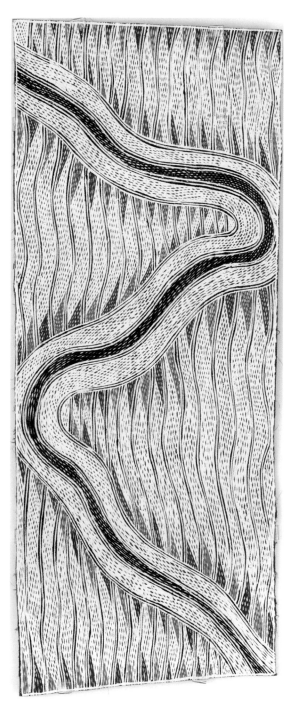

Galumu Maymuru, *Wayawu Mungurr*, 2007, ochre on bark, 82 x 35 cm. Private collection. [Courtesy Buku-Larrnggay Mulka and Annandale Galleries.]

LEFT: Crusoe Kuningbal, *Morkuy Figures*, c.1970s, ochre on bark, 103.5 x 48 cm. Private collection. [Courtesy Sotheby's.]

clan and heritage rights of what and who is allowed to paint specific stories and designs of those stories. The line work, or cross-hatching, which characterises the designs and backgrounds of the barks of Arnhem Land, is called 'rarrk'.

The Two 'Halves' of Arnhem Land:
Dhuwa and Yirritja Moieties

Arnhem Land society is divided into two 'halves' or groups. This forms the social structure for law and for marriages and other relationships. While people belong to many different language groups and clans, all belong to either the Dhuwa or Yirritja moieties. As Professor Howard Morphy has noted, Eastern Arnhem Land's Riratjingu, Marrakula and Djapu people belong to the Dhuwa moiety; the Gumatj, Mardaprpa and Munyuku clans belong to the Yirritja moiety. A person's moiety is determined by that of their father; and those from one moiety must marry someone from the other moiety. 'The division in the moieties applies to the whole universe, so ancestral beings, plants and animals likewise belong … to clans of one [or the other] moiety'.[3]

The founders of the Dhuwa moiety are the creation beings the Djang'kawu Sisters who, with their brother, traversed Arnhem Land from east to west, creating people and places, landforms, waterholes and other phenomena in their path. The rituals celebrating the creations of the Djang'kawu Sisters (whose names changed, including to the Wagilag Sisters, during their journey west) are numerous and specific to each place and event.

The art derived from ceremonial body painting of the Dhuwa and Yirritja moieties reflects their difference. Diamond patterns belong to painters of the Yirritja moiety; intersecting bands of lines are seen in the art of members of the Dhuwa moiety.

Arnhem Land Art:
The Sacred and the Secular

The images represented in bark paintings are both sacred and secular. Major creation beings, which feature in much art, include the Rainbow Serpent, the Dugong, and the Mimih spirits, with secular images relating the stories of hunts and events also shown. The art, as with much Aboriginal art, often contains multiple levels of meaning. Artist David Malangi described:

> It's OK you see this painting, this is my waterhole, made by one of the Djang'kawu sisters. I can tell you this, but this painting also has sacred–secret story I cannot tell you. I teach my sons this story, paint it on them for their initiation and we sing and dance this story in our ceremony … This is how we keep our culture strong, pass on this sacred story.[4]

Young boy being painted with his clan's symbol, Arnhem Land, 1997. [Photo.Penny Tweedie, Wildlight.]

While Arnhem Land art is often linked by familial connections, heritage and moiety, there is much differentiation in style between regions. Painting in Groote Eylandt, to the east, is often distinctly different from much mainland art. Characterised by deep blacks or lighter brown backgrounds, images are clearly delineated. Although many paintings represent creation myths and ancestral journeys, Groote Eylandt paintings are also notable for featuring, from early on, contemporary narratives or events of everyday life, such as the regular visits by the Macassans, the island's flora and fauna and community activities.

194

A notable difference between the art of western and central Arnhem Land (Gunbalunya, Milingimbi, Maningrida, Ramingining) and that of the east (Yirrkala, Blue Mud Bay) is that, in the latter, the infill lines, or cross-hatching, generally covers the whole canvas, whereas in the art of the central and western areas, cross-hatching is generally confined within outlined images.

The Famous X-ray Art

Some figuration is incorporated into clan designs in eastern Arnhem Land art, but the figurative tends to dominate in central regions. Anthropologist Ronald Berndt observed that painters from these areas show a preference for open spaces and a concentration on the central figure or figures against a plain background; detail is subordinated to the main design; and there is an impression of suddenly arrested motion. Naturalism and figuration is emphasised, with a minimum of stylisation; roundness and curves are favoured rather than angles and straight lines.[5]

The famous X-ray style – so-called because the internal organs are displayed in section as part of the external image – is mainly seen in paintings from the central areas around Gunbalunya and Kakadu.

The art of the Tiwi Melville and Bathurst islands is very different. Although part of Arnhem Land, the Tiwi's history and development was far more self-contained. This separateness is reflected in the art from these regions, such as the famous pukumani, or burial poles.

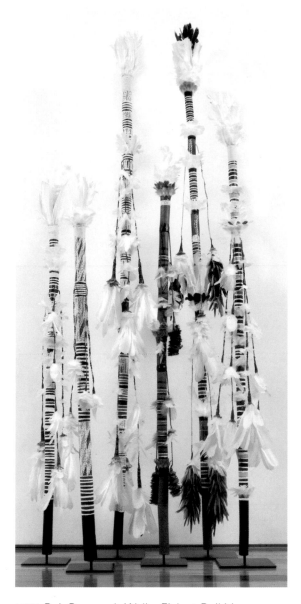

LEFT: Bob Burruwal, *Walka-Fish at Bolkjdam*, 1997, ochre on wood, 215 x 15 x 10 cm. Private collection. [Courtesy Maningrida Arts & Culture and Gallery Gabrielle Pizzi.]

Gali Yalkariwuy Gurruwiwi, *Morning Star Poles*, 2006–07, natural ochre, feathers and mixed media, variable height to 2 metres. Private collection. [Courtesy Elcho Island Arts and Crafts and Vivien Anderson Gallery.]

Three-Dimensional Paintings:
The Unique Bark Art of the North

The highly specific designs, organic properties of the materials and three-dimensional qualities make barks highly individual works of art. Bark is taken from the trees at the end of the wet season (November–March), stripped from the trunk by making a cut at the top and bottom of a section of the tree, levering the bark outwards and pulling upwards. Then it is placed on a blazing fire for a few minutes and the outer fibre stripped, leaving a flexible sheet that is easily flattened by weighting the bark down with stones on the ground and leaving it in the sun for several days.

Before ochre is applied, the bark's surface is fixed with a sealant – traditionally the sap of tree orchids or the yolk of sea-going turtle eggs was used. Today commercially available polyvinyl acetate (PVA) glue is more popular. A fine 'brush' made of a twig or blade of dried grass is used to apply ochres that are ground and mixed with water to form a smooth paste. Red, yellow, black and white pigments and occasionally green, derived from the mixing of black and yellow, are used. Traditionally, pigments from different areas were traded among people. A natural source of blue pigment was never found, although when the Reckitts brand of dyes and washing bleach were introduced via European settlement in the late 1800s, they were used occasionally in rock art.

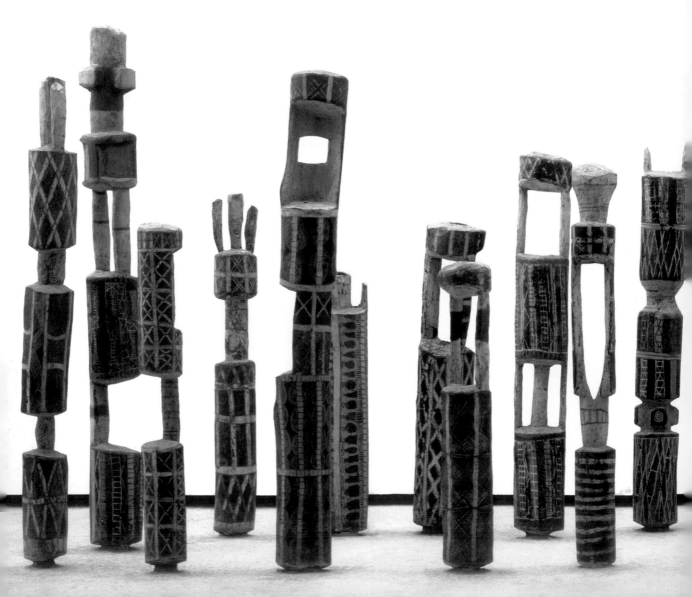

Carving and Sculpture

Carvings are made throughout the Top End and include the Tiwi's figurative birds, animals and the burial pukumani poles. Carved and painted hollow-log coffins are made throughout the coastal regions, from Yirrkala in the east to Milingimbi, Maningrida, Ramingining, Elcho and Groote islands. Ramingining is also known for its long history of pole-making, which included the 200 hollow-log coffin Aboriginal Memorial, commissioned by the National Gallery of Australia in 1988. Yirrkala's artists have become known for their carved and painted ceremonial poles, most notably the Larrakitj, or memorial poles, made by artists such as Gawarrin Gumana, Naminapu Maymaru-White and Gulumbu Yunupingu who have all won prizes at

the National Aboriginal and Torres Strait Islander Art Awards. Artists such as Owen Yalanda and his brother Crusoe Kurddal from Maningrida are particularly notable for their carvings of Mimih and other spirits, and Maningrida's Lena Yarinkura has become famous for her imaginative sculptural works that combine carving, weaving and assemblage of many different objects. Elcho Island's artists are known for their sculptural decorated morning star poles.

Arnhem Land is also the traditional home of the popular musical instrument the didgeridoo (didgeridu), now made globally by non-Aboriginal people. The instrument has many names, but is best known by its north-east Arnhem Land name 'Yidaki'. The didgeridu serves both artistic, musical and ceremonial purposes and has been exhibited in major fine art exhibitions.

Fibrework, Jewellery and Fabrics

Many women throughout the Top End, as well as being painters and carvers, make a great variety of woven goods including baskets, floor mats, fish nets, dilly bags (loosely-woven carry bags), shell and bead jewellery and a range of artefacts. Increasingly these items have been seen in the fine art domain through major exhibitions such as *Twined Together, Art on a String* and *Stringworld* (see Recommended

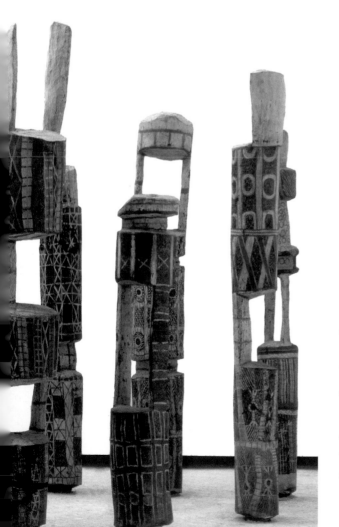

Artists including Laurie Nelson Mugatopi, Bob One Apuatimi, Big Jack Yarunga, Charlie Quiet and others, *Seventeen ceremonial poles from the Pukumani ceremony*, 1958. Commissioned by T. Tuckson and gift of S. Scougall. Art Gallery of New South Wales. [Courtesy Art Gallery of New South Wales.]

These poles are important elements of the Tiwi mourning ceremony and also carved for display as sculpture in the fine art context.

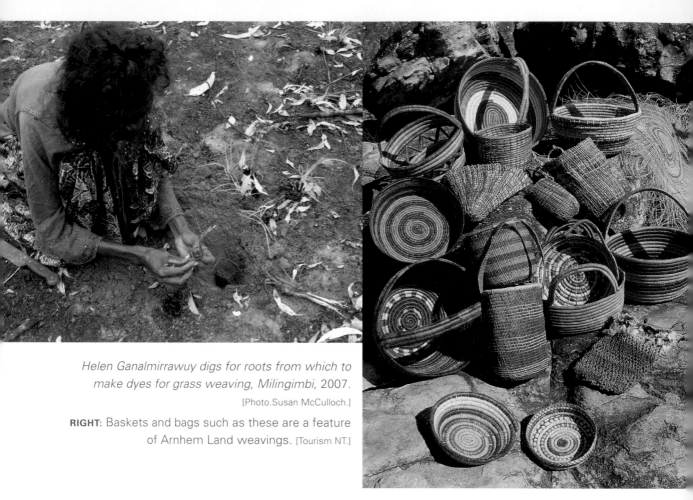

Helen Ganalmirrawuy digs for roots from which to make dyes for grass weaving, Milingimbi, 2007.
[Photo.Susan McCulloch.]

RIGHT: Baskets and bags such as these are a feature of Arnhem Land weavings. [Tourism NT.]

Reading) Tiwi Designs at Bathurst Island is Arnhem Land's major fabric-producing centre, and arts centres such as the Tiwi's Jilamara produce tie-dyed and other fabrics. Jilamara has also produced a range of sophisticated silver jewellery.

Printmaking

Many bark and other artists from all areas have extended their art into printmaking in the mediums of linocuts, screenprints and etchings. In the 1990s the printmaking workshop Northern Editions was established by Basil Hall, Leon Stainer and others at the Charles Darwin University, Darwin. Artists from Arnhem Land and other areas travel to work with master printmakers, using the university's printmaking facilities and hold exhibitions. In 2002 Basil Hall formed his own company, Basil Hall Editions, to work with Aboriginal and non-Aboriginal artists. Other leading printmakers such as Theo Tremblay from the

Canberra School of Art and the Australian Print Workshop's Martin King have also played major roles in conducting regular print workshops with artists at many communities throughout Arnhem Land. Maningrida has also established its own printmaking room in the arts centre.

From Outstation to Gallery:
Northern Art in the Modern Era

During the mid to late 1980s with the interest generated in contemporary Aboriginal art through its resurgence in the Central Desert regions, bark painting was further embraced as a contemporary art form. The scale of the works also grew, from the small souvenir panels whose making in the 1950s was encouraged by missionaries and others at Groote Eylandt, Yirrkala, Gunbalunya, Milingimbi and other areas, to the larger works in keeping with contemporary art practice.

With the increased demand for artworks, a growing number of arts centres were established, from the 1970s up until the

present. Milingimbi established a profitable craftshop outlet in 1967, which operated on and off until 2004 when an arts centre manager was appointed and the centre reopened. Maningrida's arts centre started as a branch of the local progress association in 1968, following the Milingimbi model, and has grown as Maningrida Arts & Culture to become one of the largest arts centres in Australia. So too, Yirrkala's designated arts centre, Buku-Larrnggay Mulka, which opened in 1975. Ramingining's Bula' bula opened in its new building in the early 1980s. Gunbalunya's Injalak Arts opened in 1989. Other Arnhem Land arts centres detailed in the following pages include Galiwin'ku (Elcho Island) Elcho Island Arts Centre; Ngukurr's Ngukkur Arts Centre; Groote Eylandt's Anindilyakwa Art and those of the Tiwi Islands of Bathurst and Melville. Other Top End art centres such as those at Daly River and Peppimenarti have regular annual open days or festivals while those in towns such as Katherine and Darwin are more regularly accessible. Many of the more remote centres readily welcome visitors. However, permits are needed for many communities and enquiries regarding visits made on an individual basis as opening hours and dates vary.

Collections and exhibitions

Major collections of Arnhem Land art of the late 19th century are largely contained in Australia's museums, especially the National Museum of Australia, Museum Victoria, the Australian Museum and the South Australian Museum. The University of Melbourne also has a major collection of early bark paintings, as does Darwin's Museum and Art Galleries of the Northern Territory, while the Art Gallery of New South Wales was one the earliest galleries to collect 20th century barks and carvings and place them in an art, rather than ethnographic, context. The National Gallery of Victoria and the National Gallery of Australia have concentrated on purchasing major works of Arnhem Land artists and carvers. Sydney's Museum of Contemporary Art also holds major collections of barks, weavings and sculpture,

Janice Murray, *Mumu 1*, 2007, etching, 40.5 x 36.2 cm. Multiple collections. Printers Basil Hall and Natasha Rowell. [Courtesy Jilamara Arts & Crafts and Basil Hall Editions.]

including the historical Arnott's Collection of 273 bark paintings from the 1930s to the 1970s (featuring 41 paintings by leading painter Yirawala), and over 800 works acquired since 1990 from the communities of Ramingining and Maningrida (the latter held in trust for the people of Maningrida). Arnhem Land art is also held in a number of significant museums internationally, including the Musée du Quai Branly, which opened in Paris in 2006; the Smithsonian Institution, Washington DC; and several university and museum collections in Europe and the United Kingdom.

Gulumbu Yunupingu, *Gan'yu–Stars*, 2006, ochre on bark, 150 x 72 cm (variable). [Courtesy the artist, Buku-Larrnggay Mulka and Alcaston Gallery.]

Winner of the National Aboriginal and Torres Strait Islander Art Award in 2004, Yirrkala artist and cultural leader Gulumbu Yunupingu described her paintings of stars as statements of unification as all people share the same sky.

Significant exhibitions that have featured the art of Top End and Arnhem Land artists include *An Exhibition of Australian Aboriginal Art, Arnhem Land Paintings on Bark*, Art Gallery of Western Australia, 1957 (curator R. Berndt); *Australian Aboriginal Art*, Art Gallery of New South Wales (AGNSW) and touring, 1960–61 (curator T. Tuckson); *Australian Aboriginal Art from the Scougall Collection*, Qantas Gallery, New York, 1961; *Aboriginal Bark Paintings from the National Museum of Victoria*, Museum of Fine Arts, Houston, USA, 1965 (curator A. McCulloch); *Painted Objects from Arnhem Land*, National Gallery of Australia (NGA), 1986 (curator W. Caruana); *Dreamings: The Art of Aboriginal Australia*, Asia Society, New York and touring, 1988 (curator P. Sutton and others); *The Inspired Dream*, Museum and Art Galleries of the Northern Territory (MAGNT) and Queensland Art Gallery, 1988 (curator M. West); *Aratjara: Art of the First Australians*, Germany and touring, 1993 (curator B. Luthi, D. Mundine and others); *Rainbow; Sugarbag and Moon; Bardayal Nadjamerrek and Mick Kubarkku*, MAGNT, 1995 (curator, M. West); *Windows on the Dreaming*, NGA, 1989 (curator W. Caruana); *Spirit in Land*, National Gallery of Victoria, 1990 (curator J. Ryan); *Painters of the Wagilag Sisters Story*, NGA, 1997 (curators W. Caruana, N. Lendon); *Saltwater: Yirrkala Bark Paintings of Sea Country*, Australian National University Drill Hall and touring, 1999 (Buku-Larrngay Arts Centre); *The Native Born: Objects and Representations from Ramingining*, Museum of Contemporary Art and touring internationally, 2000 (curator D. Mundine); *Stringworld, On and On: Stringworld Touring Exhibition*, 2002–03; *Crossing Country*, AGNSW (curator H. Perkins) 2004; *Rarrk! Flowing on from Crossing Country*, Annandale Galleries, 2004.

Lush tropical growth, sapphire seas and expansive country are features of Darwin – Australia's northernmost city – and the surrounding areas of the Top End of Australia. The region includes several significant art-producing areas such as Daly River, Peppimenarti, Wadeye (Port Keats) to the south-west of Darwin, and the town of Katherine, 330 kilometres south on the Stuart Highway.

Further south, the small tropical town of Batchelor houses the Coomalie Cultural Centre at Batchelor College. Since 2004 the managers have been the long-time coordinators from Elcho Island Arts, Steve and Brenda Westley, who have arranged some interesting cross-cultural projects with artists from Elcho Island and other areas. The centre has a mix of art from different areas including local paintings with some figurative works from students of the college and the local community as well as selected works from Arnhem Land and Central Australia. The centre holds two exhibitions a year of the students' work.

Katherine and Surrounds

Thirty kilometres from the popular tourist town of Katherine, the beautiful Katherine Gorge in the Nitmiluk National Park has wonderful examples of rock art. In Katherine itself, Mimih Arts and Crafts represents all the communities and the many different styles of artists from this large region.

These include the well-known senior Wardaman artist Bill Harney, from Menngen

Overlooking the Arafura and Timor seas, Darwin, is closer to Asia than it is to the southern parts of Australia and reflects this in its fusion of cultures. [Tourism NT.]

in the Victoria River region, 120 kilometres to the south-west. His ochre-coloured canvases most famously depict the Lightning Men, whose images are found in the rock art of his region. Other well-known artists working with Mimih Arts include Barney Ellaga from Minyeri, 220 kilometres south-west, whose colourful, individualistic works have become highly popular. Under the direction of Barbara Ambjerg Pedersen since 2007, Mimih Arts has worked with Warlpiri artists from the long-established Lajamanu community to the west. They include Liddy Nelson Nakamarra, Lorna Fencer Napurrula, Molly Tasman Napurulla, Rosie Tasman Napurrula and others.

To the east of Katherine, a variety of art of the region including didgeridoos, artefacts such as clapsticks, seed necklaces and other jewellery, and paintings are sold through the Aboriginal-owned Manyallaluk Art and Craft Centre.

DARWIN and SURROUNDS

Darwin: A Cross-Cultural Fusion

Darwin proper is a city of around 110 000 permanent residents from many ethnic origins; annual visitor numbers more than double the population. It is the setting-off point for Kakadu, the Tiwi Islands and other tourist destinations, and is the city closest to Arnhem Land. Darwin extends over a wide area and has numerous small, satellite towns and communities located to the west, east and south of the main centre.

A popular mecca for tourists and an important business and professional centre as well as military and naval depot and seaport, much of Darwin's history is as hidden from public exposure as the Second World War oil-storage tunnels that run underneath the town. Home to the Larrakia people, the region was named Port Darwin in 1839 after Charles Darwin who surveyed the north-west coastline aboard HMS *Beagle*.

Thelma Dixon, *Olden Time Policeman*, 2007, screenprint acrylic paint on paper, 35 x 25 cm. Several collections.
[Courtesy Museum and Art Gallery of the Northern Territory.]

Borroloola artist Thelma Dixon was awarded a high commendation for this simple, direct and quirky image of days gone by in the 2007 National Aboriginal and Torres Strait Islander Art Award.

OLDEN TIME POLICE MAN

Thelma Dixon
2/f

Home of the Larrakia

In 1869 an overland telegraph station was established near the present city and the town was renamed Palmerston. This name remained until 1911 when it reverted back to Darwin. Many of the early, non-Aboriginal settlers were Chinese workers on the overland telegraph station who stayed on, creating market gardens and building businesses. For some years, the Chinese formed the majority of the population.

Darwin is on the land of the Larrakia, whose population numbers around 1600. It has also long been a place of residence or visiting place for Aboriginal people from many Top End areas including the Tiwi Islands, Arnhem Land, Wadeye (Port Keats), and the Katherine and Daly River regions.

Although Macassans and Europeans frequently visited and made several unsuccessful attempts at creating settlements in the region, the Larrakia were completely unprepared for permanent settlement when it did finally occur in the 1870s. When the Northern Territory Survey Expedition arrived in the 1800s, the Larrakia assisted them by finding water and food. But, when it became evident that the visitors were to become permanent, the Larrakia retaliated with acts of violence and sabotage, stealing survey pegs and holding ceremonies late into the night – thus using sleep deprivation as a form of psychological warfare against the enemy.[1] This state of semi-warfare continued for many years. Aboriginals were herded into institutions and camps, which were often overcrowded and impoverished.

In 1953 full-blood Aboriginal people were made wards of the state under legislation that required them to gain permission from the Northern Territory Director of Welfare for almost everything, from getting married to opening a bank account.

Today Darwin and its surrounding regions has six officially sanctioned Aboriginal town camps and a number of ad hoc communities – many situated on sites that were prime fishing and hunting spots for thousands of years. Long-grassing (sleeping in the long

spear grass that is flattened
by winds every April and
May) is also a well-known
Darwin Aboriginal practice
and has its origins in
the Larrakia way of life.
Belyuen, 128 kilometres
south-east on Darwin
Harbour, was the home of
important Larrakia leaders
such as Old King George
and his son, Prince of Wales
(Mitbul) (1938–2002), who,
in his later years, became
a famous artist. Kulaluk
Town Camp in the suburb of
Nightcliff, north of the city
centre, is home of Larrakia
leader Bobby Secretary, co-
designer of the Larrakia flag
(known as the Kulaluk flag).

Darwin's modern history
includes having been bombed
more than 60 times during
the Second World War
and, as with other northern coastal areas, is
frequently battered by cyclones. But Cyclone
Tracy, which devastated the town on the night of
Christmas Eve, 1974 remains Australia's greatest
natural disaster. According to the Larrakia, the
cyclone was caused by disturbance to the sacred
site of Old Man Rock, or Dariba Nungalinya.[2]

Prince of Wales (Mitbul), *Body Marks*, 2002, acrylic paint
on canvas, 120 x 131 cm. Private collection. [Courtesy Joel
Fine Art.]

**This leading Darwin artist translated the body paint
designs of his Larrakia people onto canvases of
glowing color.**

Art in Jail

The Fannie Bay Gaol, built in 1882, was the
place of imprisonment for many Aboriginal
Australians and Asians jailed for minor offences
including trading in alcohol. Closed in 1979 and
now a museum, Fannie Bay Gaol offers a
grimly fascinating insight into the colonial
history of Darwin and includes information
about the earliest exhibition of works by
Aboriginal artists. Titled *The Dawn of Art*, this
was Darwin's contribution to Melbourne's Great
Exhibition of 1888. Works by Aboriginal inmates
of the jail, whose names were recorded as
Jemmy Miller, Paddy, Davie and Wandy Wandy,
were included. These small line drawings and
pen-and-wash studies recorded daily life with
some references to traditional ceremonial
practice and body art.

Larrakia Art: Disruption, Reconnection and Cultural Melding

Through continued disruption, as Larrakia
artist Gary Lee noted, little remains today of
traditional Larrakia art, which includes skilful
woodcarving and body-marking for ceremony.
[3]The carvings of Larrakia artist Koolpinyah
Richard Barnes (Koolpinyah), such as his totem
poles at Mindil Beach, are notable continuations

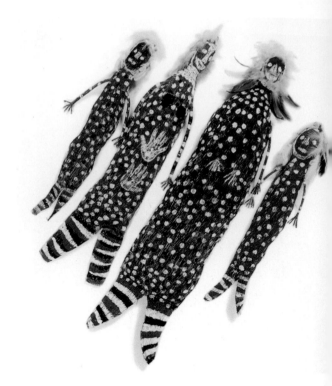

Maningrida artist Lena Yarinkura's imaginative works forged new dimensions in fibre sculpture and won for her the three dimensional award of the National Aboriginal and Torres Strait Islander Art Award in 1997.

of this tradition. He was taught painting as a child by the artist Ian Fairweather, who lived in the hulk of a wreck on the beach in Darwin in the early 1950s before setting off on a Kon-Tiki-like journey on a homemade raft. Koolpinyah's paintings, with their lines and layering, resemble Fairweather's paintings, which, in turn, contains elements of an Aboriginal sensibility of the significance of land and subtle references to body markings. Many of Koolpinyah's paintings, such as the triptych *Gwalya Dorennage (This is Our Land)*, document the Larrakia's struggle for land rights and their meetings with officials over this issue.

Koolpinyah's cousin, Prince of Wales (Mitbul), was the most famous exponent of early Larrakia art. The senior Larrakia elder, he began painting at the age of 57 after suffering a serious stroke. His striking, minimalist images are based on traditional Larrakia body design and are a rare example of non-ceremonial portrayal of such imagery. Son of Larrakia leader Old King George and grandson of King Miranda, the origin of Prince of Wales's name was most likely a natural progression from that of his father, although it is possible he earned it after dancing for the Queen in the 1960s. Prince of Wales won the painting award at the National Aboriginal and Torres Strait Islander Art Award in 2001 and his work was seen in leading galleries such as Darwin's Karen Brown Galleries,

Melbourne's Gallery Gabrielle Pizzi and Sydney's Hogarth Gallery, where he exhibited in 1998 with Anthony Duwun Lee (Duwun).

Duwun was named after his maternal great-great-grandmother, Annie Duwun, who in turn was named after Duwun Island off the Cox Peninsula – an area involved in the Larrakia land claim. Much of Duwun's art is concerned with this issue. Mitbul's work had a large influence on Duwun; his works on paper and his paintings, although of broader palette, bear some resemblance to the large dots and lines of Mitbul's paintings. Duwun's work also reflects Darwin's unique blend of Aboriginal and Asian cultures, where celebrations such as Chinese New Year have been incorporated into Aboriginal ceremony as far back as 1912, and the post-Second World War camps at Parap have led to a modern-day fusion of Aboriginal, Asian and Mediterranean cuisine, culture and ways of life.

This blend of cultures is well-expressed in the work of Gary Lee, an artist and curator who often works in the medium of photography. His portraits of Darwin residents capture the lives and histories of the town, particularly its male inhabitants, and his own family's history. In 2002 Lee curated the first exhibition of contemporary Larrakia artists for 24HR Art: Northern Territory

the TOP END

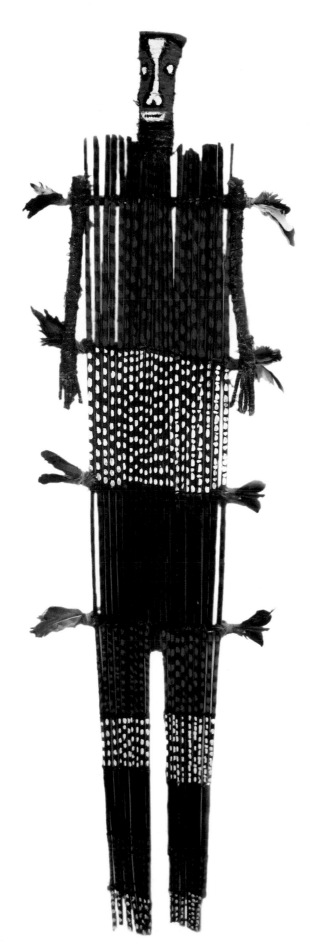

Centre for Contemporary Art. Entitled *Dirula*, the Larrakia name for Dreaming, the exhibition featured work by Mitbul, Koolpinyah, Duwun, Gulluwan and Topsy Secretary. Lee's work has been exhibited in the annual National Aboriginal and Torres Strait Islander Art Award (NATSIAA) and the Togart Contemporary Art Award 2006.

The late elder, Topsy Secretary, is an example of Larrakia women artists who are often skilled weavers or who work in textiles. Another is June Mills, one of the famous Darwin Mills clan of artists and musicians.

Art centres in Darwin include the Larrakia Nation Aboriginal Corporation at Karawa Park, which represents Larrakia artists who work on bark and canvas in a Top End, figurative style, and Dunnilli Arts, established in 1995, housed in Nungalinya College in Casuarina. It runs courses on batik and screenprinting for indigenous students.

Darwin has long been a meeting place for Aboriginal people from surrounding regions and has, understandably, become a city with gallery outlets for many styles of Aboriginal art. Artist Harold Thomas, who designed the Aboriginal flag, exhibits regularly in Darwin, despite being a Luritja artist from Central Australia. Classically trained Thomas is a landscape painter. His oils and watercolours are mainly landscapes containing images of rivers and koi carp, waterlilies, brolgas and other natural features.

Darwin: Arts Festival Town

Among the large range of commercial galleries, some community arts centres also have galleries in town including Maningrida Arts and Culture and the Tiwi Art Network. Every August Darwin comes alive with the Darwin Festival and the National Aboriginal and Torres Strait Islander Art Award (NATSIAA). The festival is opened by a unique free concert featuring Aboriginal bands on the Esplanade and everyone joins in the celebration. Established in 1984 by curator Margie West, the NATSIAA, held annually at the Museum and Art Gallery of the Northern Territory (MAGNT), is the richest, longest running and most prestigious

Opening night, National Aboriginal and Torres Strait Islander Art Award, Museum and Art Gallery of the Northern Territory, 2006. [Photo.E. McCulloch Childs.]

prestige of winning was of greater value than the prize money itself. But from the early 2000s onwards, the nature of the award changed as top Aboriginal artists became more able to sell their works at a price close to that offered by the award and, consequently, there was less incentive to enter. In 2006, in an attempt perhaps to redress this, the award was made non-acquisitive, thereby allowing artists to sell their work and also win the award. (Telstra also sponsors MAGNT to buy a selection of works from the award.)

A striking display in the balmy night air

As the NATSIAA's have evolved, there has been an increase in other events held at the same time. More than seventeen exhibitions and art events occur throughout Darwin to coincide with the NATSIAA. In 2007 the inaugural Darwin Art Fair was held. Organised by Maningrida Art and Culture arts director Apolline Kohen, the Art Fair has become an annual event with participants from more than twenty community arts centres showing and selling their work direct to the public. Other events include art outside such as the exhibition of prints by the Buku-Larrnggay Mulka Arts Centre from Yirrkala, Arnhem Land in the Botanic Gardens. Hung in trees whose trunks are painted white, they make a striking display in the balmy night air.

In 2006 the Toga Group, developers of the new wharf precinct in Darwin, initiated the Togart Contemporary Art Award held at the Darwin Courthouse. Artwork, including much indigenous art, will be incorporated into the design of the wharf precinct, making it a living outdoor art museum that celebrates the Northern Territory's indigenous heritage.

Some Darwin artists

Marjorie Bil Bil, Naomi Briston, Peter Garamanak Browne, Richard Koolpinyah, Anthony Duwun Lee (Duwun), Daniel Roque Lee, Gary Lee, Nadine Lee, June Mills, Des Kootji Raymond, Prince of Wales (Mitbul).

award in indigenous art. Since 1992 the awards have been sponsored by Telstra (originally Telecom), and has become widely referred to as 'the Telstras'. The main prize was of special significance when the prize money increased incrementally during the 1990s, from $15 000 to $18 000, then to $40 000. Some five other awards, including those for works on paper, bark art and three-dimensional works are also given, and the exhibition attracts more than 800 entrants, with some two hundred works being selected for display.

The award exhibition is always a great meeting place for indigenous artists from around Australia as well as gallery directors, arts centre managers and collectors. The opening on the lawns of MAGNT overlooking Fannie Bay at sunset is unique in Australian art gallery openings. As with other major awards, the NATSIAA has also attracted controversy that has included debates about the winning works and questions surrounding authenticity.

Until 2006 the award was acquisitive and began as a low-key exhibition that aimed to showcase the best of contemporary work from indigenous communities and individual artists from around Australia. For many years the

Some 200 kilometres south-west of Darwin, the town of Daly River is famed for its barramundi fishing and mango farms. Several kilometres from these fishing spots that draw thousands of visitors annually, the Aboriginal community of Nauiyu seems an oasis of calm. On the banks of the broad and deep Daly River, the community is surrounded by lush, tropical country. Water has always been abundant and foods include turtles from the local billabongs, magpie geese, goannas, bandicoots, crocodile eggs, yams and waterlily roots.

Artists from Nauiyu and the communities of Peppimenarti and Wadeye (Port Keats) to the west are often related and share ancestral law. They also share more recent histories. When the Wadeye mission was established in 1936, it serviced the regions of Peppimenarti and the Daly River until the Nauiyu community was established with its own Catholic church in the 1950s.

The community's original name, Nauiyu Nambiyu, means 'coming together in one place'. The name Daly River was given by white explorers from South Australia in the 1850s after the South Australian governor of the day. As author and arts centre founder Eileen Farrelly relates in the book *Dadirri: The Spring Within,* from the mid 1860s to the late 1890s, Jesuits made three attempts to found settlements in the area, each one failing due to crop failures, malaria and other tropical illnesses, isolation and the nomadic nature of the Aboriginal population.[1]

It was not until the mid 1950s that the community, which had grown considerably with a more permanent population working the mango farms and other farms of the region, that the community of Nauiyu was established by Catholic missionaries. A school, church, clinic, dormitories and work sheds were built. In 1988 the community was incorporated under an elected council and the area returned to Aboriginal control completely in the 1990s.

Today's community, on the lands of the Malak Malak people, has around 10 different language groups, with the Ngan'gikurunggur predominating. An orderly and largely peaceful place, people continue to engage with their spirituality and culture on a daily basis, incorporating Christianity into these practices.[2]

'We had a new freedom'

Each morning the atmosphere in the community is purposeful, with women artists starting the day by sweeping the street outside the community's Merrepen Arts centre. Parrots cry and swoop around the attractive timber, tin and glass building which sits high amongst the tree-tops. Inside, the polished wooden floorboards and spacious gallery further an air of calm sophistication.

Little is recorded of the art of this region from pre-mission times, although the community's most senior elder, Jimmy Nambatu, painted barks that may have been collected by Prof. W. E. H. Stanner before the Second World War. Later, Nambatu made artefacts such as boomerangs and spears while the women's main art form at the time was weaving.

Merrepen Arts was founded by Eileen Farrelly, assisted by the impetus of author, artist and local school principal Miriam-Rose Ungunmerr and other women of the community. Ungunmerr recalled: 'We needed boards, brushes and paints. Once we had these there was no stopping us. We had a new freedom.'[3]

The art centre evolved out of a women's centre established in 1986 – the name Merrepen relating to the sand palm that is used in women's weaving. During the late 1990s it was managed by Meng Hoeschle, who raised the profile of the artists in southern city galleries and organised the book *Dadirri: The Spring*

DALY RIVER
(Nauiyu)

Within about the region's art and artists. 'Dadirr' means, according to Miriam-Rose Ungunmerr, the quality of 'inner, deep listening and quiet awareness…We call on it and it calls to us…It is something like what you call contemplation.'[4]

The Art of Merrepen: Flashes of Colour of a Lush Country

Merrepen's approximately 30 artists are mostly women who produce a variety of works, from painting on canvas, paper and silk to fibre weaving, papier-mâché work and prints. Much of the art is a blend of Aboriginal and Western figuration, employing bright colours that mirror the brilliance of the tropical landscape. Many of the paintings represent ancestral laws of the surrounding homelands and sacred sites, to which artists and community members travel regularly.

The subjects of paintings range from storytelling, often involving animal legends and parallels, to stories about faith and healing, customs and the land. The influence of Christianity, largely from relatives at Wadeye (Port Keats), has been strong and seen in the art by a fusing of Christian imagery with traditional beliefs, seen in works such as in Patricia Marrfurra McTaggart's painting *The*

Stations of the Cross, which hangs in the Anglican cathedral in Darwin.

One of the community's best-known artists is Mary Kanngi (or Kungi), mother of Miriam-Rose Ungunmerr, whose paintings reflect the lush flora of the region in flashes of bright colour. As well as painting large maps of country, her work also includes tiny, unusual details such as the concentric ripples in a river caused by a water rat taking a breath. She held a solo exhibition at Gallery Gabrielle Pizzi, Melbourne in 2002.

Several of the artists also work adeptly across several mediums. Patricia Marrfurra McTaggart, a trained linguist, is also a printmaker, painter and glass artist whose subject matter is equally wide-ranging. Biddy Lindsay is a printmaker and weaver of fish traps, while senior artist Mercia Wawul's images are of the plentiful bird life of the area, such as the pigeons whose calls can be interpreted as a welcome or a warning.

Some Nauiyu artists

Mary Kanngi, Biddy Lindsay, Aaron McTaggart, Patricia Marrfurra McTaggart, Kenneth Minggun, Jimmy Nambutu, Elaine Sambono, Miriam-Rose Ungunmerr, Molly Yawalminy.

Two large, colourfully painted boulders signal the turn-off for the Peppimenarti community and the road is lined with neatly placed black-and-white painted rocks. Painting also features on the verandah posts of many community buildings. It is clear that art is a significant force in this small community, 250 kilometres south-west of Darwin.

Peppimenarti means Big Rock (*peppi* meaning rock, *menarti* meaning large) and is named after a large group of rocks and pools, an important traditional site located several kilometres from the community centre.

Peppimenarti was established in 1973 by artist Regina Pilawuk Wilson and her husband Harold Wilson. A member of the stolen generations, Harold Wilson decided to return to his country and use his Aboriginal and European heritage to create a strong community. The main language of this small subtropical town is Ngangikurrungurr, with other language groups including Nangowmeri, Marrashabin and Marradun.

Situated on the floodplains of Tom Turner Creek, the plains of Peppimenarti, which fill with water during the wet season, have been celebrated in song by one of Australia's most revered songwriters, the late Slim Dusty, who visited Peppimenarti many times and whose family are close friends of the Wilson family.

Art in the Land of Weaving

The basis of Peppimenarti's contemporary art movement is weaving, as well as men's designs on wooden objects such as spears, and ceremonial body paint designs (the Peppimenarti people are famed dancers throughout the Daly River area.)

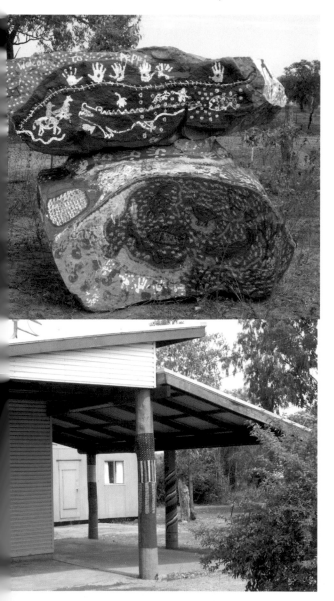

FAR LEFT: *Merrepen Arts, Nauiyu (Daly River).*

LEFT: *Aboriginal hunting ceremony, Peppimenarti.* [Photo. Penny Tweedie, Wildlight.]

ABOVE: *Rock signs to Peppimenarti community*, 2007.

LEFT: *Council buildings, Peppimenarti*, 2007. [Photos S. McCulloch.]

The painting on rocks and poles indicate the significance of art to this community south of Darwin.

PEPPIMENARTI
Lush Plains and Rocks

Margaret Kundu (left) and Patsy Marfura, demonstrating dilly bag weaving at the Peppimenarti Open Day, September 2007. [Photo.Harriet Fesq.]

CENTRE: Regina Wilson, *Message Sticks*, 2006, (detail), acrylic on canvas, 200 x 210 cm. Private collection. [Courtesy the artist and Agathon Gallery.]

RIGHT: Pincher Talunga, *Untitled (Men's Ceremonial Designs)*, c.2003, acrylic on canvas, 100 x 96 cm. [Courtesy Sotheby's.]

The weavings of Regina Pilawuk Wilson and others from the region had been shown in exhibitions and collected by leading art institutions since the 1970s. Regina Pilawuk Wilson was taught weaving by her maternal grandmother. A basket of hers was included in the exhibition *Women's Work*, Museum Victoria, 1992. An extremely skilled weaver, some of her large pieces, such as fishnets more than two metres in length, take many months to complete. Dye from a variety of plants is used to colour the fibre, which is then coiled, plaited or woven into baskets and dilly bags (wargarri).

The move to contemporary art by Peppimenarti artists started after Regina Wilson and her niece Theresa Lemon represented the community, at the invitation of Darwin art dealer Karen Brown, at the Contemporary Art Biennale of the Pacific Arts Festival in Noumea in 2000. Through meeting other women artists from across the Pacific and viewing the works on display, the Peppimenarti women's dedication and enthusiasm for contemporary art was solidified. On their return, the weavers started to experiment with painting, which resulted, almost immediately, in innovative canvases of great finesse.

Wilson's paintings were especially groundbreaking for her representation of the stitches and patterns of weaving in paint. Backgrounded often with a luminous coloration and using a softer, more neutral palette, her most enduring theme is the stitch and weave of the syaw (fishing net) – used to gather fish, prawns and other seafood and made from the fibre of the pinbin (bush) vine.

These fine works immediately captured the attention of art lovers and critics when exhibited at the National Aboriginal and Torres Strait Islander Art Award in 2001 and in a large display with Karen Brown Gallery at the Melbourne Art Fair in 2002. In 2003 Wilson won the NATSIAA General Painting Award, held exhibitions at Karen Brown Gallery and was represented by Agathon

Galleries in Sydney and Melbourne, 2005–06. In 2008 she was a finalist in the Wynne Prize at the Art Gallery of New South Wales.

Wilson also largely directs the Peppimenarti arts centre, which, after a chequered history of working with private dealers, opened a small new building Durrmu Arts and employed a coordinator, Harriet Fesq, in 2007. Other artists of the Wilson family include Regina's daughter, Anunciata, her elder sister, Mabel Jimarin, and her cousin, Patsy Marfura. They hold regular weaving workshops to maintain the skills taught to them by their mothers and grandmothers, and pass them on to the children of the community. Patsy Marfura's paintings, also based on weaving, are distinctly different in coloration and style to Wilson's. Her palette tends towards deeper shades of blues, greens and reds in patchwork-like patterns across the canvas.

One of the few men to take up painting at Peppimenarti was elder Pincher Talunga. He held exhibitions at Karen Brown Gallery, Darwin, and his 2005 exhibition at William Mora Galleries in Melbourne was a sell-out.

Since the establishment of Durrmu Arts in 2007, the artists of Peppimenarti have become more prolific, with exhibitions including those in Singapore, New Zealand, Sydney and Cologne. In 2008 Patsy Marfura was selected for the final *XSTRATA Coal Emerging Artists Award*.

Some Peppimenarti artists

Maryanne Dumbul, Kevin Gilbert, Linda Gilbert, Mabel Jimarin, Kathleen Korda, Margaret Kundu, Theresa Lemon, Patsy Marfura, Pincher Talunga, Rosina Tirak, Anunciata Wilson, Anne-Carmel Wilson, Regina Pilawuk Wilson, Nimbali Wilson.

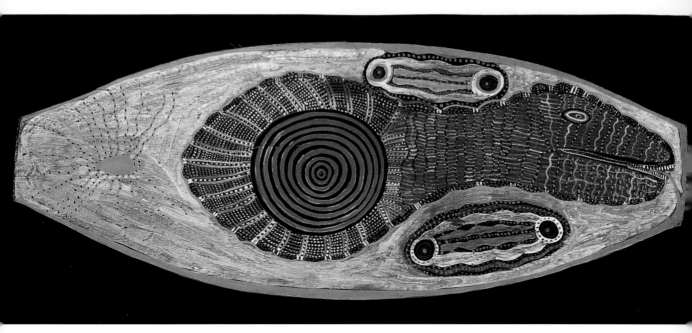

Bobyin Nongah, *Kungmanggurr Story (Spider and Snakes)*, pre-1963, ochre on bark, 21.5 x 71 cm. Private collection. [Courtesy Sotheby's.]

WADEYE
(Port Keats)
the art of 'Everywhen'

The largest Aboriginal community in Australia, with a population numbering around 2500, Wadeye (pronounced 'wad-air') has been of profound significance in the fields of anthropology, Aboriginal art and the Aboriginal land rights movement.

Situated on the west coast of the Northern Territory, approximately 420 kilometres by road south-west of Darwin, the port was named Port Keats after Vice-Admiral Sir Richard G. Keats during exploration of the region by Captain Phillip Parker King in 1819. It was not until the 1930s, however, that a mission was established.

The area encompassed the traditional land of the Kardu Dimarrin, the Murrinh-Patha (or Murrinbata) language group, with some 10 other language groups living in the surrounding area. The 'saltwater' people and inland 'freshwater' people were highly feudal. Many of these disputes continue today. Called the 'barbarous frontier' by anthropologist W. E. H. 'Bill' Stanner (1905–1981), the area was feared, partly because of its people's mercenary ways and because of the Aboriginal resistance leader Nemarluk (c.1911–1940) who murdered three Japanese shark fishermen, anchored near Port Keats, for encroaching on his territory.[1]

Nemarluk was a fierce warrior, a fully initiated man of magnificent appearance, who, along with members of his band of warriors, would attack travellers around the Moyle Plain and Port Keats. His posse, painted in red and armed with traditional weapons, would also engage in ritual blood-feuds with other Aboriginal groups. Nemarluk eluded police trackers for a long time, and even managed to escape from Fannie Bay Gaol in Darwin. He was romanticised by Ion L. Idriess in his book *Nemarluk, King of the Wilds* published in 1946.

In 1935 missionary Father Richard Docherty, with anthropologist W.E.H. Stanner and the Murrinbata people they had met in Darwin, set up a small mission at Werntek Nganayi (Old Mission), subsequently moving to the site known as Wadeye in 1939. Ever since, the community has been profoundly influenced by the Catholic doctrine.

The 'Everywhen'

The importance of the influence of Murrinbata art, particularly on the field of anthropology, was due largely to the work of two friends, Stanner and Murrinbata man Nym Bunduk (or Bandak, also Nimbandik) (1904–1974). A man of many talents – anthropologist, academic and military man – Stanner has been lauded by many, including historian Robert Manne who said of him: 'No one was of more significance…in my opinion…If [he was] not the greatest of the anthropologists…then certainly [he was] the most interesting writer on Aboriginal society Australia has ever seen'.[2] After helping to establish Wadeye, Stanner patrolled Australia's north, as part of the Australian army, with his famous 'Nackeroos', the North Australian Observation Unit. He is also credited with the popularisation of the term 'Dreaming' by naming his book *White Man Got No Dreaming*, derived from a quote by an Aboriginal friend.

Stanner himself preferred the term the 'Everywhen' to better encapsulate the timeless nature and breadth of Aboriginal cosmology. His education of the Australian public with his particular understanding of Aboriginal religion helped the Aboriginal land rights movement enormously. Amongst his dedicated work in the field of academia was the establishment of the Centre for Cross-Cultural Research at the Australian National University in Canberra.

The World of Nimbandik

In the early mission years, Stanner befriended the Murrinbata man Nym Bunduk (Nimbandik). When Stanner returned many years later, in 1958, he asked Nym Bunduk to paint a map of his country. The resulting paintings, including the *Map of Murrinhpatha* (exhibited in the National Gallery of Australia's 1993 *World of Dreamings* exhibition), provided much of the background for Stanner's essays on Aboriginal religion, later compiled in the book, *On Aboriginal Religion* published in 1963.

Nym Bunduk's paintings exemplify his complex view of Murrinbata cosmology. Like other Aboriginal bark paintings, many depict mythological totemic creatures such as the famous Rainbow Serpent, as well as other sacred snakes, emus, goannas, seabirds, brolgas and fish, along with important hunting figures, waterholes and ceremonial ground designs.

Aboriginal art curator Wally Caruana commented on the 'fluid lines' of Bunduk's paintings (painted on oval-shaped composite boards cut to represent the traditional wooden artefacts used for painting) and noted that they were a 'departure from the highly formal compositions on bark…which displayed many elements which were to appear some twenty and thirty years later in paintings by eastern Kimberley artists'.[3]

The comparison with eastern Kimberley art

'… a fierce warrior, and fully initiated man of magnificent appearance…his posse [was] painted in red and armed with traditional weapons…'

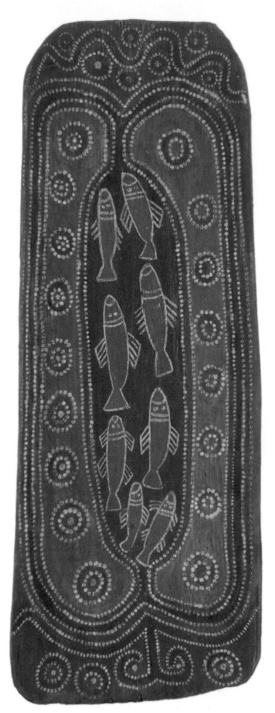

Nym Bunduk, *Sacred Waterhole with Fish*, c. 1960s, ochre on bark, 76.5 x 26 cm. Private collection. [Courtesy Mossgreen.]

An important cultural leader who worked to impart the culture of his country to a wider audience, Nym Bunduk's paintings such as this, which depicts the Rainbow Serpent, the billabongs and waterholes created, have become highly collectible.

is an indicator of the geographical location of Wadeye on the cusp of the desert, Kimberley and Top End regions. While community tensions and violence have often been the result of this complex social layering, Wadeye artists are in the unique position of being able to claim both artistic and ceremonial links with their neighbours to the north, east and south. These links, as curators such as Caruana and Margie West noted, have created strong design elements that are particularly impressive in the mid-20th century works.[4]

In keeping with the community's Catholic focus, which banned ceremonial activities for many years, Bunduk also painted a series of panels for the mission church built in 1961.

As West has noted, the history of art at Wadeye is not well documented (with the establishment of the mission, the Church had even destroyed the people's sacred ritual boards). Yet the local area abounds in cave paintings. Bark paintings were also produced during the 1940s by Nym Bunduk and others including Indji, Barri and Tjimari and sold through the mission. Others, including Charlie Mardigan and Charlie Rock Ngumbe, began to paint in the 1950s.[5]

Wadeye Today

After many failed attempts, Wadeye Art and Craft was eventually established in 1993. In 1998, as related in the documentary film *Art From the Heart* screened on ABC TV, the artists sold their own work from the back of the arts centre, but soon after, retail outlets were established both at the community and in Darwin.[6]

One of the most prominent contemporary artists, Timothy Dumoo, born in 1955 is known for his experimentation with painting. Another artist, Anthony Nemarluk, learnt traditional painting from his namesake, the resistance leader Nemarluk, at the age of nine. The tradition of ochre painting is seen in the palette of the Wadeye artists, who favour these colours.

The women's tradition of weaving remains strong, the production of dilly bags and mats are prevalent, using the fan palm (thithimambe) dyed with colours from traditional plants.

Arts centre, Wadeye (Port Keats). [Tourism NT.]

The famed toughness of the people has not diminished since the days of Nemarluk; over the past few years Wadeye has been in the media for gang violence. More than half the population of Wadeye is under 20 years of age. The local male gangs are influenced by the mercenary lyrics of heavy metal groups, with a major gang naming themselves 'Judas Priest', while the female gangs are, even more puzzlingly, known as Kylie Minogue and Celine Dion.[7] Most of these reports failed to notice the historical factors behind the town's frustrations. Anthropologists have noted that the church urged the antipathetic saltwater and freshwater people to live together in harmony, perhaps an overly optimistic proposal, leading to further feuding.[8] Much of the aggression is also caused by the lack of traditional pastimes of hunting and more modern station work. Instead of hunting magpie geese, young men hunt each other. Since 2000 there has been an increase in alarming reports of appalling conditions in the township, with overcrowding, poverty, child abuse and poor school attendance. The community was chosen for early Government intervention in 2007.

Yet art remains an important focus here. In 2000 Margie West noted that a least a quarter of the then 1200 residents were artists.[9] Art from Wadeye has been included in major exhibitions such as *Aratjara*, touring internationally, 1993–94; *Aboriginal Art in Modern Worlds,* State Hermitage Museum, Russia, 1999; and *Likan'mirri –Connections, Works from the AIATSIS Collection*, Drill Hall Gallery, ANU, Canberra, 2004.

In the mid 1990s a new air-conditioned art gallery, the Dirrmu Ngakumarl Gallery, was opened and tourists can now fly directly from Darwin and purchase paintings. According to one report, since 1997 as many as 126 locally based artists have sold works through the Dirrmu Ngakumarl Gallery or through the Wadeye Art and Craft store in Darwin.[10] The paintings are now mostly acrylic on canvas and have become more figurative and symmetrical than those of the 1940s and 1950s.

Some Wadeye artists

Birari, Nym Bunduk (or Bandak), Timothy Dumoo, Indji, Jarri, Francis Mardian, Charles Mardigan, Majindi, Leo Melpi Newili (Charlie Brinken), Anthony Nemarluk, Robin Nilco, B. Nongah, Simon Ngumbe, Basil Parmbuk, William Parmbuk, Tjimari, Aileen Warnin, Helena Warnir.

WADEYE

215

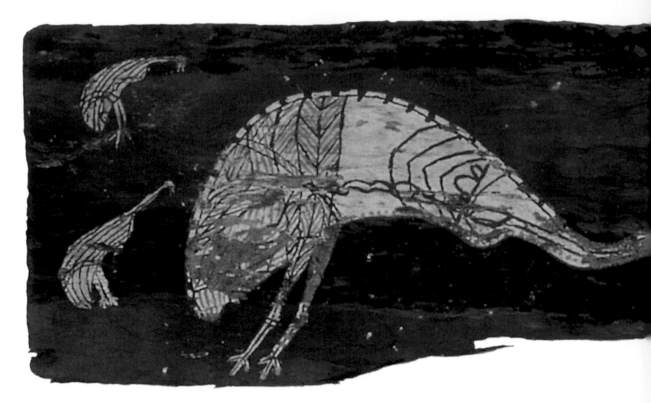

The settlement of Gunbalunya (Oenpelli) is situated on the western border of Arnhem Land, adjacent to the flood plains of the East Alligator River and 300 kilometres south of Darwin. Surrounding the small settlement are wide plains abundant with wildlife, rising to dramatic rocky escarpments containing the most extensive rock art galleries in Australia. The area is home to about ten language groups, most of whom speak the most common language, Kunwinjku, and whose ancestral land and related stories range across much of western Arnhem Land.

The name 'Gunbalunya' is an anglicised version of the Kunwinjku name 'Kunbarllanjnja' (the name of the council that manages some

500-square kilometres of the region including the main settlement). The name 'Kakadu' is an anglicised version of 'Gagadju', the main language group, and 'Oenpelli' derives from 'Unbalange' – the traditional owners' name for the region.

Thousands of tributaries, seeping over the flood plains from the East Alligator River, sustain vast quantities of wildlife including flocks of ibis, duck and other water birds that congregate to feed on the abundant fish and plankton. The significance of water is recognised by the Gunbalunya people, who call themselves 'Birriwinjku' – freshwater people.

Antiquity Meets Modernity in a Plentiful Land

Supplies of food and raw material for making utilitarian objects such as canoes, spears, boomerangs and shelters is in abundance, while the numerous caves in the rock escarpments, which feature throughout the land, make ideal cover during the prolonged wet from November to March. Traditionally, the Gunbalunya people also constructed bark shelters for this purpose. They decorated walls

GUNBALUNYA
A Land of Dramatic Contrasts

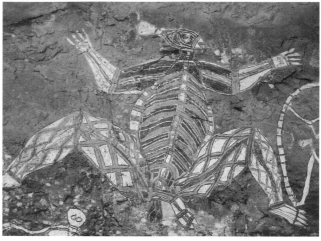

Rock art, Kakadu. [Tourism NT.]

LEFT: Artist unknown, *Emu and chicks*, c.1949, natural pigments on bark, 29 x 77.4 cm (irregular). Private collection. [Courtesy Deutscher Fine Art, 1989.]

Some of the earliest Aboriginal art in Australian museums was collected by locals such as buffalo hunter and pastoralist Paddy Cahill and ethnographers such as Baldwin Spencer and this bark (above left) by Charles Mountford.

of caves and bark shelters with paintings of spirit ancestors and flora and fauna. In 1912 ethnographer Baldwin Spencer commissioned the first large bark paintings – the earliest substantial collection of barks from Arnhem Land – based on the paintings made on such shelter walls. Images include the famous X-ray paintings (so called because the internal organs are revealed as well as the external features) of figures, animals, birds and fish, and those featuring the Mimih Spirits said to inhabit rock crevices, the Rainbow Serpent, the Lightning Man and many other creation beings.

By the early 1900s a settlement had grown up around Oenpelli that initially was an adjunct to service the permanent bases and homesteads of buffalo hunters such as Paddy Cahill in the early 1900s (buffalo hunting was banned during the Second World War but until then had been a substantial industry) and for visiting travellers, traders and workers. Paddy Cahill, whose station abutted Injalak Hill, learnt several Aboriginal languages and encouraged Aboriginal people to continue their tribal customs. He collected hundreds of artefacts and commissioned bark paintings (more than

100) for Baldwin Spencer and the Museum of Victoria. Later anthropologists who visited the area and recorded the way of life included Charles Mountford (American–Australian Expedition to Arnhem Land 1948, 1949) and Ronald and Catherine Berndt (1947, 1950).

In 1925 an Anglican mission was established under the Christian Missionary Society and in 1963 Gunbalunya was returned to Aboriginal control when it became part of the Arnhem Land Aboriginal Reserve. Today the population numbers around one thousand and includes more than two hundred painters, weavers, and other artists.

The Art of Injalak

Bark paintings, weavings, carvings, beads and other artefacts have been sold through various outlets at Gunbalunya for much of the twentieth century. The official arts centre, Injalak Arts and Crafts (named after the area's most notable rocky hill), was established in 1989 with its first manager appointed in 1991. Central to the long building is the original painting shed, flanked by long, covered verandas where artists paint, grinding and mixing the glues for painting on the adjacent ground. The arts centre is owned by the two hundred or more artist members and also services artists living at more remote outstations.

Bark continues to be a medium favoured by a number of artists. But, because of the demand for bark and the resulting damage to trees, works on paper primed with gouache have proved an extremely popular medium for Injalak artists. In 1991 US collector John W. Kluge commissioned 45 works on paper and produced a book on the collection.

Bark artists such as Lofty Bardayal Nadjamerrek, whose works have been

collected by leading galleries since the 1960s, translate paintings based on rock and bark art into masterful imagery on paper. Projects such as the 2006 Injalak Hill print project with Darwin's Basil Hall Editions, demonstrate the highly successful evolution of ancient rock art into many forms of new media while retaining the traditional cultural heritage.

Rainbow Serpent: creator of all

The creator of all is, for the Kunwinjku of Central Arnhem land, the Rainbow figure, Yingarna. An androgynous being, Yingarna's child Ngalyod, the Rainbow Serpent, is the creator of waterholes, rock formations and other natural phenomena, the maintainer of seasons and the guardian of sacred sites. Depictions of Yingarna and Ngalyod (called Borlung in some areas) are one of the main painting themes of Gunbalunya and throughout Central Arnhem Land from rock and bark art to contemporary works on paper such as Lofty Bayardal Nadjamerrek's classic 2007 painting in which Yingarna, is part fish, part animal with the waterlilies growing from her back, indicating her strong relationship with waterholes. Using fine cross-hatching to create effects of shimmer, many paintings, as curator Luke Taylor notes, demonstrate the relationship between the corporeal – the pythons which frequent the area and whose skins shimmer

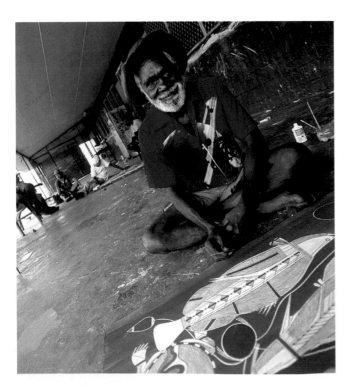

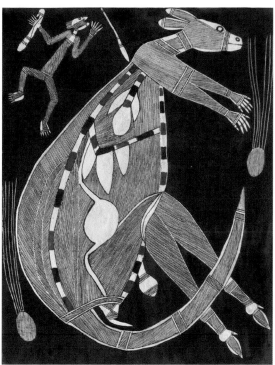

with rainbow effects – and the creation and ceremonial worlds. By the Kunwinjku's application of the finest of fine cross hatching the act of painting pays homage to and evokes ancestral power.[1]

Exhibitions in which works of Gunbalunya artists have appeared include those at the Museum and Art Gallery of the Northern Territory (MAGNT) under the curatorship of Margie West from 1974 to 1998, such as the 1995 *Rainbow, Sugar Bag and Moon*, featuring the work of Mick Kubarkku and Lofty Bardayal Nadjamerrek.

Injalak Arts and Crafts has also been instrumental in incorporating traditional weavings into the fine art domain, presenting the medium in commercial galleries and in major exhibitions in public galleries such as the 2001 *Twined Together* at Museum Victoria and the 2002 touring exhibition *Art on a String* organised by Craft Australia.

A permit is required to visit the community, but Injalak Arts and Crafts welcomes visitors and sells many works to the thousands of visitors who visit the nearby Kakadu region.

Some Gunbalunya artists

Mick Kubarkku, Paddy Nabamdjorie Malngurra, Gabriel Maralwanga, Yuwunyuwun Marruwarr, Lofty Bardayal Nadjamerrek, Jimmy Kalarriya Namarnyilk, Glen Namundja.

FAR LEFT: *Artists paint on the verandah at Injalak Arts and Crafts.* [Tourism NT.]

ABOVE CENTRE: Bardayal 'Lofty' Nadjamerrek, *Ngalyod Djang*, 2006, ochre on paper,152 x 51 cm. Private collection. [Courtesy the artist, Injalak Arts and Mossenson Galleries.]

RIGHT: Kalarriya 'Jimmy' Namarnyilk, Mimih Hunting Korlobarr (Big Red Kangaroo), 2003, ochre on paper, 76 x 102 cm. Private collection. [Courtesy the artist, Injalak Arts and Mossenson Galleries.]

Master Arnhem Land artist Lofty Bardayal Nadjamerrek is one of the custodians of the region whose art practice has included rock art in the early years of the 20th century to fine works on bark and paper.

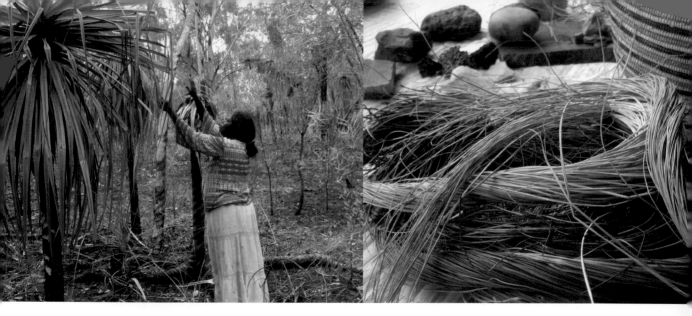

Milingimbi, 500 kilometres east of Darwin and half a kilometre from the coast, is one of the Crocodile Island group. Although the whole island is called Milingimbi, the name specifically refers to the island's main settlement area and its soakage spring. Commonly known as the 'Macassan Well' after the Macassan trepang harvesters who were constant visitors until the early 1900s, the 'well' is a natural spring and important meeting and ceremonial place for many tribal groups. According to Aboriginal lore it was created by the Rainbow Serpent.[1]

Huge tamarind trees line the sea-front of the small settlement town which is home to some 1300 people. Mangrove forests and mud-flats, rich in food such as large mud crabs and shellfish, lead from the white sands into fresh, clear waters, with small islands (many of which are homeland settlements) stretching into the Arafura Sea. The area's minuscule sand midges are known for their vicious bites; traditional preventative measures include

MILINGIMBI
A Rich Heritage

building enclosed bark huts, lighting numerous smoky fires, and using finely woven mats for protection.

Reverend James Watson of the Methodist Overseas Mission chose a site for a mission in 1916, and the building was completed in 1923. For many years, Milingimbi was the largest mission station in north-east Arnhem Land.[2] Home to at least eight different language groups including Grupapungu, Djambarrpuyngu and Lilyagalawumirri, the land on which the main settlement is located is Yirritja moiety (see p. 194) land belonging to the Batjimurrungu, Walamangu and other clans. The northern part of the island is Dhuwa moiety land belonging to the Gorryindin, Gamalangga and other clans. A 'sea closure' under the Northern Territory's Aboriginal Land Act applies. This extends seawards around Milingimbi for two kilometres from the average low water mark. Broadly, this prohibits non-Aboriginal people from entering and remaining in that area of sea country without permission. (Common-sense exceptions apply to this law, including an exception for those in transit.)[3]

In 1940, the mission undertook a contract to build a landing strip for the RAAF on Milingimbi. In 1942, the missionaries Harold and Ella Shepherdson relocated the Milingimbi sawmill and other equipment to Galiwin'ku (Elcho Island). The Japanese bombed Milingimbi on 9 and 10 May 1943. One Aboriginal was killed, others were wounded, and the raids caused substantial damage.[4]

Early artistic expression

Milingimbi has a long history of bark painting, carvings and weaving. Ethnographer Baldwin Spencer collected the first examples of this work in the early 1900s. Many later anthropologists and writers made it their base for field-trips. These include US sociologist William Lloyd Warner between 1927 and 1929 when he collected barks for the Australian Museum, Sydney, and researched his 1937 book, *A Black Civilisation*; Donald Thomson, who made it his base on a number of occasions in the 1930s; Charles Mountford; Ronald and Catherine Berndt; and writer Alan Marshall.[5]

During the 1950s teachers and missionaries, including the first missionaries Edgar and Ann Wells, actively encouraged bark painting and the making of artefacts. Milingimbi mission and its subsidiaries in Darwin and the southern cities were the main outlets for art from the area before settlements such as Ramingining were established. In 1954, works by Tom Djawa and Binyinyuwuy were entered into a national award, the Leroy-Alcorso Textile Design Competition for fabric design. They did not win the award but the National Gallery of Victoria (NGV) bought their works as decorative arts.[6]

Between 1948 and 1951 teacher, critic and artist Wallace Thornton bought many works from Milingimbi mission, a number of which were later acquired by Tony Tuckson for the Art Gallery of New South Wales (AGNSW). Dr Stuart Scougall also donated works to the AGNSW in 1959.[7]

LEFT TO RIGHT: *Milingimbi women, such as Lena Walunidjunali (left) cut pandanas leaves to dye for weavings. Painter Margaret Rarru Garrawurra (right) cuts bark for her award-winning paintings. The fish traps (centre) are made by Milingimbi women from pandanus while the group of works (right) demonstrates the variety of today's art from this important early art centre.*
[Photos. S. McCulloch.]

From 1961 teacher Alan Fidock further encouraged the acquisition of art by significant collectors including Tuckson for AGNSW and Karel Kupka for the Oceanic arts collection in France (now housed in the Musée du Quai Branly). Later collections include the 1970s collection of Ed Ruhe and Louis Allen from the USA, now largely in the collection of the Art Gallery of Western Australia (AGWA).[8]

In 1967 the practical mud-brick arts centre was built in the beachside location where it still stands; Fidock was its first manager. Djon Mundine was appointed art and craft adviser in 1979, working from Milingimbi and later Ramingining for the next ten years. He noted later:

> The role of the person in an art and craft adviser position at that time was to solicit, engender and stimulate art production from the local community, in forms that were meaningful in local terms. I had been told by people in the industry that there were three standards for judging the value of Aboriginal art: (1) a work's traditional status; (2) the technical soundness of a work's production;

(3) the aesthetics of a work. Interestingly, these criteria would now run almost in a reverse order, since perspectives on Aboriginal art have become more sophisticated.[9]

During the 1980s and 90s, Milingimbi as an independent arts centre was eclipsed by developments at the nearby mainland settlements of Maningrida and Ramingining. A number of artists were instrumental in establishing the Ramingining settlement and in developing its arts centre closer to their homelands. Sales of art at Milingimbi dwindled until 2004 when Milingimbi artists again employed a permanent manager.

From late 2005 Chris Durkin, former field officer at Papunya Tula Artists Pty Ltd, has been manager. The profile of the approximately 50 artists working through the centre lifted considerably through exhibitions in leading galleries and award-winning exhibitions around Australia.

Central Arnhem Land classics:
the art of Milingimbi

Milingimbi is well-known for figurative and abstract bark paintings as well as for a wide range of carvings including yidaki (didgeridu), hollow log coffins, ceremonial poles and figurative sculptures. Artists also make a wide range of weaving and shell and seed beads. Interest in weaving as an art form has especially gained currency during the 2000s with the exhibition of woven objects in the fine art domain.

Many famous 20th century central Arnhem Land artists have lived or spent time at Milingimbi. These include David Malangi, Dawidi Djulwarak (one of whose sons is well-known painter Philip Gudthaykudthay), Paddy Dhathangu, Micky Durrng, and many others whose paintings are in public collections but whose names weren't recorded.

Djang'kawu Sisters and the Ngarra ceremony

One of central-northern Arnhem Land's main creation stories is that of Dhalkurrngawuy

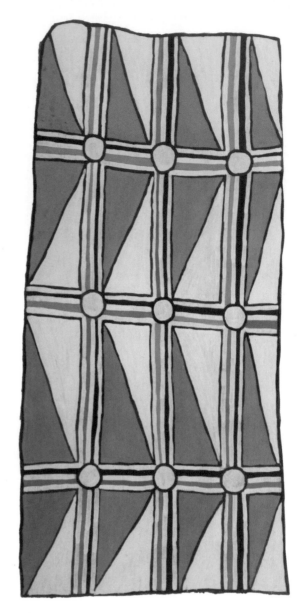

and Barradawuy, the two Djang'kawu Sisters who were responsible for creating the Dhuwa moiety (see p. 194). During creation time, the sisters travelled from the east, near Groote Eylandt, to the west throughout the lands of the Dhuwa clans, creating plants and animals as well as land forms such as waterholes and springs by piercing the ground with their digging sticks. One of the ceremonies associated with the sisters' travels is that of the senior men's ceremony called the Ngarra, held in the dry months (May–September) throughout central coastal areas. The sisters gave the designs and the colours miku (red), watharr (white) and buthalak (yellow) to paint with. These colours

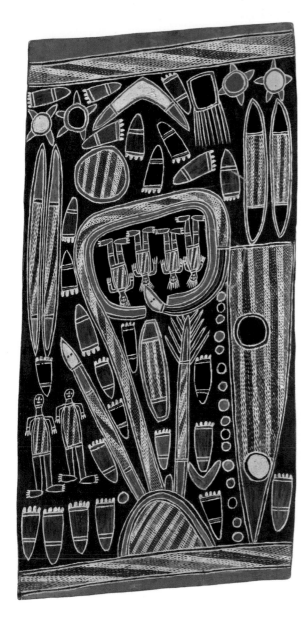

A major central Arnhem Land artist, Dawidi's painting depicts the most widespread of creation stories of central Arnhem Land – that of the two sisters who travel from east to west. Milingimbi artist Margaret Rarru Garrawurra portrayed another part of this story in her award-winning painting of the Ngarra ceremony.

are used in the bold sacred stripes of Djirrididi pattern used in the Ngarra ceremony. For many years, the only artists with authority to paint the Djirrididi were the brothers, the late Tony Dhanyala and Micky Durrng.[10]

'First we sing for travel and fish, then we sing for our totem Wadu (catfish), then we sing for Gapu (water). The Morning Star is next, then the bird Djirrididi. The last song is Welu (sun),' described the late Micky Durrng.[11]

The Ngarra ceremony relates partly to death and the preparation of spirits for their return from whence they came, but it is also a story of creation and regeneration. Before his death, Micky Durrng gathered his family to pass on rights

to paint the story. Senior Milingimbi artist and Micky Durrng's sister, Ruth Nalmakarra explained:

> Before, he [Micky] was the only one with the authority to paint these artworks. But before he passed, he talked to his brothers, sisters, sons, daughters and cousins and made them responsible for the stories. If we stop painting these stories, they will never happen again. We are continuing painting to pass it on to our youngest children.

'These artists are passionate about their traditional colours, designs and ceremonies. They adhere strictly to these traditions in their paintings,' said Milingimbi Art Centre's manager, Chris Durkin.[12]

In 2007, Margaret Rarru Garrawurra, sister of Micky Durrng and Ruth Nalmakarra, demonstrated the significance of this evolution when she won the bark award of the National Aboriginal and Torres Strait Islander Art Award with her painting *Ngarra Story*.

Some Milingimbi artists

Billy Black, Raymond Bulumbula, David Burmila, Joe Dhamanydji, Tony Dhanyala, Margaret Rarru Garrawurra, George Milaypurna, Ken Minyipirrwuy, Ruth Nalmakarra, Margaret Mantay, Gali Yalkariwuy Gurruwiwi, Colin Yirilil Dhamarnandji.

MILINGIMBI

Ramingining is a central Arnhem Land community 30 kilometres inland from the coast and 400 kilometres east of Darwin; residents include the Djadawitjibi people of the Djinang group. It was founded as a cattle station in 1977 by Aboriginals and missionaries from Milingimbi mission after some 15 years of searching for a suitable location. Artists such as David Malangi (1927–1999), Dawidi Djulwarak (1921–1970), George Milpurrurru (c.1934–1998) and many others of the region had sold works through the art and craft centre at Milingimbi from the 1940s. The largest missionary settlement of this region of Arnhem Land for many years, the island of Milingimbi, had become home to many coastal dwellers keen to move closer to their traditional country. When Ramingining was established, a number of Milingimbi residents and those from Darwin and other areas moved back to their homelands.[1]

In 1977 the Ramingining Arts and Crafts organisation was established with community worker Peter Yates employed as manager. There had long been interest in art from this area, which had been included in important collections such as those of Donald Thomson (for the Museum of Victoria), Charles Mountford during the American–Australian expeditions of the 1960s and Karel Kupka for works now in the collection of Musée du Quai Branly, Paris.

In 1979 Sydney exhibition director Nick Waterlow selected work by Djalambu Bunguwuy, David Malangi and George Milpurrurru for the Sydney Biennale, thereby placing Aboriginal art in a mixed exhibition of contemporary international art for the first time.

RAMINGINING
An Ancient Tradition
Re-Interpreted

In 1983 Ramingining artists Jimmy Barnabal, Joe Djembungu, David Malangi, Ray Munyal and Jimmy Wululu were represented in *Australian Perspecta* at the Art Gallery of New South Wales. In 1984–85 Sydney's Museum of Contemporary Art acquired a comprehensive specialist collection of around 220 contemporary Ramingining works by over 70 artists.

The art of Ramingining, known for its striking bark paintings, weaving and ceremonial poles, also became the subject of a copyright *cause celebre* in 1966 when the Reserve Bank of Australia included a section of artist David Malangi's work *The Hunter* on Australia's new decimal one dollar (paper) note without his knowledge or consent. Malangi's painting had been purchased by Hungarian art collector Karel Kupka three years before for a French collection. Designer Gordon Andrews was given a photograph of the work and incorporated a line interpretation of Malangi's painting into his design. The image was recognised by a former teacher at Milingimbi and others who knew Malangi's work. The story of the stolen design reached the press, causing severe embarrassment to the then Governor of the Reserve Bank, Dr H. C. (Nugget) Coombs, a well-known champion of Aboriginal rights who had assumed the image had been derived from some 'anonymous and probably long dead artist'. Compensation, which included a $1000 fee and a silver medal, was organised for Malangi.

The image used on the one dollar note was of Gurrmirringu, a great ancestral hunter and one of Malangi's main themes represented throughout his art, such as the c.1968 carving, *Gurrmirringu's Wife*. Its clear incision and confident placement of design based on a body 'paint-up' for ceremony demonstrates Malangi's precise and clear placement of design that made his work outstanding.

Two of the most significant themes of central Arnhem land art featured in much of Ramingining art include Witij (the Great Python) and the journeys of the Wagilag Sisters. Leading Milingimbi/Ramingining artist Dawidi Djulwarak (1921–1970) became entitled to paint the entire

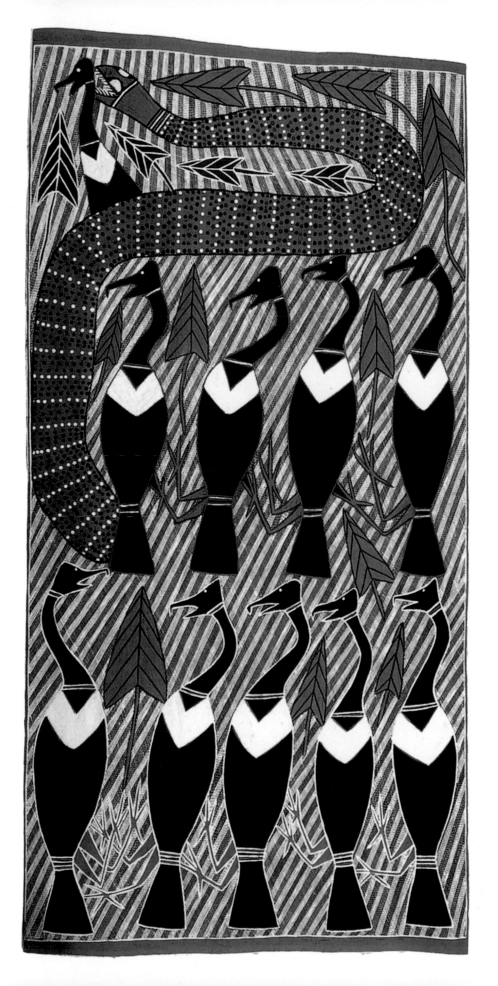

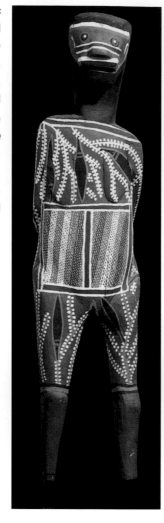

David Malangi, *Gurrmirringu's wife*, c.1968, ochre on carved wood, h. 85 cm. Private collection. [Collection J. Davidson, 1960s. Courtesy estate of the artist, Bula'bula Arts and Sotheby's.]

PREVIOUS PAGE: George Milpurrurru, *Gurrumatji magpie geese and water python*, 1987, ochre on bark, 158 x 77 cm. National Gallery of Australia. [Courtesy Bula'bula Arts and NGA.]

Wagilag Sisters story in 1963. Ramingining is also famous for the 1988 work *The Aboriginal Memorial* commissioned by the National Gallery of Australia to mark the indigenous aspect of Australia's Bicentennial year. Working with one-time Ramingining arts centre manager, then NGA curator, Djon Mundine, 43 artists including Paddy Dhathangu, David Malangi, George Milpurrurru and Jimmy Wululu worked on the project comprising 200 hollow log coffins to mark each year of white settlement of their land.

A Dynamic and Versatile Art Practice

In 1990, in response to a growing need for a community-based arts centre, the artist-owned Bula'bula Arts Aboriginal Corporation was created. 'Bula'bula means the 'tongue', 'voice' or 'message' of the Kangaroo (Garrtjambal), the area's principal creator.

In 1991 a new arts centre was built in an elevated timber building with side-verandahs and shaded by lush rainforest foliage. A dynamic and versatile art practice of Bula'bula's approximately 200 artists has included the production of silkscreened, limited edition T-shirts in the 1990s and the establishment of an ongoing school of printmaking. Ramingining artist George Milpurrurru was offered a retrospective exhibition at the National Gallery of Australia (NGA) – the first Aboriginal artist to hold a retrospective in a major public gallery. Milpurrurru's paintings such as the 1987 *Gurramatji, (Magpie Geese) and Water Python* have a strong sense of balance and are distinguished by a boldly delineated design incorporating figurative imagery with abstract clan design. Other important contemporary exhibitions in which Ramingining art has featured include *The Painters of the Wagilag Sisters*, NGA, 1997; *The Native Born*, Museum of Contemporary Art, Sydney, and touring, 2001–03; and the solo touring exhibition of works by David Malangi, *No Ordinary Place: The Art of David Malangi*, NGA and touring, 2005–06.

In 2006 Ramingining came into the public spotlight as the home base for the film *Ten Canoes*, directed by Rolf de Heer, based on Donald Thomson's photographs of the region and its people in the 1930s. In 2007 Philip Gudthaykudthay was featured in the NGA's inaugural major triennial of Aboriginal art, *Cultural Warriors*.

Some Ramingining artists

Djardi Ashley, Namyal Bopirri, Burandai, Dawidi, Mick Daypurryun, Paddy Dhathangu, Jimmy Djelminy, Dorothy Djukukul, Tom Djumburpur, Robyn Djunginy, Charlie Djurritjini, Philip Gudthaykudthay, David Malangi, Wally Mandarrk, George Milpurrurru, Jimmy Moduk, Jimmy Wululu. Fibre artists include Judy Baypangala, Elsie Bulung, Elizabeth Djuttara, Robyn Djunginy, Elsie Ganbada, Clara Matjandatjpi (Wugukwuguk) and Nellie Ngarridthun.

Around 50 kilometres north-east of Milingimbi is Galiwin'ku (Elcho Island). Approximately 50 kilometres long and six kilometres wide, it is the second-largest Aboriginal community in the Northern Territory with main languages Djambarrpuyngu and Gupapuyngu and at least 12 other language groups. Elcho Island has a fluctuating population of around 2000, many of whom have close ties throughout north-east Arnhem Land. It was returned to Aboriginal control in 1974.

The community of Galiwin'ku, at the southern end of the island, was established by lay minister Harold Shepherdson as an outpost of Milingimbi Methodist mission in 1942. It was given its English name, Elcho, after a British naval commander, Lord Elcho. During World War II many Yolngu as well as white workers and equipment such as the Milingimbi sawmill were relocated to Elcho. The influx of people at this time is one reason for the island's many different clan and language groups. Another reason is that the island's mission became a major foster home for part-Aboriginal children removed from many other areas in Australia over several decades from the 1950s.

As anthropologist Ian McIntosh in the *Oxford Companion to Aboriginal Art and Culture* notes, Galiwin'ku is known internationally for two reasons: 'the richness of its Yolngu heritage; and the touring 'black crusade'.[1] – the island's Christian brigade. Significant in the history of the island was the 'adjustment movement' (as it was named by anthropologist Ronald Berndt in 1962) in the 1950s. The aim was unification between black and white, and for Aboriginal people at Elcho living away from their homelands to adjust to different lands and customs. To symbolise this, in 1957 a group of carved and painted sacred totem poles, previously unseen other than by participants in men's ceremonies, was erected on the island's beach near the mission church. Each of the island's clan groups was represented by at least one pole. With a cross added to one, the poles also acknowledged the significance of Christianity. In 1993, a traditional Ngarra ceremony was held near the poles. In

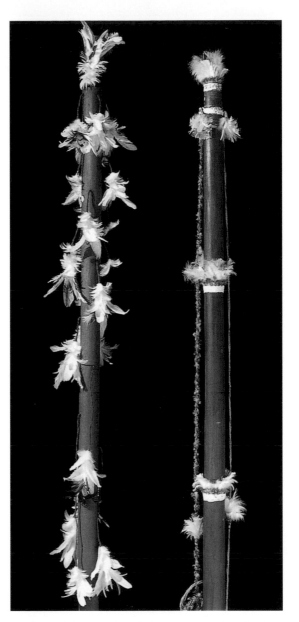

Madjuwi, *Morning Star Poles*, 1979, string, feathers, ochre on wood, 102 x 5 x 5 cm. Collection, Museum and Art Gallery of the Northern Territory. [Courtesy MAGNT.]

GALIWIN'KU
(Elcho Island)
Land of the Morning Star

Sylvia Mulwanay, *Macassans arrive at Elcho Island*, 1998, ochre on paper, 152 x 103 cm. Collection Museum and Art Gallery of the Northern Territory. [Courtesy the artist, Elcho Island Arts and Crafts and MAGNT.]

The feathered Morning Star poles are a feature of Elcho Island art as are ochre on paper paintings, often featuring whites as a significant colour and relating events such as the frequent visits by the Macassans in centuries past.

1997, to mark their 40th anniversary, a brush hut cover and fence was built to protect the carvings and the graves next to them.[2]

Elcho Island Arts was established shortly after the mission itself, selling works through Milingimbi mission and other outlets until 1992 when the arts centre at Elcho opened its own premises in a long-roomed clifftop building that was originally the island's hospital. Managers for much of the 1990s were Steve and Brenda Westley who strongly promoted the work of Elcho Island in southern galleries.

Individuation within tradition:
the art of Elcho Islanders

Media includes bark painting, weaving, sculpture, yidaki (didgeridu) and the morning star poles, or banumbirr, which are especially notable for their beauty and ceremonial significance. As well as ceremonial performances and song cycles that connect clans and the whole life-cycle from birth to death, the strings of the poles connect the deceased's soul to its resting place. Beautifully decorated with ochre, feathers, woven string and shells, the poles also represent spiritual ancestors who pulled the star into the sky from the east at dawn.

Exquisite jewellery such as delicate feather-decorated shell and seed necklaces are also featured, as are strongly woven and often large fishing nets, bags and other twine-based weavings, as well as a large variety of pandanus bags and baskets. Some works on paper and bark also feature figurative imagery with Aboriginal iconography and extensive use of white. Elcho Islanders have also had long contact and association including inter marriages with the Macassans – and whose stories and images depicting their visits are often seen in Elcho Island art.

Exhibitions in which Elcho Island artists have featured include regular inclusions in the National Aboriginal and Torres Strait Islander Art Awards well as solo and other exhibitions in leading private galleries. These include *The Elcho Island Story,* Kimberley Art, Melbourne, 1997; *The Inspired Dream*, (MAGNT), 1988; *Aboriginal Art: The Continuing Tradition*, (NGA), 1989; *Keepers of the Secrets: Aboriginal Art from Arnhem Land*, (AGWA), 1990; *Dreamings*, Asia Society Galleries, New York, 1990; *The Art of Place*, Australian Heritage Commission, Canberra, 1998; *Emerge: Discovering New Indigenous Art*, MAGNT, 2003.

Some Elcho Island artists

George Liwukan Bukulatjpi, Charlie Matjuwi Burarrwanga, Peter Datjin Burarrwanga, Sylvia Mulwanany, Burarrwanga, Mick Daypurryun, Elizabeth Djandilnga-Thorne, Johnny Djilipa Garrawurra (No. 1), Wilson Manydjarri Ganambarr, John Mandjuwi, Terry Dhurritjini Yumbulul.

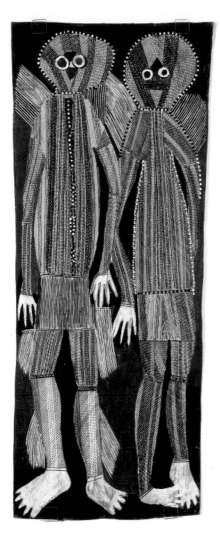

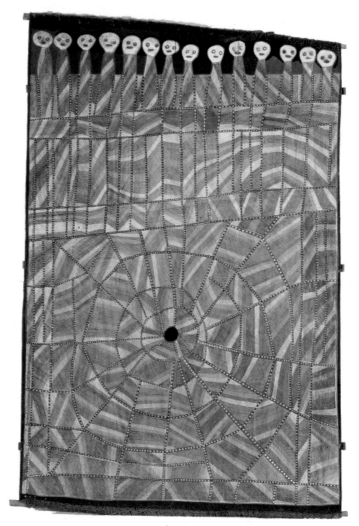

Bound by the Arafura Sea to the north and the Liverpool River to the west, Maningrida is located 400 kilometres east of Darwin. Its 10 000 square kilometres, 32 outstations and main town are managed by the Bawinanga Aboriginal Corporation. Maningrida evolved from a mid-20th century trading post that was established in 1947 and by 1957 it was a settlement of around 500 people. By the year 2000 there were more than 2000 residents.

The coastal area is rich in plant, land and sea life. There are more than ten language groups in the Maningrida region, the main one being Ndjebanna. Others include the Kunwinjku of the west, the Rembarrnga and Dangbon of the south and the Gurrgoni and Djinang of the east. The name Maningrida is an anglicised version of the Ndjebbana name, 'Manayingkar'rra' from the phrase 'Mane djang karirra', meaning 'the place where the dreaming changed shape'.[1]

LEFT: Peter Maralwanga, *Two Mimih Spirit Figures*, c.1970s, ochre on bark, 146 x 72 cm. Collection, Edith Cowan University. [Courtesy Maningrida Arts & Culture and Edith Cowan University.]

ABOVE: John Mawurndjul, *Ancestors at Milmilmingkan*, 1994, ochre on bark, 168 x 110 cm. Private collection. [Courtesy Maningrida Arts & Culture and Joel Fine Art.]

MANINGRIDA
Art in the Land of Diversity

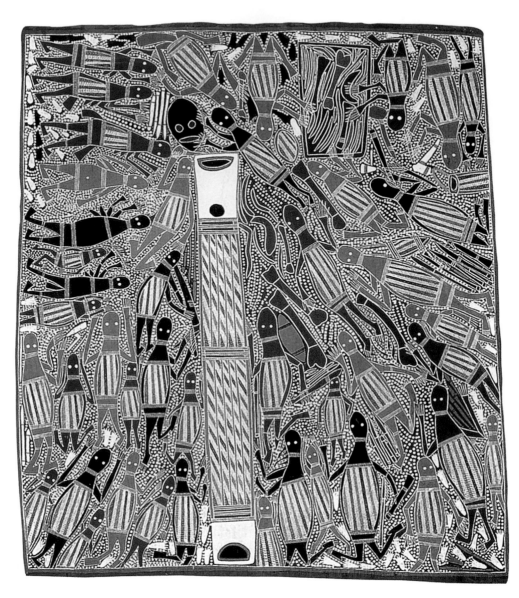

John Bulun Bulun, *Mortuary story*, 1982, ochre on bark, 111 x 97.1 cm. Museum and Art Gallery of the Northern Territory. [Courtesy Maningrida Arts & Culture and MAGNT.]

This intricate and lyrical work depicts the final stages of a burial ceremony in which the deceased's bones are broken and placed in a hollow log coffin.

Maningrida Arts & Culture

One of the largest Aboriginal arts centres in Australia, Maningrida Arts & Culture co-operative represents more than 800 artists. The centre occupies a one-time soup kitchen and mechanical workshop that had become unable to accommodate the growth of art production and activities which had increased enormously since early 1900. In 2008 plans were established for a new and larger centre costing over $3 million.

A short distance from the centre is the Djomi Museum, which opened in 1980 and was refurbished in 1990. Its purpose is to hold some of the area's finest cultural material for the community, to benefit younger generations, and to present for visitors an encyclopaedic historical and contemporary display as an

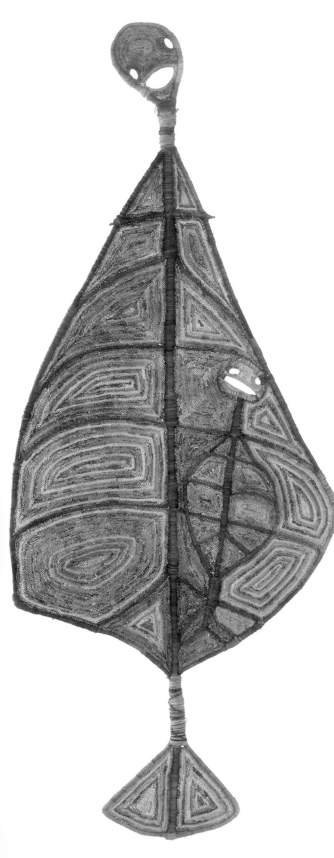

introduction to Maningrida art and craft.

Maningrida Arts & Culture evolved from the sale of bark paintings and art from the early days of the settlement, As professor Jon Altman has noted, Maningrida Arts & Culture evolved from the sale of bark paintings and art from the early days of the settlement and especially from 1963 when chaplain, Reverend Gowan Armstrong, inspired by arts practices on Goulburn and Milingimbi islands, set up a room under the manse from which to sell art and craft.[2]

From 1964, noted Altman, there was regular accounting for arts and crafts in Maningrida's annual reports with sales rising to around $20 000 in 1971. The enterprise was almost exclusively a program aimed at self-employment and income rather than culture. In 1968 it was decided that an arts and crafts centre should be built. It opened in 1973 and moved to the current location in 1992. The arts centre operated as Maningrida Arts & Crafts until 1997 when its name changed to Maningrida Arts & Culture.

The first art advisers were Dan Gillespie and Peter Cooke. With assistants, who included artists Peter Bandjurlurl and John Bulunbulun, they made a concerted effort to supply materials and collect work from the numerous outstations. In the first six years, despite setbacks such as Gillespie's and Cooke's removal from their positions by the Commonwealth Government, sales grew steadily and some important exhibitions for individual artists were held. Cooke was re-appointed several years later and continued his work, which included the establishment of the Djomi Museum in 1980. Art advisers during the 1980s included

Anniebelle Marrngamarrnga, *Yawk yawk*, 2007, pandanus spirals, n.s. Finalist National Aboriginal and Torres Strait Islander Art Award, Darwin, 2007. [Courtesy the artist, Maningrida Arts & Culture and Museum and Art Gallery of the Northern Territory.]

Imaginative fibre weavings have become a characteristic of women's art of this rich art-producing region.

artists Geoff Todd and George Burchett, curator and writer Djon Mundine, Burarra man Charles Godjuwa and curator and fibre art specialist Diane Moon, who encouraged women's art practice and helped place Maningrida art and artists into the wider fine art arena. Moon also worked with rock art researcher and linguist Murray Garde to establish a cultural research office. Later advisers Andrew Hughes, Fiona Salmon and others continued to foster the centre's success. When the French curator and art historian Apolline Kohen was appointed manager in 2002, the scope and facilities for Maningrida art dramatically increased.[3]

By 2008 annual sales at Maningrida Arts & Culture exceeded $2 million. Other highlights include John Mawurndjul receiving the 2003 Clemenger Contemporary Art Award, held at the National Gallery of Victoria, and the commissioning of one of his designs for the Musée du Quai Branly in Paris. In addition, a number of international art exhibitions of the work of Maningrida artists have toured Europe, UK, USA and the United Arab Emirates, and a major survey exhibition, *Crossing Country: The Alchemy of Western Arnhem Land Art* was held at the Art Gallery of New South Wales in 2004–05.

Maningrida women, who in the past assisted their husbands and fathers in the male-dominated field of bark painting, have now become artists in their own right. Dorothy Galaledba, daughter of the late England Banggala (1925–2001) won the bark-painting category of the National Aboriginal and Torres Strait Islander Art Award (NATSIAA) in 2000. Fibre artist Lena Yarinkura has received wide acclaim for her innovative fibre sculptures and has twice won the three-dimensional award at the NATSIAA

In 2004 Maningrida Arts & Culture opened a retail outlet in Darwin to sell prints, necklaces, baskets, fibre sculptures, small bark paintings, timber and metal sculptures. Maningrida Arts & Culture Darwin also presents exhibitions such as a Christmas show aimed at the local market and an exhibition coinciding with the Museum and Art Galleries of the Northern Territory's NATSIAA

opening. Maningrida manager Apolline Kohen was also responsible for organising Darwin's first indigenous art fair held in August 2007.

Freedom, Vigour and the Ability to Innovate: The Artists of Maningrida

Maningrida art is characterised by a diversity of media. Bark painting is predominant, but sculpture and carving (including painted hollow logs and the didjeridu) are also significant representations of Maningrida art and culture, as is weaving and jewellery-making. The fibre arts are particularly strong, with approximately 60 per cent of Maningrida women artists producing ceremonial regalia for sale, such as dancing-belts, armbands, headbands, bark-fibre skirts, woven sculptures and a large range of basketry, mats and other weaving.

Printmaking

In 1979 John Bulunbulun and David Milaybuma produced with Port Jackson Press, Melbourne, the first limited edition prints by Aboriginal artists to be widely marketed. In 1983 John Bulunbulun and England Banggala produced lithographs at the printmaking workshop in the Canberra School of Art. Since then, many printmaking workshops have been held, including with Charles Darwin University's Northern Editions printmaking studio and with individual printmakers. Women artists such as Kay Lindjuwanga have become especially involved in printmaking.

Fibre and Carvings

Maningrida weavings include coil-woven baskets and similar items; tightly-woven, almost solid string conical bags and the looser, open weave of the well-known dilly bags. Fibres of the pandanus and other plants are stripped and dyed with natural plant dyes made from roots, leaves, twigs and ash to create subtle shadings of yellows, reds, browns, purples and orange. Bags and baskets are often decorated with feathers, seeds, shells and other materials, while huge mats are intricately woven in flat form.

During the 1990s, weavings such as huge fishing nets and string bags were displayed as

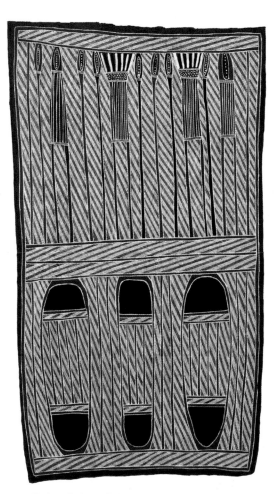

John Bulun Bulun, *Bakarra*, 2007, ochre on bark, 121 x 67 cm variable. Private collection. [Courtesy the artist, Maningrida Arts & Culture and Alcaston Gallery.]

LEFT: Samuel Namunjdja, *Yabbi site*, 2007, ochre on bark, 156 x 59 cm. Private collection. [Courtesy the artist, Maningrida Arts & Culture and Niagara Galleries.]

fine art in leading galleries including Sydney's Museum of Contemporary Art, which houses a substantial collection of modern Maningrida art. Artists such as Lena Yarinkura, Carol Liyawanga, Marina Murdilnga and others have also taken fibre into new and exciting realms – their large and complex sculptures often feature a wide variety of figurative representations of spirit ancestors, birds and animals.

Carvings of traditional ceremonial poles and hollow logs (lorrkon) are also a feature of Maningrida art, as are the spirit figures such as the Mimih and the mermaid-like yawkyawks.

Experiments with material

Maningrida artists have resisted using synthetic or manufactured materials, although there was some experimentation with ochre on canvas for several years from the mid 1980s. The late Lin Onus, a Melbourne artist who regularly visited Maningrida in the 1980s and 1990s, related that the late Jack Wunuwun had experimented with painting on canvas. The practice did not take off, Onus believed, because of the preferred painting surface of bark and a desire to stick to traditional ways. On one of Onus's visits he described the excitement of some leading artists in discovering new colours such as a green. 'My understanding in conversations with George Garrawun who seemed to pioneer the use of

green was that green was a "nothing" colour', said Onus. 'Therefore he was able to experiment with imagery and concepts that would ordinarily fall outside his proscribed moiety entitlements.'

Les Mirrikkuriya and others at Maningrida's Cadell outstation showed even greater breadth of coloration including pinks, browns, greens and occasional mauves. Onus also asked Jack Wunuwun about the use of a brilliant orange that he had not seen before. 'He told me the colour was "airstrip" and mined from a small deposit of ochre at the southern end of the Maningrida tarmac', said Onus.[4]

Arts centre manager Apolline Kohen notes that she believes artists have not adopted the use of canvas because their painting techniques and the effects of rarrk (cross-hatching) do not look as effective on canvas and paper surfaces.[5]

The paintings of Maningrida artists are also highly individual and distinguished by a strong freedom of expression, such as John Mawurndjul's paintings which show the fine rhythmic quality of his line work. 'One of the exciting things about Maningrida art is its vigour and that artists have the freedom to innovate,' noted cultural advisor Murray Garde. 'Within traditional iconography artists create works of great individual difference.'[6]

Figuration features in a number of paintings while others are of more abstracted design.

The works of Maningrida artists have featured in numerous significant exhibitions such as *The Inspired Dream*, Museum and Art Galleries of the Northern Territory (MAGNT), 1988; *Windows on the Dreaming*, National Galley of Australia, 1989; *Spirit in Land*, National Galley of Victoria, 1990; *Aratjara*, Düsseldorf and touring, 1993–94; *Rainbow Sugarbag and Moon*, MAGNT, 1995; *Maningrida: The Language of Weaving*, Australian Exhibitions Touring Agency, 1995; *Men of High Degree*, National Gallery of Victoria, 1996; *Bush Colour: Works on Paper by Female Artists from the Maningrida Region*, Maningrida Arts & Culture / NT University Art Gallery, 1999; *Transitions*, MAGNT and touring nationally, 2000; and the large survey exhibition, *Crossing Country*, Art Gallery of New South Wales, 2004–05.

Maningrida has also worked with leading galleries such as Sydney's Annandale Gallery in exhibitions such as *Rarrk! Flowing on from Crossing Country*, Sydney, 2005; and those of individual artists such as John Mawurndjul. In Melbourne's Gallery Gabrielle Pizzi holds regular Maningrida exhibitions on a particular theme such as *Fibrework – Spirit Beings and Animals* (by Lena Yarinkura, Carol Liyawanga and Marina Murdilnga), 2006; *Lorrkon, Spirit Beings and Fibrework*, 2007. Works by other artists such as Samuel Namunjdja are shown at Niagara Galleries, Melbourne, in solo exhibitions.

The commissioning of 'big' barks had been requested by early collectors such as Baldwin Spencer who wished to replicate, as closely as possible, the size of paintings on bark shelters on which the commissioned paintings are based. Many smaller barks have always been produced for practical reasons such as transportability and durability, but from the 1990s a noticeable trend in Maningrida and in north-east Arnhem Land's Yirrkala has been an increase in the size of barks and sculptures. The work of newer generations has also long been encouraged. Many, such as Susan Marawarr and Kate Miwulka, are relatives of older artists. Kay Lindjuwanga (married to artist John Mawurndjul) and her brother Samuel Namunjdja are children of the late Peter Marralwanga. Their award-winning paintings are highly individual yet continue their father's and forebears' legacy, as do many of the other artists from this rich area of art and culture.

Some Maningrida artists

John Bulun Bulun, Tommy Gondorra Steeke, James Iyuna, Crusoe Kuningbal, Crusoe Kurrdal, Kay Lindjuwanga, Peter Marralwanga, Susan Marawarr, John Mawurndjul, Les Mirrikkuriya, Samuel Namunjdja, Terry Ngamandara, Irenie Ngalinba, Jimmy Njiminjuma, Jack Wunuwun, Owen Yalandja, Lena Yarinkura, Billy Yirawala.

Some carvers of the lorrkon (hollow-log coffins)

James Iyuna, John Mawurndjul, Ivan Namirrki, Jimmy Njiminjuma, Timothy Wulanjbirr.

Approximately six hundred and fifty kilometres from Darwin and 50 kilometres off the eastern coast of Arnhem Land, Groote Eylandt was sighted by Dutch seafarers in 1623. It was named by Abel Tasman in 1644, using the archaic Dutch for 'large island'. The island's clans include Warndiliyaka, Warnungawerrikba and Warrnumgwamakwula and the predominant language is Anindilyakwa. Groote Eylandt was little known by much of Australia until 1921 when the Anglican Church Missionary Society established a mission at Emerald River. This was moved in 1943 to the present main community site of Angurugu in the west when the Emerald River airstrip was taken over by the RAAF.

Another settlement at Umbakumba (Port Langdon) on the north-east coast was established in 1938 by former patrol officer Fred Gray, who aimed to establish a non-denominational farm and settlement for Aboriginal people. This also became a Qantas flying-boat base.

The island long had contact with and was a base for the Macassans, who had established at least one camp there to boil and cure bêche-de-mer (sea cucumber) – a delicacy in many Asian cuisines.[1] The last Macassan ship, or prau, to visit the island was in 1907. After this time, other countries were prohibited from fishing in Australian waters. Yet the influence of the Macassans remained significant on the island for many years, with a number of barks from the 1930s featuring depictions of Macassan people, boats and their catch.

Anthropologist Donald Thomson, who visited Groote Eylandt a number of times between 1935 and 1943 noted that, compared to other areas of Arnhem Land, the women had been particularly secluded on his first visits, and no strange man was permitted to see them. They carried screens to conceal themselves, most likely from Macassans. No woman, he notes, was seen by the first missionaries for the first four years of the mission station in the early 1920s.[2]

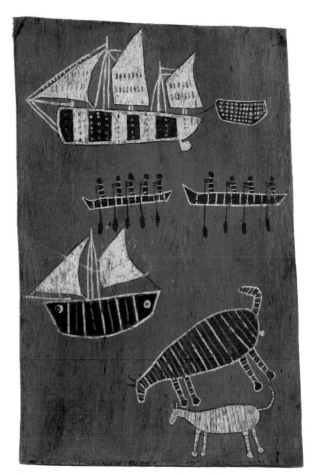

Qartpot Nangenkibiyanga Wurramarra, *Missionary boat* Holly *with dinghy, canoes with paddling figures, Fred Gray's boat* Obituli *and goats*, c.1941–45, ochre on bark, 46 x 29 cm. Photo.Andrew Curtis. Collection, University of Melbourne. [Courtesy Ian Potter Museum of Art.]

Early art developments

Paintings such as the narrative painting above, showed life on the island in the early years. This was one of a number of examples of

GROOTE EYLANDT
Narrative meets Tradition

'...he refused to give religious teachings – a stance that caused him to become the subject of hostile criticism from missionaries.'

Groote Eylandt work collected by ethnographer Leonhard Adam to whom Gray had sent works from the 1940s to the early 1950s for the University of Melbourne. A number of these featured in a 2006–07 exhibition *Creation Tracks and Trade Winds: Groote Eylandt Paintings from the University of Melbourne Art Collection*, curated by Joanna Bosse in consultation with the Groote Eylandt community.

Writer Alan Marshall, who visited Gray's home on Groote Eylandt in 1948, noted that it was 'not his [Gray's] object to destroy the native culture' and that he refused to give religious teachings – a stance that caused him to become the subject of 'hostile criticism from missionaries'. Rather, Gray encouraged the continuation of traditional social structure and practices of the approximately 150 indigenous residents. He established a large garden, imported some cattle and aimed to start a school. [3]

Gray also actively promoted the making and sale of paintings, which may account for the comparatively large number of Groote Eylandt works of the era that have long appeared on the secondary market and in public collections, and for the increasing refinement of style during the 1930s and 1940s.

The 1944 painting by Minimi Numalkiyiya Mamarika *Excavation of Stone Axe-heads During the Building of the Dam at Umbakumba* was illustrated in the 1964 book *Aboriginal Art* edited by Ronald Berndt and exhibited in *Creation Tracks and Trade Winds*, 2006–07. The painting shows a mix of the contemporary and ancestral in its documentation of the building of the dam, at Umbakumba in the 1940s and the ceremonial axes uncovered while working on the project.

Narratives such as this and those relating to the Macassans as on p. 18, featured in the first-known works from the area collected in 1921

by Norman Tindale for the South Australian Museum. Tindale noted that Groote Eylandt people painted on a range of surfaces including their own bodies, ceremonial objects, paddles, spear-throwers, spears and wet-weather bark shelters. Other collectors included Charles Mountford (1958) and Helen Groger-Wurn (1969). [4]

The economy, culture and life of the island changed dramatically with the discovery of manganese near Angurugu. As early as 1803, Matthew Flinders had observed the presence of ironstone and quartz on the island. In 1907 the South Australian Government geologist noted manganese outcrops, but it was not until 1955 that commercial samples were taken from the island. Between 1960 and 1963 negotiations between Broken Hill Proprietary (BHP) and the Church Missionary Society (representing the local Aborigines) worked out royalty payments and agreements that allowed large-scale mining to start. In 1964 the BHP subsidiary, Groote Eylandt Mining Company (GEMCO) was granted mining rights and established a large manganese mine at Alyangula on the north-west side of the island.

Images Against the Dark:
The Paintings of Groote Eylandt

As island dwellers, the Anindilyakwa people of Groote Eylandt and the adjacent Bickerton Island developed their own distinctive social organisations, ceremonies and styles of painting that largely consist of rock art, and is plentiful throughout the island.

As curator and author Margie West noted, 'Stylistically Groote Eylandt art is quite distinctive, particularly in the use of decorative detail based upon dashes, parallel lines and herringbone motifs'. [5] West also observed stylistic differences between the art from Umbakumba in the north-

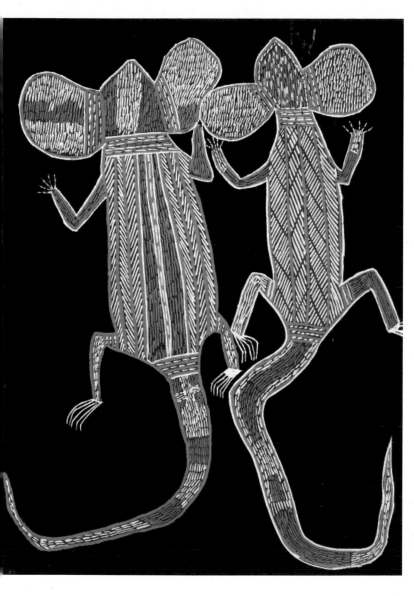

Nandabitta, *Water Monitors*, c.1970, ochre on bark, 63 x 74 cm. Private collection. [Courtesy Sotheby's.]

Pictures of sea creatures, flora and fauna with cross hatching clearly etched against a darker or lighter ground are characteristic of Groote Eylandt art from the early to mid 20th Century.

east and that of Bickerton Island, whose people were moved to Angurugu in the west. Their greater proximity to mainland influences is reflected in the more abstracted patterning seen in other parts of Arnhem Land.

Art from the Umbakumba region features black or brown ochre backgrounds and clearly defined imagery such as the striking 1960s painting by Nandabitta, *Water Monitors*. This style developed during the Fred Gray years, when paintings were being actively promoted to private and institutional collectors. Fauna, fish and other sea creatures often feature as the subject matter, as do stories of the wind, boats, stars and the moon.

Until the mid 2000s the art of Groote

Eylandt was sold through the Christian Missionary Society, and through Fred Gray and other individuals at Umbakumba from the 1930s to the mid 1970s. It was also acquired by individual or institutional collectors through private treaty.

In 2005 an arts centre, Anindilyakwa Art, was established at Angurugu with artists painting barks and producing carvings, such as didgeridus, artefacts and weavings in traditional style.

Some Groote Eylandt artists
Steven Bara, Nambaduba Maminyamanja, Minimi Numalkiyiya Mamarika, Nandabitta, Felicity Wanambi, Joanna Wurramara, Nadjalgala Wurramara, Paul Murabuda Wurramarrba and Quartpot Nangenkibiyanga Wurrumurrba.

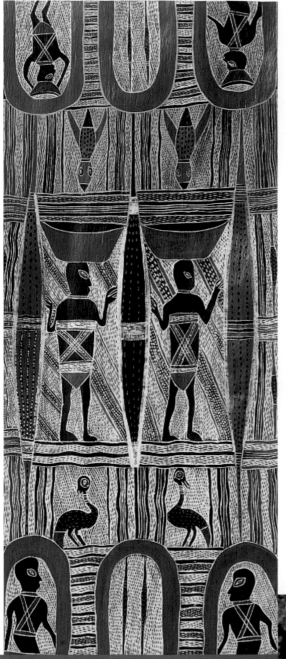

Situated at the mouth of a small fresh water creek, called Yirrkala, on the east Arnhem Land coast 1051 kilometres from Darwin, Yirrkala's people have played many pivotal roles in Aboriginal–European dialogue, especially through art. Nearby, the town of Gove (Nhulunbuy) is the headquarters of the area's large bauxite mine.

The region is called 'Miwatj' (or Morning Side) and covers a radius of 250 kilometres, including around 26 outstations. It is home to approximately 1000 people of some 17 Yolngu clan groups that include the Gumatj, Rirratjingu, Djapu, Mardappa, Dhalwangu, Ngaymil and Waramirri.

Yirrkala was established as a Methodist mission in 1935 and returned to Aboriginal control in the 1970s. The first missionary, Rev. W. Chaseling, encouraged the making and collecting of paintings – many of which were sent to form collections in museums in Melbourne, Sydney and Brisbane.[1]

Other important items were collected in the 1930s by Donald Thomson (for Museum of Victoria); in the 1940s by ethnographers Ronald and Catherine Berndt (for the Berndt Collection, Perth, and others) when they were based at Yirrkala for a year; and Charles Mountford for the American–Australian Scientific Expedition to Arnhem Land (for the South Australian Museum and US museums). In the late 1950s Sydney surgeon Dr Stuart Scougall and his assistant Dorothy Bennett visited Yirrkala with artist and

YIRRKALA

Art, Culture and Landrights in a Tropical Paradise

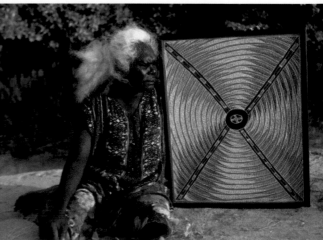

deputy director of the Art Gallery of New South Wales Tony Tuckson, acquiring works donated by Scougall to the Art Gallery of New South Wales.[2]

Private collectors included Melbourne collector Jim Davidson, Americans Ed Ruhe and Louis Allen and, on behalf of French public collections, artist Karel Kupka.[3]

In the 1950s the artists, with the support of lay missionary Douglas Tuffin who promoted sales of the art, devised the system of attaching a split stick to the top and bottom of barks to make them more durable and more readily able to be hung for display. By 1964 the system of labelling the back of the barks to indicate authenticity and provenance had been adopted. In the 1960s artist and cultural leader Narritjin Maymuru set up his own gallery in a shelter by the beach.

The 1960s was a time of upheaval and concern with the threat of significant bauxite mines, first mooted and then becoming a reality, despite strong representations by the Yolngu. Art was an integral element in this debate, with paintings such as the encyclopaedic works made for the community church that were, in effect, title deeds recording the Yolngu's right, through heritage, to the land. The striking four by three metre ochre on masonite panels 'Church Panels', now occupying a central position in the community's exhibition centre, are intricately painted and meticulously detailed. Each of the panels encapsulates the events, mythologies and travels of creation ancestors, people and ceremonies. Eight of the most highly regarded artists from the leading clans of each area were chosen to paint the work, which took many months to complete. Made and shown first in the Yirrkala church opposite today's arts centre, its unveiling in 1963 was a major part of the events of the first visit by a federal parliamentary delegation who visited Yirrkala while gathering information about land claims.

Individual paintings such as Mathaman Marika's 1950s *Morning Star Myth* and others in public collections show, in similar style, the detailed nature of paintings of the era.

In 1963 the Yirrkala people made history by creating the 'Bark Petition' (see p. 192) for presentation to the federal government seeking, unsuccessfully, to stop the intrusive Nabalco bauxite mine, which had been permitted to mine the area without consultation or compensation for its people. Although later royalty agreements gave the Yolngu an increased share of mining profits, the mine has created a lasting effect on the community, says artist Banduk Marika.

A division exists between the members of the Rirratjingu clan willing to accept mining royalties and those of us who do not want it ever. Alcoholism, chronic smoking, kava, petrol-sniffing, violence within families, untraditional marriages and harmful sexual behaviour, the stupid use of money,

FAR LEFT: Narritjin Maymuru, *Aspects of the Napilingi Myth*, (detail) c.1965, ochre on bark, 122 x 51 cm. Private collection. [Courtesy Buku-Larrnggay Mulka and Sotheby's.]

CENTRE: *Dhuwarrwarr Marika with her painting of sacred waterhole near Yirrkala.* [Photo.Penny Tweedie, Wildlight.]

CENTRE: *Buku-Larrnggay Mulka Centre*, 2006. [Tourism NT.]

time-wasting gambling, suicide and murder have entered our lives … New tracks have caused soil erosion, vegetation damage and destroyed turtle nesting areas. Pollution … affects our sea food … our offshore islands [are] used for target practice.[4]

The homelands movement, following handing back of the land to Aboriginal control in the 1970s, has had a noticeably positive effect not only on people's survival but the making of art.

The Sun on Your Face

Until the 1970s the organising and sale of paintings, carvings and other artefacts was largely the domain of the Yirrkala mission. But, as Professor Howard Morphy has noted, by the mid 1970s, with annual art sales of over $100 000, it was clear that there was need for a dedicated arts centre.[5]

In 1975 the Buku-Larrnggay Mulka Arts was incorporated. It takes its name from 'Buku Larrnggay' meaning the feeling on your face as it is struck by the first rays of the sun – representing the east. 'Mulka' is a sacred but public ceremony.

The first art advisor, Michael O'Ferrall, was appointed in 1977. Subsequent managers have included Steve Fox, Andrew Blake and Will Stubbs.

Lush palms and other rainforest surround the well-appointed arts centre and museum, which represents more than 300 artists from the region. The renovated and extended former mission house was converted to an arts centre in 1975. Its museum opened in 1988 and both were renovated and expanded with a new courtyard and gallery in 1995. Separated from the main display/museum building by a pool-centred courtyard, a light-filled separate exhibition area holds both solo and mixed exhibitions.

The museum features a comprehensive display of important paintings, photographs, hunting and other materials tracing Yirrkala's Yolngu heritage, with the 'Church Panels' a central feature of the display.

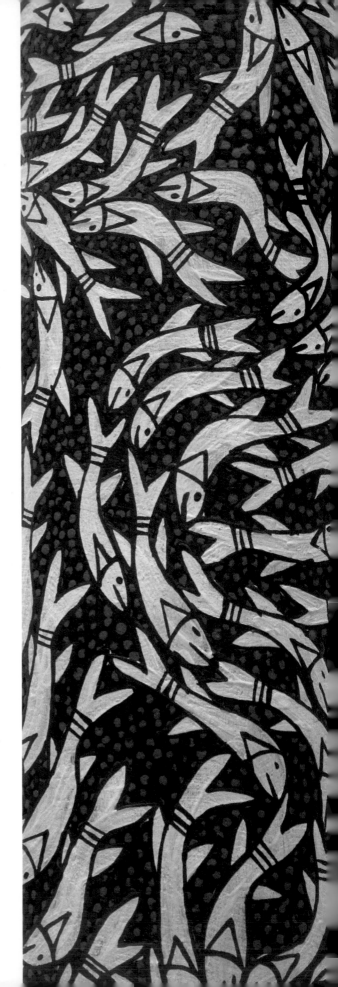

Clan Designs: The Art of Yirrkala

As with the majority of Arnhem Land artists, Yirrkala painters work with the natural materials of ochres on bark. Formal arrangement of clan design and overall patterning distinguishes much of the art of eastern Arnhem Land painters from the art to the west in which larger planes are used, and the X-ray paintings of the Gunbalunya region.

Paintings such as those of Mawalan Marika's *Djang'kawu Story No. 5*, 1959, typifies the style of painting of artists of the era.[6] See p.192.

Of prime artistic concern is to create works of sharp brilliance to evoke the living spirit of ancestral power. Yirrkala's older generation of bark painters such as Mawalan Marika also taught their daughters to paint far earlier than was typical in many other areas. Marika's three daughters including Banduk Marika all became painters of note. Yanggarriny Wunungmurra taught his two daughters and three sons to paint. Many other artists such as husband and wife Yalpi Yunipingu and Yananymul Munungurr create joint works. An even younger generation including Wolpa Wanambi, youngest daughter of painter Durrndiwuy Wanambi, show the strong generational continuation of bark painting in this region.

Big Barks: Tradition in the Contemporary Context

In 1995 Buku-Larrnggay Mulka Arts Centre took bark painting into new dimensions with the creation of a series of 'big barks' reminiscent of the encyclopaedic barks of the 1960s. Around 3.5 metres tall, these paintings were the largest to have left the community and aimed to take bark painting firmly into the contemporary realm while losing nothing of their cultural integrity.

'Barks are perhaps harder for non-Aboriginal people to come to grips with', says arts centre manager Andrew Blake. 'But once people start to investigate the levels of meaning, they find the paintings extremely interesting. The painter is, after all, not offering to the viewer a work of art as such, but their most sacred possession – their land. For those who respond it quickly

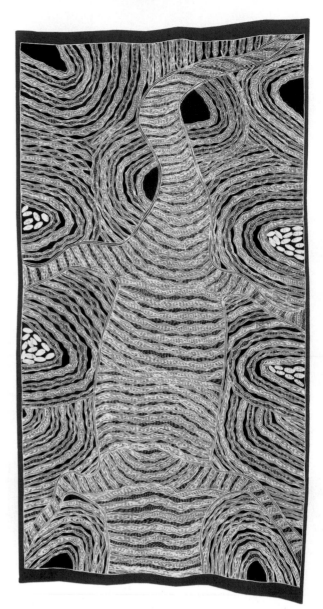

Djambawa Marawili, *Little Baru*, 2003, ochre on bark, 154 x 78 cm. Private collection. [Courtesy the artist, Buku-Larrnggay Mulka and Annandale Galleries.]

LEFT: Wukun Wanambi, *Larrakitj*, 2006, (detail 15 cm), ochre on bark, 214 x 65 cm. Private collection. [Courtesy the artist, Buku-Larrnggay Mulka and Niagara Galleries.]

Community spokesperson Djambawa Marawili is a Yirrkala artist who creates 'big barks' of shimmering detail. Award-winning painter Wukun Wanambi took up painting in 1997 with fluid yet detailed works such as this.

Gulumbu Yunupingu, *Stars*, 2006, etching on paper, 19 x 14 cm. Multiple collections. Printers Basil Hall and Natasha Rowell for Basil Hall Editions. [Courtesy the artist, Buku-Larrnggay Mulka and Basil Hall Editions.]

develops into a passion and they become our best patrons'.[7]

Collections and exhibitions

Yirrkala artists are well represented with historical works in the Art Gallery of Western Australia, the Art Gallery of New South Wales, Museum Victoria, Sydney's Museum of Contemporary Art and the National Museum in Canberra, as well as the Museum and Art Galleries of the Northern Territory in Darwin.

In the late 1990s artist Wäka Munungurr discovered an illegal barramundi fishing camp that desecrated the sacred site Garranali, for which he was caretaker, an ancient home of Bäru (Crocodile). He painted specific paintings depicting miny'ti, the sacred designs of his land and sea, to educate non-Yolngu people about the significance of this and other sites. Other artists followed suit with 80 paintings in all, each depicting their connection to their land and sea and resulting in the exhibition and book *Saltwater Country: Yirrkala Bark Paintings of Sea Country*, Drill Hall Gallery, Australian National University, and touring 1999–2001.

Yirrkala artists have also been working with galleries, including Annandale Galleries, Sydney; Raft Gallery, Darwin; and Niagara, Melbourne, in both the 'big barks' and other contemporary barks. Distinguished by extremely fine brushwork, paintings by artists such as Djambawa Marawili, Galuma Maymuru, Wakun Wunabi, Wanyubi Marika and a number of others are noted for a wonderfully rhythmic, shimmering quality that has taken bark painting into new and impressive contemporary realms.

Yirrkala artists have regularly exhibited and won major prizes at the National Aboriginal and Torres Strait Islander Art Award(NATSIAA) (seven awards 1997–2007 including the main prize won by Yanggarriny Wunungmurra, 1997, and Gawarrin Gumana, 2002.) In 2004 artist and cultural leader Gulumbu Yunupingu won the award with her star-filled memorial pole that led her to become one of the eight Australian artists to be commissioned for an architectural design for the Musée du Quai Branly that opened in 2006 in Paris. A healer, leader, translator, carver, painter, weaver and jeweller, Yunupingu's wish to educate the Western world about her culture stems from a long line of those with similar aims. Commenting on the designs of the winning work *Garak* (*The Universe*), she said stars were a reminder that people can work together in unity. 'We can all look at the stars whichever sky we are looking at.'[8]

Some Yirrkala artists

The Ganambarr family including Merrkiyawuy and Mowarra; the Gumana family including Birr'kitji, Gawarrin 1 and Waturr; the Marawili family including Djambawa, Nogirrn, Nongirrnga 2, Nyapanyapa and Yalmakanmy; the Marawili family including Dhangayal and Djambawa; the Marika family including Banduk, Banygul, Dadaynga (Roy), Dhunggala, Dhuwarrwarr, Mathaman, Mawalan, Mawalan 2, Milirrpum, Wandjuk, Wanyubi and Yalmay; the Maymuru family including Baluka, Galuma 1, Galuma 2, Narritjin, Naminapu 1, Naminapu 2, Nanyin; the Mungurrawuy family including Rerrkirrwanga; the Munungurr family including Banbiyak 1, Djutdjadjtuda, Dundiwuy 2, Marrnyula 2, Mutitjpuy, Nogirrnga 2, Yananymul 1; the Wanambi family including Durrndiwuy, Wolpa, Wukun; the Yunupingu family including Barrupu, Gayili, Gaymala 1, Gulumbu, Mandaway, Marawili, Munggurrawuy, Nyapanyapa.

The township of Ngukurr is an inland eastern Arnhem Land community bordered on one side by the sweeping reaches of the Roper River, after which the town was first named. Several hundred kilometres to the north, through swathes of lush grassy plains and wetlands, is the Gulf of Carpentaria; to the south, the township of Borroloola. Language groups of the approximately 800 residents include the traditional Ngandi, Ritharrngu and Wandarrang, while Ngukurr is also notable as having links to many different areas, often thousands of kilometres apart. These include the people of the central and eastern desert who have moved to Ngukurr in modern times, usually for family reasons.

Ginger Riley Munduwalawala, *Garimala – Wet Season*, 1990, acrylic on canvas, 126 x 176 cm. Private collection.
[Courtesy estate of the artist and Alcaston Gallery.]

Established by the Anglican Mission Society in 1908 as the Roper River Mission, the settlement became a focal point for food and shelter for people within a radius of several hundred kilometres. An earlier, lower lying settlement was destroyed by flood in 1940. In 1968 its name was changed to Ngukurr when it reverted to Aboriginal control.

The Spirit of Colour

Modern-day painting started at Ngukurr in the late 1980s through the Katherine Open College of TAFE, which set up a screenprinting workshop in the community school, but the work of the best-known Mara artist of the area, Ginger Riley Munduwalawala (1937–2002), had its genesis many years earlier.

Melbourne art dealer Beverly Knight of Alcaston Gallery described how some years before in a trip to Alice Springs as part of the land rights movement, Ginger had seen Albert Namatjira paint and immediately wanted to do so, but 'when he got home the only paints were ochres which didn't allow him to paint with the colours he wanted'.[1]

Depressed by his lack of success, Riley didn't attempt to paint for some years until the TAFE classes introduced him to strong, bright colours. He had found the colours of his country – the lush grasses and trees, vibrant reds of rocks and the deep blue sky – all were captured with this new medium.

In 1997 Riley held a large and vibrantly colourful solo exhibition at the National Gallery of Victoria with works such as *Garimala, the Wet Season*, 1990, which relates the journeys of the ancestral creation taipan Snake, Garimala.

Artists including Sambo Barra Barra (1944–2006), Willie Gudapi (1917–1996) and his wife Moima Samuels, as well as others such as Gertie Huddlestone, were also attracted by the

NGUKURR
A lush vibrancy

Sambo Burra Burra, *Cypress Pine Mortuary Rite*, 1994, acrylic on canvas, 180 x 100 cm. Private collection.

[Courtesy Alcaston Gallery.]

One of the founding painters of the modern art movement at Ngukurr, Burra Burra incorporated the images of Arnhem Land rock art into paintings on canvas.

strong, clear colours and started painting highly individual interpretations of traditional stories related to more contemporary events.

Some bark paintings were produced in the area in the mid 1900s, but painting on cave walls is more common. Willie Gudapi's work is notable for its vividly coloured, segmented canvases derived from images on the walls of caves in his country. Favouring a decorative figurative style, each of his panels tells both its own story and relates to those of its neighbours, and often incorporates more recent events such as the Second World War with traditional stories. Moima Samuels, Gudapi's wife of over 50 years, who painted love stories with him, continued to paint alone after his death. Gertie Huddlestone's individualistic style continues the decorative, colourful style of Gudapi and Samuels, as do

later painters such as Maureen Thompson, Betty Roberts and others.

Sambo Burra Burra (whose country was many kilometres further north-west in Arnhem Land) often produced very large canvases and focused on fewer, more stylised images based on traditional stories. Paintings such as *Cypress Pine – Mortuary Ritual,* shows elements of the traditional cross-hatching, X-ray figures, and similar formal design and restricted palette of traditional Arnhem Land bark art.

His widow, Amy Jirwulurr Johnson became one of a newer generation of Ngukurr artists to gain recognition in the 1990s for her colourful, figurative paintings.

Ngukurr Arts

Ngukurr artists have a long history of working on an individual basis with galleries such as Melbourne's Alcaston Gallery and Darwin's Karen Brown Gallery.

In 2002 a new arts centre, Ngukurr Arts, was established as an extension of the Community Development Employment Program. It is supported by senior artists such as Sambo Barra Barra, who exhibited with artists of a younger generation such as Amy Jirwulurr Johnson, Maureen Murrarngu, Norman Jakanimba Wilfred, Faith Thompson and Lurick Fordham (son of well-known painter Paddy Fordham Wainburranga) in exhibitions from 2004 onwards held in Victoria, Canberra and other states.

Artists of the region are known for their highly individual and diverse styles that often reflect their different traditional lands in a melding of imagery, as can be seen in the work of Alyawerre painter Dorothy Club. She was born at the eastern desert community of Utopia in 1976 and moved to Ngukurr in 2002. Others who have attracted particular attention since 2000 include Barney Ellaga.

Some Ngukurr artists

Dorothy Club, Barney Ellaga, Willie Gudapi, Amy Jirwulurr Johnson, Gertie Huddlestone, Ginger Riley Munduwalawala, Moima Samuels, Norman Jakanimba Wilfred.

Kitty Kantilla, *Pumpuni Jilamara*, 2003, ochre on canvas, 56 x 76 cm. Corrigan Collection. [Courtesy Jilamara Arts & Crafts and Corrigan Collection.]

Kitty Kantilla's 'jilamara' (designs) were those of her father's traditional country and evolved over her long painting career into works of a highly distinctive quality.

The Tiwi Islands, 800 kilometres north of Darwin across the Dundas and Clarence Straits, comprise the 3200 square kilometre Melville Island and the smaller, adjacent Bathurst Island. Because of the treacherous nature of the seas separating the islands from the mainland, art and culture of the Tiwi have developed in relative isolation. Therefore it is distinctly different from that of the nearest coastal areas of Arnhem Land. During the tropical wet season up to 2500 mm of rain can flood the plains and lower lying areas of the islands. Spectacular lightning strikes and dense cloud formations often accompany the build-up to the wet – a time of high humidity that increases steadily until the heavy clouds finally burst in torrential downpours.

The Tiwi Islands are lushly forested, with sandy and rocky shorelines and a plentiful supply of water. Both marine and plant life is abundant; the sea life includes dugong, turtles, sharks, numerous varieties of fish and freshwater and saltwater crocodiles.

TIWI ISLANDS
An Art of Tropical Isolation

Images in Abstraction:
The Art of the Sacred Design

A characteristic element found in Tiwi art is the geometric abstract design relating to sacred or significant sites and seasonal changes. Geometric abstraction is the basis for the shapes of traditional carvings such as the pukumani poles used in burial ceremonies as well as the basic imagery on barks and, more recently, on fabric, paper, pottery, canvas and jewellery. Abstract patterns give the works a unique formalised quality but also allow for strong personal interpretation.

Three major arts centres are located on the Tiwi Islands: Jilamara Arts & Crafts Association and Munupi Artists on Melville Island and Tiwi Design at Bathurst Island. A smaller centre, Ngaruwanajirri Inc., opened at Nguiu, Bathurst Island, near Tiwi Design, in 1994. This centre for people with disabilities has also developed a vibrant art program with works first exhibited at Alison Kelly Gallery, Melbourne, in 2005, and at other galleries since, including William Mora, Melbourne, 2006, Sydney's Aboriginal and Pacific Island Arts among others. Using traditional ochres and images of classic Tiwi design, many of the works show a great fluidity and innovation.

In 1998 the Tiwi Art Network, an alliance between the three major art centres, was formed to market and promote Tiwi art. The network facilitates the highly popular Tiwi Art Tours, which organises flying tours to each of the three arts centres and has also established a showroom and gallery in Darwin.

Artist unknown, *Pukumani Pole.* c.1975, ochre on wood, 193 cm. Private collection. [Courtesy Jilamara Arts & Crafts and Deutscher-Menzies Fine Art, 1999.]

Poles such as this are a major part of the Tiwi mourning (pukumani) ceremony and also carved for artistic and display purposes in the modern art context.

Melville Island Art:
Tradition and Innovation

Melville Island, at 3200 square kilometres, is Australia's second largest island after Tasmania. Its population is around one thousand. Jilamara Arts and Crafts, at Milikapiti (Snake Bay) on the island's west grew out of women's adult education classes in the mid 1980s. Adjacent to the arts centre, which is a long corrugated iron building whose sides can be opened to allow the cooling sea breezes, is the Muluwurri Community Museum. This small, temperature-controlled building contains many fascinating artefacts and carvings from the area dating back to early years of the 19th century, as well as examples of work produced today. Thirty kilometres to the west at Pularumpi, Munupi Arts and Crafts incorporates a pottery and printmaking facilities.

The art of the two centres is quite distinctly different. Jilamara artists prefer to concentrate on more traditional designs, allowing for significant individual differences, and the use of natural ochres; artists from Munupi use multi-coloured acrylics and often incorporate both figurative and traditional elements in their work.

With the employment of fabric artist James Bennett as arts advisor at Jilamara in the mid 1980s, the centre became a thriving fabric-printing centre. The main material used was silk, dyed in vibrant colours and painted with traditional designs. During the 1990s with other art advisers, notably Felicity Green, the artists developed an interest in revisiting their own heritage through the works reproduced in

ARNHEM LAND

246

books by early collectors such as
Charles Mountford and others.
Circles, squares, rectangles
and lines are in-filled with finely
drawn criss-cross lines – a
technique that increases visual
depth and perspective. Jilamara
artists have traditionally carved
the poles (tutini) used in the
pukumani burial ceremony
and made the bark baskets
(tunga) used in the ceremony.
It was from Milikapiti in 1958
that Stuart Scougall and Tony
Tuckson commissioned the poles
that became a feature of the
collection of the Art Gallery of
New South Wales (see p. 196).
Smaller figurative carvings are
also produced, as are works on
paper and canvas. Senior artist
Kitty Kantilla (c.1928–2003)
became one of Jilamara's most
noted modern artists for her innovative works
that included the use of lush white ochres and
freedom of design. The work of artists such
as Timothy Cook, Pedro Wonaemirri and many
others is equally distinctive.

Nina Puruntatameri, *Tiwi Island Culture*, 2007, ochre
on canvas, n.s. Private collection. Finalist National
Aboriginal and Torres Strait Islander Art Award, 2007.
[Courtesy the artist, Jilamara Arts & Crafts and Museum and Art Gallery
of the Northern Territory.]

Bathurst Island –
Home of the Screenprinted Fabric

The silkscreening workshop of Tiwi Design
at Bathurst Island is housed in an open-sided
building with a separate enclosed display
area carrying fabrics, some paintings and Tiwi
carvings of birds and animals. The arts centre
supplies galleries and art and craft shops
throughout Australia with its distinctive fabrics
as well as also selling them to centre visitors.

Tiwi Design was started in 1969 by
Madeleine Clear, an art teacher working at the
central Mission School who encouraged three
teenage boys to make woodcuts of animals,
birds and insects. Translated via rice paper
onto silkscreen, the designs were printed on
fabric and made into tablecloths and dress
lengths. Largely realistic in imagery, they were

**A younger generation of Tiwi artists is carrying
forward the classic paintings of the modern art
movement founded in the 1990s by artists such as
Kitty Kantilla, Pedro Wonaemirri and others.**

described by former art co-ordinator Diana
Conroy as designs with 'something of the
quality of Eskimo art, while not being at all
closely related to indigenous Tiwi art'.

Conroy had arrived at Bathurst Island early
in 1974 and was employed by the Aboriginal
Arts Board of the Australia Council to act as art
adviser to Tiwi Design. She described the early
printing processes:

I worked mainly with Bede [Tungutulam –
one of the original screenprinters] … We
tentatively explored other possibilities of
screen-printing – using all-over repeating

patterns instead of isolated 'floating' motifs. We changed to printing on calico and Indian cotton as well as linen … Bede in particular showed great interest in reproductions of the magnificent bark paintings collected in Snake Bay [Milikapiti] on Melville Island which were generally finer than the barks being produced at the time on Bathurst Island.[1]

During the next few months she said that Bede Tungutulam made many striking designs 'similar in feeling to the traditional style', using irregular circles and cross-hatching to make all-over fabric design.[2]

Another of the early artists, Giovanni Tipungwi, became equally inspired and produced many geometric patterns related to traditional designs.

The colours first used were natural ochres, yellow, red, black and white. These broadened during the 1990s to include a wide range of colours, which proved popular with clothing designers and for home wares such as curtains, blinds, cushions and other coverings. Some pottery was also produced at Tiwi Design in the 1980s by original screenprinters the late Eddie Puruntatameri and John Boscoe Tipiloura with pots decorated with traditional abstract designs.[3]

The production of distinctive Tiwi Design printed fabrics, including cottons and silks, has continued successfully. More recently, a number of fabric artists such as Jean Baptiste Apuatimi, Maria Josette Orso and others have also become successful painters.

Special Exhibitions

Tiwi works have been shown in numerous leading galleries around Australia and internationally since the 1990s including in the National Gallery of Australia's *Cultural Warriors*, 2007. Some important survey exhibitions of Tiwi art have included *Tiwi Prints: A Commemorative Exhibition 1969–1997*, Museum of Contemporary Art, Sydney, 1997; *Kiripuranji: Contemporary Art from the Tiwi Islands*, touring Asia and New Zealand, 2002; *Pumpuni Jilamara*, Yiribana Gallery, Art Gallery of New South Wales,

2002; and *Yingarti Jilamara, The Art of the Tiwi Islands*, Art Gallery of South Australia, 2006–07. In 2007 the National Gallery of Victoria held a solo exhibition of the work of Kitty Kantilla.

Some Melville Island artists

Timothy Cook, Kitty Kantilla (Kutuwalumi Purawarrumpatu), Ian Cook Mungatopi, Maryanne Mungatopi, Janice Murray, Delilah Freddy Puruntatameri, Leon Puruntatameri, Matthew Freddy Puruntatameri, Patrick Freddy Puruntatameri, Freda Warlapinni, John Wilson, Pedro Wonaemirri.

Art from Bathurst Island includes the rich ochre by the artists living at a disability centre at Nguiu working through Ngaruwanajirri Inc. and the vibrant fabrics of the long-established Tiwi Designs.

Some Tiwi Design artists

Jean Baptiste Apuatimi, Maria Osmond Kantilla, Alan Kerinaua, Therese Anne Munkura, Josette Orsto, Carmelia Puantulura, Eddie Puruntatameri, Ita Myra Anne Tipiloura, Vincent Tipiloura, Ita Tjungwuti, Bede Tungutulam,

Some Ngaruwanajirri artists

Frances Kerinauia, Michael Munkara, Alfonso Puautjimi, David Tipuamantumirri.

Fabrics made by the artists of Tiwi Design.

LEFT: Estelle Munkanome, *Untitled*, 2008, ochre on paper, 59 x 38 cm. Private collection. [Courtesy the artist, Ngaruwanajirri Artists and Alison Kelly Gallery.]

ABOVE: Lorna Kantilla, *Untitled*, 2008, (detail), ochre on paper, 58 x 78 cm. Private collection. [Courtesy the artist, Ngaruwanajirri Artists and Alison Kelly Gallery.]

TIWI ISLANDS

QUEENSLAND
and the
TORRES STRAIT
ISLANDS

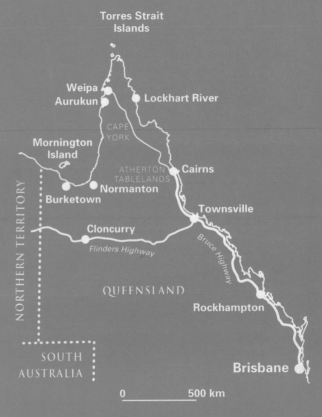

Torres Strait
Islands

Weipa
Aurukun

Lockhart River

CAPE
YORK

Mornington
Island

ATHERTON
TABLELANDS

Cairns

Burketown

Normanton

Townsville

NORTHERN TERRITORY

Cloncurry

Bruce Highway

Flinders Highway

QUEENSLAND

Rockhampton

SOUTH
AUSTRALIA

Brisbane

0 500 km

QUEENSLAND

Over hundreds of years, cross-cultural interchanges in Queensland's coastal areas, including those from Melanesia, Torres Strait Islanders and Macassans, have resulted in some unique items becoming part of the art and craft of indigenous Queenslanders.

These include masks, shields, wooden drums and men's as well as women's ritual grass skirts. Art from more inland areas, such as those of the rainforest and Queensland's vast tracts of lightly forested and open plain country, include carvings of many types and the unique bi-cornial baskets. But as well as the benign exchanges of these and other goods, the quantity of shields and other items of warfare denotes a more conflicted history. Inter-tribal clashes, significant battles against the encroachment of pastoralism, and the brutality of police and others resulted in massacres throughout Queensland.

Some of this history was detailed in sketches and paintings by a cattleman known only as Oscar. Early 20th century Queensland artists include Kalboori Youngi, born around 1900 near Boulia, who carved figurative sculptures in soapstone. Youngi traded her sculptures for rations at stations and sold others in the Boulia Hotel. In 1936, scientist R.H. Goddard acquired a collection of her sculptures from a station near Boulia and exhibited them at artist William Rubery Bennett's gallery in Sydney to enormous critical acclaim. Youngi's artistic style may have spread or she traded her sculptures which then became attributed to others such as Nora Nathan who lived near Cloncurry. Around 1942, artist Margaret

Preston acquired works (now in the collection of the Art Gallery of New South Wales) by Nathan and her mother, Linda Craigie. Other well-known 20th century artists include Hope Vale's bark painter Tulo Gordon (1918–89) and Barrow Point's Joe Rootsey (1918–63) who began painting while convalescing from tuberculosis. His work much publicised, Rootsey became known as 'the second Namatjira'. Later well-known 20th century practitioners include painter Dick Roughsey (1920–85) and his brother Lindsay Roughsey (c. 1907/11–2007) from Mornington Island, and ceramicist Thancoupie (b.1937) from Weipa on the western coast of Cape York Peninsula.

However, as author Marion Demozay in the book *Gatherings II* notes, while art and artefacts made for sale as well as ceremonial use were popular and shown in exhibitions such as those for National Aboriginal Week, Queensland indigenous art remained 'largely outside the mainstream' until the 1990s.[1]

This may have been partly due to the dominance of the Queensland Aboriginal Creations shop (QAC) established in Brisbane in 1959 which not only sold products made by

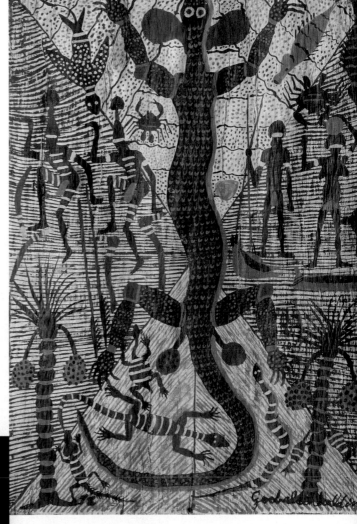

Dick Roughsey, *Untitled*, c. 1970s, ochre on bark, 57 x 35 cm. Collection Mornington Island Arts & Craft. [Courtesy Mornington Island Arts & Craft.]

LEFT: Artist unknown, *Bicornial Basket*, n.d., laywer cane and ochre, 45 x 46 x 22 cm. Private collection. [Courtesy Sotheby's.]

CENTRE: Nora Nathan, *Emu Egg Hunt,* c. 1940, soapstone, 13 x 16.7 x 6.2 cm. Collection Art Gallery of New South Wales. [Courtesy, AGNSW.]

BELOW: Arthur Koo'ekka Pambegan Jr. *Bonefish Story Place*, 2007, ochres with acrylic binder on wood and bush cord, 188 x 190 x 35 cm. Collection Michael and Kylie Rayner. [Courtesy the artist and Andrew Baker Art Dealer.]

RIGHT: Samantha Hobson, *Grandparents worry for those kids*, 2006, acrylic on canvas, 173 x 106 cm. Private collection. [Courtesy, the artist and Vivien Anderson Gallery.]

FAR RIGHT: Joanne Currie, *The River is Calm*, 2007, acrylic on canvas, 165 x 240 cm. Private collection. [Courtesy the artist and Art Gallery of New South Wales.]

Contemporary Queensland artists include senior Aurukun carver and painter Arthur Pambegan Jnr, Lockhart River painter Samantha Hobson and winner of the 2008 Wynne Prize for landscape, Joanne Currie.

indigenous Queenslanders but for many years even directed what was made. As curator and writer Margie West notes in the *Oxford Companion to Aboriginal Art and Culture*, QAC was a centralised wholesale-retail marketing outlet for artwork produced at missions and government reserves throughout Queensland. While highly influential, the downside of its significant promotion and sale of indigenous

artefacts was its setting up of 'government-controlled workshops for the mass production of tourist 'curios'… including those not indigenous to the state such as bullroarers, didgeridus and bark painting which were produced as blank objects in regional areas and sent to Brisbane for decoration by the indigenous people (Murri) of Brisbane'.[2]

Later items included decorated glass bottles, Torres Strait Islander pearl shells and decorated emu eggs. QAC revised its policies in the 1980s, proving an important outlet for early work by contemporary Queensland artists such as Vincent Serico and Richard Bell.[3]

Into new dimensions

During the 1990s and increasingly post-2000, contemporary indigenous art in Queensland, both in Brisbane and regionally, has developed so significantly that the area now demonstrates some of the most notable growth in contemporary Aboriginal art. Well-known contemporary Queensland artists include Arone Raymond Meeks, Danie Mellor, Lisa Michl, Tony Albert, Vernon Ah Kee, Richard Bell, Fiona Foley, Jenny Fraser, Gordon Hookey, Laurie Nilsen and dozens of other artists, some of whom work with the artist collective, ProppaNOW. The Brisbane-based Campfire Group at Fireworks Gallery is one of several other artists co-operatives based in Brisbane.

At Ravenshoe, Michael Boiyool Anning is an important shield-maker and Desley Henry is a fibre artist who weaves jawun, or baskets. The Kuku Yalanji people of Mossman Gorge are also adept basket-weavers, one of the most well known being Wilma Walker who makes kakan (black palm) baskets.

At Laura, the Kuku Thaypan people have an important history of rock art, with cave walls featuring the giant Quinkan spirit. The far north community of Cape York's Lockhart River has become one of the best known of Queensland's contemporary arts centres through the work of the Lockhart River Art Gang whose artists include Rosella Namok, Samantha Hobson, Fiona Omeenyo, Silas Hobson and Adrian King. At Napranum (Weipa) an arts centre was opened in 2002 that represents people from more than 20 different language groups. The sculptural art of Aurukun is making an impact in the strong carvings by artists such as Craig Koomeeta, Arthur Pambegan Jr, Jubilee Wolmbu, Ron Yunkaporta, Joe Ngallametta and Garry Namponan, who carve both symbolic and more modern figurative sculptures out of wood, such as dogs, crocodiles and other animals.

South of Cairns the Yarrabah Arts and Crafts Centre, which also has a pottery room, was established in 1994 and includes the work of

basket-weavers such as Ruby Ludwick and her niece Philomena Yeatman. Cairns itself has developed a number of thriving art and craft practices which include those emanating from print and painting classes at its secondary and tertiary colleges. The Cairns Regional Gallery, contemporary arts space KickArts, and many others throughout regional Queensland, such as Artspace Mackay and other regional galleries including at Caloundra, Toowoomba and Rockhampton, regularly feature the work of Queensland artists. Post-2002, the art movement of Mornington Island whose initiators in the 1950s included Dick and Lindsay Roughsey, Arnold Watt, Billy Koorubbuba and others, received a huge impetus when Bentinck Islander artist Sally Gabori and her six sister relations started painting to great critical acclaim.

Vernon Ah Kee, *austracism*, 2003, ink on polypropylene, satin laminated, 120 x 180 cm. Edition of 3. Private collections and National Gallery of Australia. [Courtesy the artist and Bellas Milani Gallery.]

Ah Kee is one of the younger generation of artists who are bringing a new dynamism to Queensland contemporary art.

In 2003, the Queensland Art Galley's large exhibition, *Story Place: Indigenous Art of Cape York and the Rainforest*, provided the most comprehensive survey of Queensland art from northern/coastal regions with other exhibitions of Queensland art 1995–2008 including *Now Days – Early Days: Works by Yu-P'la Me-P'la: Four Contemporary Aboriginal and Torres Strait Islander Artists*, Cairns Regional Art Gallery, 1995; *Fortitude: New Art from Queensland*, Queensland Art Gallery, 2000; *Kank inum – Nink inum (Old way – New way): An Exhibition of Cast Works from the Aurukun Community*, Urban Art Projects, Eagle Farm, Queensland, 2002; *Beneath the Monsoon: Visions North of Capricorn*, Artspace Mackay. Other initiatives have been those established by the state government body, the Queensland Indigenous Art Marketing and Export Agency established in 2004, and its sister organisation, Arts Queensland. These include funding for arts centre infrastructure, exhibition management and other promotional programs which have helped to lift the profile of Queensland artists both nationally and internationally.

I'm not racist but... I don't know why Aboriginal people can't look after their houses properly and.... I'm not racist but... Aboriginal people weren't doing anything with the land before we came and.... I'm not racist but... they never even wore any clothes before we came and.... I'm not racist but... you can't tell me that the government doesn't look after them and.... I'm not racist but... my taxes are paying for their food and.... I'm not racist but... what about us White people? and.... I'm not racist but... us White people have it pretty hard too you know and.... I'm not racist but... my father worked hard to buy this land and.... I'm not racist but... my family have been here for 200 years and.... I'm not racist but... I don't see why we can't all just speak English and.... I'm not racist but... maybe they're poor because they just don't know how to manage money and.... I'm not racist but... maybe they're poor because they want to be and.... I'm not racist but... well, look at how they live and.... I'm not racist but... didn't we give them the Vote? and.... I'm not racist but... if Aboriginal people could just learn to behave normally and.... I'm not racist but... they just sit on their Missions and Reserves and do nothing and.... I'm not racist but... if only Aboriginal people could just learn to live like us.... I'm not racist but... if it wasn't for us White people, they would've died out a long time ago and.... I'm not racist but... some people, you just can't talk to and.... I'm not racist but... there are times when I just can't relate to them and.... I'm not racist but... they just don't understand how the law works and.... I'm not racist but... a lot of them can't read and write and.... I'm not racist but... well, you just can't teach them anything and.... I'm not racist but... for 200 years we've been trying to live with these people and.... I'm not racist but... they're not very religious and.... I'm not racist but... a lot of them don't believe in God and.... I'm not racist but... they're very primitive people and.... I'm not racist but... well, it's not like they invented the wheel is it? and.... I'm not racist but... you can't expect too much of them really and.... I'm not racist but... I can understand how frustrated some of my friends get and.... I'm not racist but... trying to teach their kids is too hard sometimes and.... I'm not racist but... I think that just giving them back their land is asking too much and.... I'm not racist but... I just think everyone should be treated equal and.... I'm not racist but... haven't they got the same rights that we do? and.... I'm not racist but... if us White people can't hunt native animals then they shouldn't be allowed to either and.... I'm not racist but... my job is to guard against terrorism and.... I'm not racist but... people can't just enter this country without a passport and.... I'm not racist but... those people don't even speak English and.... I'm not racist but... someone's got to protect our way of life and.... I'm not racist but... some of those Native Title claims are just unreasonable and.... I'm not racist but... alcohol consumption on Aboriginal communities is reaching distressing levels and.... I'm not racist but... levels of domestic violence on Aboriginal communities is really those communities have a history of child abuse and neglect and.... I'm not racist but... they don't know how to maintain a healthy diet and.... I'm not racist but... other countries should look at their own human rights records before they look at Australia's and.... I'm not racist but... I may have been and.... I'm not racist but... Australia has some current policies that may be and.... I know and.... I'm not racist but... the past should just remain the past and.... I'm not racist but... we were very kind to them and.... I'm not racist but... they're very ungrateful people and.... I'm not racist but... biscuits cost money and.... I'm not racist but... it is with deep and sincere regret.... I don't know why Aboriginal people can't look after their houses properly and.... I'm not racist but... Aboriginal people weren't doing anything with the land before we came and.... I'm not racist but... they never even wore any clothes before we came and.... I'm not racist but... my taxes are paying for their food and.... I'm not racist but... what about us White people? and.... I'm not racist but... us White people have it pretty hard too you know and.... I'm not racist but... my father worked hard to buy this land and.... I'm not racist but... I don't see why we can't all just speak English and.... I'm not racist but... maybe they're poor because they just don't know how to and.... I'm not racist but... didn't we give them the Vote? and.... I'm not racist but... if Aboriginal people could just learn to behave normally and.... I'm not racist but... they just sit on their Missions and Reserves and do nothing and.... I'm not racist but... if it wasn't for us White people, they would've died out a long time ago and.... I'm not racist but... some people, you just can't talk to and.... I'm not racist but... there are times when I just can't relate to them and.... I'm not racist but... they just don't understand how the law works and.... I'm not racist but... a lot of them can't read and write and.... I'm not racist but... for 200 years we've been trying to live with these people and.... I'm not racist but... they're not very religious and.... I'm not racist but... a lot of them don't believe in God and.... I'm not racist but... they're very primitive people and.... I'm not racist but... well, it's not like they invented the wheel is it? and.... I'm not racist but... you can't expect too much of them really and.... I'm not racist but... I can understand how frustrated some of my friends get and.... I'm not racist but... trying to teach their kids is too hard sometimes and.... I'm not racist but... I think that just giving them back their land is asking too much and.... I'm not racist but... I just think everyone should be treated equal and.... I'm not racist but... if us White people can't hunt native animals then they shouldn't be allowed to either and.... I'm not racist but... my job is to guard against terrorism and.... I'm not racist but... people can't just enter this country without a passport and.... I'm not racist but... those people don't even speak English and.... I'm not racist but... someone's got to protect our way of life and.... I'm not racist but... some of those Native Title claims are just unreasonable and.... I'm not racist but... alcohol consumption on Aboriginal communities is reaching distressing levels and.... I'm not racist but... levels of domestic violence on Aboriginal communities is really holding those people back and.... I'm not racist but... those communities have a history of child abuse and neglect and.... I'm not racist but... they don't know how to maintain a healthy diet and.... I'm not racist but... other countries should look at their own human rights records before they look at Australia's and.... I'm not racist but... I may have been and.... I'm not racist but... I know people who may be and.... I'm not racist but... Australia may have been in the past and.... I'm not racist but... Australia has some current policies that may be and.... I'm not racist but... the past should just remain the past and.... I'm not racist but... we were very kind to them and.... I'm not racist but... they're very ungrateful people and.... I'm not racist but... biscuits cost money and.... I'm not racist but... it is with deep and sincere regret....

On the north-west tip of the Cape York Peninsula, Aurukun is home to around 1000 people and is known artistically for its strong carvings and sculpture. Aurukun was established as the Archer River Mission Station in 1904 by two German-speaking Moravian Presbyterians. On the reaches of the Archer River, its traditional landowners include the Wik and Kugu people and 13 other different tribal groups.

The influence of long-serving minister Reverend William MacKenzie, who was mission superintendent from 1923 to 1965, played a significant role in the early development of Aurukun's art. As Peter Sutton in the catalogue exhibition *The World of Dreamings* (National Gallery of Australia, 2000) notes, MacKenzie 'ruled the mission with a rod of iron' and during the 1920s people living at Aurukun became noticeably more isolated from their neighbours at Weipa and other regions as a result of mission policy.

> Certain forms of traditional Wik life were encouraged by the mission in this period, including those ceremonial forms deemed acceptable to William MacKenzie. He himself was initiated at Archer River and spoke at least basic Wik-Mungkan, the regional lingua franca. Western-style changes were also imposed or encouraged, and among these were the engagement of Wik men as workers in the mission sawmill and in learning carpentry for building and repairs. The woodworking skills they already had were thus augmented not merely by the use of better steel tools but also by the use of carpentry techniques…

Applying these skills to sculpture, notes Sutton, has, from the 1940s, led to the production of some of the most 'visually arresting' sculptures of Aboriginal Australia.[1]

Items of Aurukun sculpture were included in the 1920s and 30s collections of Ursula McConnel (now in the South Australian Museum) and Donald Thomson (in Museum Victoria) with the first substantial collections of Wik ceremonial sculptures by missionaries J.B. McCarthy in 1949 and William MacKenzie in 1954, 1955 and 1958 (Anthropology Museum, University

TOP INSERT: *Arthur Koo'ekka Pambegan Jr. dancing at the opening of* Story Place, *Queensland Art Gallery*, 2003. Photo Mick Richards. [Courtesy the photographer and Andrew Baker Art Dealer.]

BELOW: Arthur Koo'ekka Pambegan Jr, *Untitled XXII [Walkan-aw and Kalben designs]*, 2008, ochre with acrylic binder/acrylic paint on canvas, 183 x 117 cm. Collection, The University of Queensland Art Museum. Photo. Mick Richards. [Courtesy, the artist and Andrew Baker Art Dealer.]

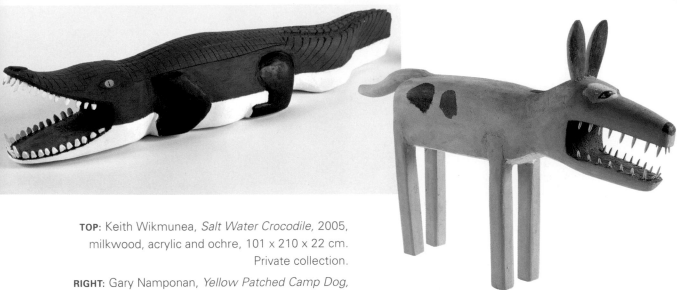

TOP: Keith Wikmunea, *Salt Water Crocodile*, 2005, milkwood, acrylic and ochre, 101 x 210 x 22 cm. Private collection.

RIGHT: Gary Namponan, *Yellow Patched Camp Dog*, 2006, milkwood, acrylic and ochre, 98 x 61 x 16. Private collection. [Both works, courtesy the artist, Wik & Kugu Arts and Craft and Australian Art Resources.]

of Queensland). The largest single collection of Wik sculptures (now in the collection of the National Museum of Australia) was made in 1962 by Frederick McCarthy, who also made a documentary film of a performed ceremony.[2]

While MacKenzie played an influential role in the creation of carvings, their tradition dates to at least the late 1890s with the introduction of metal horseshoes. Before then, objects for both sacred and secular purposes had been modelled from clay.

A combined tradition

The cross-links between people of Melanesia and the Torres Strait Islands are evident in the ceremonial practices of the region which include a strong emphasis on dance, wooden drums, ritual grass skirts, face and body masks. In 1976, Aurukun appointed its first art adviser, Jeanie Adams, and the centre became the Wik and Kugu Arts and Crafts Centre. The making of ceremonial objects continued and others became items for sale.[3]

The sculpture of Aurukun has developed its own highly unique style. Most famous of the 15 or so contemporary sculptors is Arthur Pambegan Jnr, born in 1936. Pambegan's father, Arthur Snr (1895–1972), was instrumental in preparing the dances for the 1962 performance filmed by McCarthy. Arthur Pambegan Jnr's sculptures are often poles painted with designs of body paint, joined by fine lines from which hang stylised shapes representing the stories of the creation ancestors Bonefish and Flying Fox of which he is custodian. Pambegan has frequently accompanied the openings or unveilings of his installation-style sculptures with a traditional ceremonial dance performance.

Other contemporary sculptors whose boldly carved items have attracted attention include Craig Koomeeta, who won the three-dimensional award in the 2001 National Aboriginal and Torres Strait Islander Art Award. Works by Aurukun artists have been included in exhibitions such as *Aratjara*, touring internationally 1993–94; *Painting the Land Story*, National Museum of Australia and touring, 1999; *World of Dreamings*, National Gallery of Australia, 2001; *Contemporary Australian Aboriginal Art in Modern Worlds*, Hermitage, Russia, 2001; and *Story Place*, Queensland Art Gallery, 2003. In 2006, Melbourne sculptor Mike Nickolls was artist-in-residence at Aurukun and Lockhart River, and worked with the artists to create striking sculptures that were exhibited in *Carved from the Cape*, Australian Art Resources, Melbourne, 2006.

Some Aurukun artists

Jack Bell, Craig Koomeeta, Duncan Korkata, Gary Namponan, Arthur Pambegan (Snr and Jnr), Keith Wikmunea.

LOCKHART RIVER

'**When I left** school I was like all the other mothers in Lockhart: I stayed home, had no job, got bored. Then Rosie Lloyd [a TAFE teacher at Lockhart River] came and asked me to work at the art room at the school. From there my life started getting better. I thought to myself, what the hell, I'm not going to waste my life sitting at home all the time. I'm going to get out and make a name for my family.'[1]

Fiona Omeenyo, who made this observation when she was 19 in 2000, is from the far north Queensland community of Lockhart River and one of the group that became known as the Lockhart River 'art gang'. Lockhart River is 850 kilometres north of Cairns on the eastern coast of Cape York Peninsula, a 12-hour drive on a rough track or a two-hour small plane flight over vibrant turquoise seas, a coral reef and rainforested mountains.

Fiona Omeenyo, *Marks in the sand*, 2006, acrylic on canvas, 122 x 184 cm. Private collection. [Courtesy the artist and Andrew Baker Art Dealer.]

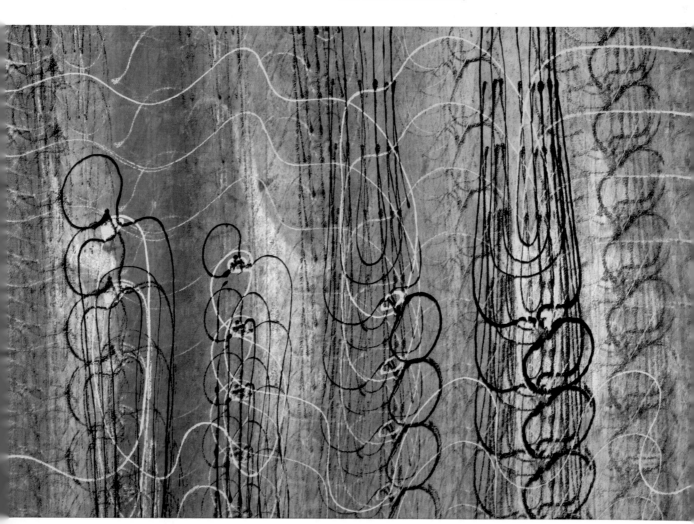

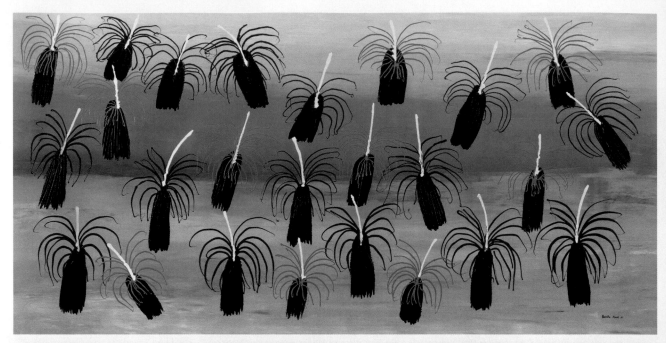

Rosella Namok, *Sand Marks low tide, we're Quintal*, 2006, acrylic on board, 102 x 174 cm. Collection, Gold Coast City Art Gallery. [Courtesy the artist and Andrew Baker Art Dealer.]

ABOVE: Rosella Namok, *Thuluu… we call black boyz… sunset time*, 2007, acrylic on board, 172 x 342 cm. Private collection. [Courtesy the artist and Andrew Baker Art Dealer.]

TOP RIGHT: *Beach, Lockhart River, 2000.* [Photo. Geoff Barker.]

Lockhart River was established in 1924 as an Anglican missionary station on a coastal location but in 1965 was moved 60 kilometres south to be closer to a World War Two airstrip. The community of around 600 is managed by an elected community council.

Lockhart's original site was close to the water, enabling traditional sea and beach hunting and culture. The move inland meant a dilution of traditional customs and practice. Until its modern-day art movement, in which youngsters

actively seek out stories from their elders and draw inspiration from these all-but-forgotten tales, few of the artistic representations of stories had been passed on, although some ceremonial practices were still enacted.

'I hadn't heard some of my people's stories ever,' said Fiona Omeenyo. 'It was only when I wanted to do a painting for the Art of Place [Heritage] Awards in Canberra [in 2000] that I asked my relatives for some of the stories. My uncle told me this really important story which I paint all the time now. I tell it to my daughter every night; she won't go to sleep without hearing it.'[2]

The Lockhart River 'art gang' (named as the artistic equivalent of a road or other occupational 'gang') arose out of an alternative education program in which teenagers could choose whether to continue with formal education or take art and craft classes. In the early 1990s, New South Wales couple Geoff and Fran Barker started visiting the area, housesitting for various friends at the nearby beach village of Portland

Roads and at Lockhart. A former teacher and local government project officer, Fran started volunteer work with the Lockhart community auditor and the couple became increasingly drawn to the area. Some of the young people working in the secondary art program wanted to continue their art but once they'd graduated from their secondary years had no opportunity to do so. 'The idea of doing more just grew from there,' says Geoff Barker. 'They were keen to do it, and we thought we could help so we asked the community if it would be okay. We had no funding so thought the best way was through printmaking as we needed goods we could sell to provide an ongoing cashflow.'[3]

Canberra School of Art printmakers Basil Hall and Theo Tremblay were employed to teach basic techniques. The group was approved to use an empty former health clinic, so the Barkers bought the materials to construct a screen-printing and etching press, and some ten young people started printing.

The results were a set of striking screen prints and etchings which the Barkers took to Canberra in 1997, along with the artists themselves, for the opening of the Art of Place Heritage Awards. Spreading out the folio in the foyer of Old Parliament House where the exhibition was held, a crowd soon gathered, including art luminaries, former National Gallery director Betty Churcher and indigenous art curator Margo Neale.

'The prints were just so fresh and wild,' says Neale. 'Here were these young people who had never really done anything in art before and this couple who hadn't either. But the artists had talent, you could see that immediately.'[4]

Neale (now curator of indigenous art at the National Museum of Australia) bought prints for the Queensland Art Gallery and Churcher bought some for the National Gallery of Australia. Requests soon came from leading commercial galleries and the group's production grew. Soon their space became too cramped so ATSIC funded the building of new rooms and storage areas. Since then, the group has experimented with various forms of art and craft, including

jewellery. Increasingly, acrylic painting on canvas has become the main medium, with some artists now also experimenting with sculpture in concrete. Traditional skills such as basket- and mat-weaving using fine grasses have also been revived as the community's senior women found a new market for their work through the art and culture centre.

Interstate artists such as Yvonne Boag, Michael Leunig, Guy Warren and Garry Shead have also undertaken artist-in-residency programs at Lockhart River.

The art movement's success led to the establishment of an art and culture centre in a former medical clinic with several exhibition rooms and expansive work spaces, including a large veranda and slat-sided room in which artists work.

The style of Lockhart River art varies widely, with each of its 12 main artists distinguished by their very individual approach. The most well known of the Lockhart River artists is Rosella Namok whose works have attracted attention since she produced her first prints in 1997. Since then, her paintings have been selected for leading public survey exhibitions such as the Adelaide Biennale and the Wynne Prize. A continuing series focuses on the two sides or moieties of her family which she depicts in concentric ovals or rectangles ranging from monochromatic shades to multi-hued colours. The beach and sea are also key elements in her work as she carves out designs in thick layers of white, blue, brown and red shining acrylic to mirror the ripples on the sand made by strong tidal pulls. Other images are based on the sacred 'Ngaachi Kincha' ground still used for ceremony; the tangled roots of the mangroves; traditional fish traps; 'para' [white/European] 'nother way', and abstract representations of generations and houses in the community.

Fiona Omeenyo's early pictures are grounded in narrative, telling the story of the parrot sisters who were kidnapped by a jealous man the night before they were to marry the son of the sea eagle. 'The sea eagle still goes up and down the coast looking for them,' she says. Her images include ghostly figures appearing as though through a fog, silhouetted figures of the sisters and their protective eagle. In 2007 her work showed a new development into freer imagery and more abstracted design.

Different again are the paintings of Samantha Hobson whose expressionist abstract works have, since she first started painting in the late 1990s, often been based on the topics of domestic violence as well as those of her land such as fire and the coast. According to Hobson, she does not paint to confront but depicts what she experiences and observes on a daily basis. Although much-exposed in the media from around 2006, the subject of domestic violence is one that few in the indigenous or non-indigenous world have had the courage – or maybe the desire – to express through art.

'Sometimes what I see really upsets me,' says Hobson. 'What [people] do and what happens to them … That makes me hurt inside too … the painting makes the bad feeling go away.'[5]

In 2004 the Barkers retired as arts centre managers, with Sue Ryan and Greg Adam assuming the positions, followed in 2007 by Camille Masson-Tansier.

Having already established themselves by their late 20s, the first generation of Lockhart River artists was succeeded in the early 2000s by a newer generation that included the emergence of artists such as Silas Hobson,

whose work in 2008 showed a quantum leap into urban/traditional imagery. And in a lovely circular fashion, some of the 'old ladies' from whom Namok and others had obtained stories developed as painters in their own right in exhibitions such as those by Elizabeth 'Queenie' Giblett at Sydney's Hogarth Galleries and Brisbane's Andrew Baker Art Dealer. In April–May 2008, Perth's Emerge Artspace held a joint exhibition by a group of four, *We Old Girls work together to make a painting*.[6]

Some Lockhart River artists

Sammy Clarmont, Denise Fruit, Samantha Hobson, Silas Hobson, Elizabeth 'Queenie' Giblett, Adrian King, Mora Macumboy, Rosella Namok, Fiona Omeenyo, Terry Platt.

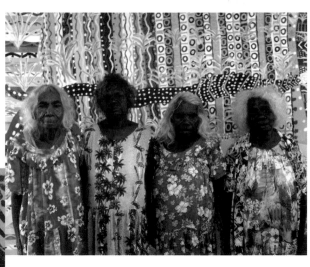

Maria Butcher, Dorothy Short, Susie Pascoe, Elizabeth Queenie Giblett in front of their painting *Umpoula Kououkouounji Umpoula Ma'apina (We Old Girls Make Painting)*, 2008, acrylic on canvas, 200 x 350 cm. Private collection. [Courtesy the artists, Lockhart River Arts Centre and Emerge Artspace.]

LEFT: Denise Fruit, *Untitled*, 2007, acrylic on canvas, 66 x 97 cm. Private collection. [Courtesy the artist, Lockhart River Arts Centre and Emerge Artspace.]

FAR LEFT: Samantha Hobson, Flying over the Reef, 2007, (detail) acrylic on canvas, 183 x 285 cm Private collection. [Courtesy the artist and Andrew Baker Art Dealer.]

CENTRE: *Samantha Hobson painting, 2007*. [Photo. Geoff Barker, Courtesy Andrew Baker Art Dealer.]

MORNINGTON ISLAND

'The Heart of Everything'

Mornington Island is one of a network of 23 islands that form the Wellesley Islands group in the Gulf of Carpentaria off Australia's far north Queensland coast. The traditional owners are the Lardil people. Sixty-five kilometres in length and ranging from seven to twenty-six kilometres in width, Mornington Island is linked to the mainland by a series of smaller 'stepping-stone' islands that are home to the Yangkaal. In pre-European times there was regular trade and cultural exchanges between Mornington Island's Lardil people and the mainland Gangalidda via the Yangkaal peoples. East of Mornington Island lies Bentinck Island, home to the Kaiadilt people.

The work of today's Lardil, Yangkaal and Gangalidda artists is grounded in a long tradition of art practice and recorded in European histories from the arrival of Presbyterian missionaries in 1914. This has included a substantial bark painting movement from the 1960s, a simultaneous development of figurative images in acrylic on canvas, and later abstracted designs based on body paint or 'paint-up' for dance performance.

'At the heart of everything is the land. It is the way we think and feel about the land that makes us Aboriginal ...'

The late Larry Lanley,
chair Mornington Island Council.

Most famous of Mornington Island artists for much of the last half of the twentieth century were Dick Roughsey and his brother Lindsay Roughsey. Their example led to the formation of a thriving art and craft practice paralleled by the growing fame of the Mornington Island Dancers who travel Australia and the world.

Central to this evolution has been its arts centre, Mornington Island Arts and Craft, located in the township of Gununa which has operated under various names since the 1960s. Since 2002, under the management of Brett Evans – a resident of the island since 1984 and married to Lardil woman Emily Evans (granddaughter of Dick Roughsey) – a vibrant new art movement has developed. Most extraordinary has been the blossoming of a completely new style spearheaded by elderly Kaiadilt artists Sally Gabori, May Moodoonuthi, Dawn Naranatjil, Paula Paul, Netta Loogatha, Amy Loogatha and Ethel Thomas.

Originally from Bentinck Island and removed to Mornington Island as children, these seven related women had never painted before 2005. This distinguishes them from the island's Lardil,

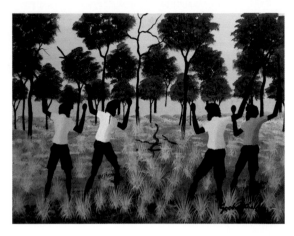

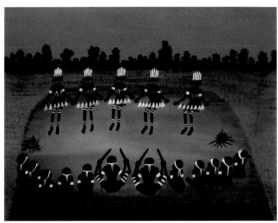

Arnold Watt, *Seagull and Crane Dance*, 2004, acrylic on canvas, 101 x 76 cm. Collection Mornington Island Arts & Craft.

ABOVE: Dick Roughsey, *Boys Killing Snakes,* c. 1970s, acrylic on board, 35 x 44 cm. The Hinds Collection.

LEFT: Sally Gabori, Netta Loogatha, May Moodoonuthi, Dawn Naranatjil, Amy Loogatha, Paula Paul, Ethel Thomas, *Dulka Warngiid (Land of All),* 2007, acrylic on canvas, 201 x 613 cm. Collection, National Gallery of Victoria. [All photos courtesy the artists and Mornington Island Arts & Craft.]

The richly varied art of Mornington and Bentinck Island artists includes figurative works from the 1950s and 1990s and the vibrantly coloured acrylics by the elderly Kaiadilt artist Sally Gabori and her sisters.

Reggie Robertson, *Headband* Design, 2005, acrylic on canvas, 137 x 121 cm. Private collection. [Courtesy the artist and Mornington Island Arts & Craft.]
Top right: *Netta Loogatha painting Mornington Island Arts & Craft, 2008* [Photo. Jonah Jones.]

Leading artist Reggie Robertson is a passionate advocate for the continuation of his culture and translates designs for ceremonial headbands into striking canvases. The arts centre in which the artists work, as the picture (right) shows, contains items of ceremonial and historical artistic significance.

Yangkaal and Gangalidda artists with their substantial painting history. The exuberant and joyous art of these women is innovative and fresh yet derives strongly from the return to their homeland movement. The enthusiastic response to their lushly coloured canvases has spurred new development, creativity and individuation not only in their work but in that of the established Lardil, Gangalidda and Yangkaal painters. A group of talented younger artists has also drawn inspiration from their inventiveness.[1]

'Proper way'

In pre-mission times and up until the 1950s, traditional painting practices on Mornington Island were confined to decorated artefacts and paint-up in ochre paints for ceremonial dances by men and women. Like the tradition in central Australia, body design included the addition of feather down and small ochre balls stuck to the body with human blood.

In 1914, Reverend Robert Hall established a Presbyterian mission on the island. He was speared to death three years later when the Lardil warriors took control of the mission station. Retribution by police from the mainland was swift: arrests were made, life sentences given, and some perpetrators removed to Palm Island. A second missionary, R.H. Wilson, arrived in 1918. As Dr Paul Memmott, who has written widely on the culture of the region, described, Wilson instigated, a 'process of cultural change aimed at eliminating practices morally offensive according to the Christian church' such as male initiation rites. Public dancing, however, was deemed acceptable and allowed to continue.[2]

Lindsay (Burrurr or Burud) Roughsey was born some time between 1907 and 1911. Living to almost 100, he played a pivotal role in the development of art on the island. His brother Dick Roughsey, who became a famous artist, illustrator and Lardil spokesperson, was born in 1920. The name 'Roughsey' was given to the brothers' father, one of whose names, Kiwarbija, means 'rolling' or 'rough' sea. Another of his names was Kubulathaldin which Dick Roughsey later used to sign his paintings 'Goobalathaldin'.

Early artistic development

As many Lardil men including Dick Roughsey began working on boats and travelling to the mainland, a new style of bark painting that incorporated the cross-hatched technique of Arnhem Land artists combined with traditional

Lardil body decoration began to develop. The production of decorated artefacts and bark paintings was encouraged, and a thriving school emerged.

While working on the mainland in the 1960s, Dick Roughsey became friends with airline pilot and hotel owner Percy Trezise. Trezise, himself a painter, took an interest in Roughsey and provided him with acrylic paints. Roughsey's style changed to feature figuration where he used silhouetted form for figures and incorporated elements of traditional design set amongst bush landscape. Exhibited from the early 1960s these works became highly popular in sell-out shows throughout Australia. Roughsey also authored the first Aboriginal autobiography, *Moon and Rainbow: The Autobiography of an Aboriginal*, in 1971 and in 1973 became the first chair of the newly created Aboriginal Arts Board of the Australia Council. He continued to paint until his death in 1985.

Roughsey's wife, Elsie Roughsey (Labumore) (1923–85), was also a noted artist and author; she is known for her distinctive clay dolls depicting women's ceremonies.[4]

The Kaiadilt of Bentinck Island

Until the 1940s, the Kaiadilt of Bentinck Island – who include Sally Gabori, May Moodoonuthi, Dawn Naranatjil and Paula Paul – had lived a very isolated life on their island home east of Mornington Island. Comprising 180 square kilometres, Bentinck Island is a low-lying island of saltpans and infertile scrub, frequently flooded during monsoons yet conversely also lacking in fresh water due to its size and the prevalence of salt water. The Kaiadilt devised

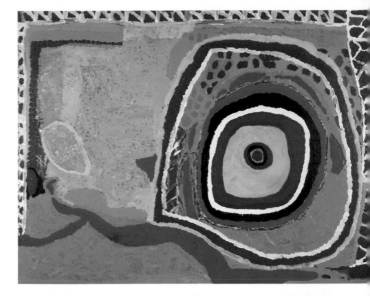

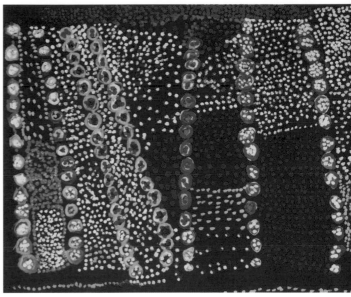

Paula Paul, *Shells*, 2007, acrylic on canvas, 91 x 121 cm. Private collection. [Courtesy the artist and Mornington Island Arts & Craft.]

ABOVE: Netta Loogatha, *Makarrki*, 2006, acrylic on canvas, 137 x 183 cm. Private collection. [Reproduced QIAEMA Calender, 2006. Courtesy the artist and Mornington Island Arts & Craft.]

LEFT: Joseph Watt, Lindsay Roughsey and Sally Gabori painting Mornington Island Arts & Craft, 2005. [Photo. Brett Evans. Courtesy Mornington Island Arts & Craft.]

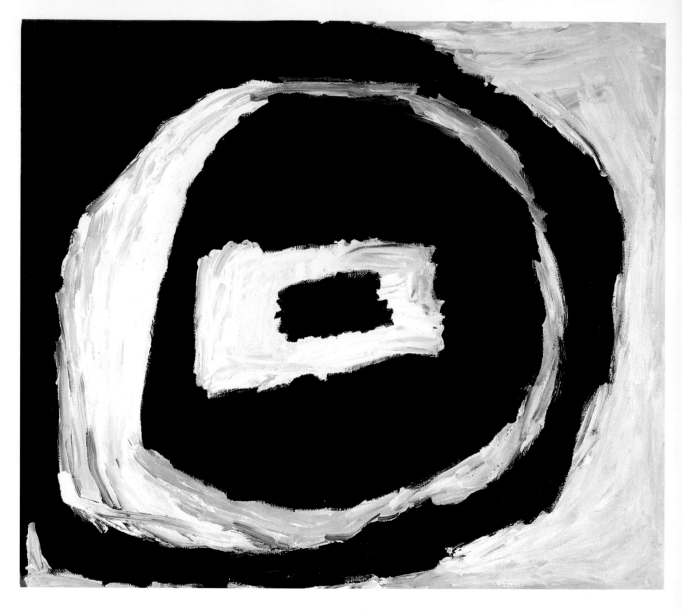

Sally Gabori, *Ninjiki*, 2006, acrylic on canvas, 136 x 151 cm. Collection Musée du Quai Branly, Paris. [Courtesy Mornington Island Arts & Craft and Alcaston Gallery.]

large stone-wall fish traps extending out to sea to help them catch fish, dugong, turtle, and other sea foods. Until the 1940s, except for sporadic visits by Europeans, they lived a self-contained life and were, as Paul Memmott, has described, the last Aboriginal peoples to live a fully traditional coastal hunter-fisher lifestyle.[6]

However, during the 1940s, severe drought forced the removal of the Kaiadilt to Mornington Island where they remained a self-contained group, hardly mixing with the island's Lardil and other peoples.

A new art movement

By the early 2000s, the market for artefacts and the style of bark paintings had dwindled. In 2000, a book project in which some long-time artists, many of whom were also leading dancers with the Mornington Island Dancers such as Melville Escott, Billy Koorubbuba, Andrew Marmies, Reggie Robertson, Arnold Watt and Joseph Watt, translated their body decoration onto canvas and board using a mixture of acrylic and ochre paints. Reproduced in the 2001 book *Paint-up*, the project encouraged a new style of art. In 2002, when Brett Evans became arts centre co-ordinator, he, together with the island's Woomera Aboriginal Corporation's general manager Peter

Cleary, set a new direction for the arts centre. Simon Turner of Brisbane's Woolloongabba Art Gallery conducted several workshops in 2004 and 2005 with a largely male group of artists.

During the second of these workshops, the elderly Kaiadilt woman Sally Gabori, who at that time was living in an aged-care facility on the island, visited the arts centre and started experimenting with paint. The results, in what became Gabori's characteristic bright coloration and free design, were entirely different to the more formalised designs of the Lardil artists. Never having painted before, Gabori nevertheless took to the medium with confidence, producing a sufficient number of works within several months to hold her first exhibitions. With the proceeds, she chartered a plane to take herself and her husband back to Bentinck Island for a visit. (Her Kaiadilt relatives had been gradually moving back to their island since the late 1970s when Mornington Island was returned to Aboriginal control.)

Shortly after, Gabori's relatives – Dawn Naranatjil, May Moodoonuthi, Paula Paul, Netta Loogatha, Amy Loogatha and Ethel Thomas – also decided to take up painting. Each has developed her own very distinctive style that depicts representations of the highly specific places belonging to each on their island home, as well as work based on ceremonial body marks.

Concurrent with the rise of the Kaiadilt painters is that of Mornington Island's Lardil, Yankgaal and other artists, including Lindsay Roughsey who started painting again in his 90s and continued until his death in 2007. Well-established artists such as Arnold Watt,

Reggie Robertson and Gordon Watt developed new and more contemporary styles, joined by others including Thelma Burke whose narrative paintings relate stories of the mission days and other events. A younger group includes Emily Evans, whose sophisticated, minutely dotted canvases shimmer with movement. Beverley Escott's dramatically minimalistic paintings are based on body marks, and Karen Chong's softly coloured works are of abstracted landforms. Annika Roughsey's paintings include abstracted patterns based on the scales of the Rainbow Serpent, and Joyanne Williams's monochromatic works reflect the shiny scales of the barramundi. They are just some of the 30 practitioners who have found new means of expression that extend the traditions of this long-established art school.

Some Mornington Island artists

Thelma Burke, Karen Chong, Beverley Escott, Melville Escott, Emily Evans, Sally Gabori, Lance Gavenor, Billy Koorubbuba, Amy Loogatha, Netta Loogatha, May Moodoonuthi, Dawn Naranatjil, Paula Paul, Reggie Robertson, Annika Roughsey, Lindsay Roughsey, Dick Roughsey, Joelene Roughsey, Ethel Thomas, Lex Toby, Gordon Watt, Arnold Watt, Joseph Watt, Joyanne Williams, Bradley Wilson, Renee Wilson.

Installation XStrata Coal Indigenous Art Award, Queensland Art Gallery with Emily Evans' work on the wall, 2006. [Courtesy the artists and Queensland Art Gallery.]

TORRES STRAIT ISLANDS

The 274 islands that form the Torres Strait Island (TSI) group have had a great impact on Australian art and politics yet may never have become part of Australia at all. Situated off the coast of Cape York Peninsula between Papua New Guinea and Australia, the islands were the subject of dispute until they became annexed to Australia in 1879. They were named after the Spanish navigator Luis Váez de Torres who sailed the strait in 1767.

While for many years the TSI almost did not figure in the consciousness of mainland Australians as being part of Australia, many events of significance in Australia's history occurred here from as early as 1770 when, from the TSI, Captain Cook claimed British sovereignty over the eastern part of Australia. More than two centuries later, it was the federal court case initiated by Torres Strait Islanders, and named in honour of leading proponent, Eddie Mabo which,

in 1992, successfully overturned the belief that the lands of indigenous people were *terra nullius* (no one's land).

Due to their proximity to Papua New Guinea, Australia and the Pacific and Indian oceans, historically the islands have been amongst the most visited by European, Asian and other explorers and traders, especially once pearls were discovered in the early 1900s. Japanese, South Sea Islanders and Malaysians regularly visited the islands, with trade becoming such a major part of islander life that it formed the basis of their culture or 'Ailan Kastom'. Pearls, trochus, wauri shells, stone clubs (gabagaba) and shell ornaments were commonly traded internationally; ochre, spears and spear-throwers were traded with central Australian Aboriginals; and popular trade items with Papua New Guineans included canoe hulls, drums, bird of paradise and cassowary feathers.[1] Additionally, these visitors were accepted by families into traditional kinship, in particular creating links between Aboriginal and Papua New Guinean people that still exist today.[2]

Despite being part of Australia and having contact with both Aboriginal and Melanesian cultures, the culture of Torres Strait Islanders is unique. Their ancestors settled the islands at least 3500 years ago, which is much later than

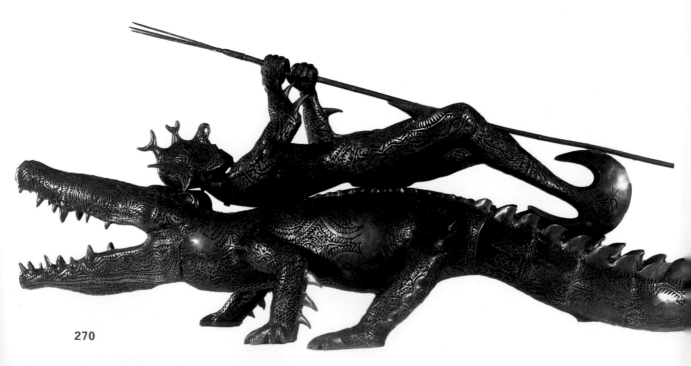

either Aboriginal or Papua New Guinean settlers, and their origins are not clear.[3] What is known is that the TSI were always a sea-faring people. Their connection with the sea was manifested in sacred sites comprised of dugong bone mounds, and much TSI mythology focuses on the sea. In addition, magic, the presence of spirits, and changes in the weather are all equally important in both ritual belief and for daily survival.

Massive change was introduced into TSI traditional life in the late 19th century. Islanders still celebrate 'The Coming of the Light' which commemorates the day the London Missionary Society arrived on Erub (Darnley Island) on 1 July 1871. The islands were to be dominated by this privately funded, Protestant society for many years.

The Cambridge Expedition

Torres Strait Island artefacts were enthusiastically collected by British, European and other institutions. The London Missionary Society collected many as did anthropologists William McFarlane and A.O.C. Davies who collected artefacts that are now held in the Queensland Museum. But the major haul of TSI goods was gathered during the Cambridge Expedition from 1898 organised by Alfred Cort Haddon. Amongst its members were psychologists, physiologists, doctors and linguists, all of whom had expertise in photography, film, music and art. They made field notes and sound recordings, took photographs and gathered objects for collections. The expedition mostly focused on the islands of Mer and Mabuiag where Haddon enjoyed close relationships with the islanders. Indeed, Haddon seemed to have had genuine respect for the islanders and their culture, and fearing its demise, attempted to capture as many aspects of it as possible. He commissioned numerous replicas and models and his collections included hand-held dance ornaments and storyboards that depicted the movement of the stars, the currents of the sea and the changing seasons.

Billy Missi, *Kulba Yadail (old Lyrics)* 2006, linocut, 84.5 x 47.5 cm. Collection, Mornington Peninsula Regional Gallery. Photo. Mark Ashkanasay. [Courtesy the artist and MPRG.]

LEFT: Dennis Nona, *Ubirikubiri of the Awailau Kasa*, 2007, bronze sculpture, 1100 x 1200 x 3200 cm, ed. 6. [Courtesy the artist and Australian Art Print Network.]

Leading TSI artist Dennis Nona was the youngest recipient of the prestigious National Aboriginal and Torres Strait Islander Art Award when he won in 2007 with this extraodinary 3. 5 metre-long sculpture. Printmaker Billy Missi continues the fine tradition of striking printmaking established by Nona and others.

Alick Tipoti, *Aralpia Ar Zenikula*, 2007, (detail) linocut, 700 x 1000 cm, ed. 98. Multiple collections. [Courtesy, the artist and Australian Art Print Network.]

These ceremonial objects are considered to be the origins of the dance machines made today.

The Cambridge Expedition resulted in six volumes of information on the islands, and the collection is now housed in the British Museum, the University of Cambridge Museum of Archaeology and Anthropology, with smaller representations in the National Museum of Ireland, Dublin; the Pitt Rivers Museum, Oxford; and the Queensland Museum, Brisbane.[4] (In 2008 the Australian government is attempting to repatriate this collection to Australia.)

The TSI culture has been referred to as 'one of the most over-analysed, measured, tested, collected, documented and 'picked over' cultures in the world'. [5] Yet these collections have proved valuable for contemporary TSI artists such as Dennis Nona and Billy Missi who have travelled to the UK to view them, and consequently been able to discover aspects of this culture that may have disappeared. Textile artist Rosie Barkus has also made use of the Cambridge collection, claiming that all her drawings and designs stem from studying the book on Haddon's expedition.[6]

Mask-making in the Torres Strait

Torres Strait Islanders are famous for masks which are central to ceremonial practice and, through the work of leading artists, have become contemporary artworks. The Torres Strait Islanders are the only known producers of the composite turtleshell masks (krar) found in the western and central islands. These are intricately detailed, with totemic designs representing clans and depictions of human faces, and can be traced back to a relationship with the Easter Islands. The heavy masks are held between the teeth during ceremonies and harvest festivals, an act requiring great skill and strength. The feathered headdress, known as dari-dhoeri, used in dance is such a major symbol of cultural identity to islanders that it was incorporated into the TSI flag as a sign of unity between the islands.[7]

The importance of dance features regularly in Torres Strait Islander art. With the introduction of Christianity and consequent outlaw of 'magic', dance became the primary cultural practice.[8] As Dennis Nona notes: 'I am a dancer myself when I draw.'[9]

Since the late 1980s, artists such as Ken Thaiday Snr have reinvigorated this mask-making by the creation of highly complex and beautiful sculptural headdresses or 'dance machines'. A dancer and sculptor, Thaiday's head-dresses are most often adorned with a representation of the shark totem belonging to the Meriam clan of the eastern islands of the Torres Strait. His Beizam (a Pidgin-English term for ancient shark headdresses worn by the Bomai-Malu cult) headdresses combine the image of the hammerhead shark with planes from World War II. Thaiday's early headdresses used real shark jaws. He held a solo exhibition in Paris in 2006 and the Queensland Art Gallery staged a major exhibition of his work, *Old Fashioned Dance: The Art of Ken Thaiday*, in the same year.

Younger artist, Janice Peacock's sculptures of pearlshell luggers and crates (shopping trolleys decorated to resemble crocodiles and planes) also reference the headdresses in a more contemporary postcolonial fashion which includes replacing the traditional bird of paradise or cassowary feathers with plastic bags.

Contemporary artists Dennis Nona and Alick Tipoti, mostly known for their works on paper and sculptures, have since the early 2000s also been making masks and headdresses.

Other significant artists creating the striking headdress dance machines include James Eseli, Richard Joeban Harry, Allson Edrick Tabuai, Patrick Thaiday and Victor McGrath. Their works have been shown in exhibitions such as *Dhari a Krar: Headdresses and Masks from the Torres Strait*, National Museum of Australia, 2006; and *Spirit Dancing: Ken Thaiday and Roy Wiggan*, University of the Sunshine Coast Art Gallery, 2007.

Ken Thaiday Snr, *Beizam (Hammerhead Shark) Headdress*, 1999, mixed media, 79 x 92 x 95 cm. Private collection. [Courtesy the artist and Sotheby's.]

The development of works on paper

Whilst TSI culture expresses itself strongly in three-dimensional form (the drums, warrup and buru buru-boro boro are also important representations of islander identity), as Simon Wright notes in the catalogue of the exhibition *Sesserae: The Art of Dennis Nona*, there is no word for two dimensional 'art' in Nona's language.[11]

Modern development of TSI works on paper started in the 1960s when an Australian historian, Margaret Lawrie, commissioned watercolours from several TSI men for her book, *Myths and Legends of the Torres Strait*.[12] Testament to the richness of the mythological narratives of these islands is the fact that none of these watercolours – by artists including Ephraim and Ngailu Bani, Segar Passi, Locky Tom and Kala Waia – could possibly hope to illustrate more than fragments from each story. (In 2008, Margaret Lawrie's significant collection of Torres Strait Islander materials was given to the State Library of Queensland.)

Many years later, in the early 1990s, a group of young TSI artists studied printmaking at the TAFE college in Cairns. Amongst them was Dennis Nona. Nona's highly skilled work was

Dennis Nona, *Muturau Goiga*, 2007, (detail) etching, 40.5 x 36.2 cm. Multiple collections. [Courtesy the artist and Basil Hall Editions.]

recognised early on by groups such as the Sydney-based Aboriginal Art Print Network, established in 1996, which fostered Nona's work and continues to represent him as well as a number of other TSI printmakers. The tradition of carving and tattooing, working in relief, and the intricate islander style that combines both decorative and figurative elements translates well into linocut as represented first by Nona. Increasingly popular during the 1990s, Nona's solo exhibition *Sesserae*, curated by the Dell Gallery, Queensland College of Art in 2005, one of the most widely toured solo exhibitions in Australia, includes prints on the various themes of constellations, weather elements, ceremony, food, hunting, traditional stories, medicine, spirit charms, totems and life and death. His master narrative, *Sesserae: The Badu Island Story*, concerns the story of a young fisherman who successfully caught the much-prized dugong, igniting the envy of neighbouring warriors. In the ensuing fight, he changed into a Willy Wagtail, a bird regarded by Badu Islanders as cheeky and elusive.

Nona's work is based on fluid and intricate lines and ranges from black and white to hand-coloured linocuts. In 2007, aged only 33, Nona won the coveted National Aboriginal and Torres Strait Islander Art Award (NATSIAA) – the youngest ever winner of the prize. His entry was a huge bronze sculpture, *Ubirikubiri of the Awailau Kasa*. At 3.5 metres, it weighs 650 kilograms and is one of six in a series. Depicting the mythological crocodile and tattooed man, it is a powerful depiction of islander culture. The work was also exhibited in *Cultural Warriors: National Indigenous Art Triennial 2007*, with the National Gallery of Australia purchasing one of its editions.

Pioneering artists such as Nona gave encouragement to successive artists. During the 1990s, TSI printmakers became amongst the most prolific and important printmakers in Australia. Artists including Nona, Alick Tipoti, Billy Missi, Brian Robinson, Joel Sam, Joey Laifoo and Leroy Alua Savage have held many exhibitions, won awards, and their work is sought after by top art collectors. Billy Missi, who was a crayfish diver before becoming a major printmaker, was acknowledged with a prize in the 31st Fremantle Print Award, 2006; he also held an important solo exhibition of linoprints, *Urapun Kai Buai: One Big Kin*, at KickArts in Cairns in 2008. As well as focusing on the familiar island aspects of sea faring life, Missi's work depicts cultural and historical elements of his people, such as links between Aborigines and Papua New Guineans, and the distinctions between islands as evidenced by the important Mawa ceremony which heralds the arrival of native fruits and yam and differs from island to island.[13]

Rosie Barkus, another Cairns TAFE graduate from Moa and Mer islands, originally began making jewellery from beach debris and opened her own craft shop in 1986. The niece of late artist Ephraim Bani, she subsequently began printmaking on fabric. Her work, which includes textile designs of headdresses, bush food and marine imagery, is an example of TSI women's art and has appeared in important exhibitions alongside TSI men's work, illustrating the complementary relationship between men and women's art in the islands.

Dennis Nona, Billy Missi, David Bosun and Victor Motlop were able to lead the printmaking movement from their home, with the establishment of two art centres in the TSI. Gab Tutui Cultural Centre is located on Waiben, and the Mualgau Mineral Artist Collective Art Centre at Kubin Community on Moa Island. Dennis Nona established the latter in 1999 as a print workshop with assistance from the community council, Torres Strait Regional Authority, and printmaker Theo Tremblay.

Out of the Islands

Developments in TSI contemporary art practice were spearheaded in the 1990s by Erub/Mer artist Ellen José, a painter, sculptor, printmaker, photographer and lecturer. José lives in Melbourne, one of many 'mainland islanders' – the term for those who live on mainland Australia. José's work ranges from investigations into the islanders' role in World War II to her haunting images of tropical dresses in the landscape, a symbol of islander women; and images of island life, such as seafood. They are painted in melancholic shades of deep blues and greens and refer to the artist's conflicting feelings towards colonisation and her own homesickness.

Destiny Deacon and Clinton Nain are also Torres Strait Islander artists who live and work in Melbourne. Their work, which examines a contemporary urban Torres Strait Islander experience, includes photography, multimedia and performance art.

Some Torres Strait Islander artists

Mario Assan, Ephraim Bani, Ngailu Bani, Rosie Barkus, Tatipai Barsa, Solomon Booth, David Bosun, Destiny Deacon, Joseph Dorante, James Eseli, Janet Fieldhouse, Annie Gela, Mary-Betty Harris, Richard Joeban Harry, Ellen José, Stanley Laifoo, Joey Laifoo, Billy Missi, Victor McGrath, Archie Moore, Victor Motlop, Jenny Mye, Clinton Nain, Masa Nakachi, Desmond Nelimam, Dennis Nona, Sharni O'Connor, Segar Passi, Janice Peacock, Lamickey Pitt, Brian Robinson, Allson Edrick Tabuai, Ken Thaiday Snr, Ken Thaiday Jnr, Patrick Thaiday, Alick Tipoti, Locky Tom, Kala Waia, Florence Ware, Andrew Williams.

Dennis Nona, *Sesserae*, 2007, hand-coloured linocut, 1250 x 2100 cm, ed. 45. [Courtesy the artist and Australian Art Print Network.]

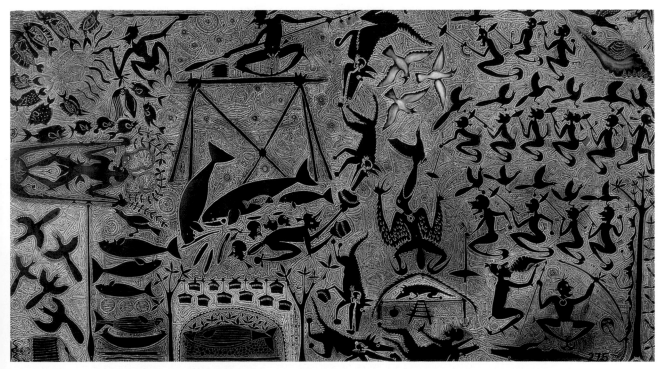

INTO the NEW

City-based and New Media Art

> '**Along with the proliferation of painting by artists from the desert, Top End and other regions, Aboriginal art post-2000 has been particularly notable for the meteoric rise of photomedia, video and installation art by city-based artists.**'

INTO the NEW
City-based and New Media Art

Paralleling the growth of art in Aboriginal communities in the bush has been that of indigenous artists in Australia's cities and surrounding areas. With the changing social climate of the 1970s and the rise of the land rights movements, artists of Aboriginal heritage living in cities such as Sydney, Brisbane and Melbourne, as well as regional towns, began to express through their art both their personal experiences and those of Aboriginal people in general.

Bicentennial:
A black day in Aboriginal history

In 1988, the bicentennial of official European landing in Australia was celebrated as a huge commemorative event. Costing many millions of dollars, it comprised a year-long festival and provided funding for hundreds of community and other projects. However, for Aboriginal people and many others sympathetic to their history, the year was one of mourning. Many artistic projects in different art forms reflected these concerns. One of the most significant is the National Gallery of Australia's *Aboriginal Memorial*. Originated and carved by the men of Arnhem Land's Ramingining area, the 200 hollow log coffins mourning 200 years of white occupation remains one of the most powerful artistic and political statements in the country.

At an individual level, artists such as Brisbane-based Gordon Bennett and Adelaide's Trevor Nickolls produced works expressing a strong indictment of European treatment of Aboriginal people. In 1990, Nickolls and Kimberley painter Rover Thomas were the first Aboriginal artists to represent Australia at the Venice Biennale (with Emily Kngwarreye, Judy Watson and weaver Yvonne Koolmatrie representing Australia in 1997). Whereas Thomas's ochre paintings were 'landmaps' of his Kimberley and Western Desert country, Nickolls's works, such as *From Dreamtime to Machine Time* (1990), offer both cynical comments on the changes that have occurred in Aboriginal societies and a cry for justice for Aboriginal people.

The brightly coloured screenprints of Perth-based Palku/Nyamal artist/writer Sally Morgan, whose award-winning book *My Place* created awareness of some of the problems of the adopted generation of Aboriginal people, have attracted international attention for their direct storytelling imagery.

While different in nature, strong colours in paintings are also employed by Sydney's Bronwyn Bancroft, who is of Bandjalung descent; South Australian Ngarrindjeri painter Ian Abdulla; the New South Wales Wiradjuri artist H.J. Wedge; and Ngaatjatjarra artist Mary Pitjinji McLean of Kalgoorlie, Western Australia. McLean won the 1995 National Aboriginal and Torres Strait Islander Art Award (NATSIAA) with *Ngura Walkumunu – Being in a Good Camp* which, with its tumbling black figures, stylised dogs, bright colours and flattened perspective, shows a place notable for its good water and abundant food.

Christopher Pease, *Surveying the King George Sound*, 2007, oil and balga resin on hessian board, 150 x 230 cm. Private collection. [Courtesy the artist and Goddard de Fiddes.]

While their personal experience and the stories they relate are very different, Bancroft's, McLean's, Wedge's and Abdulla's works all employ an 'art naif' style with foreshortened perspective, bright colours, simple figuration and a sense of spontaneity.

Yorta Yorta three-dimensional artist Treanha Hamm works in a variety of media – such as her 1996 National Aboriginal Heritage Award-winning piece *Remains to be seen*. Using materials such as wood gathered from her home country along the banks of the Murray River, she employs the Western techniques of printmaking to create subtle composites reflecting a personal interpretation of her heritage. Her latest work includes a renewal of possum-skin cloaks, a traditional Koori art form.

Three-dimensional works are also integral to Torres Strait Islander Melbourne resident Ellen José, whose work is often based on concern for environment, the balance between the organic and inorganic, and the notion that practices of the past may be employed towards the salvation of the world.

Politics in paint

The contemporary painting movement of Aboriginal artists living in cities and surrounding areas has a proud history. In the 1980s and 1990s, Victorian artist Lin Onus (1948–96) fused Western and Aboriginal painting to create a new style. Drawing from a range of traditions including Arnhem Land bark painting, Onus communicated his political and spiritual ideas in a contemporary way through his paintings, which were characterised by wit, irony and cross-cultural references. Paintings such as the *Barmah Forest*, which won him Canberra's National Aboriginal Heritage Award in 1994, showed a professional development from earlier, more decorative images into works of great clarity, luminosity, and subtlety.

Onus had grown up and lived most of his life in Melbourne's Dandenong Ranges. His father, William (Bill) Onus, was a leading

Lin Onus, *Barmah Forest*, 1994, (detail) acrylic on canvas,
183 x 144 cm. Collection, Australian Heritage Commission.
[Courtesy estate of the artist and Australian Heritage Commission.]

Aboriginal activist and craftworker and his
mother was a Glaswegian, Mary McLintock
Kelly. Onus was a strong political activist who
worked to forge cross-cultural links. It was
this freedom from stereotyping that formed
the basis of Onus's work and character. In one
work he could represent in hyper-real clarity
the timeless nature of the river country of his
father's traditional land in Northern Victoria,
the rarrk cross-hatching taught and 'gifted' to
him by Arnhem Land painter Jack Wunuwun,
a perceptive and laconic sense of humour,
and political commentary all underpinned by

a strong presence of the spirit world that is
intrinsic to both Celtic and Aboriginal culture.

Onus's contemporaries include Nickolls
and self-taught Ngaku artist Robert Campbell
Jnr (1944–93), a painter who similarly became
known as one of the first wave of indigenous
artists whose contemporary illustrative works
addressed both his own Aboriginality and
broader indigenous issues.

In Sydney in the 1980s, Bandjalung painter
and textile artist Bronwyn Bancroft founded
Boomalli Aboriginal Art Cooperative, along with
fellow artists Euphemia Bostock, Brenda L.
Croft, Fiona Foley, Fernanda Martins, Arone
Raymond Meeks, Tracey Moffatt, Hetti Perkins,
Avril Quaill, Michael Riley and Jeffrey Samuels.
The Boomalli artists are innovative and culturally

political; much of their work challenges stereotypes and their stated aims include to 'illustrate the complexity and diversity of black cultural life and provide an opportunity for the wider community to participate in contemporary indigenous culture'.[1]

The post-millennium boom in artists' collectives includes several Aboriginal collectives such as Brisbane's Campfire Group and proppaNOW.

A northern cultural politics

Amongst the most overtly contemporary city-based artists are Queensland's Richard Bell, a painter of Anglo-Celtic and Kamilaroi, Kooma, Jiman and Goreng Goreng descent; Vernon Ah Kee, a painter, draughtsperson, printmaker, video artist and teacher of Kuku Yalanji, Waanyi, Yidindji and Gugu Yimithirr descent; and Gordon Hookey, a painter of Waanyi descent, whose work is deeply engaged with politics and satire.

In 2003, Bell won the prestigious NATSIAA, eclipsing his victory by wearing a T-shirt bearing the slogan 'white girls can't hump' to accept the award. His 2006 *Telstra Painting* with its statement 'Australian art is an Aboriginal thing' is a neat riposte to the fall-out of the win of this Telstra-sponsored award and, with its references to many Western art styles, encapsulates both Bell's artistic sensibilities and pointedly prescient texts that characterise his work. The word-play of Bell's work is engaging and the message he sends is clear – to provoke Australian society to examine race relations and the situation for Aboriginal people, especially artists; and to question the materialistic side of contemporary indigenous art.

Bell's contemporary Gordon Hookey's art is almost entirely concerned with race relations. He often

Julie Dowling, *Mollie at Coorow Hotel,* 2000, acrylic, red ochre and plastic on canvas, 100.3 x 120. 2 cm. [Courtesy the artist and Brigitte Braun Gallery.]

Ian Abdulla, *Mum & Aunty Teaching us kids to cook damper,* 2007, acrylic on canvas, 92 x 122 cm. Private collection. [Courtesy the artist and Greenaway Gallery.]

also includes text and directly confronts contemporary and historical issues of segregation and racism as indicated by the title of some exhibitions such as *Interface Inya Face* (Canberra Contemporary Art Space, 1995) and *Ruddock's Wheel* (Casula Powerhouse Arts Centre, 2001).

Fellow Queenslander Vernon Ah Kee combines visual imagery and text to deliver political and social critiques such as a red, black and white text-based series on Australian society and race relations. Much work also displays his skill as a draughtsman and offers a gentler examination of identity and family relations in award-winning portraits of his father, uncle and grandfather which relate both the hardships and joys of those of mixed heritage.

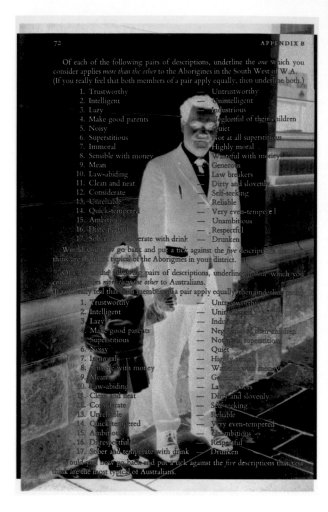

RIGHT: Brenda L. Croft, *Trustworthy (difference)*, 2005, giclée print on hahnemühle paper, edition of 10, 112 x 75 cm. Multiple collections. [Courtesy the artist and Niagara Galleries.]

BELOW: Clinton Nain, *a e i o u – who are you?*, 2006, bitumen and acrylic house paint on canvas, 152 x 122 cm. Private collection. [Courtesy the artist and Nellie Castan Gallery.]

A different perspective

Western Australian city-based artists tell different stories yet they also grapple with the history of political and colonial repression. Painter Julie Dowling examines the issue of the stolen generations using iconography derived from a large range of influences – from social realism to images of the Papunya school. Jodie Broun, a Yindjibarndi painter from Pilbara/Perth, WA, deals with race relations, in particular land rights, such as her NATSIAA winning work *Whitefellas Come to Talk 'Bout Land* (1998). Christopher Pease uses appropriation to great effect in his paintings, juxtaposing the position of his Nyoongar people's history with that of Western colonialism.

A newer generation of artists in other states such as Archie Moore and Daniel Boyd similarly use appropriation in contemporary form. Moore's re-writing of the *Archie* comic book series in which he exchanges the American

protagonist for an autobiographical Aboriginal 'Archie' cleverly and humorously depicts the historical injustices of the past and Moore's own experiences as a Queensland Aboriginal. Cairns-born, Redfern-based painter and installation artist Daniel Boyd quotes various cultural signifiers occurring within Australian cultural history, from paintings by E. Phillips Fox and F. Wheatley depicting Captain Cook's arrival to the AIATSIS Aboriginal language map, re-contextualising a history and art long the domain of the 'coloniser' into an Aboriginal interpretation.

Others such as painter and performance artist Clinton Nain, a Torres Strait Islander artist based in Melbourne, show wide ranges of influences, including Jean-Michel Basquiat, graffiti art and abstraction, to question identity and the cultural authority.

Gayle Maddigan is a Wamba Wamba/Wetigkia/Nari Nari painter and photographer who won the NATSIAA Works on Paper award in 2005. Her paintings often feature strong cobalt blue and black, with white linear markings that bear similarity to Western abstraction but are inspired by her culture, from the Murray River in northern Victoria. A similar sense of indigenousness and Western abstraction is seen in the work of other artists such as Perth's Shane Pickett and Darwin's Joshua Bonson. Bonson's textured paintings such as *Skin* (2007) depict the texture and circular shapes of crocodile skin while simultaneously representing family and the connections between people and the stones of the earth.

Queensland artist Joanne Currie Nalingu, winner of the 2008 Wynne Prize (see p. 255), is similarly engaged with abstraction within the field of landscape painting. Her works centre around the Maranoa River that lies by the mission where she grew up as one of the Mandandanji people (Gunguri language group) of the Mitchell area in south-west Queensland.

The rise of new media

Along with the proliferation of painting by artists from the desert, Top End and other

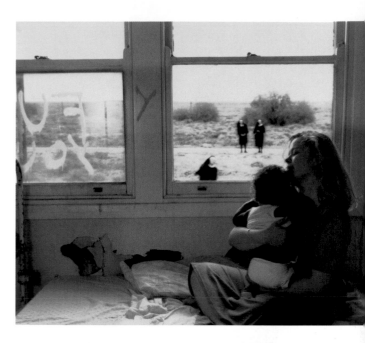

Christian Thompson, *The International Look,* 2005, edition of 10, c-type print, 190 x 127 cm. Multiple collections. [Courtesy the artist and Gallery Gabrielle Pizzi.]

ABOVE: Tracey Moffatt, *Up In The Sky # 1*, 1997, from a series of 25 images off set print, 72 x 102 cm. Multiple collections. [Courtesy the artist and Roslyn Oxley9 Gallery.]

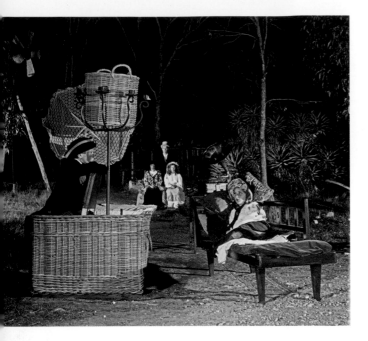

Destiny Deacon, *Over the fence*, 2000, From the series Sad & Bad, lamda print from Polaroid original, 80 x 100 cm. Private collection. [Courtesy the artist and Roslyn Oxley9 Gallery.]

ABOVE: Darren Siwes, *Terra Nullius*, 2006, cibachrome 5/8, 100 x 120 cm. Private collection. [Courtesy the artist and Nellie Castan Gallery.]

OPPOSITE: Fiona Foley, *HHH #2*, 2004, ultrachrome print on paper, edition of 10. 101 x 76 cm. Multiple collections. [Courtesy the artist and Niagara Galleries.]

regions, Aboriginal art post-2000 has been particularly notable for the meteoric rise of photomedia, video and installation art by city-based artists.

Pioneer was photomedia and film artist Tracey Moffatt, one of Australia's most internationally famous artists. Moffatt, who divides her time between New York and Sydney, creates photographs and films using scenes with sets and actors to achieve effects or relate narratives. Her image *Something More #1* (1989) in which the artist features in a torn red cheongsam dress in front of a painted landscape backdrop and wooden shack inhabited by a variety of figures to represent outback colonial and postcolonial characters such as a station manager, a white prostitute, goldfields 'Chinaman' and schoolboys, has become an iconic contemporary image. (In 2002, the series of nine in the *Something More* series sold at a London auction for $220,000, the record for any Australian photographic series at the time.) Moffatt's 1990s images include the poignant *Scarred for Life* series which depict scenes from her youth based on tales as told to her by her friends incorporated with photography. A later series, the 2005 *Under the Sign of Scorpio* (Roslyn Oxley9, Sydney) features images of 40 women throughout history born under her own star sign, including singer Björk and her own art dealer, Roslyn Oxley. In a sister series, *Being – Under the Sign of Scorpio*, Moffatt photographed herself 'being' many of these characters.

Moffatt's work, which in itself often imitates or pays homage to other artists, has now entered the art lexicon sufficiently for it to be quoted by a newer generation such as Bidjara artist Christian Bumbarra Thompson. Thompson's 2004 series *Gates of Tambo* (exhibited in the National Gallery of Australia's *National Indigenous Art Triennial '07: Culture Warriors*) features himself as Moffatt and other artists in a Cindy Shermanesque manner. To Thompson, Moffatt is of as much import as Andy Warhol.

Alongside Moffatt in the 1990s, Kamilaroi–Koamu artist Leah King-Smith was working in another style of photomedia, creating

in another style of photomedia, creating hauntingly poignant multi-layered high gloss cibachrome photographs. They spanned generations through the superimposition of 19th-century sepia photographs of people on reservations taken for 'scientific purposes' held in the State Library of Victoria onto views of today's urban life.

Similarly haunting imagery is seen in the work of Darren Siwes, an Adelaide-based photographer and painter of Ngalkan and Dutch ancestry. Siwes' double-exposed photographs of Aboriginal 'ghosts', often in historical places against colonial architecture, have been exhibited in biennials in Australia and Europe. Much of Siwes' investigation concerns Australian colonial race interactions and historical concepts such as *terra nullius* or 'empty land'.

Photography forms the basis of the very different work of Sydney artist/curator Brenda L. Croft of Gurundji/Mutpurra/Anglo-Australian heritage. Croft's photographs convey a myriad of references to social and Aboriginal issues.

In a different strain yet again are Melbourne-based Torres Strait Islander Destiny Deacon's 'found' object photographs in which Deacon offers commentaries on urban life and girls' (and women's) experiences. Deacon's work blurs the lines between the personal and public, and conjures the postcolonial maxim 'the personal is political'. In her 2004 retrospective at Sydney's Museum of Contemporary Art entitled *Walk and Don't Look Blak* which comprised videos made in her living room in Brunswick, Melbourne, in the early 1980s, an actual installation of the room itself was featured alongside her more recent emotional photographic investigation into her mother's origins and experiences in northern Queensland.

Fiona Foley, a Batdjala woman from Hervey Bay, south-east Queensland, now based in Sydney, creates photographs that have become similarly well known for a different portrayal of women through unadorned portraits of faces and bodies. Her installations include both these and references to the universal Aboriginal link with the land. Foley has noted that her work was confronting even at art school and has retained its political impact.[2] A residency in the US led to her biting commentary on race relations in the 2005–06 series *No Shades of White* and she also addresses issues such as political corruption in Australian history, for instance the Queensland government's role in manufacturing and selling heroin in the 19th century in the series *Black Friday* (2006). In addition, Foley portrays highly personal stories, such as photographs drawn from her experiences in love and life, as in the 2008 *Sea of Love*, Andrew Baker Art Dealer, Brisbane.

The new millennium

Artists embraced the new technology that became available in the 2000s. The Gamileroi/Wailwan REA's work, for instance, uses computer-manipulated photo-imaging processes to examine the power relations within Australia, focusing in particular on the black woman and the representation of the black female body. Tasmanian artist Karen Casey, whose work spans a large range of media, uses video and installation art, often in a public setting, such as her large permanent installation *Heartland* at Melbourne's Docklands. New South Wales artist Jonathan Jones, winner of the 2006 Xstrata Coal

Installation of Gordon Hookey's, *Paranoya –anoya,* 2005, mixed media, variable height. [Courtesy the artist and Nellie Castan Gallery.]

Queensland artist Gordon Hookey is known for his no-holds-barred works of pithy commentary such as this installation at his Melbourne gallery.

Indigenous Art Award, uses fluorescent lights to create his installations that reference various artists before him, from Gordon Bennett to Jackson Pollock. Amongst this referencing is his Aboriginal heritage, such as patterns derived from Kamilaroi/Wiradjuri carvings.[3]

This new technology has enabled indigenous artists to successfully manipulate imagery in order to communicate issues of identity. As in all Aboriginal cultures, these city-based artists are still irrevocably tied to their land. Seeking to re-address colonial and postcolonial representations of this land, artists such as Diane Jones, a Nyoongar woman from Western Australia, insert themselves into 'typical' white-bread Australian family photographs and known colonial imagery such as landscape paintings and iconic Western art images, for example the *Mona Lisa*. NATSIAA exhibiting photographer Nici Cumpston produces sumptuous landscape photographs that clearly display her love and respect for the land.

New media/old media

During the 1990s, Yvonne Koolmatrie, a Ngarrindjeri/Pitjantjatjara weaver from South Australia, re-ignited an interest in the use of traditional materials in a contemporary art context. Julie Gough, a Palawa Kani artist/curator from Tasmania, reflects a spiritual belief in her mixed-media installations: 'My feeling is that there is something "other" through which humans individually mediate the world ...' she said in relation to her exhibition *Intertidal* at Gallery Gabrielle Pizzi in 2005.

Additionally, Gough epitomises the strengths that Aboriginal artists living in cities can draw from despite the displacement caused by years of colonisation. Access to Western education (Gough holds a PhD) and research skills can create powerful ammunition for the colonised against the coloniser. Much of Gough's work from the 1980s, like King-Smith's, was informed by the profound disturbance she experienced during her academic researches into 19th-century museum practice which objectified and de-personalised indigenous people. Yet with

this disturbance comes enlightenment and revelation through the practice of art.

Other artists have shown the strength of tradition hidden beneath the surface of the indigenous cultures of Australia's eastern cities. Koorie artist Vicki Couzens's possum-skin cloaks are contemporary examples of an age-old tradition of a dress style and craft created by Aboriginal people living in Victoria. Intricately etched with symbolic designs, they proudly bear the origin of Preston, a suburb in Melbourne's north.

Lorraine Connelly-Northey, a Wurundjeri weaver from Mallee, Swan Hill, Victoria, uses a combination of collected and traditional materials including fly-wire and rusted tin and iron to make her dilly bags, coolamons and narrbong (string bags). Her work was chosen amongst others to represent the Commonwealth in the NGVA exhibition for the Commonwealth Games, *Contemporary Commonwealth* (2006).

Sydney-based Brenda Saunders (Palma) is another artist who creates fibre installations, such as an investigation of Aboriginal women in domestic service which comprises a series of aprons (*Parallel Lives*, 1996, Campbelltown City Bicentennial Art Gallery). Perth-born 'bush sculptor' Janine McAullay Bott, who descends from the Nyoongar, creates work evolved from a strong female tradition. Her mother

Brook Andrew, *Peace, the Man and Hope*, 2005, screenprint, collage, triptych, 145 x 252 cm. Printed by Brook Andrew and Larry Rawling. Multiple collections. [Courtesy the artist and Tolarno Galleries.]

and forebears, such as her great-grandmother, dominate her influences. Their spirit and traditions are expressed in her woven fish traps, brooms, bowls and bush safes.

Queensland painter and sculptor Laurie Nilsen, winner of the NATSIAA Wandjuk Marika 3D Memorial Award 2007, creates large installations of native species, such as life-size emus, that are enchanting with their whimsical qualities yet originate from a concern for the environment and the politics of Aboriginality, as well as from memories of his childhood and traditional life. His use of barbed-wire recalls the bush environment in which he grew up in Roma, outback Queensland, and also the threat to endangered species, noting that barbed-wire kills emus. His connection to birds originates from his Aboriginal mother, whose strong spiritual connection to birds had an impact on Nilsen.

Danie Mellor, whose mother's family originates from the rainforest area around Cairns, is a draughtsman and ceramic sculptor whose images of native flora and fauna symbolise cultural memory and quote imagery

and subjects from colonial exotic Australiana. His work, while undeniably political and engaged with a serious deconstruction of colonial and postcolonial identity, nonetheless manages to include wit and a wry humour in its social commentary. A lecturer in Theories of Art Practice at the University of Sydney, Mellor says his work 'addresses the notion of presentation and display and relates to my investigation of museum collections and the way in which material culture and iconic objects are shown'.[4]

An international perspective

Increasingly, Aboriginal artists living in cities are being viewed as international contemporary artists in overseas art meccas such as New York and Europe. Whilst Aboriginality is often their subject matter, the artist's own ethnicity is considered of secondary import, with

their work placed in the same category as conceptual, postmodern artists from around the globe. Such artists include Brook Andrew, a photomedia artist whose work examines issues such as indigenous male identity. Andrew's savvy and visually arresting iconic image *Sexy and Dangerous* (1998) overlays the colonial European placement of Aboriginal people with a warrior-like strength. His large screenprints of controversial Aboriginal rugby player turned boxer turned musician Anthony Mundine combined alongside cigarette advertising imagery further examine the identity of the Aboriginal man. Andrew's screenprints prompted other investigations of this theme by curator Djon Mundine whose exhibition *More than my skin* at the Campbelltown Art Centre in 2008 featured works exploring indigenous masculinity by artists Michael Aird, Mervyn Bishop, Gary Lee, Ricky Maynard, Peter Yanada McKenzie and Michael Riley.

Pop cultural referencing is also seen in the work of Brisbane-based artist Tony Albert whose persona 50perCENT (a half-white/half-black Aboriginal rapper) reflects the popularity of American hip hop music amongst Aboriginal

TOP: Danie Mellor, *An unparalleled vision (what curiosity lay before them)*, 2008, mixed media on paper, 60 x 70 cm. Private collection. [Courtesy the artist.]

RIGHT: Andrea Fisher, *Just ticking the Box,* 2007, mixed media, n.s Finalist National Aboriginal and Torres Strait Island Art Award, 2007. [Courtesy Museum and Art Gallery of the Northern Territory]

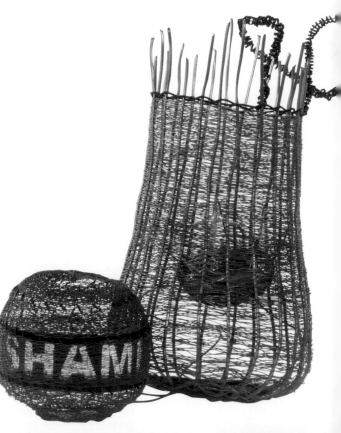

youth, and the rise of Aboriginal hip hop culture itself. Through portraits taken of 50perCENT and his compatriots Notorious B.E.L.L (artist Richard Bell) and 'Lil Gin, Albert aims to explore politics and identity, and to defy binary constructs he decribes as 'black vs. white, high vs. low art, TradAb vs RadAb art'.[5]

Is Aboriginal art 'dead'?

The survival of Aboriginal art has been questioned since the passing of the first wave of Papunya painters from the 1980s. Yet one of the greatest strengths of Aboriginal art and culture has been its constant ability to adapt. This has been so since the innovation of adding wood to the top of bark paintings in the late 1800s to enable these to be sold to tourists and others. In this sense there is no such thing as 'traditional' Aboriginal art; conversely, all Aboriginal art is traditional or at least based firmly on tradition. For, as with the Aboriginal belief system itself, art is an evocation of living culture as well as that of the past and is therefore constantly reinventing itself.

As with all new generations, young indigenous people aim to find their own identity and expression. The excitement with which the Papunya school of painters embraced acrylic paint cannot be recreated for the youth in the many regions in which painting has now become an everyday activity. However, many of a younger generation are still being inspired to use the medium of paint. In Aboriginal culture elders rule societies; it is they who hold the secret-sacred knowledge,

Jodie Broun, *Meeting with the Minister*, 2005, acrylic on canvas, 120 x 150 cm. Private collection. [Courtesy the artist and Indigenart-Mossenson Galleries.]

BELOW: Tony Albert, *50perCENT feat. SISSY*, 2006, type C photograph, 100 X 100cm. Collection, Sunshine Coast Regional Council. [Winner, Sunshine Coast Art Prize, 2007. Courtesy the artist and Caloundra Regional Gallery.]

Michael Jagamara Nelson, *Wild Yam, 1998,* acrylic on canvas, 201 x 176 cm. Collection, Queensland Art Gallery. [Courtesy the artist, Campfire Group and QAG.]

FAR RIGHT: Doreen Reid Nakamarra, *Sandhills at the Rockhole Site of Marrapinti,* 2006, acrylic on canvas, 122 x 91 cm. Private collection. [Courtesy the artist , Gallery Gabrielle Pizzi and Aboriginal Artists Agency Ltd.]

Leading Papunya artist Michael Jagamara Nelson has collaborated with groups such as Queensland's Campfire Group in paintings which meld traditional iconography with western abstraction while Kintore painter Doreen Reid Nakamarra's paintings demonstrate that with a younger generation art from Australia's most well known art centre, Papunya Tula Artists Pty Ltd established in 1972, continues to evolve.

stories, songs and ceremonial information. Elders are regarded, in effect, as professors and treated as such. This largely explains the phenomenon throughout contemporary Aboriginal art of the newest painters being the oldest citizens.

As the younger generation does not attain full status nor the rights to paint certain stories, the development of their painting evolves over a long period. Others, such as the young group of Lockhart River artists, set about to deliberately learn through their art the stories that had been all but lost due to displacement, as well as to relate contemporary and personal events. Other young artists turn to new media such as photography, spray paint, film, and other media. One such was the 2005 government-funded project at Warmun (Turkey Creek) organised by Ned Civil in which ten members of the community aged between 15 and 25 were given disposable cameras and photography workshops. The results were exhibited *as Snaps from Turkey Creek: Photos from Warmun Aboriginal Community*, Citylights Gallery, Melbourne, 2005 and showed a rare and frank portrayal of community life. Several of the artists came to Melbourne for the exhibition to work with Citylights stencil and graffiti artists, thus linking the 'urban' life of a community and the street life of a major city.

At Warburton, WA, the Warburton Youth Arts project co-ordinates an ongoing series of workshops in new media art and craft, including jewellery and glass-making with visiting artists. Projects have included fashion shows and, in 2007, experiments with importing photography onto glass with a contemporary Adelaide artist.

Exhibitions in private galleries such as those of the 'rising stars' of Papunya Tula artists at

galleries like Melbourne's Gallery Gabrielle Pizzi, Darwin's Cross-Cultural Art Exchange, Sydney's Utopia Gallery and others; as well as exhibitions of works of first-time younger artists such as the Kimberley's Lloyd Kwilla, and exhibitions of related artists of different generations from a number of communities around Australia are demonstrating these new developments. So too are regular exhibitions by Melbourne and Perth's Mossenson Galleries under the title *30 under 30* and Perth's Randell Lane's *Generation Next*, to mention only a few. At a national level the 2007-established National Gallery of Australia's triennial exhibition *Cultural Warriors* is a hugely significant survey exhibition which regularly explores the work of contemporary indigenous artists of all ages and media and demonstrates its extraordinary range and depth.

As these events and the work of a huge range of contemporary Aboriginal artists – whether practising in a regional, urban or global context; and in whatever medium be it paint, photography, sculpture, printmaking or installation – demonstrates, a new identity is being forged for contemporary indigenous art. It is one that constantly redefines Aboriginal art itself, and indeed the visual culture of Australia, placing it on the world's art stage in a manner more noticeable than ever before and with a profile that gains more attention each year.

Some city-based and new media artists

Ian Abdulla, Vernon Ah Kee, Michael Aird, Tony Albert, Shirley Amos, Brook Andrew, Bronwyn Bancroft, Bianca Beetson, Richard Bell, Gordon Bennett, Mervyn Bishop, Joshua Bonson, Euphemia Bostock, Daniel Boyd, Jodie Broun, Trevor 'Turbo' Brown, Kevin Butler, Robert Campbell Jnr, Karen Casey, Craig Allan Charles, Christine Christophersen, Lorraine Connelly-Northey, Isabell Coe, Vicki Couzens, Brenda L. Croft, Nici Cumpston, Destiny Deacon, Julie Dowling, Danny Eastwood, Andrea Fisher, Fiona Foley, Jenny Fraser, Kerry Giles, Julie Gough, Treanha Hamm, Mini Heath, Adam Hill, Sandra Hill, Alice Hinton-Bateup, Gordon Hookey, Sylvia

Huege de Serville, Joe Hurst, Diane Jones, Gary Jones, Jonathan Jones, Roy Kennedy, Francine Kickett, Leah King-Smith, Yvonne Koolmatrie, Lawrence Leslie, Irwin Lewis, Peta Lonsdale, Janine McAullay Bott, Peter Yanada McKenzie, Gayle Maddigan, Fernanda Martins, Ricky Maynard, Arone Raymond Meeks, Danie Mellor, Lisa Ann Michl, Tracey Moffatt, Archie Moore, Pauline Moran, Sally Morgan, Clinton Nain, Joanne Currie Nalingu, Laurie Nilsen, Trevor Nickolls, Caroline Oakley, Lin Onus, Tiriki Onus, Christopher Pease, Nicole Phillips, Shane Pickett, Avril Quaill, REA, Adam Ridgeway, Michael Riley, Elaine Russell, Jeffrey Samuels, Brenda Saunders (Palma), Vincent Serico, James Simon, Darren Siwes, Dorsey Smith, Jake Soewardie, David Spearim (Fernando), Gordon Syron, Christian Bumbarra Thompson, Ian Waldron, Judy Watson, Lilla Watson, H.J. Wedge, Jason Wing, Yondee (Shane Hanson).

The living art of Aboriginal Australia

1. D. Langsam, *Art Monthly*, March 1996.
2. W. Hilliard, introductory essay to folio of reproductions, *Central Australian Aboriginal Paintings: Brilliant Abstract Designs of the Pitjantjatjara*, Melbourne, 1965.
3. *Aboriginal Art and Integration,* 2nd Biennial Assembly of the Australian Society for Education Through Art, Western Australia, May 1967.
4. G. Bardon and J. Bardon, *Papunya Tula: A Place Made After the Story*, The Miegunyah Press, Melbourne, 2004, p. 15.
5. S. McCulloch, interview, 1996.
6. Ibid.
7. S. McCulloch, interview, 1997.
8. V. Johnson, *Dreamings of the Desert*, AGSA, 1996, p. 22
9. V. Johnson, *Aboriginal Artists of the Western Desert: A Biographical Dictionary*, Craftsman House, Sydney, 1994; reprinted 2001, p. 89.
10. See also *McCulloch's Encyclopedia of Australian Art*, Aus Art Editions and The Miegunyah Press, Melbourne, 2006, pp. 4–15.

ENDNOTES

From the bush to the city:
a buyer's guide

1. P. Toohey, 'The day they took Molly Rogers', *The Weekend Australian,* 26–27 May 2001, p. 3; S. Rintoul, 'Black artists forced into sweatshops', *The Australian,* 13 September 2003, p. 3; S. Rintoul, S. McCulloch, G. Safe, ''Poached' artists not a pretty picture', *The Weekend Australian,* 13–14 September 2003, p. 19.
2. Bardon's many articles and books on Papunya Tula such as *A Place Made After the Story*, The Miegunyah Press, Melbourne, 2004, record in extensive detail the problems of money, jealousy, official interventions and many other issues surrounding the early days of Papunya art.
3. Judith Ryan in *Emily Kame Kngwarreye: Alhalkere Paintings From Utopia,* QAG/Macmillan 1998. p. 40.
4. S. McCulloch 'Black Art Scandal', *The Australian,* 8 Nov. 1997 pp. 1-3. 'Dots before artist's eyes but they're not his,' *The Australian*, 25 Feb. 1999, p.1. 'The crisis in Aboriginal Art; the hand that signed the paper,' *The Weekend Australian,* 24 Apr. 1999, p. 1 & R.1. N. Rothwell, 'Scams in the desert', *The Australian*, 4 March 2006. p. 19.

Central Australia
Introduction

1. Kathleen Petyarre quoted in Anne Brody, *Utopia: A Picture Story*, Heytesbury Holdings, Perth, 1990, p. 12.

Alice Springs to Tennant Creek

1. *Papunya Tula Genesis and Genius*, Art Gallery of New South Wales, Sydney, 2000, p. 226.
2. www.keringkearts.com.au (2008).

Papunya Kintore and Kiwirrkura

1. G. Bardon, *Papunya Tula: Art of the Western Desert*, McPhee Gribble/Penguin, Melbourne, 1991, p. 21.
2. Ibid., p. 68.
3. G. Bardon quoted in J. Ryan, *Mythscapes,* National Gallery of Victoria, Melbourne, 1990, p. 85.

Haasts Bluff

1. M. Strocchi, *Ikuntji: Paintings from Haasts Bluff 1992–94*, IAD Press, Alice Springs, 1994, p. 9.

Yuendumu

1. G. Tyson, assistant art coordinator Yuendumu, relating comments by Paddy Stewart to S. McCulloch, Yuendumu, April 1996.
2. *Kuruwarri-Yuendumu Doors*, Aboriginal Studies Press, Canberra, 1992.
3. Website information www.warlu.com and conversations with Cecelia Alphonso, S. McCulloch, 2004–08.

Utopia

1. A.M. Brody, 'Portrait of the Outside' in M. Neale (ed.), *Emily Kame Kngwarreye – Alhalkere: Paintings from Utopia*, Queensland Art Gallery and Macmillan, Melbourne, 1998, p. 10.
2. S. McCulloch, interview, Alice Springs, August 1993.
3. S. McCulloch, interview, Alice Springs, 1995.
4. Ibid.
5. Australian Art Sales Digest (www.aasd.com.au) listing for Emily Kngwarreye for secondary sales to 2008.
6. M. Eather, *Minimal Fuss: Emily Kame Kngwarreye, Tony Tuckson and Minnie Pwerle*, Fire-Works Gallery, Brisbane, exhibition notes, 2003.
7. S. McCulloch, 'Black art scandal', *The Australian*, 8 November 1997, pp. 1–3.
8. S. McCulloch, 'All in the family', *The Weekend Australian*, 8 November 2003 and 'A shy woman of wild colours' (obituary), *The Age*, 8 April 2006.

Hermannsburg

1. M. West and J. Kean (eds), *Lyate Nwerne Urrkngele Mpareme (Now We Are Working With Clay)*, Hermannsburg Potters, Museum and Art Gallery of the Northern Territory, Darwin, 1996, p. 9.
2. Ibid., pp. 6–7.

PY and NPY Lands
Introduction

1. C. Mountford, *Nomads of the Australian Desert*, Rigby, Adelaide, 1976, pp. 95–96.
2. Ibid., p. 96.
3. A number of images in this significant book almost certainly ought not be seen by the uninitiated. However, its withdrawal from sale was also reflective

of the concerns of the time, when Aboriginal land rights and the significance of Aboriginal culture and people's rights to disseminate this as they chose was of great concern. Mountford died some months after the book was withdrawn from sale.
4. thrivinginthedesert.blogspot.com.

Maruku
1. Brochure, *Maruku Arts: Aboriginal Handcrafts from the Central and Western Desert*.

Spinifex
1. Catalogue, *Desert Mob*, Araluen, 2006, p. 30 and Spinifex Arts Project website www.spinifex.org

Ernabella
1. D. Kaus, *Ernabella Batiks,* National Museum of Australia, Canberra, 2004, pp. 20–22.
2. V. Johnson, *Dreamings of the Desert*, Art Gallery of South Australia, Adelaide, 1997, p. 90.

Kaltjiti
1. S. McCulloch, email correspondence with B.Peacock, March 2008.
2. Ibid.

Indulkana
1. W. Caruana and S. Jenkins, *Desert Mob,* Araluen Arts Centre, Alice Springs, 2006, p. 23.

Amata
1. P. Brokensha, *The Pitjantjatjara and Their Crafts*, Aboriginal Arts Council, Sydney, 1975, p. 49.

Nyapari and Kalka
1. www.waru.org/communities/nyapari (2008).
2. C. Mountford, *Nomads of the Desert,* Rigby, Adelaide, 1976, p. 115.

NPY Lands
Introduction
1. Brochures and information issued by Hub Media, Perth, and on website of Western Desert Mob www.westerndesertmob.com.au

Warburton
1. Chronology of key dates in *Mission Times in Warburton,* Warburton Arts Project, WA, 2002, pp. 81–82 and www.tjulyuru.com/timeline.asp (2008).
2. G. Proctor, *Oxford Companion to Aboriginal Art and Culture*, Oxford University Press, Melbourne, 2001, p.731.

Papulankutja
1. D. Isgar, catalogue essay, *Blackstone Art,* Dickerson Gallery, Melbourne, April 2008.
2. S. McCulloch, conversation with D. Isgar, Melbourne, April 2008.
3. R. Churcher in R. Crumlin (ed.), *Aboriginal Art and Spirituality*, Dove Publications, HarperCollins, Melbourne, 1991, p 68.

Irrunytju
1. Report by lawyer and accountant, Neil Bell, Report of Organisational Audit Irrunytju Arts, commissioned by Desart and presented to the Senate Enquiry on Aboriginal Art, November 2006.

www.aph.gov.au/.../ecita_ctte/completed_inquiries/2004-07/indigenous_arts/submissions/sub49att3.pdf.
2. N. Rothwell, 'Desert artists make a move', *The Australian,* 17 October 2006, p.10.
3. As reported in the media (S. Butcher, 'Breach puts art dealer in jail', *The Age,* 25 July 2007), Ioannou had pleaded guilty, and was ordered by a Victorian County Court judge, to serve a further six month jail sentence added to that of a previous 10 months served, for breaching a partly suspended sentence for 'violent offences against his estranged wife.'

Warakurna
1. Letter to the authors via art centre manager Edwina Circuitt from David Brooks, principal anthropologist, Ngaanyatjarra Council, 2008.

Tjukurla
2. www.tjulyuru.com/comm.asp (2008).

The West and Kimberley
Introduction
1. J. Ryan, *Images of Power: Aboriginal Art of the Kimberley*, National Gallery of Victoria, Melbourne, 1993, p. 3.
2. S. McCulloch, interview with Queenie McKenzie, October 1996.
3. *Footprints Across Our Land*, Magabala Books, Broome, 1995, p. 118.

Balgo
1. C. Watson, *Piercing the Ground*, Fremantle Arts Centre Press, Perth, 2003, p. 127.
2. Ibid., p. 126.
3. Ibid., p. 70.

Fitzroy Crossing and Wangkatjungka
1. J. Ryan, *Images of Power: Aboriginal Art of the Kimberley*, National Gallery of Victoria, Melbourne, 1993, p. 66.

Kununurra
1. *Last Tango in Wyndham,* Raft Artspace catalogue, February 2008, quoting N. Rothwell, *The Weekend Australian*, 21 July 2007.

Broome / Bidyadanga
1. E. Rohr, speech notes provided to the authors for opening of Bidyadanga Artists, exhibition *Jila,* Chapman Gallery, Canberra, February 2006.
2. E. Rohr, catalogue *Winpa*, Raft Artspace, Darwin, 2007.

Warmun
1. S. McCulloch, telephone interviews with M. Macha, 1995.
2. W. Caruana, *Roads Cross,* exhibition catalogue, National Gallery of Australia, Canberra, 1994 and interviews with S. McCulloch, 1995.

Kalumbaru and Derby
1. A. Elkin writing in *Australian Aboriginal Art*, Ure Smith, Sydney, 1964, p. 15.
2. J. Ryan, *Images of Power*, National Gallery of Victoria, Melbourne, 1993, p. 15.

The Martu

1. S. Davenport and P. Johnson, *Cleared Out: First Contact in the Western Desert,* Aboriginal Studies Press, Canberra, 2005, p. ix.
2. Ibid.
3. Ibid., pp. 7–16.
4. Wangka Maya Pilbara Aboriginal Language Centre information on website of Archaeological Computing Laboratory, University of Sydney (http://acl.arts.usyd.edu.au).
5. S. Rintoul, 'Boldy out of the West', *The Australian,* 22 November 2007.
6. M. Walker, media release for Jurtirangu exhibition by Martumili Artists, Randell Lane Fine Art, 25 January–15 February 2008.

Top End and Arnhem Land

Introduction

1. P. Tweedie and D. Bennett, *Spirit of Arnhem Land,* JB Books, Marleston, 2005, p. 27.
2. Ibid.
3. H. Morphy, *Aboriginal Art,* Phaidon, London, 1998, p. 152.
4. Quoted in P. Tweedie and D. Bennett, *Spirit of Arnhem Land,* op. cit., p. 23.
5. R. Berndt, *Australian Aboriginal Art,* Methuen, Sydney, 1951, p. 87.

Darwin and surrounds

1. T. Bauman, *Aboriginal Darwin,* Australian Institute of Aboriginal and Torres Strait Islander Studies (AIATSIS), Canberra, 2006, p xxi.
2. Ibid., p. 128.
3. S. Kleinert and M. Neale (eds), *Oxford Companion to Aboriginal Art and Culture,* Oxford University Press, Melbourne, 2000, p. 153.

Daly River

1. E. Farrelly, *Dadirri – The Spring Within: The Spiritual Life of the Aboriginal People from Australia's Daly River Region,* Terry Knight and Associates, Darwin, 2003, p. 3.
2. Quoted in Farrelly, op. cit., p. 1.
3. Ibid., p. viii.

Wadeye

1. Entry for Nemarluk, *Australian Dictionary of Biography,* www.adb.online.anu.edu.au
2. R. Manne, 'Pearson's gamble, Stanner's dream', *The Monthly,* August 2007.
3. W. Caruana, *Aboriginal Art,* Thames and Hudson, London, 2003, p. 96.
4. Ibid. See also M. West, *Oxford Companion to Aboriginal Art and Culture,* Oxford University Press, Melbourne, 2003, p. 726.
5. Ibid.
6. *Art from the Heart* documentary directed by R. Moore, Ronin Films, Canberra, 1999.
7. G. Manton, 'Wadeye people', www.reddust.org.au/about/news/article-wadeye-people (2008).
8. K. Barber, *Aboriginal Art in Modern Worlds,* National Gallery of Australia, Canberra, 2000. (available online)
9. M. West, op. cit., p. 726.
10. J. Taylor and O. Stanley, 'The opportunity costs of the status quo in the Thamarrurr region', Centre for Aboriginal Policy and Research, Canberra, 2005.

Gunbalunya

1. L. Taylor, *Painting the Land Story,* National Museum of Australia, Canberra, 1999, p. 49.

Milingimbi

1. A. Marshall, *Ourselves Writ Strange,* Cheshire, Melbourne, 1994. Tom Djawa quoted in D. Mundine, *The Native Born,* Museum of Contemporary Art, Sydney, 2001, pp. 41 and 51.
2. N. Peterson and D. Thomson in *Donald Thomson in Arnhem Land,* The Miegunyah Press, Melbourne, 2003, p. 93.
3. www.lyl.nt.gov.au (2008).
4. The Arnhem Land Progress Association Inc: www.alpa.asn.au (2008).
5. Entry for W. Lloyd Warner (1898–1970), *Australian Dictionary of Biography,* www.adbonline.com.au and W.L. Warner, *A Black Civilization: A Social Study of an Australian Tribe,* Harper and Row, New York, 1937.
6. J. Ryan, *Spirit in Land: Bark Paintings from Arnhem Land,* National Gallery of Victoria, Melbourne, 1999, p. 18.
7. Catalogue of *Australian Aboriginal Art: Bark Paintings, Carved Figures, Sacred and Secular Objects,* arranged by the State Galleries of Australia 1960–1961, p. 23.
8. P. Tweedie, *Spirit of Arnhem Land,* JB Books, Marleston, 2005, p. 18; D. Mundine, *The Native Born,* op. cit., p. 65.
9. D. Mundine, op. cit., p. 78.
10. Information sheet, *Goyurr Manda Dhan'kawu and the Morning Star,* Mossenson Galleries, Collingwood Vic., 31 Jan–15 Feb 2007.
11. B. and S. Westley, Managers Elcho Island Arts, 1990s, quoted on Aboriginal Art Online forum www.aborginalartonline.com.au (2008).
12. Information sheet, *Goyurr Manda Dhan'kawu and the Morning Star,* op. cit.

Ramingining

1. D. Mundine, *The Native Born,* Museum of Contemporary Art, Sydney, 2001, pp. 73–75.

Galiwin'ku

1. A number of Galiwin'ku's famous artists are also church leaders. McIntosh in *Oxford Companion to Aboriginal Art and Culture,* Oxford University Press, Melbourne, 2000, p. 580.
2. The melding of religions was named the 'adjustment movement' by R. Berndt in his book *The Adjustment Movement in Arnhem Land, Northern Territory of Australia,* Mouton and Co., Paris, 1962.

Maningrida

1. www.maningrida.com (2008).
2. J. Altman, 'Brokering Kuninjku Art: Artists, institutions and the market', *Crossing Country,* Art Gallery of New South Wales, Sydney, 2004, p. 175.
3. Ibid., pp. 175–77.
4. S. McCulloch, interviews with Lin Onus, Melbourne, 1994–96.
5. S. McCulloch, email correspondence with Apolline Kohen, February 2008.
6. S. McCullloch, interview with Murray Garde, Maningrida, 1995.
7. D. Moon, *Artlink,* Autumn/Winter 1990.

Groote Eylandt

1. D. Thomson, *Donald Thomson in Arnhem Land,* (ed.

N. Peterson), The Miegunyah Press, Melbourne, 2003, p. 110.
2. Ibid., pp. 110–11.
3. A. Marshall, *Ourselves Writ Strange,* Cheshire, Melbourne, 1955, pp. 133–35.
4. M. West, *Oxford Companion to Aboriginal Art and Culture*, Oxford University Press, Melbourne, 2000, p. 597.
5. Ibid.

Yirrkala
1. A. McCulloch, *Aboriginal Bark Paintings from the Cahill and Chaseling Collections*, National Museum of Victoria/Museum of Fine Arts, Houston, Texas, 1965.
2. S. McCulloch, interview with Margaret Tuckson, Sydney, July 2006.
3. H. Morphy in *Oxford Companion to Aboriginal Art and Culture*, Oxford University Press, Melbourne, 2001, p. 550.
4. Banduk Marika, *Aratjara*, Germany, 1993, p. 69.
5. H. Morphy, *Aboriginal Art*, Phaidon, London, 1998, p. 550.
6. R. Berndt and others, *Aboriginal Art*, Collier Macmillan London and Ure Smith, Sydney, 1964, p. 28.
7. S. McCulloch, interview with Andrew Blake, 2000.
8. S. McCulloch, 'Galumbu Yunipingu', *Australian Art Collector*, 30, Oct–Dec 2004.

Ngukurr
1. S. McCulloch, 'Ginger Riley', *The Australian,* 15 July 1997, p. 5.

Tiwi Islands (Bathurst and Melville)
1. D. Conroy, 'Tiwi Designs: An Aboriginal Silk Screening Workshop' in R. Edwards (ed.), *Aboriginal Art in Australia*, Ure Smith, Sydney, 1978, pp. 50–51.
2. Ibid., pp. 51–52.
3. K. Barnes, 'Tiwi designs', *Artlink*, Contemporary Aboriginal Art Issue, vol. 10, no.s 1 and 2, 1999.

Queensland and Torres Strait Islands
Introduction
1. A. Herle and J. Philip, 'Between Islands' in *Oxford Companion to Aboriginal Art and Culture*, Oxford University Press, Melbourne, 2000, p.155.
2. B. Robinson and T. Tremblay, *Ailan Currents: Contemporary Printmaking from the Torres Strait*, KickArts, Cairns, 2007, p. 20.
3. S. Wright, *Sesserae: The Works of Dennis Nona*, Griffith Artworks, Brisbane, 2005, pp. 7–8.
4. A. Herle and J. Philip, 'Between Islands' in *Oxford Companion*, op. cit., p. 157.
5. *Janice Peacock: Acquisition*, Art Gallery of South Australian newsletter, October/November 2005.
6. www.nma.gov.au/exhibitions/now_showing/dhari_a_krar/rosie_barkus (2008).
7. A. Herle and J. Philip, 'Between Islands' in *Oxford Companion*, op. cit., p. 162 and p. 158.
8. B. Robinson and T. Tremblay, op. cit., p. 9.
9. S. Wright, op. cit., pp 9–10.
10. Ibid.
11. Ibid.
12. Margaret Lawrie's collection and documentation of the history, language and culture of Torres Strait

Islanders in the State Library of Queensland is highly significant. Her books include *Myths and Legends of the Torres Strait,* University of Queensland Press, Brisbane, 1970.
13. B. Robinson and T. Tremblay, op. cit., p. 23.

Aurukun
1. P. Sutton, 'High Art and Religious Intensity: A Brief History of Wik sculpture' in *Aboriginal Art in Modern Worlds*, National Gallery of Australia, Canberra, 2000. (available online)
2. Ibid.
3. J. Bosse, interview with Jeanie Adams, *Puulway, Wik and Kugo Totems: Contemporary Australian Sculpture from Aurukun*, Gallery Gabrielle Pizzi, Melbourne, n.d.

Lockhart River
1. S. McCulloch, interview, Lockhart River, 1999.
2. Ibid.
3. S. McCulloch in 'Water marks', *The Weekend Australian,* Review section, 21–22 July 2001.
4. M. Neale quoted in 'Water marks', op. cit.
5. S. McCulloch, interview with Samantha Hobson, Vivien Anderson Gallery, Melbourne, 2002.
6. Invitation, *Umpoula Kououkouounji Ma'apina: We Old Girls work together to make a painting*, Emerge Art Space, Perth, 30 April–18 May 2008.

Mornington Island
1. Abbreviated from the introductory essay by P. Memmott and S. McCulloch in *The Heart of Everything: The Art and Artists of Mornington and Bentinck Islands*, McCulloch & McCulloch Australian Art Books, Melbourne, 2008, pp. 12–13.
2. P. Memmott, 'Origins of the Contemporary Art Movement' in *The Heart of Everything*, op. cit., pp. 17–18.
3. Ibid., p. 18.
4. D. Roughsey, *Moon and Rainbow: The Autobiography of an Aboriginal*, Reed, Sydney, 1971. E. Roughsey (ed. P. Memmott and R. Horsman), *An Aboriginal Mother Tells of the Old and the New,* McPhee Gribble/Penguin, 1984.
5. N. Evans, 'People of the Strand: The Kaidilt of Bentinck Island' in *The Heart of Everything*, op. cit., p. 55.
6. P. Memmott in *The Heart of Everything*, op. cit., p. 19.

Into the New
1. Introduction to Boomalli on its website www.boomalli.org.au which explains the difficulties of urban indigenous artists having their work shown as 'authentic' Aboriginal art which led to the foundation of this artists' cooperative in 1987.
2. F. Foley, 'On the Power and Beauty of Political Art', *Art Monthly*, Issue 209, May 2008.
3. Katrina Schwarz, *Art & Australia*, www.artaustralia.com/emergingartist_jonathanjones.asp
4. http://209.85.173.104/arch?q=cache:XpLlvWGt2dUJ:www.nt.gov.au/nreta/publications/media/pdf/2007/07/20070725daniemellor.pdf+danie+mellor&hl=en&ct=clnk&cd=7&gl=au
5. Media release, 50perCENT, Jan Manton Art, Brisbane, 2007.

General references

Art & Australia, 'Special Aboriginal issues', 13 April 1976, 16 April 1979, 31 January 1993, Ure Smith, Sydney.

Artlink, 'Special Aboriginal Issue', Autumn/Winter 1990, reprint 1992.

Berndt, R. and C., *The World of the First Australians*, Aboriginal Studies Press, Canberra, 1999.

Berndt, R. and others, *Aboriginal Art*, Collier Macmillan London and Ure Smith, Sydney, 1964.

Black, R., *Old and New Australian Aboriginal Art*, Angus and Robertson, Sydney, 2004.

Caruana, W., *Aboriginal Art*, Thames and Hudson, London, 1993; revised edition 2002.

Croft, B. (ed.), *Beyond the Pale: Contemporary Indigenous Art, 2000*, Art Gallery of South Australia, Adelaide, 2000.

Croft, B. (ed.), *Cultural Warriors*, National Gallery of Australia, Canberra, 2007.

Crumlin, R. and Knight, A. (eds), *Aboriginal Art and Spirituality*, Dove Publications, HarperCollins, Melbourne, 1991; reprinted 1992, 1995.

Davies, S. (ed), *Collected;150 years of Aboriginal Art*,

SELECTED RECOMMENDED READING

Macley Museum, University of Sydney, NSW, 2006.

Ebes, H., *Nangara: The Australian Aboriginal Art Exhibition from the Ebes Collection*, exhibition catalogue, Melbourne, 1996.

Edwards, R. (ed.), *Aboriginal Art in Australia*, Ure Smith, Sydney, 1978.

Flood, J., *Archaeology of the Dreamtime: The Story of Prehistoric Australia and its People*, Angus and Robertson, Sydney, 1999.

Hamby, L. and Young, D., *Art on a String*, Object – Australian Centre for Art and Design, 2001.

Hiatt, L.R., *Arguments about Aborigines: Australia and the Evolution of Social Anthropology*, Cambridge University Press, Cambridge, 1996.

Horton, D. (ed.), *The Encyclopedia of Aboriginal Australia*, Institute of Aboriginal Studies Press, Canberra, 1994.

Isaacs, J., *Aboriginal Paintings*, Weldon Publishing, Sydney, 1989.

Isaacs, J., *Australia's Living Heritage: Arts of the Dreaming*, Lansdowne Press, Sydney, 1984.

Isaacs, J., *Renewing the Dreaming: The Aboriginal Homelands Movements*, The Australian Museum, Sydney, 1977.

Isaacs, J., *Spirit Country: The Gantner Myer Collection*, Hardie Grant, Melbourne, 2001.

Kleinert, S. and Neale, M. (eds), *Oxford Companion to Aboriginal Art and Culture*, Oxford University Press, Melbourne, 2000.

Kupka, K., *Un Art à L'état Brut*, Lausanne, Switzerland, 1962; English translation *Dawn of Time*, Angus and Robertson, Sydney, 1965.

Layton, R., *Rock Art: A New Synthesis*, Cambridge University Press, Cambridge, 1992.

Luthi, B. (ed.) and Aboriginal Arts Board of the Australia Council, *Aratjara, Art of the First Australians: Traditional and Contemporary Work by Aboriginal and Torres Strait Islander Artists*, Germany, 1993.

McCulloch's Encyclopedia of Australian Art, Aus Art Editions and The Miegunyah Press, Melbourne, 2006.

McGuigan, C. (ed.), *New Tracks Old Land: Contemporary Prints from Aboriginal Australia*, exhibition catalogue, Aboriginal Arts Management Association, Sydney, 1992.

Morphy, H., *Aboriginal Art*, Phaidon, London, 1998.

Morphy, H. and Lendon, N. (eds), *Synergies*, Australian National University, Canberra, 2003.

Morphy, H. and Smith Boles, M., *Art from the Land*, University of Virginia, Virginia, 1999.

Mountford, C., *Nomads of the Australian Desert*, Rigby, Adelaide, 1976.

Myers, F., *Painting Culture: The Making of an Aboriginal High Art*, Duke University Press, Durham, 2002.

National Aboriginal and Torres Strait Islander Art Award, annual catalogues, 1990–2004.

National Gallery of Australia, *Aboriginal Art in Modern Worlds*, National Gallery of Australia, Canberra, 2000.

Neale, M., *Yiribana: Catalogue of the Aboriginal and Torres Strait Islander Art Collection*, Art Gallery of New South Wales, Sydney, 1992.

Perkins, H., *Aboriginal Women's Exhibition*, Art Gallery of New South Wales, Sydney, 1991.

Perkins, H. (ed.), *One Sun One Moon*, Art Gallery of New South Wales, Sydney, 2007.

Rothwell, N., *Another Country*, Black Inc., Melbourne, 2007.

Ryan, J. (ed.), *Colour Power*, National Gallery of Victoria, Melbourne, 2005.

Ryan, J., *Landmarks: Indigenous Australian Art in the National Gallery of Victoria*, National Gallery of Victoria, Melbourne, 2006.

Sayers, A., *Aboriginal Artists of the Nineteenth Century*, Oxford University Press, Melbourne, 1994.

Spencer, B., *The Native Tribes of Central Australia*, 1899; *Northern Tribes of Central Australia*, 1904; *Native Tribes of the Northern Territory*, 1914; *The Arunta*, 1927; *Wanderings in Wild Australia*, 1928; all published by Macmillan, London.

Sutton, P. (ed.), *Dreamings: The Art of Aboriginal Australia*, Viking, New York, 1988.

Taylor, L. (ed.), *Painting the Land Story*, National Museum of Australia, Canberra, 1999.

West, M. (ed.), *The Inspired Dream*, Queensland Art Gallery, Brisbane, 1988.

Winter, J., *Native Title Business*, Keeaira Press, Southport, 2002.

Central Australia

Desart: Aboriginal Art and Craft Centres of Central Australia, Desart, Alice Springs, 1993.

Desert Mob catalogues, annually 2002 – .

Green, J., *The Town Grew Up Dancing: The Life and Art of Wenten Rubuntja*, IAD Press, Alice Springs, 2004.

Johnson, V., *Aboriginal Artists of the Western Desert: A Biographical Dictionary*, Craftsman House, Sydney, 1994; reprinted 2001.

Johnson, V., *Dreamings of the Desert: A History of Western Desert Art, 1971–1996*, Art Gallery of South Australia, Adelaide, 1996.

Kreczmanski, J.B. and Birnberg, M., *Aboriginal Artists Dictionary of Biographies: Central Desert, Western Desert and Kimberley Region*, JB Books, Marleston, 2004.

Ryan, J., *Mythscapes: Aboriginal Art of the Desert*, National Gallery of Victoria, Melbourne, 1989.

Alice Springs to Tennant Creek

Keringke Arts, *Contemporary Eastern Arrernte Art*, Jukurrpa Books, IAD Press, Alice Springs, 2002.

Nickolls, C. (ed.), *Dancing Up Country: The Art of Dorothy Napangardi*, MCA, Sydney, 2002.

Papunya Kintore and Kiwirrkura

Bardon, G., *Papunya Tula: Art of the Western Desert*, McPhee Gribble/ Penguin Books, Melbourne, 1991.

Bardon, G. and J., *Papunya Tula: A Place Made After the Story*, The Miegunyah Press, Melbourne, 2004.

Croker, A. (ed.), *Mr Sandman Bring Me a Dream*, Papunya Tula Artists Pty Ltd, Alice Springs and Aboriginal Artists Agency Ltd, Sydney, 1981.

Johnson, V., *Papunya Painting: Out of the Desert*, National Museum of Australia, Canberra, 2008.

Johnson, V., *Clifford Possum Tjapaltjarri*, Art Gallery of South Australia, Adelaide, 2003.

Mellor, D. and Megaw, V., *Twenty-five Years and Beyond: Papunya Tula Painting*, Flinders Art Museum, South Australia, 1999.

Perkins, H. and Fink, H. (eds), *Papunya Tula: Genesis and Genius*, Art Gallery of New South Wales and Papunya Tula Artists Pty Ltd, Sydney, 2000.

Haasts Bluff

Strocchi, M. (ed.), *Ikuntji: Paintings from Haasts Bluff 1992–1994*, IAD Press, Alice Springs, 1994.

Yuendumu

Kurawarru: Yuendumu Doors, Aboriginal Studies Press, Canberra, 1992.

Opening Doors: The Art of Yuendumu, Waanders Uitgevers, Zwolle, Netherlands, 2005.

Utopia

Boulter, M., *The Art of Utopia*, Craftsman House, Sydney, 1991.

Brody, A.M., *Utopia: A Picture Story*, Heytesbury Holdings, Perth, 1992.

Isaacs, J. (ed.), *Emily Kngwarreye Paintings*, Craftsman House, Sydney, 1998.

Neale, M. (ed.), *Emily Kame Kngwarreye – Alhalkere: Paintings from Utopia*, Queensland Art Gallery and Macmillan Australia, Melbourne, 1998.

Neale, M. (ed.), *Emily Kame Kngwarreye*, National Museum of Australia, Canberra, 2008.

Nicholls, C. and North, I., *Kathleen Petyarre: Genius of Place*, Wakefield Press, Kent Town, 2001.

Hermannsburg

Amadio, N. and Kimber, R.G., *Wildbird Dreaming: Aboriginal Art from the Central Desert*, Greenhouse Publications, Melbourne, 1987.

Battarbee, R., *Modern Australian Aboriginal Art*, Angus and Robertson, Sydney, 1951.

French, A., *Seeing the Centre: The Art of Namatjira*, National Gallery of Australia and Araluen, Canberra, 2002.

Isaacs, J., *Hermannsburg Potters: Aranda Artists of Central Australia*, Craftsman House, Sydney, 2000.

West, M. and Kean, J., (eds), *Hermannsburg Potters*, Museum and Art Gallery of the Northern Territory, Darwin, 1996.

PY and NPY Lands

Eickelhamp, U., *Pitjantjatjara and Their Crafts*, Aboriginal Studies Press, Canberra, 1999.

Mountford, C., *Nomads of the Australian Desert*, Rigby, Adelaide, 1976.

Brokensha, P., *The Pitjantjatjara and Their Crafts*, Aboriginal Arts Council, Sydney, 1975.

Uluru

Isaacs, J., *Desert Crafts, Anangu Maruku Punu*, Doubleday Books, Sydney, 1992.

Tjanpi

Manguri Weaving: NPY Women's Council, Alice Springs, n.d.

Purich, T. in *Cultural Strands*, FORM Contemporary Art and Design, Perth, 2004.

Spinifex

Cane, S., *Pila Nguru: The Spinifex People*, Fremantle Arts Centre Press, Perth, 2002.

PY LANDS
Ernabella

Eickelhamp, U., *Don't Ask for Stories: The Women from Ernabella and Their Art*, Aboriginal Studies Press, Canberra, 1999.

Hilliard, W., *The People in Between: The Pitjantjatjara People of Ernabella*, Hodder and Stoughton, UK, 1968.

Kaus, D., *Ernabella Batiks*, National Museum of Australia, Canberra, 2003.

Ryan, J. and Healy, R., *Raiki Wara: Long Cloth from Aboriginal Australia and the Torres Strait*, National Gallery of Victoria, 1993.

NPY LANDS

Davenport, S. and Johnson, P., *Cleared Out: First Contact in the Western Desert*, Aboriginal Studies Press, Canberra, 2005.

Lewis, M., *Conversations with the Mob*, Fremantle Arts Centre Press, Perth, 2008.

Warburton

Warburton Arts Project, *Mission Times in Warburton*, Tjulyuru Regional Arts Gallery, Warburton, 2002.
Trust, Tjulyuru Regional Arts Gallery, Warburton, 2003.

Irrunytju

Knights, M., *Irrunytju Arts,* Irrunytju Arts Centre, Alice Springs, 2004.

The West and Kimberley

Footprints Across Our Land, Magabala Books, Broome, 1995.
Kimberley Aboriginal Law and Cultural Centre, *New Legends,* 2006.
Lowe, P. and Pike, J., *Jilji: Life in the Great Sandy Desert,* Magabala Books, Broome, 1992.
O'Ferrall, M., *Jimmy Pike: Desert Designs 1981–1995*, Art Gallery of Western Australia, Perth, 1995.
Peter, S. and Crofts, P. (eds), *Yaartji: Six Women's Stories from the Great Sandy Desert*, Aboriginal Studies Press, Canberra, 1997.
Ryan, J., *Images of Power: Aboriginal Art of the Kimberley*, National Gallery of Victoria, Melbourne, 1993.
Stanton, J.E., *Painting the Country: Contemporary Aboriginal Art from the Kimberley Region*, University of Western Australia Press, Perth, 1989.
Walsh, G., *Bradshaw Art of the Kimberley*, Takarakka Publications, Queensland, 2000.

Balgo

Cowan, J., *Wirrimanu*, Craftsman House, Sydney, 1994.
Warlayirti Artists, *Eubena Nampitjin: Art and Life*, 2006.
Watson, C., *Piercing the Ground*, Fremantle Arts Centre Press, Perth, 2003.

Fitzroy Crossing and Wangkatjungka

Mangkaja Arts Resource Agency, *Karrayili*, Tandanya, Adelaide, 1994.

Broome / Bidyadanga

McKelson, K., *Nganarna Nyangumarta Karajarrimili Ngurranga,* Wangka Maya Pilbara Aboriginal Language Centre, Western Australia, 2008.

Warmun

I Want to Paint, Holmes à Court Collection, Perth, 2003.
Thomas, R. and others, *Roads Cross,* National Gallery of Australia, Canberra, 1994.

Top End and Arnhem Land

Caruana, W., *Windows on the Dreaming*, National Gallery of Australia and Ellsyd Press, Sydney, 1989.
Caruana, W., and Lendon, N., *The Painters of the Wagilag Sisters Story 1937–1997*, National Gallery of Australia, Canberra, 1997.
Chaloupka, G., *Journey in Time*, Reed Books, Sydney, 1992; JB Books, Marleston, 1999.
Elkin, A., Berndt, C.H. and Berndt, R.M., *Art in Arnhem Land*, Cheshire, Melbourne, 1950.
Morphy, H. and Smith Boles, M. (eds), *Art from the Land,* University of Virginia, Virginia, 1999.
Holmes, S., *The Goddess and the Moon Man,* Craftsman House, Sydney, 1995.

Marshall, A., *Ourselves Writ Strange*, Cheshire, Melbourne, 1949.
Mundine, D. (ed.), *The Native Born*, Museum of Contemporary Art, Sydney, 2001.
Perkins, H. (ed.), *Crossing Country: The Alchemy of Western Arnhem Land Art*, Art Gallery of New South Wales, Sydney, 2004.
Ryan, J., *Spirit in Land: Bark Paintings from Arnhem Land*, National Gallery of Victoria, Melbourne, 1999.
Thomson, D. and Peterson, N., *Donald Thomson in Arnhem Land*, The Miegunyah Press, Melbourne, 2003.
Tweedie, P., *Spirit of Arnhem Land*, New Holland, 1998; reprinted 1999, 2001.
McCulloch, A., *Aboriginal Bark Paintings from the Cahill and Chaseling Collections*, National Museum of Victoria/Museum of Fine Arts, Houston, Texas, 1965.
Stringworld, *On and On: Stringworld Touring Exhibition 2002–2003*, Stringworld, Darwin, 2003.
Warner, W.L., *A Black Civilization: A Social Study of an Australian Tribe,* Harper and Row, New York, 1937; reprinted 1948, 1964.
Wongar, B., *Totem and Ore*, Dingo Books, Melbourne, 2006.

Darwin and surrounds

Bauman, T., *Aboriginal Darwin*, Australian Institute of Aboriginal and Torres Strait Islander Studies (AIATSIS), Canberra, 2006.

Daly River

Farrelly, E., *Dadirri – The Spring Within: The Spiritual Life of the Aboriginal People from Australia's Daly River Region,* Terry Knight and Associates, Darwin, 2003.

Wadeye

Caruana, W., *Likan'mirri: Connections*, Works from the AIATSIS Collection Catalogue, Canberra, 2004.
Idriess, I.L., *Nemarluk: King of the Wilds*, Angus and Robertson, Sydney, 1941.
Stanner, W.E.H., *White Man Got No Dreaming: Essays 1938–1973*, Australian National University Press, Canberra, 1979.
Ward, T., *The People and Their Land Around Wadeye*, Wadeye Press, Port Keats, 1983.

Gunbalunya

Kunwinjku Art from Injalak 1991–1992, The John W. Kluge Commission, Museum Arts International Pty Ltd, North Adelaide, 1994–95.
Mulvaney, J., *Paddy Cahill of Oenpelli*, Australian Institute of Aboriginal and Torres Strait Islander Studies (AIATSIS), Canberra, 2004.
West, M. (ed.), *Rainbow Sugarbag and Moon, Two Artists of the Stone Country: Bardayal Nadjamerrek and Mick Kubarkku*, Museum and Art Gallery of the Northern Territory, Darwin, 1994.

Groote Eylandt

Cole, Keith, *Fred Gray of Umbakumba*, Keith Cole Publications, Vic. 1984.

Yirrkala

Coyne, C., *Buku Larrnggay Mulka Printmakers (1996–98)*, Buku Larrnggay Mulka Centre, 1998.
Hutcherson, G., *Gong-wapitja: Women and Art from

Yirrkala, Northeast Arnhem Land, Aboriginal Studies Press, Canberra, 1998.

Isaacs, J., Saltwater: Yirrkala Paintings of Sea Country, Buku Larrnggay Mulka and Jennifer Isaacs Publishing, Sydney, 1999.

Isaacs, J., Wandjuk Marika: Life Story, University of Queensland Press, Brisbane, 1995.

Ngukurr

Normand, S., Stone Country to Saltwater: Recent Artwork and Stories from Ngukurr, Arnhem Land, Simon Normand, Ivanhoe, 2005.

Tiwi Islands (Bathurst and Melville)

Barnes, K., Kiripapurajuwi: Skills of Our Hands Good Craftsmen and Tiwi Art, National Aboriginal and Torres Strait Islander Coalition (NATSIC), 1999.

Mountford, C.P., The Tiwi: Their Art, Myth and Ceremony, Phoenix House, London and Georgian House, Melbourne, 1958.

Goodale, J., Tiwi Wives, University of Washington Press, Seattle, 1991.

Ryan, J., Kitty Kantilla, National Gallery of Victoria, Melbourne, 2008.

Schwerin, M. (comp.), Living Tiwi, Jilamara Arts and Crafts, Tiwi Islands, 2004.

Smith, H., Tiwi: The Life and Art of the Tiwi People, Angus and Robertson, Sydney, 1990; JB Books, Marleston, 1999.

Tiwi People of Melville Island, Jilamara Arts and Crafts and Munupi Arts and Crafts, 1994.

Tiwi Potters, Munupi Arts and Crafts, Melville Island, 1996.

Queensland and Torres Strait Islands

Demozay, M., Gatherings: Contemporary Aboriginal and Torres Strait Islander Art from Queensland, Keeaira Press, Southport, 2001; reprinted 2006.

Story Place: Indigenous Art of Cape York and the Rainforest, Queensland Art Gallery, Brisbane, 2004.

Tresize, P.J., Quinkan Country: Adventures in Search of Aboriginal Cave Paintings in Cape York, A.H. and A.W. Reed, Sydney, 1969.

Aurukun

Bosse, J. (ed), Puulway, Wik and Kugo Totems: Contemporary Australian Sculpture from Aurukun, Gallery Gabrielle Pizzi, Melbourne, 2007.

Carved from the Cape, Aurukun Arts Centre and Australian Art Resources, 2006.

Lockhart River

Butler, S., Our Way: Contemporary Aboriginal Art from Lockhart River, University of Queensland Press, Brisbane, 2007.

Edwards, R. and A. and the Lockhart River Art Gang, An Explorer's Guide to Lockhart River, The Rams Skull Press, Kuranda, 1999.

Warby, J., 'You-me Mates eh!', The Rams Skull Press, Kuranda,1999.

Mornington Island

Ahern, A. and the Mornington Island Elders, Paint-up, University of Queensland Press, Brisbane, 2002.

Evans, N., Dying Words: Fragile Languages and What They Have to Tell Us, Blackwells, Melbourne, 2008.

Evans, N., Martin-Chew, L. and Memmott, P., The Heart of Everything: The Art and Artists of Mornington and Bentinck Islands, McCulloch & McCulloch Australian Art Books, Melbourne, 2008.

Memmott, P. and Horsman, R., A Changing Culture: The Lardil Artists of Mornington Island, Social Science Press, Brisbane, 1991.

Roughsey, D., Moon and Rainbow: The Autobiography of an Aboriginal, Reed, Sydney, 1971.

Torres Strait Islands

Mosby, T. and Robinson, B., Ilan Pasin: This is Our Way: Torres Strait Island Art, Cairns Regional Gallery, Cairns, 1998.

Philips, J., Past Time: Torres Strait Islander Material from the Haddon Collection 1888–1905, National Museum of Australia exhibition catalogue, Canberra, 2001.

Robinson, B. and Tremblay, T., Ailan Currents: Contemporary Printmaking from the Torres Strait, KickArts, Cairns, 2007.

Tipoti, A. and Laza, A., Kuiyku Mabaigal: Waii and Sobai, Magabala Books, Broome, 1998.

Wright, S., Dennis Nona: Time After Time, The Miegunyah Press, Melbourne, 2008.

Wright, S., Sesserae: The Works of Dennis Nona, Griffith Artworks, Brisbane, 2005.

Into the New

Croft, B. and Ryan, J., Wiradjuri: Spirit Man, Craftsman House, Sydney, 1991.

Foley, F., The Art of Politics; The Politics of Art: The Place of Indigenous Contemporary Art, Keeaira Press, Southport, 2006.

Genocchio, B., Solitaire: Fiona Foley, Piper Press, Sydney, 2001.

Isaacs, J., Aboriginality: Contemporary Aboriginal Paintings and Prints, University of Queensland Press, Brisbane, 1989.

McLean, I., The Art of Gordon Bennett, Craftsman House, Sydney, 1996.

Morgan, S., The Art of Sally Morgan, Viking/Penguin Books, Melbourne, 1996.

Note re images

This book is a review and survey of Aboriginal art and artists. The images we have chosen to reproduce illustrate our text which discusses an artist's style, development or other aspect of their art or that of the relevant art centre or region. Some images were reproduced in previous editions of this book and we received, on our request, several thousand more images from artists, art centres, private and public galleries, auction houses, collectors and others for possible inclusion in this edition. Full accreditation is given with the caption of each work and we regret that we cannot reproduce more of the works supplied. We gratefully thank those who supplied the images and the artists and their agents who so freely gave permission for their reproduction. Please contact the publishers with any enquiries.

The following lists the approximately 75 arts centres throughout Australia which feature in this book. In addition, there are more than 30 smaller centres, some operating as marketing and display outlets, others in development. Almost all are members of one or several of the following advocacy and support groups:

Desart www.desart.com.au (Central, southern and western desert regions arts centres)

Ananguku Arts www.ananguku.com.au (PY and NPY Lands)

ANKAAA www.ankaaa.org.au (Northern, western, central regions artists and arts centres)

Western Desert Mob www.westerndesertmob.com.au (some NPY arts centres)

Tiwi Art Network www.tiwiart.com (Melville and Bathurst Islands arts centres)

Koorie Heritage Trust www.koorieheritagetrust.com (Presents exhibitions, maintains significant keeping places and historical information and initiates educative and other programmes and awards to facilitate and promote the art and culture of indigenous people of Victoria.)

Websites are given for arts centres and organisations; where centres do not have websites and for other information, please contact the groups above. Please note that permits and/or appointments are required for visits to many art centres. Please enquire with any centre before visiting.

ART CENTRES BY REGION

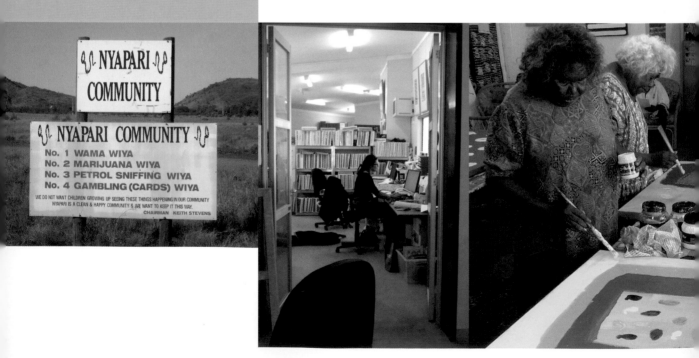

Central Australia
Alice Springs to Tennant Creek
Bindi Inc. Mwerre Anthurre Artists
Greenbush Art Group
Irrkerlantye Arts
www.irrkerlantye.com.au
Ngurratjuta Iltja Ntjarra Art Centre
www.ngurart.com.au
Tangentyere Artists
Yarrenty-Altere Artists

Surrounding Alice
Ali Curung
Ali Curung Women's Centre
www.alicurungarts.com

Santa Teresa (Ltyentye Apurte)
Keringke Arts
www.keringkearts.com.au

Titjikala
Titjikala Art Centre
www.titjikalaarts.com.au

Tennant Creek
Barkly Regional Arts
www.barklyarts.com.au
Julalikari Arts
www.julalikariarts.com
Nyinkka Nyunyu Art and Cultural
Centre
www.nyinkkanyunyu.com.au

Papunya Kintore and Kiwirrkura
Papunya Tula Artists Pty Ltd
www.papunyatula.com.au
Papunya Tjupi

Mount Liebig
Watiyawanu Artists of Amunturrng

Haasts Bluff
Ikuntji Artists
www.ikuntji.com.au

Yuendumu
Warlukurlangu Artists
www.warlu.com

Utopia
Artists of Ampilatwatja

Hermannsburg
Hermannsburg Potters
www.hermannsburgpotters.
com.au
Ntaria Women's Cultural Centre

PY and NPY Lands
Tjanpi Desert Weavers
www.tjanpiaboriginalbaskets.
com

Uluru
Maruku Arts
www.maruku.com.au
Walkatjara Art
www.walkatjara.com.au

Spinifex
Spinifex Arts Project
www.spinifex.org

PY Lands
Ernabella
Ernabella Arts
www.ernabellaarts.com.au

Fregon
Kaltjiti Arts
www.kaltjitiarts.com.au

Indulkana
Iwantja Arts and Crafts
www.iwantjaarts.com.au

Amata
Tjala Arts www.tjalaarts.com.au

Nyapari, Watarru, Kanpi
Tjungu Palya Artists

Kalka and Pipalyatjara
Ninuku Arts
www.ninukuarts.com.au

NPY Lands
Warburton
Tjulyuru Cultural and Civic Centre
www.tjulyuru.com
Warburton Arts Project
www.warburtonarts.com

Papulankutja
Papulankutja Artists
www.papulankutja.com.au

Irrunytju
Irrunytju Arts
www.irrunytju.com.au

Patjarr
Kayili Artists www.kayili.com.au

Warakurna
Warakurna Artists
www.warakurnaartists.com.au

Tjukurla
Tjarlirli Arts

The West and Kimberley
Halls Creek
Yarlilyil Art Centre

Balgo
Warlayirti Artists
www.balgoart.org.au

Fitzroy Crossing
Mangkaja Arts
www.mangkaja.com
Wangkatjungka Arts

Kununurra
Jirrawun Arts
www.jirrawunarts.com
Red Rock Gallery
www.redrockgallery.com
Waringarri Arts
www.waringarriarts.com.au

Bidyadanga
Yulparija Artists
www.shortstgallery.com.au

The sign outside Nyapari community, South Australia (far left) reminds visitors that alcohol, drugs and gambling are banned in this peaceful community. Art centre manager Cecilia Alfonso (centre) in the office adjoining the spacious display area of Warlukurlangu Art Centre, Yuendumu and the Bentinck Island artists Amy Loogatha and Paula Paul (right) paint at Queensland's Mornington Island Arts & Craft. [Photos S. McCulloch and Brett Evans.]

Large tamarind trees shade the art centre at Milingimbi, still housed in its original 1970s building. [Photo S. McCulloch.]

Bindi Inc. in Alice Springs houses a showcase and studios of Mwerre Anthurre Artists. [Photo S. McCulloch.]

Warmun
Warmun Art Centre
www.warmunart.com

Derby
Mowanjum Artists Spirit of the Wandjina
www.mowanjumarts.com

The Martu
Martumili Artists

Top End and Arnhem Land
Darwin
Dunnilli Arts
Larrakia Art Centre

Batchelor
Coomalie Cultural Centre
www.coomalie.nt.gov.au

Katherine
Jarraluk Arts and Crafts
Manyallaluk Art and Craft Centre
www.jawoyn.org
Mimi Arts and Crafts
www.mimiarts.com

Timber Creek
Ngaliwurru-Wuli Assoc.

Beswick
Djilpin Arts
www.djilpinarts.org.au

Daly River
Merrepen Arts

Peppimenarti
Durrmu Arts
www.durrmu.com.au

Wadeye
Wadeye Arts and Craft
www.aboriginalart-wadeye.com.au

Borraloola
Waralungku Art Centre
www.waralungku.com

Arnhem Land
Kakudu
Marrawuddi Gallery
www.marrawuddi.com

Goulburn Island
Mardbalk Arts
www.warruwi.nt.gov.au

Gunbalunya
Injalak Arts and Crafts
www.injalak.com

Milingimbi
Milingimbi Art Centre
www.milingimbiart.com

Ramingining
Bula'bula Arts
www.bulabula-arts.com

Galiwin'ku
Elcho Island Art and Craft
www.elchoartcraft.com

Maningrida
Maningrida Arts and Culture
www.maningrida.com

Groote Eylandt
Anindilyakwa Art
www.anindilyakwaart.com

Ngukurr
Ngukurr Arts

Yirrkala
Buku-Larrnggay Mulka Centre
www.yirrkala.com

Tiwi Islands
Bathurst Island
Ngaruwanajirri Inc.
Tiwi Design
www.tiwidesign.com

Melville Island
Jilamara Arts and Crafts site.
jilamara.com
Munupi Arts and Crafts
www.munupiart.com

Queensland
Aurukun
Aurukun Art

Lockhart River
Lockhart River Art Centre
www.artgang.com.au

Mornington Island
Mornington Island Arts and Craft
www.woomerami.org

Torres Strait Islands
Gab Titui Cultural Centre

Victoria
Koorie Heritage Trust
www.koorieheritagetrust.com

INDEX

Other books from McCulloch & McCulloch Australian Art Books

McCulloch's Encyclopedia of Australian Art
McCulloch's Encyclopedia AUSTRALIAN ART DIARY 2009
The Heart of Everything; the art and artists of Mornington & Bentinck Islands
New Beginning: Classic Paintings from the Corrigan Collection of 21st Century Aboriginal Art
And other books on Australian and Aboriginal art

www.mccullochandmcculloch.com.au

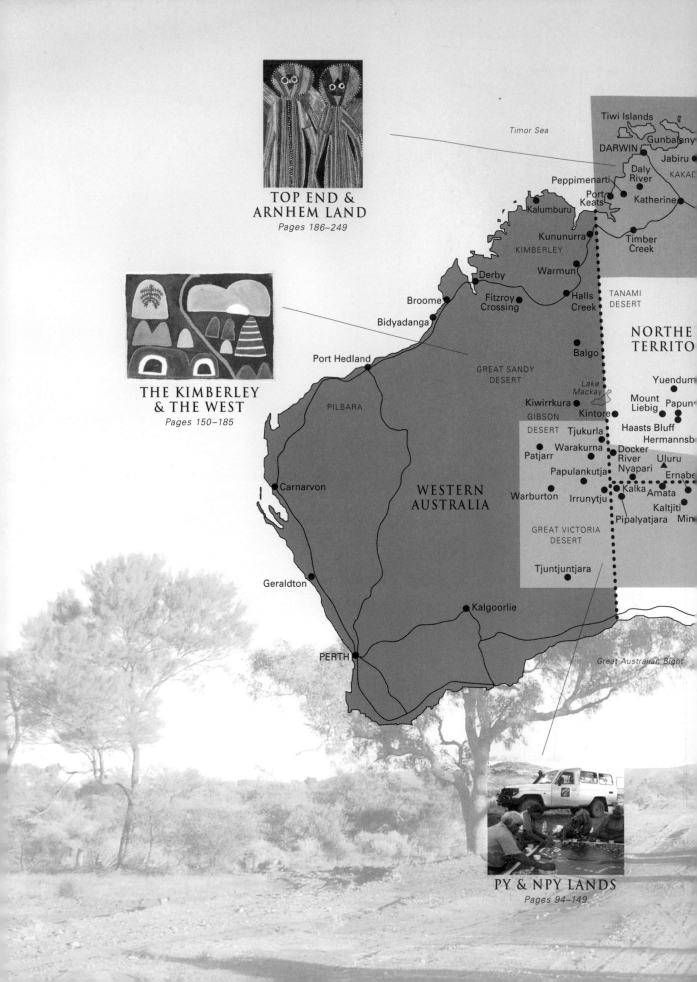

TOP END & ARNHEM LAND
Pages 186–249

THE KIMBERLEY & THE WEST
Pages 150–185

PY & NPY LANDS
Pages 94–149

Timor Sea

Tiwi Islands
DARWIN
Gunbalany
Jabiru
KAKAD
Peppimenarti
Daly River
Port Keats
Katherine

Kalumburu
Kununurra
KIMBERLEY
Timber Creek

Derby
Warmun
TANAMI DESERT

Broome
Fitzroy Crossing
Halls Creek

Bidyadanga

Balgo

NORTHE
TERRITO

Port Hedland
GREAT SANDY DESERT
Lake Mackay

Yuendum

PILBARA
Kiwirrkura
Kintore
Mount Liebig
Papun

GIBSON DESERT
Tjukurla
Haasts Bluff
Hermannsb

Patjarr
Warakurna
Docker River
Uluru
Ernabe

Papulankutja
Nyapari

Carnarvon
Warburton
Irrunytju
Kalka
Amata

WESTERN AUSTRALIA
Pipalyatjara
Kaltjiti
Min

GREAT VICTORIA DESERT

Geraldton

Tjuntjuntjara

Kalgoorlie

PERTH
Great Australian Bight